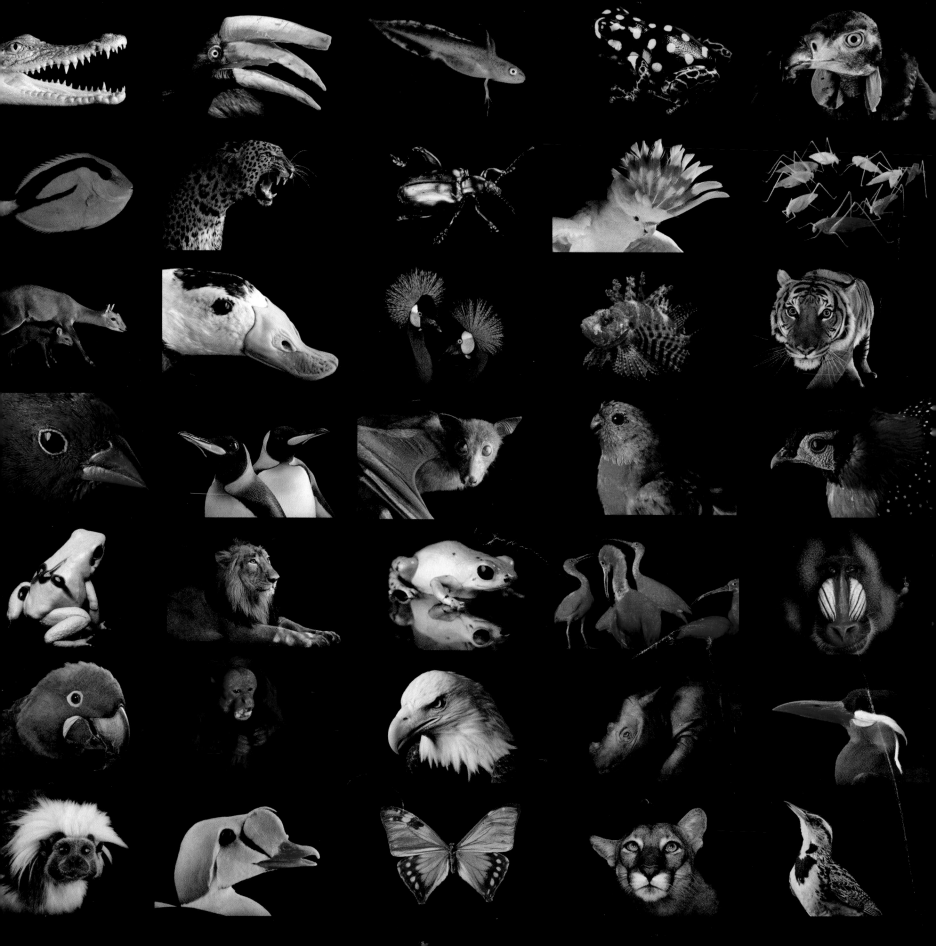

NATIONAL GEOGRAPHIC

# The Photo Ark

## ONE MAN'S QUEST TO DOCUMENT THE WORLD'S ANIMALS

### JOEL SARTORE

*Foreword by*
### HARRISON FORD

*Introduction by*
### DOUGLAS H. CHADWICK

NATIONAL GEOGRAPHIC
WASHINGTON, D.C.

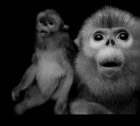
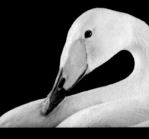

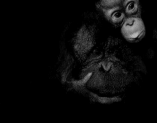
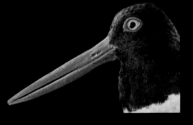
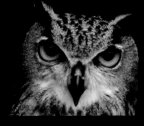
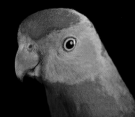
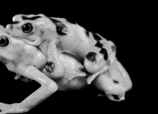

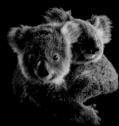
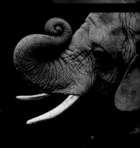

Malayan tiger *(Panthera tigris jacksoni)* CR

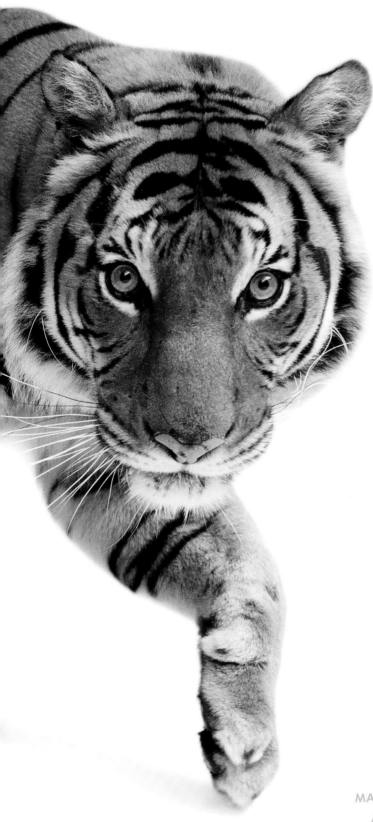

# Contents

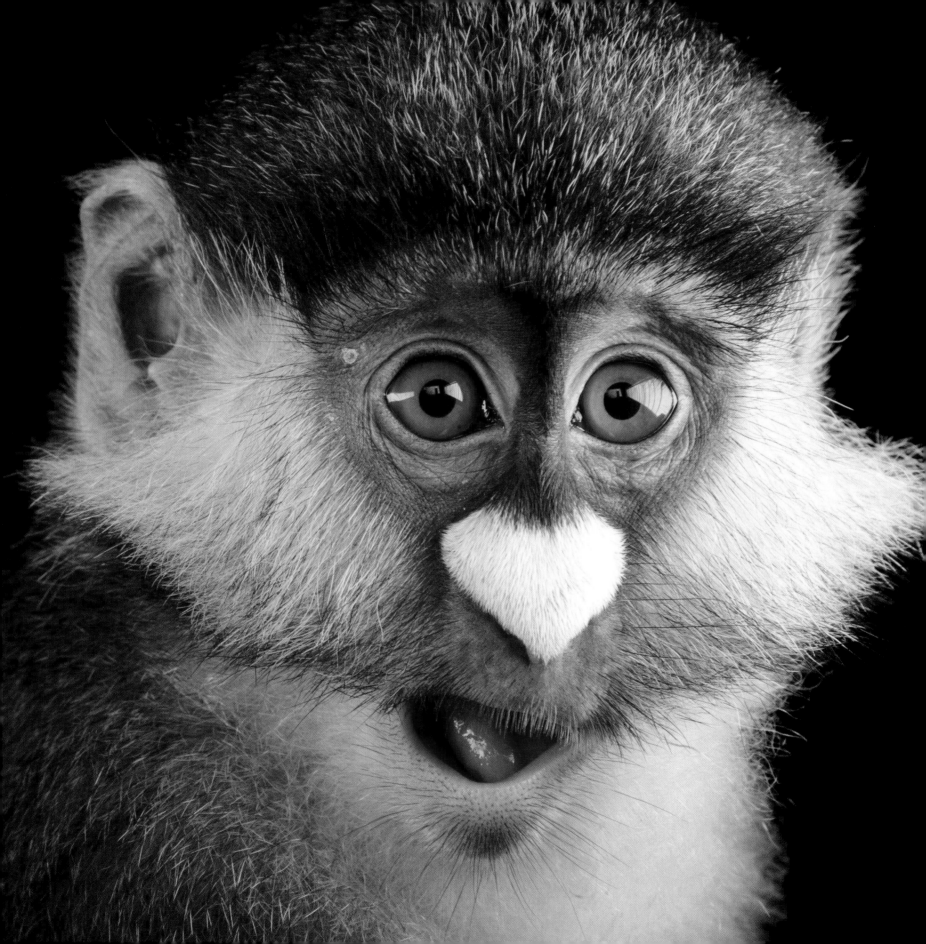

OPPOSITE: **Red-tailed guenon**
*(Cercopithecus ascanius schmidti)* LC

**Andean condor** *(Vultur gryphus)* NT

Blue-spotted Charaxes butterfly
*(Charaxes cithaeron)* NE

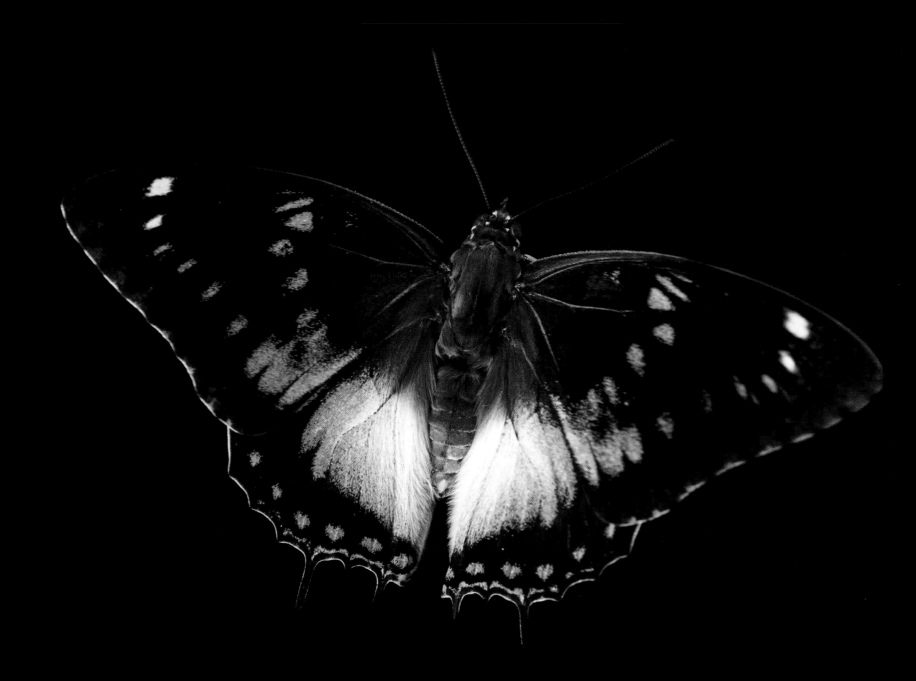

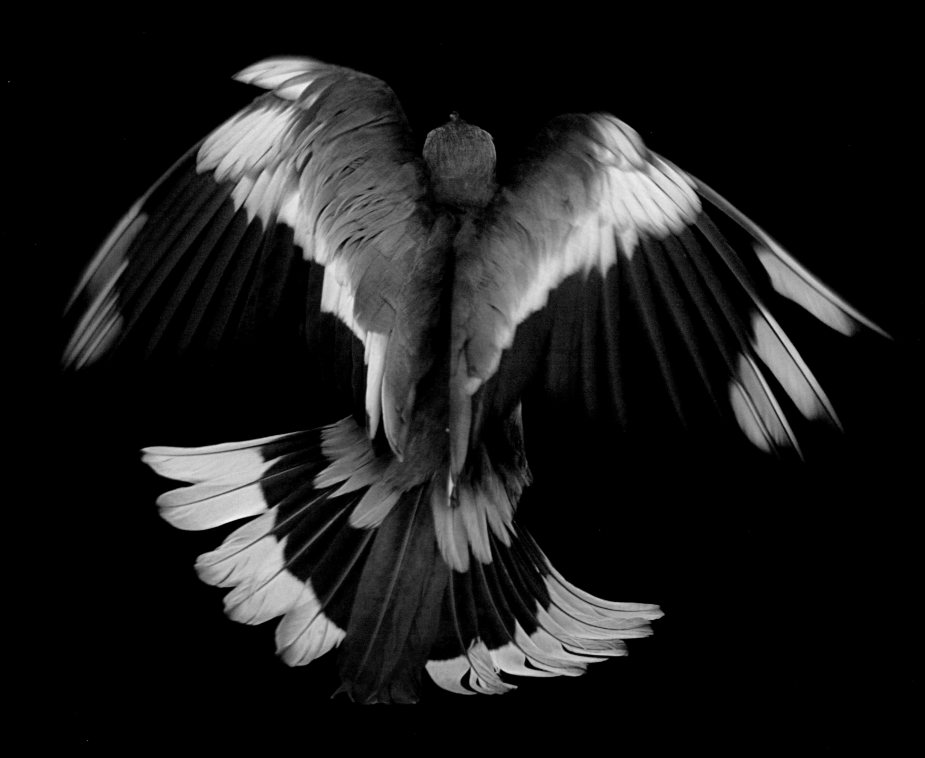

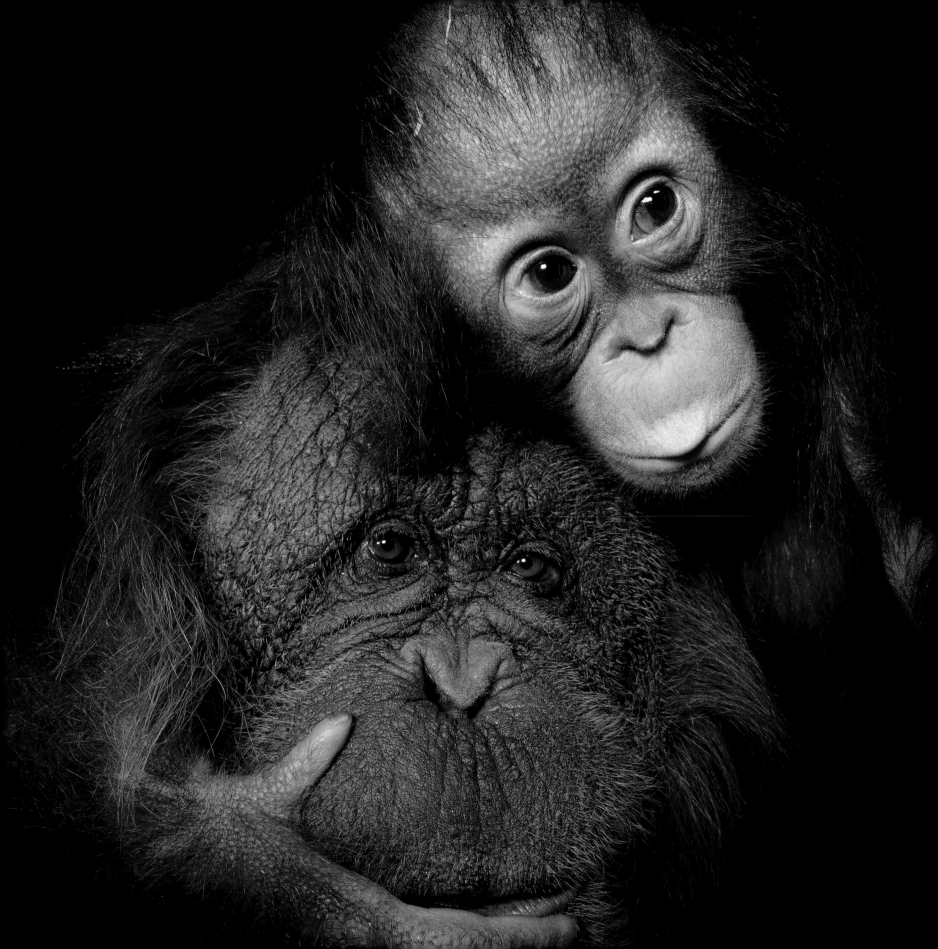

# Foreword

## HARRISON FORD

Vice Chair, Board of Directors, Conservation International

The fact that you picked up this book probably means you do not need a reminder from me of the extinction crisis that defines this moment in history. You know our planet is losing life-forms faster than at any time since the disappearance of the dinosaurs.

It is worth reflecting on what the extinction crisis means for us, though.

If you are like me, your love of nature may have begun with the feeling that wild creatures like tigers and butterflies, sea otters and rhinos are intrinsically valuable. We don't want to imagine a world without them. But increasingly we have had to. As imagination has inexorably marched into reality, those of us who care about conservation have gained a deeper understanding of how it goes beyond protecting nature for its own sake.

Ecologist E. O. Wilson wrote, "Unless we preserve the rest of life, as a sacred duty, we will be endangering ourselves by destroying the home in which we evolved, and on which we completely depend."

Ecosystems change when species disappear. Remove the pollinators, and crops will not grow. Kill off predators, and food chains collapse. Take monkeys, birds, or turtles out of a forest, and seeds will no longer be dispersed or germinated—and the trees that provide clean air and fresh water while balancing our climate will no longer flourish. We need to acknowledge that the world's forests and oceans, wetlands and savannas are not just habitats to the animals in this book. They form our collective home.

Our water, our food, the air we breathe, the fertility of our soil, and the stability of our climate: All of these depend on the complex interactions of myriad species. Think of nature as a tapestry, and each species as a thread. There is no way of knowing which threads bind the whole together. Each one that is pulled out brings the tapestry closer to unraveling.

Joel Sartore's Photo Ark focuses a lens on the individual threads in nature's tapestry. These pictures capture the incredible diversity of our planet's animal species. That diversity is the key to resilience, and it has helped the natural world withstand countless changes. Despite the massive shocks of global deforestation, ocean acidification, and global warming, nature is astonishing in its ability to adapt.

The importance of work like Joel's is that it reminds us to care about those individual threads. His subjects look us in the eye. They challenge us. They beguile. They make us laugh and sigh and wonder. We sense in his portraits an almost tangible connection between them and us. They make each animal—and, I hope, the consequences of its disappearance—real.

Humans are only one species among many. Unlike those portrayed in this book, we have the agency to change the trajectory of extinctions. The hard truth is that nature writ large will continue regardless of the specific mix of animals on the planet. It doesn't need humans to prevail. But when we start looking at species one by one, as Joel's book and project allow us to do, we learn where we can make a difference.

Preserving the world's biodiversity ultimately comes down to saving ourselves. We, and the animals in Joel's ark, are in the boat together. ◆

OPPOSITE: **A Bornean orangutan** *(Pongo pygmaeus)* CR **with her adoptive mother, a Bornean/Sumatran hybrid** *(Pongo pygmaeus × abelii)*

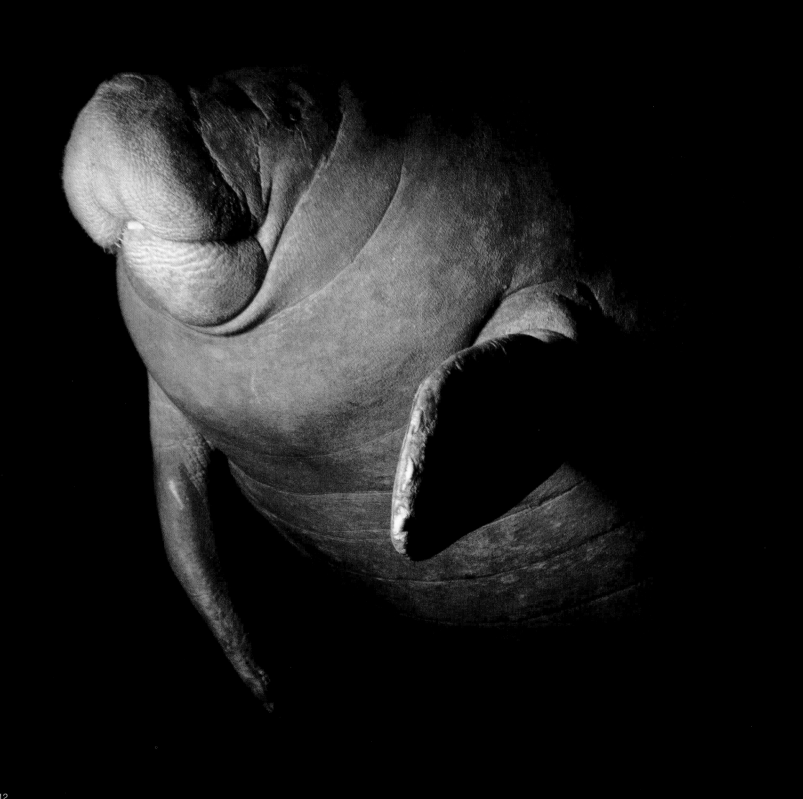

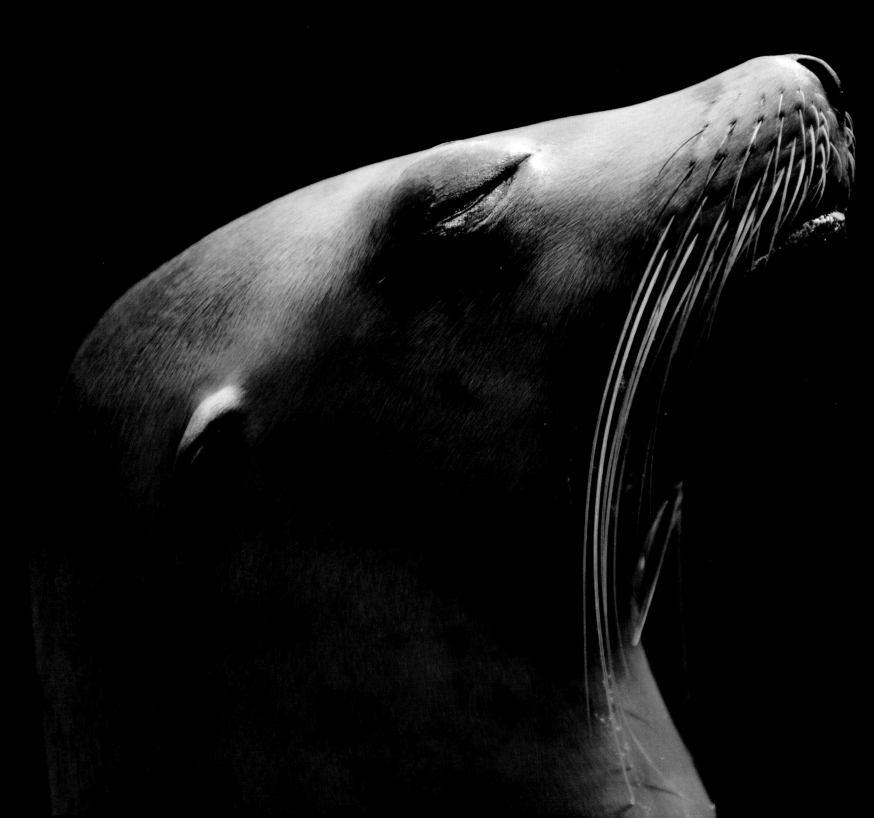

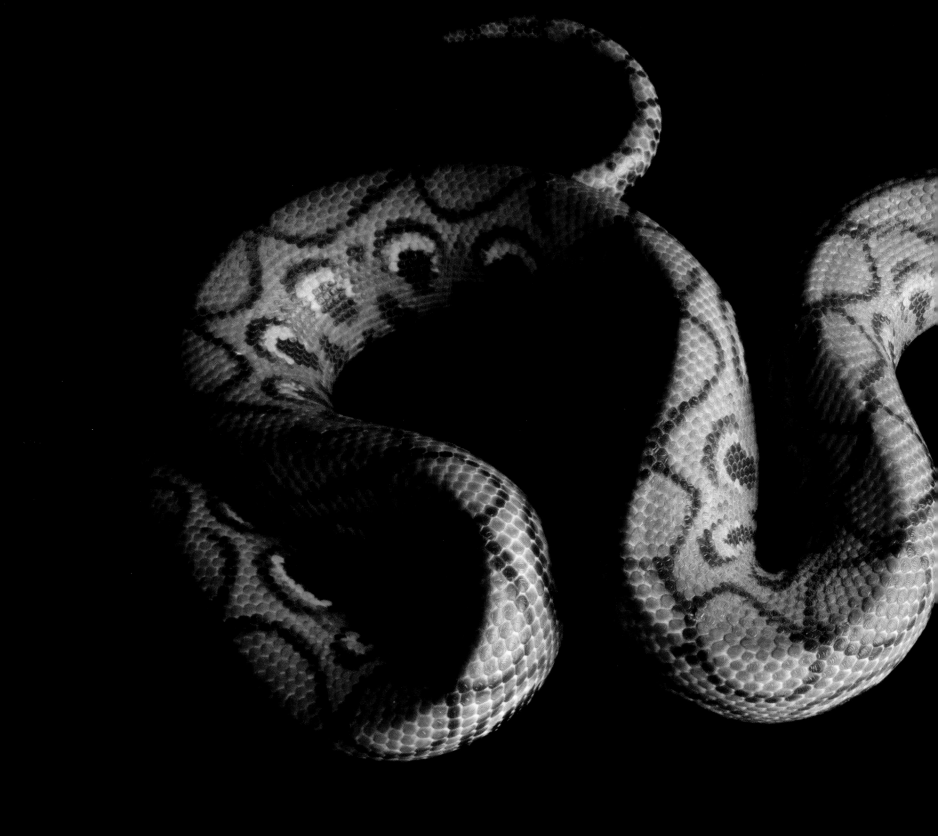

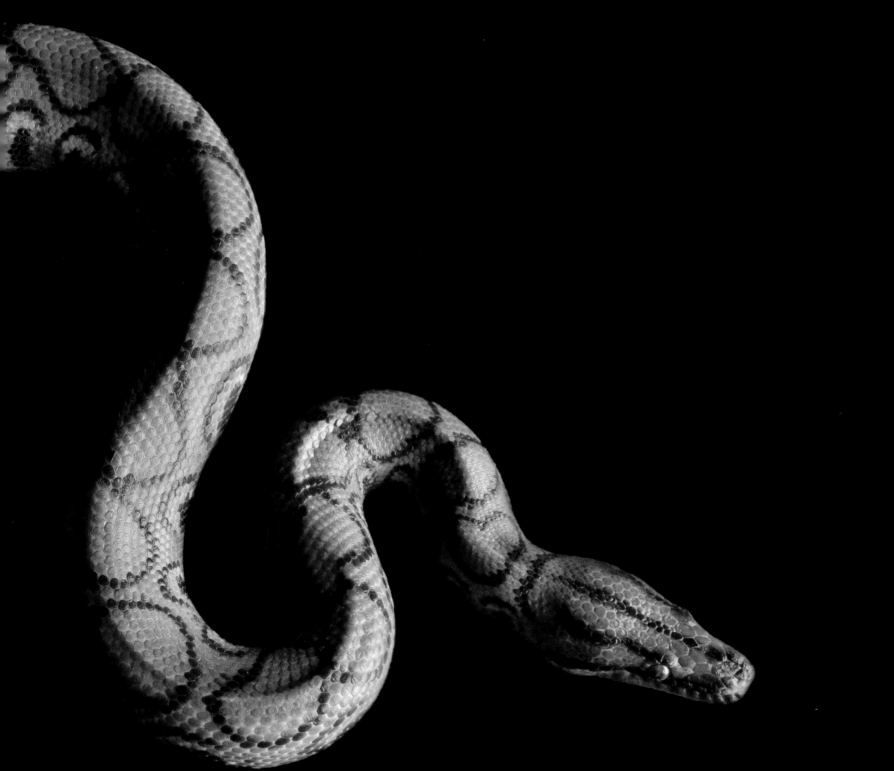

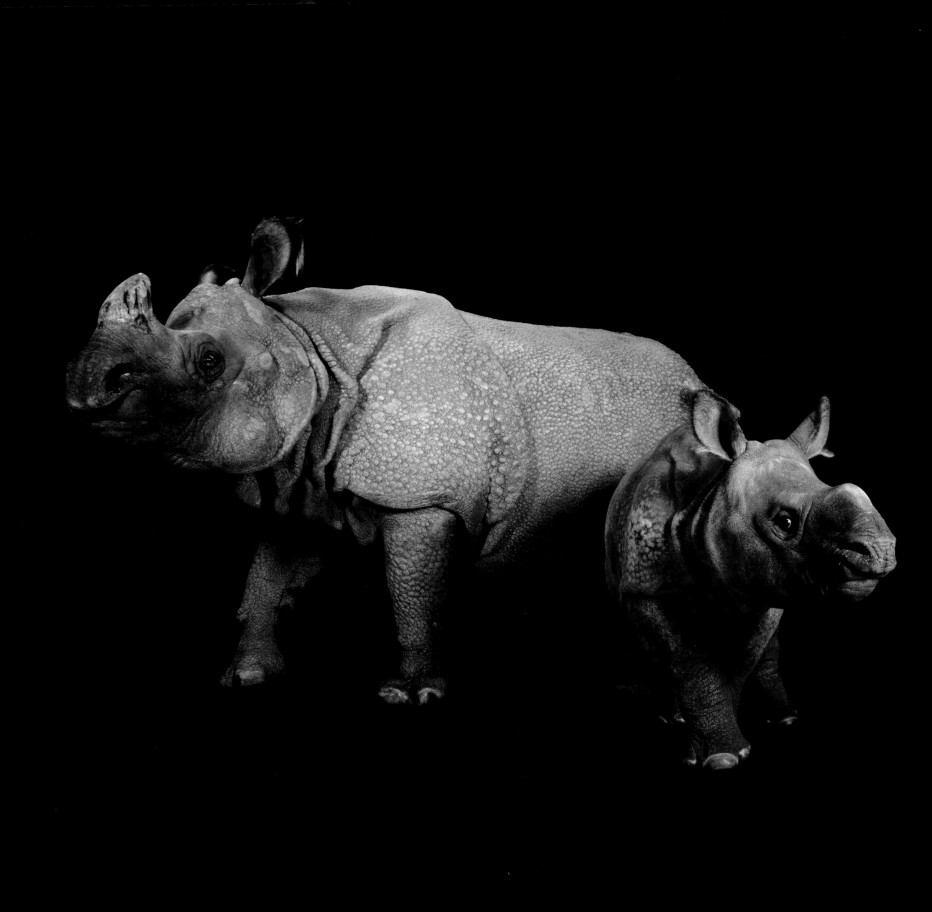

# We Earthlings

## DOUGLAS H. CHADWICK

On the arm of a spiral galaxy, 93 million miles from the closest of the stars, spins the just-right, not-too-hot-or-cold, brown and green and water-blue sphere where all the living beings known in the universe dwell. Pulsing, wriggling, sprouting, swimming, loping, fluorescing, swarming, mutating, flying, molting, yearning, branching, migrating, mating, and unfurling in a profusion of sizes, shapes, and hues and in numbers beyond counting, they turn the crusted skin of a molten-cored mineral orb fertile. They provide the oxygen in its atmosphere. They make possible humanity, nourishing our bodies and kindling our senses and spirits, as they have for ages. Each variety of creature is a revelatory right answer to the question of how to survive on this globe. Together, they define Earth as the Living Planet.

Are there other such worlds somewhere in the universe? Possibly. But I doubt that any includes angelfish and honey badgers. *And* tigers moving like flickers of flame behind tall grasses. *And* bipedal primates that read books such as the one in your hands. If extraterrestrials do exist, what forms do you suppose they might take? Big dome-headed, tentacled thingamaslithers that change colors with their moods? How about cloned automatons programmed to function as a single superorganism? Gelatinous entities with the geometry of snowflakes? Hold on. Our home planet has beasts to match all those descriptions—giant Pacific octopuses, social insects,

and urchin larvae, respectively—and others just as bizarre. There are all kinds of Earthlings whose habits remain complete mysteries, and plenty more Earthlings we haven't even discovered yet. You don't need a rocket to go exploring for creatures that can reset the bounds of our imagination.

Ask experts how many species share our home planet, and you'll hear estimates ranging from a few million to upwards of a hundred million. A gap that wide reflects the fact that the overwhelming majority of Earth's occupants are not merely small and hard to find but completely invisible to the unaided eye. Multitudes of protozoans, fungi, bacteria, and an even more ancient group of single-celled organisms, the Archaea, wait buried in the dirt of your backyard, tucked within the rock layers miles below, clustered in the cold lightless trenches of the oceans, hidden high among rain forest treetops, drifting on air currents in the stratosphere . . . practically everywhere researchers probe. Each person's body, made up of trillions of human cells, contains an equal or greater number of microbes. They belong to thousands of different species, and many of those are essential to our digestion and overall health. Maybe you've never thought of yourself as being into nature. Doesn't matter; nature has always been seriously into you. You're a walking, talking ecosystem stuffed with galaxies of nano-wildlife.

When most of us think of nature, we have larger wildlife in mind—the flora and fauna we can readily see and marvel at. Around 300,000 species of plants grow on Earth. Botanists have already named and categorized more than two-thirds of them. The zoologists, meanwhile, have identified about

OPPOSITE: **Indian rhinoceros and calf** *(Rhinoceros unicornis)* VU

1.2 million species of animals and suspect that this number is only a start. More than 95 percent of those identified so far are invertebrates, primarily insects.

All the different kinds of vertebrates—approximately 30,000 fish, 6,000 amphibians, 8,250 reptiles, 10,000 birds, and 5,420 mammals—add up to fewer than 60,000 species. That's a pretty thin slice of the spectrum of life on Earth, which includes 350,000 known species of beetles alone. To most of us, however, vertebrates are the main show. They naturally make the strongest claim on our attention, because their physical and behavioral traits are most similar to ours. After all, we share 70 percent or more of our genes with fish and 80 percent or more with the likes of wolves and wild camels. Sometimes friendly, sometimes fierce, sometimes seemingly touched with magic, these are our backboned cousins, our greater clan—our greater selves. I worry about their future, just as I worry about ours in an era of unprecedented change. Trying to understand those other lives more fully, I've spent a large chunk of my own life paying visits to their strongholds— the wilder the better.

With a small expeditionary band of Americans and Aka pygmies, I once trekked for weeks across a primeval lowland tropical forest in the heart of Africa. The place swallowed us whole. Endless columns of immense buttressed trees towered on all sides, and their canopy sealed us off from the sky. Practically every part of the understory was filled with more foliage. Every surface looked coated with lichens or moss, and every patch of those usually held a spider, fly, jeweled beetle, or ant, many—maybe most of them—unnamed. Yet farther along, the leaves might part to reveal giants instead: forest elephants, not recognized until 2010 as a different species than savanna elephants. The tangles also hid forest buffalo, along with the striped antelope called bongos, different types of smaller antelope known as duikers, water chevrotains resembling miniature fanged deer, pygmy crocodiles, rhinoceros vipers, leopards, porcupines, Cape clawless otters . . . In this expanse of the Congo Basin, a full list even for wild inhabitants their size is far from being completed.

Although the nearest human habitation lay far behind, we had all sorts of close kin around. Eleven kinds of monkeys rustled the branches high overhead. Gorillas and chimpanzees, both of which share at least 96 percent of our genes, met us closer to the ground. We were likely the first *Homo sapiens* the great apes here had ever seen. I remember the chimps lingering an especially long time. They couldn't seem to keep from edging ever closer, their eyes, so much like ours, alight with curiosity.

Years later, I shipped out with marine biologists for the Auckland Islands, a remote archipelago in the sub-Antarctic. The uplands were white with fresh snow. Yet thick stunted forests grew from sheltered spots near shore, and red-crowned and yellow-crowned parakeets ornamented the branches. Extraordinary giant herbs that grow only in the Aucklands cloaked the lower hills. Royal albatross chicks towered above the grass tussocks, waiting while their parents, gliding on 10-foot wingspans, fished far out at sea. In the absence of large land predators, New Zealand sea lions sometimes hiked overland between coastal colonies, belly-scooting among the hills with the help of

their flippers. Out in the bays, rare yellow-eyed penguins flew underwater while shearwaters floated on the air currents above.

The setting felt as animated as the distant jungle. Even when the ocean was calm, we heard sounds like big waves crashing; it was the breathing of behemoths. Hundreds of southern right whales travel from Antarctica to winter by these isles and socialize. They leaped and rolled, slapped giant rounded fins on the surface, and sang mighty songs whose purpose only whalekind knows. Like the Congo apes, they proved as curious about us as we were about them, often coming to visit our skiffs. Moments after I got into the water wearing a dive suit, three whales showed up beside me. The lead animal's saucer-size eye passed almost within touching distance, moving up and down to inspect me. Next, a whale's underside came to rest on my head. I was very glad that these organic submarines, which can grow to 80 tons, are weightless when submerged. Considering that their mouths are big as cargo holds, I was even happier that they mainly eat miniscule crustaceans sifted from the seawater.

In places like these, I can pretend for a while that I've slipped back into an earlier, biologically richer time. Yet I know that in reality, every day now dawns in the Anthropocene epoch. This is the label a growing number of scientists have proposed for the latest period of Earth's history, the one in which the activities of a single species, Homo sapiens, have been reshaping the environment on a planetary scale with the force of geologic change.

In 1866, when the German biologist Ernst Haeckel coined the term "ecology," the human population stood at about 1.3 billion. By 1970, when the first Earth Day was celebrated, we numbered 3.7 billion—already too high, many warned, for the health of the biosphere. Not quite five decades later, we have multiplied to 7.5 billion. The result is less and less room and fewer and fewer resources to sustain living wonders other than us. Even where natural habitats remain intact, many are being rapidly drained of fauna by hunters supplying the illegal wildlife trade, bush-meat markets, or simply meat for their own table.

While our population was doubling between 1970 and 2012, the count of big free-roaming individual animals sharing Earth's surface—the total population of large wildlife—fell by half. Today, more than 90 percent of the biomass, or living weight, of land-dwelling vertebrates is made up solely of people and their domestic livestock. As for untamed mammals, it has become risky just to be big; 59 percent of all the carnivore species weighing 15 kilograms (33 pounds) or more and 60 percent of all the herbivore species weighing 100 kilograms (220 pounds) or more are now listed as threatened with extinction. The count of threatened and endangered organisms of all kinds keeps rising by the year. So has the frequency of species disappearing altogether. Now add climate change, with concentrations of greenhouse gases setting records and wildlife communities struggling to adjust to heated-up conditions. Mix in the side effects of acidifying the oceans as they absorb more carbon dioxide. Pile on pollution of freshwater and salt water by increasing quantities of agricultural chemicals and industrial toxins . . .

Sorry. I'll stop. Life got under way three or perhaps even four billion years ago, and species have been arising and eventually winking out ever since. It's not as though extinctions are anything new. What I'm trying to explain is why now, in the Anthropocene, they are taking place at a rate a thousand times higher than the average in the past, as determined from the fossil record. If the current trend continues, one of every three species

around us—one of every two in some groups, such as amphibians—could be absent by the end of this century.

In any given year, this will unfold like a relentless slow-motion disaster. On geological and ecological time scales, it's more like an onrushing avalanche. Or a tsunami. Among the victims swept away will be millions of varieties of the Earthlings we never even got to know. Barring a miraculous reversal, the toll will also include many thousands of the species we will miss the most, namely our conspicuous, captivating fellow mammals and other vertebrates, the bright and the beautiful, the smart and the splendored, the powerful and the gentle alike. This is your living planet suffering a stroke.

It's hard to care deeply about lives you've never encountered, though. How I wish people had a chance to meet more of these animals, a chance to look and really *see* them, without distractions and without preconceptions; to behold and absorb each color and curve, the perfection of a design for carrying out strategies of survival; to witness the sparks of creation flying off it all; to gaze into those untamed eyes and find the gaze returned and sense in that bridge a common awareness. If we could just do that, we would want to try everything we are capable of to keep from losing so many. I truly believe this. More important, Joel Sartore believes it too.

After working as a newspaper photographer in the American heartland, Joel began a long career of shooting pictures for the National Geographic Society. Over time, he took on more and more assignments with natural history themes. The originality and poignancy that his images of people were known for carried over to his camerawork with animals. In the Anthropocene, though, you cannot pursue many stories that involve wildlife without coming face-to-face with species that might not be around much longer.

As a child, Joel had been deeply moved by photos he saw of Martha, the last passenger pigeon. Martha toppled off her perch in a cage at the Cincinnati Zoo in 1914, dead at the age of 29. One soft plunk to mark the finish for the billions that once streamed through America's skies. Four years after that, the last Carolina parakeet died in the same cage. Plunk. Eight decades later, Joel found himself taking pictures of creatures on the brink of oblivion, such as the Columbia Basin pygmy rabbit or the Rabb's fringe-limbed tree frog of Central America, and wondering which images might someday cause a child to stare and stare with a puzzled expression before finally looking up to ask, just as he had, "Mom, what happened to this animal? Why is it gone forever?"

"I never liked to see things wasted," Joel told me. "I don't get depressed. I get ticked off. Since I was among the last who would ever see some of these species alive, I wanted to make sure more people have a chance to at least know what they looked like—and see as many other species as possible while they're still here." A portfolio began to take shape in his mind—a pageant of the animal kingdom that would say, Here, one by one, two by two, or group by group, is the fullness and glory of the living planet we inherited. Look. Meet the particulars of creation. This is what we stand to lose, burly bear by fabulously feathered bird by freshwater-filtering mussel by spadefoot toad, which in its natural desert habitat may have waited underground in suspended animation for more than a year to

emerge and fill the night with calls for a mate after a thunderstorm creates temporary pools.

So many species, and so many running out of time. Joel didn't have a lot of time to spare either if he was going to make images of thousands of creatures from all over the globe in a way that captured the essence of each. He knew from experience how many days it can take to chase down a single good picture of wildlife in the field, especially the shyest types and those that have become unnaturally scarce. Some were already extinct in their native range. His best option was to work with fauna that had already been collected and confined within enclosures.

Working with captive animals, Joel could arrange to photograph subjects against a solid white or black background with controlled lighting to bring out every detail. Nothing in the featureless setting would pull the viewer's eye away from the creature itself. Moreover, in photos taken against a neutral backdrop, the mightiest and the meekest of life-forms would appear similar in size and project their presence with similar power, just as their roles can be equally valuable to the functioning of an ecosystem. Elephants, for example, are often described as architects of the tropical forests they inhabit. These titans trample out pathways through the thick vegetation and create clearings by girdling trees as they strip away bark and branches for food. At the same time, elephants maintain the remarkable diversity of the trees and other plants by feasting on their fruits and distributing the seeds far and wide in nice, big fertile piles of manure. Yet who is to say the forests' fruit bats and ants don't play equally crucial roles as legions of mini-architects that pollinate a host of flowering plants high and low and carry smaller seeds into countless niches?

In some cases, Joel seeks out species in the care of wildlife rehabilitation experts or private breeders. Otherwise, he goes to the same places that an estimated 175 million people do in a typical year: zoos. More than 10,000 have been established worldwide, and they select the kinds of animals that the public finds most fascinating, including many of the rarest forms. However, zoos vary widely in quality, for the term includes roadside tourist attractions and other compounds that would barely qualify as kennels. Joel shoots almost entirely at institutions that are accredited members of the Association of Zoos and Aquariums (AZA) in the United States or the World Association of Zoos and Aquariums (WAZA). All of these operate under mutually agreed-upon standards of care and respect for the animals they keep. Many members of these associations participate in captive breeding programs for critically endangered species and in some cases have become their only home. Although efforts to reintroduce captive-bred species to the wild have yielded mixed results, there have been notable successes, like bringing Przewalski's horse back to the steppes of Mongolia, and restoration techniques are improving by the year. A number of zoos provide financial support for wildlife research and conservation projects in various nations. Going a step further, some zoos now design special exhibits that encourage visitors to make donations of their own for protecting wild populations of the specimens on display.

Altogether, zoos contain at least 12,000 animal species. (Estimates vary, because many facilities don't list the different species they hold.) The total would probably rise closer to 18,000 if you were to count all the distinct subspecies and varieties in captivity. Joel wants to document as many as he

can, including the more than 1,000 imperiled species among them. Now in his mid-50s and a dozen years into the Photo Ark project, he's had photo sessions with more than 6,000 types of animals and hopes to add at least 5,000 to 6,000 more to the Photo Ark—"Before I get too old to keep lugging heavy camera gear around all over the place," he says. "I always figured it would turn into a 25-year-long, full-time commitment. But knowing what I do about what's happening to animals across the world, I couldn't just sit back and watch."

Having partnered with Joel on several *National Geographic* magazine assignments and a National Geographic book about America's endangered species, I understand how intently he works. On the other hand, I've never quite grasped how he manages to conjure an animal picture that is more than a picture. It seems to come down to the few milliseconds in which he senses that the creature is poised in a way that reveals something fundamental about its character, its special skills or emotional capacity, or perhaps its consciousness. Click. The result is rarely a formal portrait so much as a vibrant interaction between the viewer and the viewed.

If only with a household pet, or a bird that alighted on a nearby branch, we've all had moments when we felt the shiver of real connection. Joel finds this instant with subject after subject and embeds it in an image for posterity. That's the Photo Ark; there's life force stored in each image. And maybe a tinge of pathos or humor. Often surprise. Always a face-to-face meeting with questions on both sides. Although I'm a wildlife biologist with passports stamped by countries all over the world, this book introduced me to amazing species I hadn't even known existed before. Yes, some may become like

Martha the passenger pigeon, lost to future generations except as a picture. But an ark is, above all, a vessel to save flesh-and-blood creatures. This one is constructed to help lift many from obscurity and rescue many more from indifference, the goal being to carry all farther away from impending destruction. An ark also serves as a symbol. It embodies the hope that the animals we preserve will help rebuild full, thriving natural communities one day if and when modern civilization regains its balance and the deluge stops.

All five species of rhinoceros are in serious trouble. The Sumatran rhino has fewer than 100 individuals between it and eternal nothingness; the Javan rhino has at most 50 or 60. There is a common perception of these armor-hided hulks as examples of relics—holdovers from the distant past that are simply no match for the present era. They do represent a line that arose at the dawn of the age of mammals. Yet aside from never having evolved an immunity to poachers' bullets, they are perfectly fit for the modern habitats they occupy. You'd think the fact that their kind has been around for so many millions of years would be an extra incentive for us to protect every one we can.

Practically everybody has heard phrases like "Why go to all the trouble of trying to save _____?" and "C'mon, what good, really, is a _____?" One of the best answers is that biological diversity—defined as the full array of species in an area, together with all their processes and interactions—tends to make ecosystems resilient. This means that they can bounce back fairly quickly from short-term disturbances such as severe storms,

drought, wildfire, floods, and outbreaks of pests or epidemic disease, and prove better able to cope with shifting conditions in general. Complex communities with high levels of species diversity therefore tend to stay fairly stable over time, while ecosystems impoverished by a loss of species become more unbalanced, less productive, and subject to further declines.

Whether on a local, regional, or planetary scale, a major drop-off in biodiversity is not something you want to pass along to future generations. Unfortunately, much of the public finds such ecological concepts hard to fathom or more theoretical than grounded in common sense. Conservationists faced with the why-bother-keeping-this-or-that-species question always found it easier just to reply: "Because you never know which one might hold a cure for cancer." A few decades ago, that was dismissed as wishful thinking. Since then, researchers have discovered several such species. Among them are a conifer, the Pacific yew, which manufactures a chemical highly effective against breast, ovarian, and lung cancers; and a Madagascan shrub, the rosy periwinkle, with alkaloids that can put leukemia and Hodgkin's lymphoma in remission.

In light of the fact that there are so many more kinds of animals than plants, companies have increasingly gone bioprospecting among the world's fauna and come up with promising medicinal compounds from surprising sources such as scorpions, sea slugs, sponges, and venomous cone snails. Nearly everyone reading this is likely related to someone healed by molecules borrowed from other organisms. Biodiversity already saves human lives. It will do a great deal more to improve and prolong them, but not if we don't turn around and save biodiversity.

Certain mammals, reptiles, amphibians, insects, crustaceans, and mollusks go dormant for months at a time during hibernation or estivation. Physiologists searching for cures to kidney disease, liver failure, and metabolic disorders want to unlock these creatures' secrets, and so do scientists seeking clues about how to safely place astronauts into a state of suspended animation for long journeys. Industry engineers tap inventions from animals for new adhesives, structural materials, designs for reducing turbulence and drag around aircraft wings and ships' hulls, packaging techniques, optical filters, models for efficient flows of urban traffic (think ant colonies)—the list goes on and on.

Within the DNA of Earth's millions of organisms is a time-tested set of instructions for building things and gaining insights we will all rely on in the future. This molecularly coded information is the greatest cache of data available to us, and advances in genetic engineering keep widening the horizon of possibilities it offers. To continue extinguishing species in an eyeblink of geologic time is to heedlessly delete file after file, volume after volume, in nature's genetic library. Permanently. This isn't merely shortsighted. Apart from punching the nuclear launch button, it has got to be about the dumbest, most counterproductive thing an animal that prides itself on being intelligent could do.

But aren't species worth conserving for their own wild sakes? People have taken on the challenge of saving wildlife out of a broad spectrum of motives. What counts is that they kept at it through decade after decade of the last century. They brought whooping cranes, bison, black-footed ferrets, and alligators back from the brink in North America, did the

same for cheetahs in southern Africa, and reversed the losses of pandas in China, to list just a few examples. The sole endangered Columbia Basin pygmy rabbit population that Joel once feared he was saying goodbye to did disappear for all time in 2008. But before that happened, the last individuals were taken into captivity and bred with a similar and more numerous subspecies of pygmy rabbit. Their hybrid descendants, released into the Columbia Basin, now show promising signs of reestablishing a population within that native habitat.

Nearly every country established national parks and other nature refuges over the years as well. There is tremendous promise in the new phase of conservation aimed at connecting these core strongholds to one another through travel corridors, not only within nations but also between them. This allows animal populations to migrate more freely and exchange members and genes across large landscapes the way they did for millennium after millennium, making them much less vulnerable to local setbacks and to the effects of inbreeding in isolation.

No generation has experienced a stage of history like this before, one in which human numbers have gone viral. Not surprisingly, nobody knows exactly how to proceed from here. The one thing we know with certainty is that the situation for other Earthlings is dire. However, more grim warnings aren't going to fix it. People who believe they can make things better will.

We can do this. With enough commitment of human hearts and minds, we absolutely can. When I need a bit more incentive, I think about the alternative, not in terms of a sudden collapse of ecosystems but as a slow erosion of qualities harder to measure but just as consequential for us and our children. I think about the effect on our souls of losing a little more beauty here, a little more wonder there, another moment of grace, another rush of excitement, another inspiring dazzle of strength or athleticism, a courtship dance, a stupendous battle, a falcon swoop, a dolphin leap from sea to sky, one more tail-feather flash, one more morning song . . .

Can we survive without those things? Sure, up to a point. The question is, What exactly will we survive as? It takes animals to make us fully realize what it means to be human. Without that assemblage of other life-forms, the heritage that shaped our ancestors' reflexes and instincts and thoughts and prayers, how are we to ever comprehend where we came from and who and what we are, or—if the living planet becomes less and less alive with other beings until, when we gaze in any direction, what we mainly see is our own reflection—where we are going? Those animals are still here, though. For now.

How many more species, how many of these astonishing, beautiful, inventive, strange yet kindred ways of being alive will be lost under our watch? The answer could be in the thousands or even the millions. There are reasons for that, but there are no good reasons, not for discarding miracles. The greatest wealth, the only enduring wealth, the most precious gift given humankind, is the wealth of life that defines our home in the universe. Look. ◆

OPPOSITE: **Spectacled eiders, female in background** (*Somateria fischeri*) LC

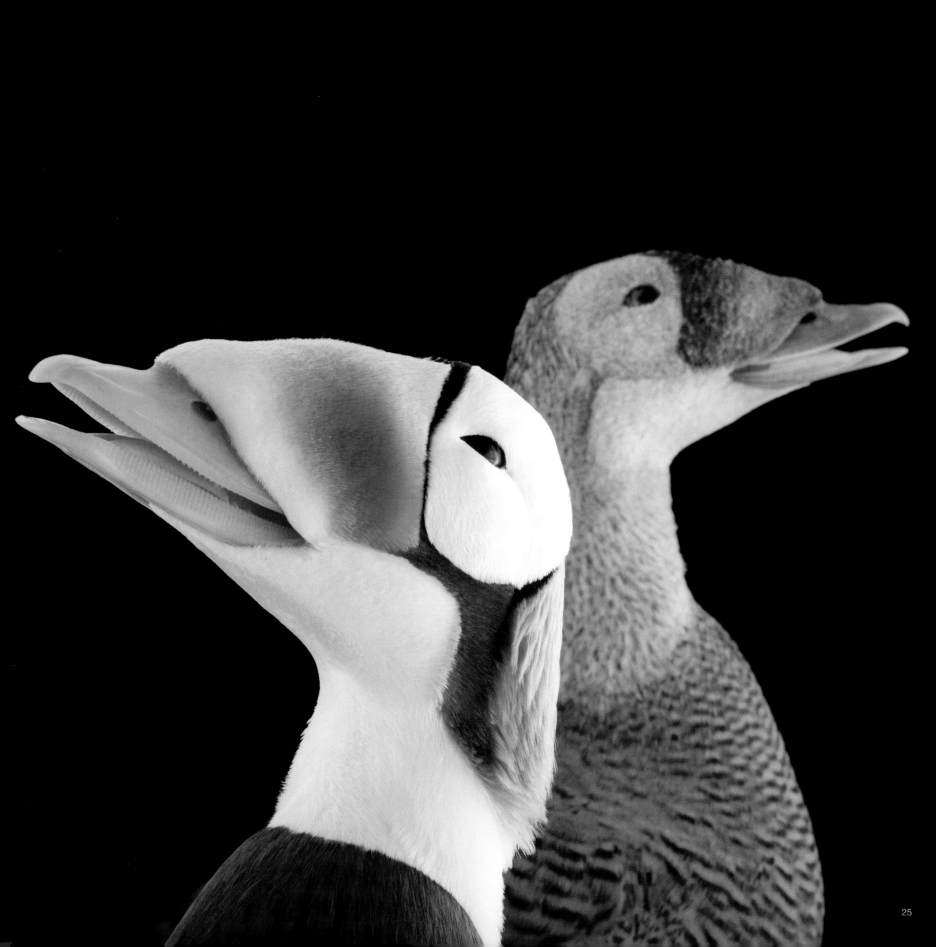

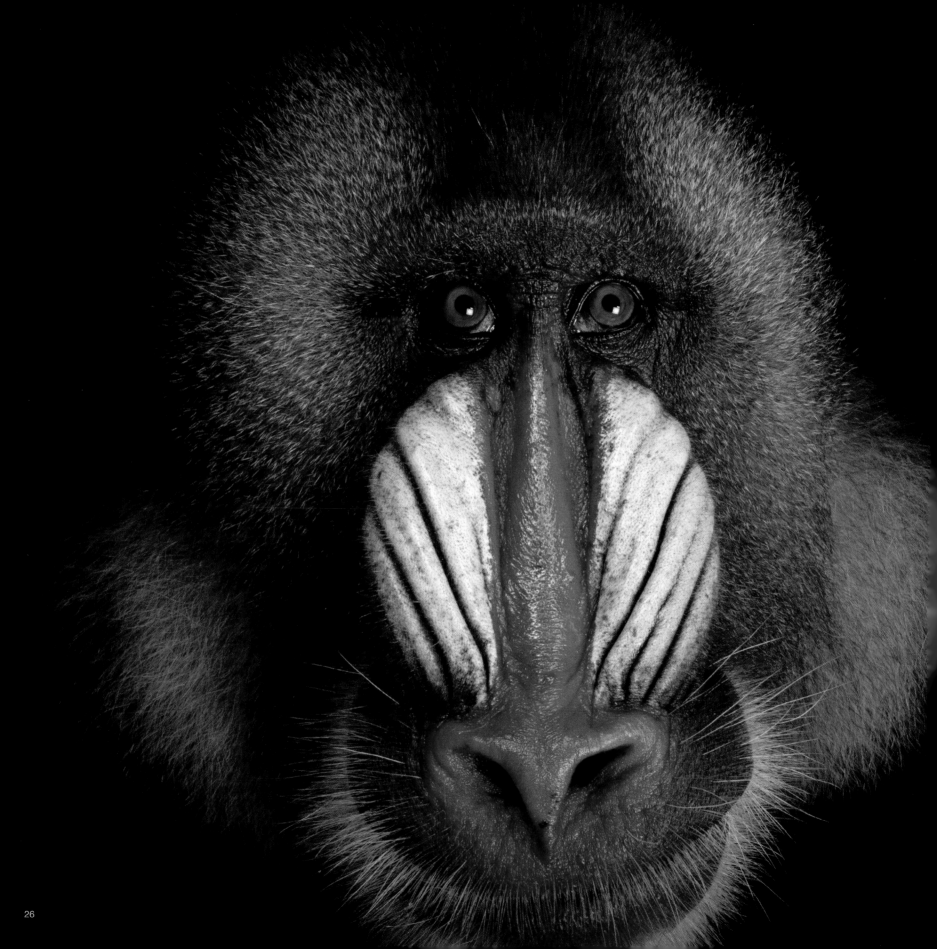

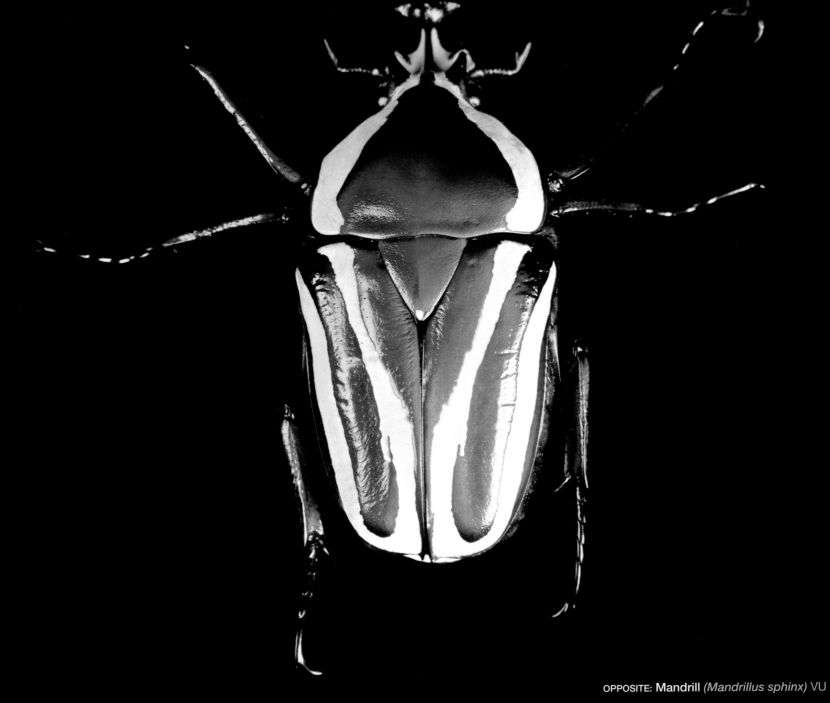

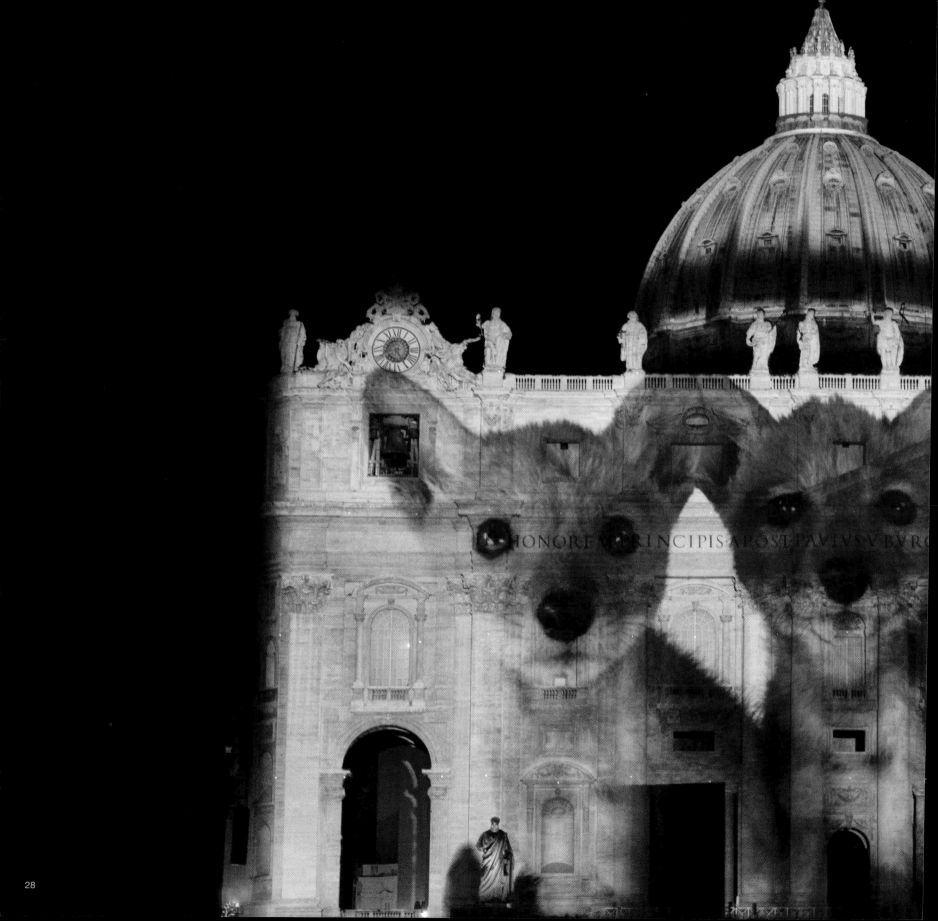

**Coyote pups** *(Canis latrans)* LC

Projected onto St. Peter's Basilica at the Vatican, these coyote pups were part of an hour-long presentation in 2015, inspired by Louie Psihoyos in connection with his film *Racing Extinction.* A similar projection occurred earlier that year on the Empire State Building in New York City, and Photo Ark images were projected onto the United Nations building in 2014, all designed to expand awareness of the species we share the planet with.

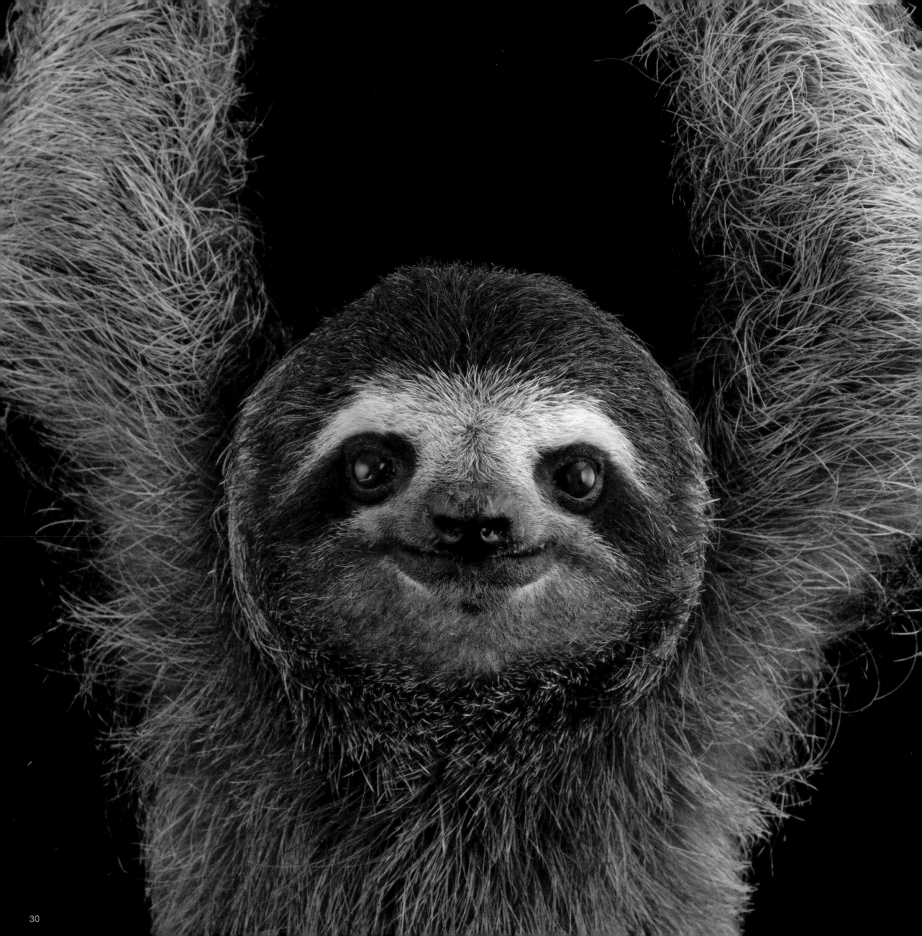

# Building the Ark

## JOEL SARTORE

To tell the story of the Photo Ark, I have to go back to the day my wife, Kathy, was diagnosed with breast cancer. Feels like it was a lifetime ago.

It was the day before Thanksgiving 2005, and all of a sudden there seemed nothing to be thankful for. I was afraid she would die. We had three young kids, the youngest just two years old, and I was pretty sure I'd be a lousy single father. And of course we'd lose our home, because without her, I couldn't go on assignment to make a living.

For more than 25 years now, I've been a contributing photographer for *National Geographic* magazine. I've had to leave home for weeks or months at a time, and the work has taken me to every continent, from the Alaskan tundra and the ice sheets of Antarctica to the Bolivian rain forest and the black sand beaches of Equatorial Guinea. The more I traveled, the more aware I became of the plight of species around the world. Things we humans were doing were changing Earth's climate and terrain dramatically. Animals I wanted to photograph were becoming more and more rare. Some were on their way to disappearing entirely.

In all those years as a *Geographic* photographer, I had never had much time to sit still. But now I needed to stay close to home for my family. I had time on my hands. As Kathy was undergoing treatments, mortality was often on my mind—hers and mine both. If she did get better, our lives were already half over. I had been working hard, but had it mattered? If I was going to make a difference, it had to happen now. How could I get my conservation work to move the needle? How to get the public to care?

My mind went to Edward Curtis, who photographed Native American cultures at risk of disappearing, and John James Audubon, who painted beautiful portraits of birds that have now gone extinct. I thought perhaps I could do something like that to get people to care about the animals I love.

I started by calling the Lincoln Children's Zoo, just a mile from my home in Nebraska, to see if I could take portraits of any of the resident animals. I asked for a subject that would stay relatively still, and we started with a naked mole rat—a small, hairless rodent that lives in the dry regions of East Africa (see pages 320–321). We placed the creature on a white cutting board in the zoo's kitchen, and I started taking pictures, and the project grew from there.

It's been more than a decade now, and Kathy is doing just fine. My parenting skills weren't as rusty as I thought, and we managed to pay the bills. And though it was no picnic, from this storm came a silver lining: We learned to appreciate every day, and I found the time to stop and really think about how I might be able to make an impact on the world with photography.

OPPOSITE: **Brown-throated sloth** *(Bradypus variegatus)* LC

So that's the personal story about how the Photo Ark began. But there is a bigger, more global story that goes along with it. The Photo Ark was born out of desperation to halt, or at least slow, the loss of global biodiversity.

Habitat destruction, climate change, pollution, poaching, and overconsumption are all influencing a massive die-off of plants and animals around the world. In Earth's long history, there have been events like this before, but what sets the current extinction apart is that it isn't caused by an ice age or an asteroid—this one is being caused by man. At the rate we're going right now, half of all Earth's species could go extinct by 2100.

I cannot just stand idly by. And so, at its heart, this is a collection of photographs documenting the world's species, many of which we have a real chance of losing in our lifetimes. It is a visual connection between the animals and people who can help protect them.

A word about the photographs themselves: They are studio-style portraits, and I have chosen that technique because it levels the playing field. The tortoise counts as much as the hare, and a mouse is every bit as magnificent as a polar bear. Isolating the animals against black and white backgrounds allows us to look them in the eye and see that these creatures contain beauty, grace, and intelligence.

It will take 25 years to document the world's myriad species as studio portraits. My goal is to record every one of the world's 12,000-plus captive species—species under human

*" I think of myself as an animal ambassador, a voice for the voiceless.*

care in locations around the world—before I die. In May 2016, I photographed the 6,000th animal: a proboscis monkey at the Singapore Zoo. A project of such magnitude takes time; I've been at it for over a decade now, and I'll go on as long as I can.

I think of myself as an animal ambassador, a voice for the voiceless, and I consider my photography the best way to engage as many people as possible to move public opinion. People can't save what they don't know exists. If they look into the eyes of these animals and see what is at stake, I'm hoping they will learn to care more and find ways that they, too, can make a difference.

In the end, will it be enough to stop our relentless march toward consuming everything on the face of the planet and wiping out hundreds, even thousands, of species in only a generation or two? I really can't say. The only thing I'm certain of right now is that if we don't clean up our act, future generations are really going to hate what we've done to the place.

When we save species, we save ourselves. Every day of our lives we rely on nature, often without even knowing it. Healthy forests and oceans regulate our climate—not just its temperature but also how much (or little) rainfall we receive, how severe hurricanes and tornadoes become, and the balance of different chemicals in our atmosphere. Pollinating insects like bees, butterflies, and even flies are critical to food production. Animals teach us new things all the time about subjects as varied as communication (dolphins and parrots), hibernation (arctic ground squirrels), and pollution (freshwater mussels).

Beyond this list of the self-serving, there is a higher reason to save the world's species; every species is a work of art, created over thousands or even millions of years, and each is worth saving simply because it is so unique and priceless. All enrich our world as nothing else can.

The era we live in is full of endless possibilities, but time is critical. No one person can save the world, but each of us certainly can have a real and meaningful impact. Many of the species featured in these pages can indeed be saved, but it will take people with passion or money or both to step up and get involved. A little attention is all some of these animals need, while other species may already be so fragile that they will be harder to protect. Every bit of effort helps, though, and awareness of the problem is the first step toward a solution.

The bottom line for me is this: At the end of my days, I'd like to be able to look in the mirror and smile, knowing that I made a real difference. Long after I am dead, these pictures will continue to go to work every day to save species. There's no more important mission for me.

*Now, how about you?* ◆

## ABOUT IUCN LISTING CODES

*The International Union for Conservation of Nature (IUCN) is a global group dedicated to sustainability. The IUCN Red List of Threatened Species is a comprehensive collection of animal and plant species that have been analyzed according to their risk of extinction. Once evaluated, a species is placed into one of several categories. Throughout the book, each species' current IUCN status is listed alongside its name.*

**EX:** *Extinct*  
**EW:** *Extinct in the Wild*  
**CR:** *Critically Endangered*  
**EN:** *Endangered*  
**VU:** *Vulnerable*  

**NT:** *Near Threatened*  
**LC:** *Least Concern*  
**DD:** *Data Deficient*  
**NE:** *Not Evaluated*  

Editor's note:

*Throughout this book, every quotation without an attribution comes from Joel Sartore himself.*

CHAPTER ONE ►◄

# Mirrors

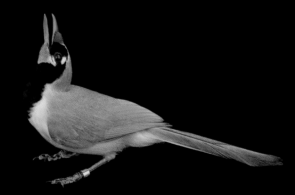

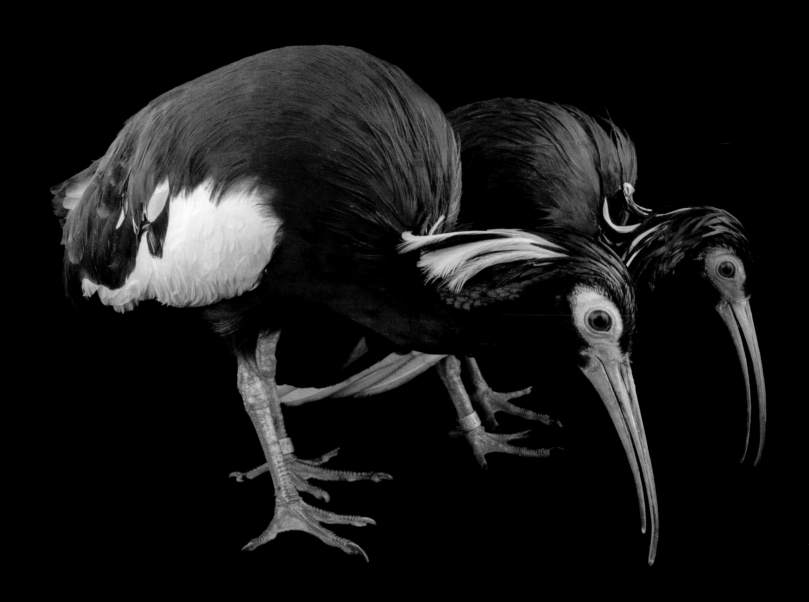

We find reflections throughout nature. Mirrors help us see into the heart and soul of every animal. We look around and see similarities, connections, identities weaving through the diversity of life-forms. Seeing oneself in the mirror is the first step; seeing oneself in another—sympathy, compassion, feeling the other's feelings—is the next. And finally, we transcend self and see the ties that bind species to species, whether by accident or circumstance or biological necessity.

In this chapter, we find reflections as they bounce around among the creatures of the world, paired identities that can pull you in toward deeper understanding or send you off laughing with delight.

A tiny Bengal slow loris and a tinier tiger-striped tree frog gaze out, eyes wide open. A springbok mantis and an arctic fox cock their heads just so. A matched pair of blue waxbills rest, perched on a branch. A triumphant chimpanzee mirrors our own primate identity. The fleshy orange caruncle of a South American king vulture reminds us of the hallowed horn of an Indian rhino. Grasshoppers and katydids, seen in profile, mirror a similar parade of the world's shrimp species. A common yabby—an Australian crayfish—and a devil's flower mantis spread legs and rise up, seeming in their defensive postures to dance to nature's music. Whiskers or feathers, tongue or beak: The binturong, or Asian bearcat, mirrors the whiskered auklet, an Alaskan seabird.

It's hard to avoid anthropomorphism—hard not to read human attitudes and intentions into the bodies and faces of these creatures. We gaze into their eyes and see another living being. These are the mirrored reflections by which we connect to the animals of the Photo Ark, finding the many ways in which they look like each other—and like us. ◆

OPPOSITE: **Madagascar ibises** *(Lophotibis cristata)* NT
"Sometimes birds are so comfortable in the shooting setting that they do whatever they'd be doing normally."
PREVIOUS PAGE: **Bog turtle** *(Glyptemys muhlenbergii)* CR, **Green jay** *(Cyanocorax yncas)* LC

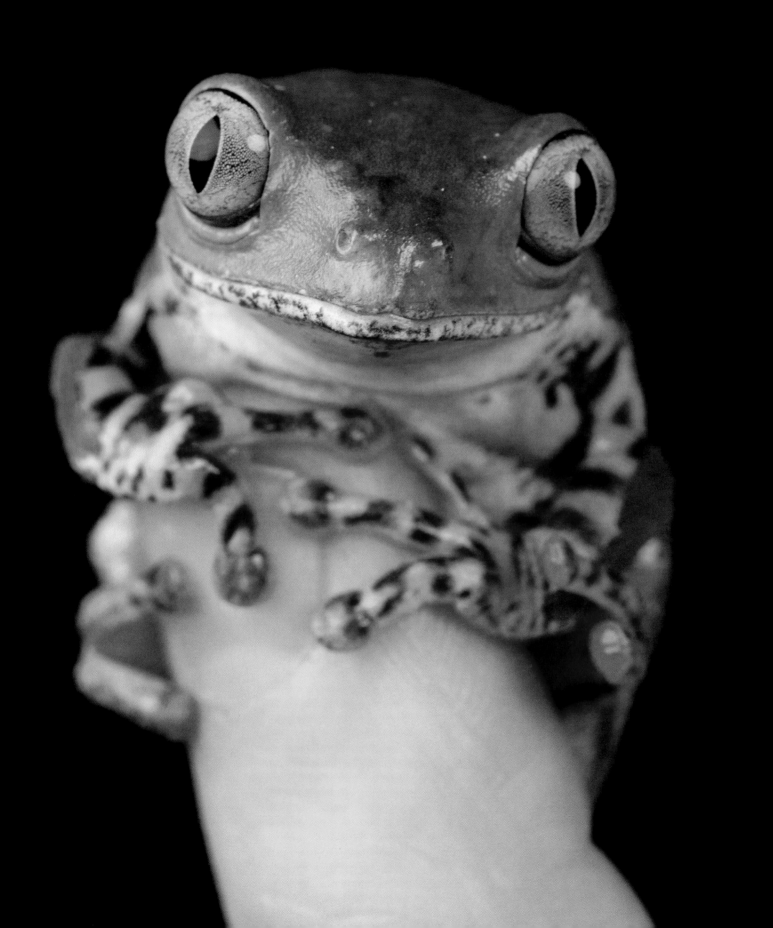

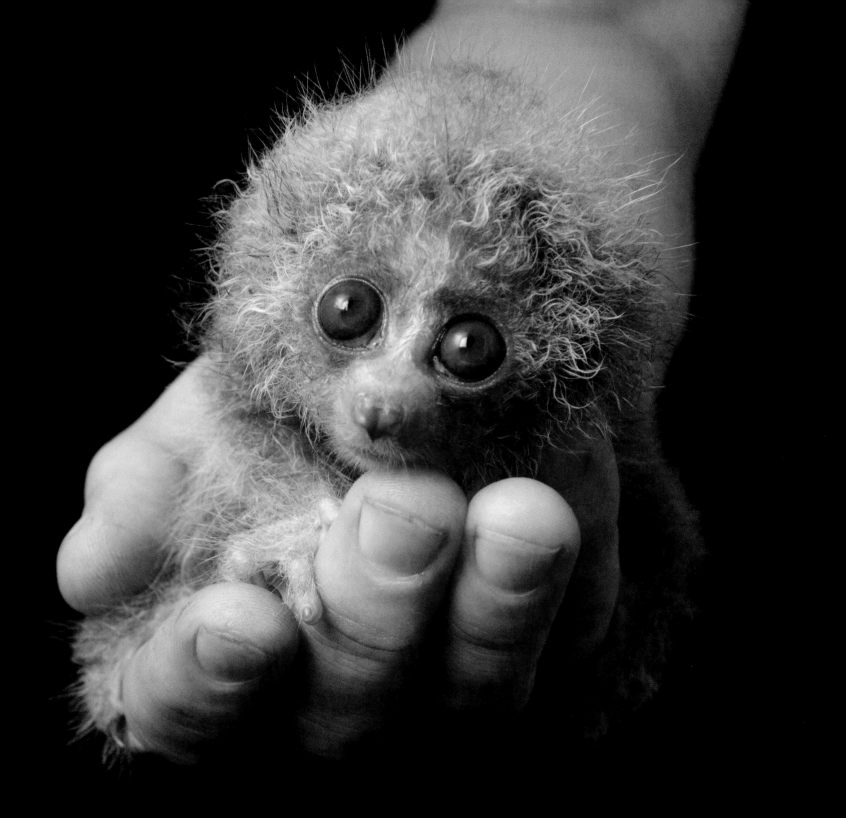

OPPOSITE: **Tiger-striped tree frog** *(Phyllomedusa tomopterna)* LC

**Bengal slow loris** *(Nycticebus bengalensis)* VU

**Mandrill** *(Mandrillus sphinx)* VU

"This juvenile mandrill was found next to a bush-meat market in Equatorial Guinea, and is likely reacting to seeing itself for the very first time, seeing its reflection in the glass filter on the front of my lens."

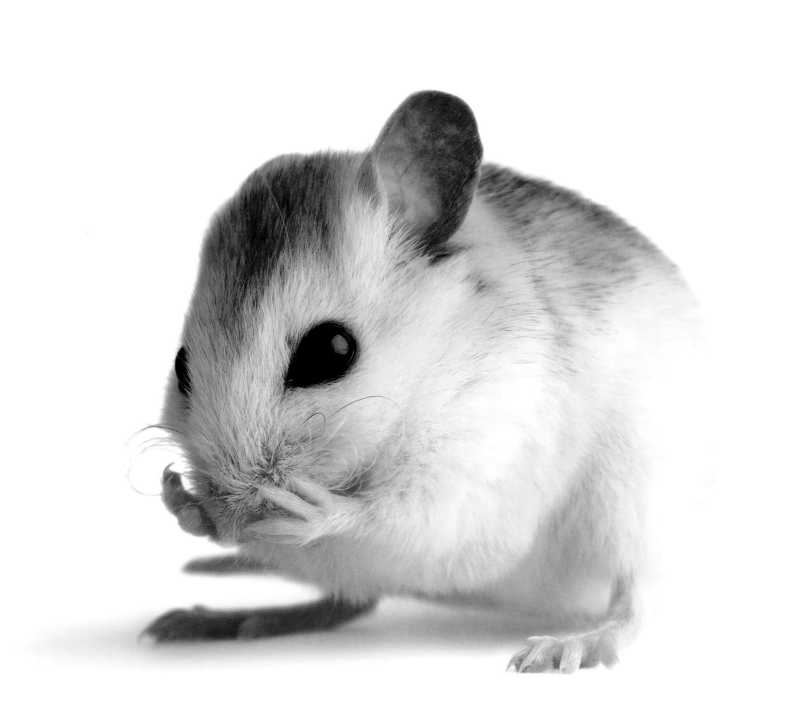

**St. Andrew beach mouse**
*(Peromyscus polionotus peninsularis)* LC

"Each subspecies of beach mouse has a color and pattern in its fur that has evolved to match the sand it lives in. This little mouse was grooming his whiskers. It's a self-soothing behavior. I think he was just camera shy."

**Ploughshare tortoises** *(Astrochelys yniphora)* CR

"You're looking at some of the rarest tortoises in the world—the ploughshare tortoise from Madagascar. These four animals were confiscated by the government from a smuggler, and were given to Zoo Atlanta for safekeeping and possible breeding when they eventually reach sexual maturity. If you look closely enough, a tortoise is as magnificent as a tiger."

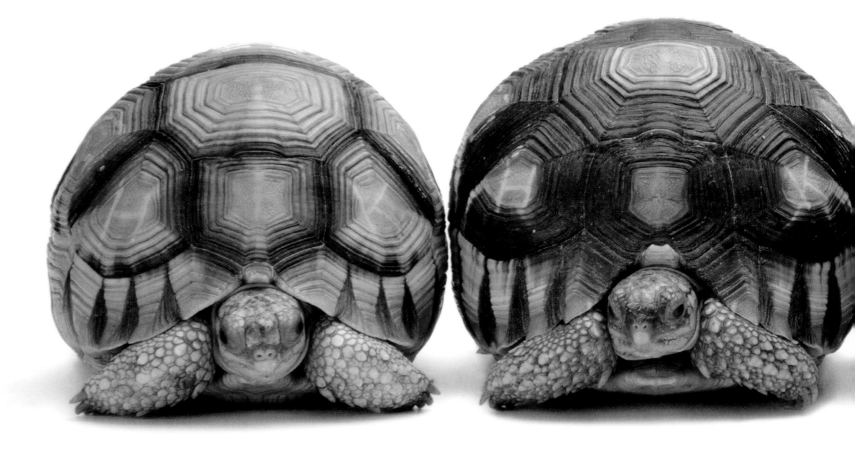

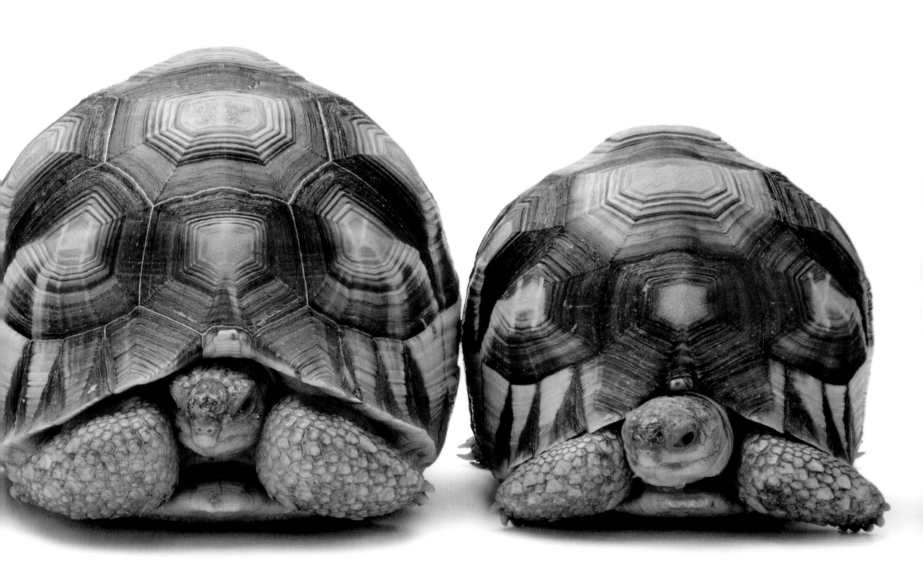

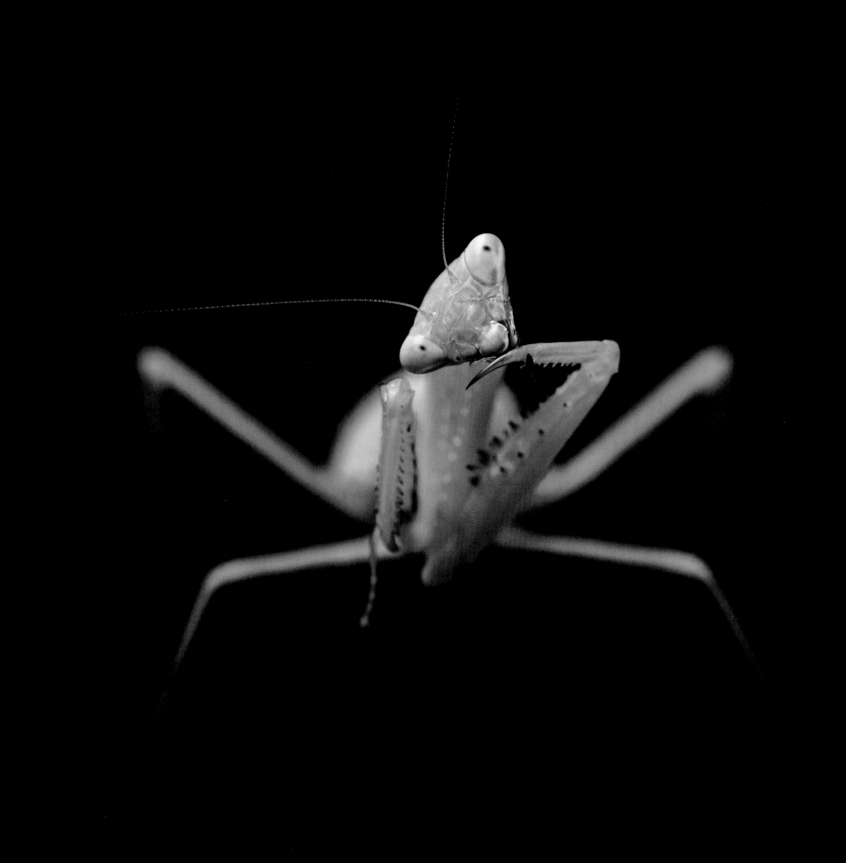

Springbok mantis *(Miomantis caffra)* NE

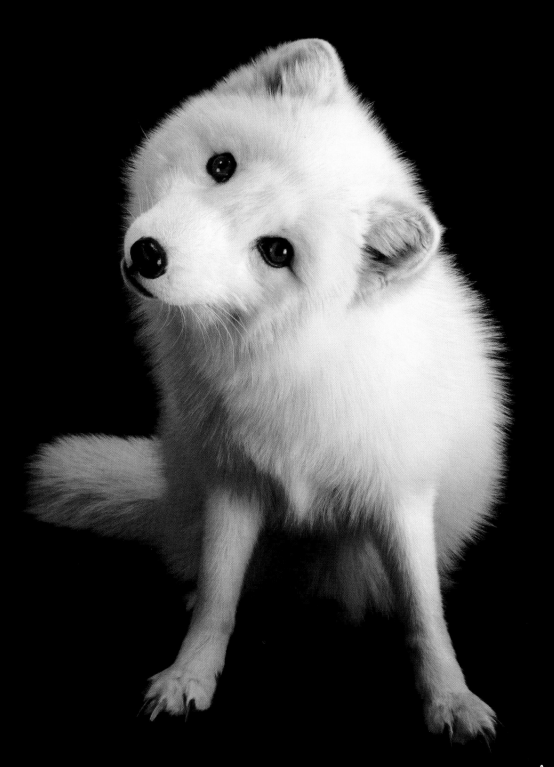

**Arctic fox** *(Vulpes lagopus)* LC

"This arctic fox would not hold still. Finally, in desperation,
I squealed like a pig. With that, he stopped, tilted his head to
figure out what that awful sound was, and I made this frame."

**Spectacled owl** *(Pulsatrix perspicillata)* LC

"He was falling asleep during this photo shoot. His eyes are about half closed in the picture, in fact."

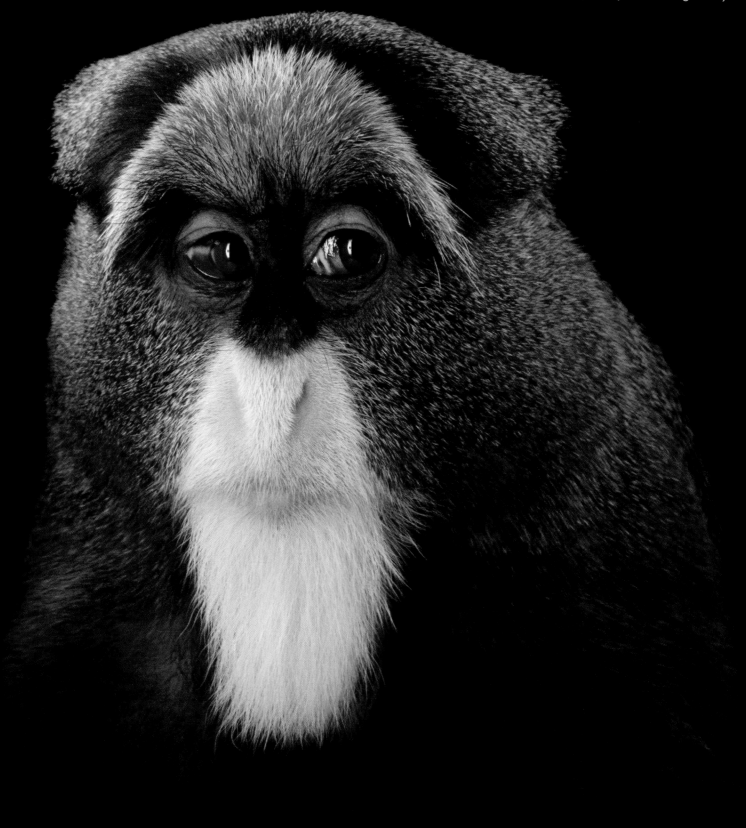

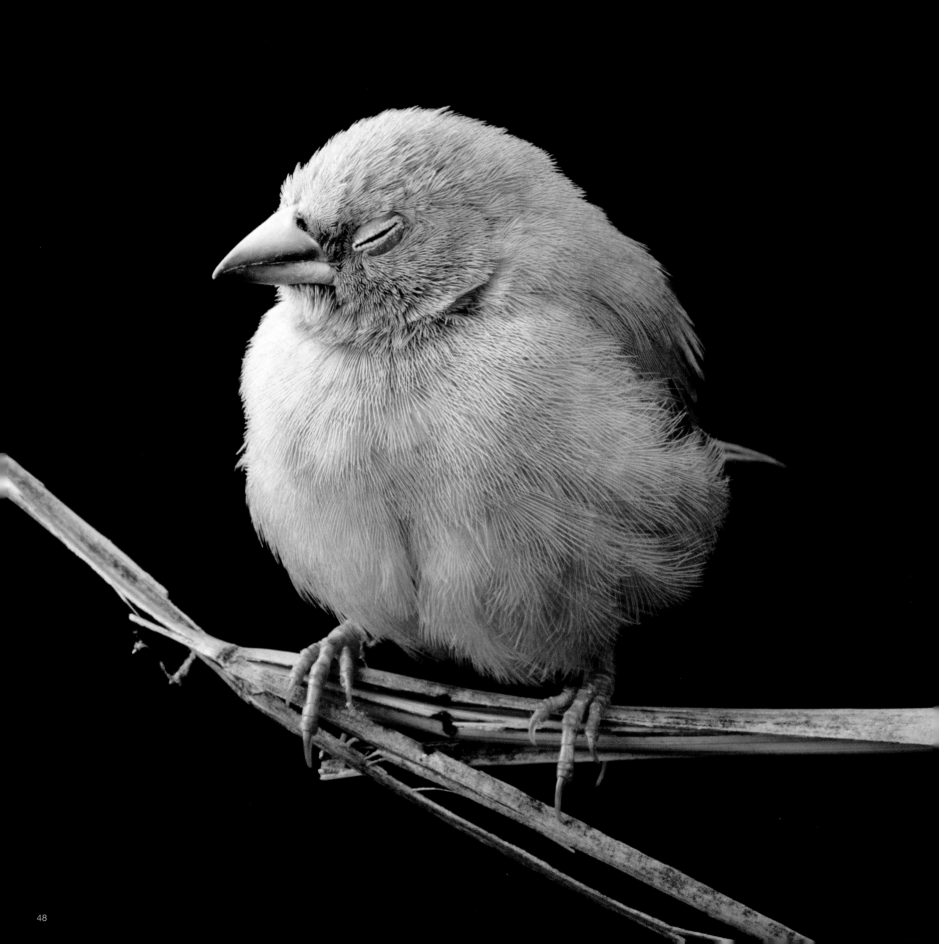

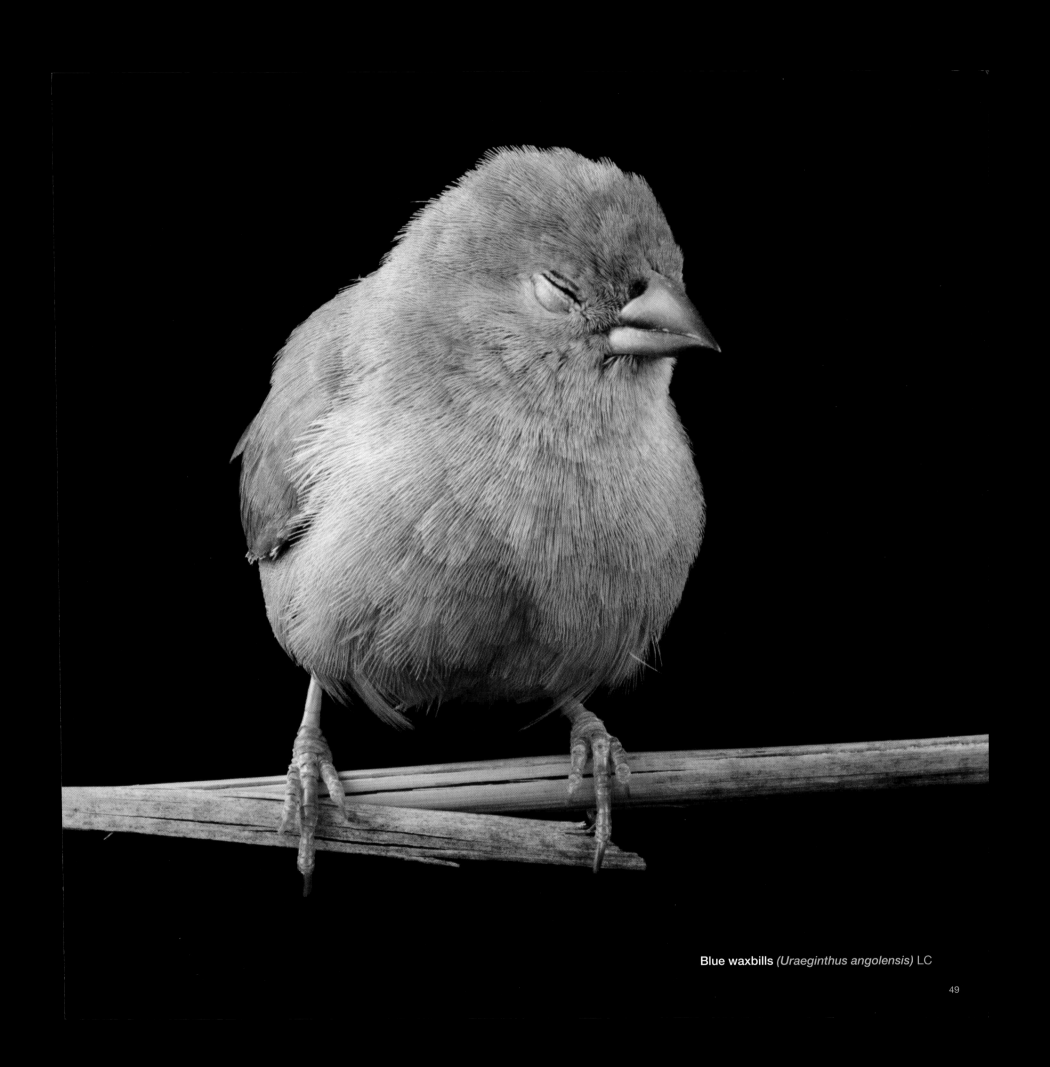

Blue waxbills *(Uraeginthus angolensis)* LC

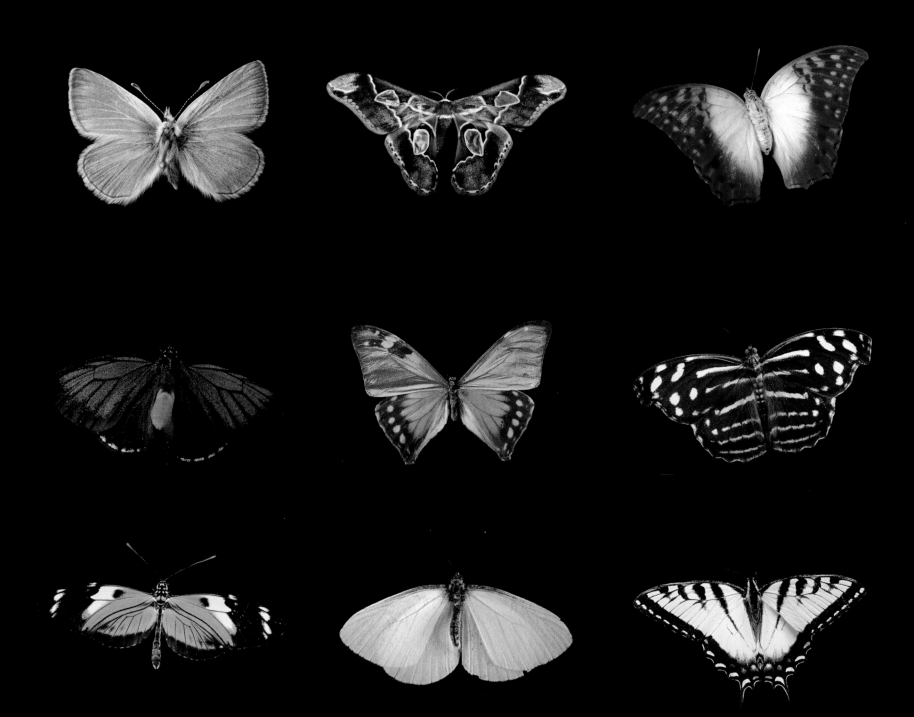

TOP ROW (L-R): "Pheres" Boisduval's blue butterfly *(Aricia icarioides pheres)* NE (pinned museum specimen; considered extinct), Forbes' silk moth *(Rothschildia lebeau)* NE, Pearl Charaxes butterfly *(Charaxes varanes)* NE MIDDLE ROW (L-R): Atala butterfly *(Eumaeus atala)* NE, Aega morpho butterfly *(Morpho aega)* NE (pinned museum specimen; odd color morph), Blue-banded purplewing *(Myscelia cyaniris)* NE BOTTOM ROW (L-R): Ismenius tiger *(Heliconius ismenius tilletti)* NE, Mustard white butterfly *(Pieris oleracea)* NE, Eastern tiger swallowtail butterfly *(Papilio glaucus)* NE

TOP ROW (L-R): Tailed jay butterfly *(Graphium agamemnon)* NE, "Peleides" blue morpho butterfly *(Morpho peleides)* NE, Mexican bluewing butterfly *(Myscelia ethusa)* NE MIDDLE ROW (L-R): Great southern white butterfly *(Ascia monuste)* NE, Common lime butterfly *(Papilio demoleus)* NE, White peacock butterfly *(Anartia jatrophae)* NE BOTTOM ROW (L-R): Gulf fritillary butterfly *(Agraulis vanillae incarnata)* NE, Common green birdwing *(Ornithoptera priamus)* NE, Malachite butterfly *(Siproeta stelenes)* NE

> "*When you look these animals in the eye, you see clearly that we're not so very different.*

**Chimpanzee** *(Pan troglodytes)* EN

"This baby was being raised by human moms who worked at the zoo. She refused to not be held by a human at all times, so we had to do the portrait with her caregiver holding on from the waist down, just out of frame. That made the baby feel safe, secure, and even willing to ham it up a bit for the camera."

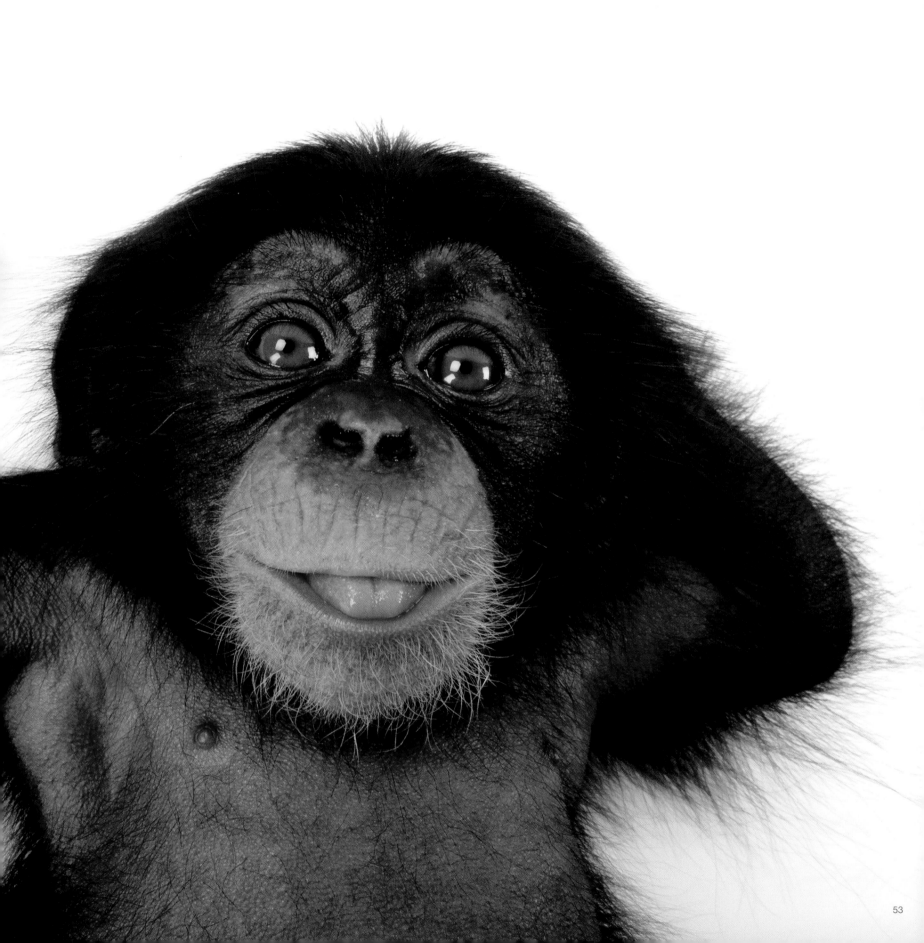

King vulture *(Sarcoramphus papa)* LC

OPPOSITE: **Sumatran rhinoceros**
*(Dicerorhinus sumatrensis)* CR

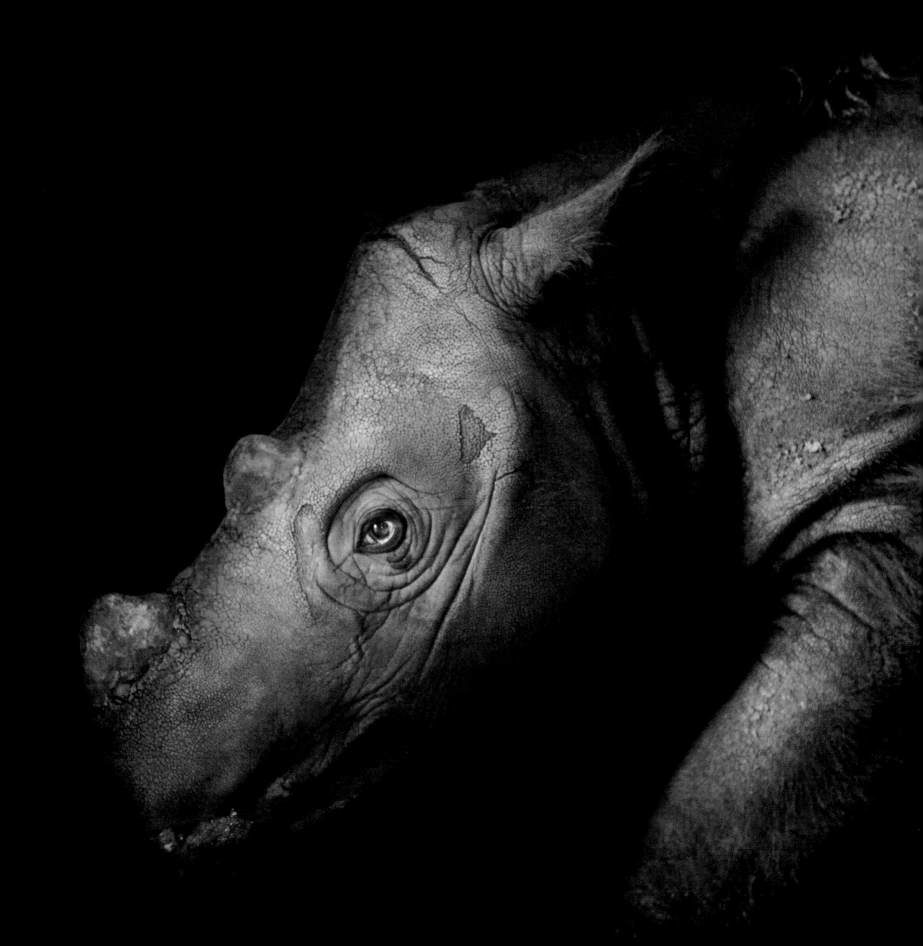

# HEROES

**Jack Rudloe**

Gulf Specimen Marine Laboratories

Panacea, Florida

Jack Rudloe's love of the sea and its creatures began during his childhood in Brooklyn, New York. The call was so strong he even slipped out to Coney Island to sneak into the New York Aquarium while it was under construction to see the beluga whales and other sea life. From that auspicious start, Rudloe has spent his life celebrating, protecting, and educating about ocean underdogs—from starfish and anemones to a crablike creature known as a giant isopod.

Rudloe and his late wife, Anne, founded Gulf Specimen Marine Laboratories out of their joint passion for marine life. The education center in Panacea, Florida, now hosts thousands of schoolchildren each year, who learn about the web of life in the nearby Gulf of Mexico. Its "living dock" lets kids use a lift net to see what creatures make a home on and around the dock. He also sends out a traveling "sea mobile," complete with tanks where kids can touch sea life, an experience that helps Rudloe reach his goal of "corrupting young minds," he says with a laugh. "The real energizing force is the kids coming through."

Rudloe's infectious attitude has led to a life of continuous discovery, and a love-hate relationship with octopuses: "It's harder to deal with an animal that's smarter than you," he says. But it's a box jellyfish that shares his name: *Chiropsella rudloei*. He collected the specimen in the 1960s from wetlands in Madagascar. When it was rediscovered in a collection at the Smithsonian Institution, the scientist who found it named it after Rudloe as a way to recognize his tireless efforts for wetland conservation. ◆

> *Whether they squirt ink, sting, hiss, pop, or bubble, they are invertebrates, and I love them all.*
>
> —Jack Rudloe

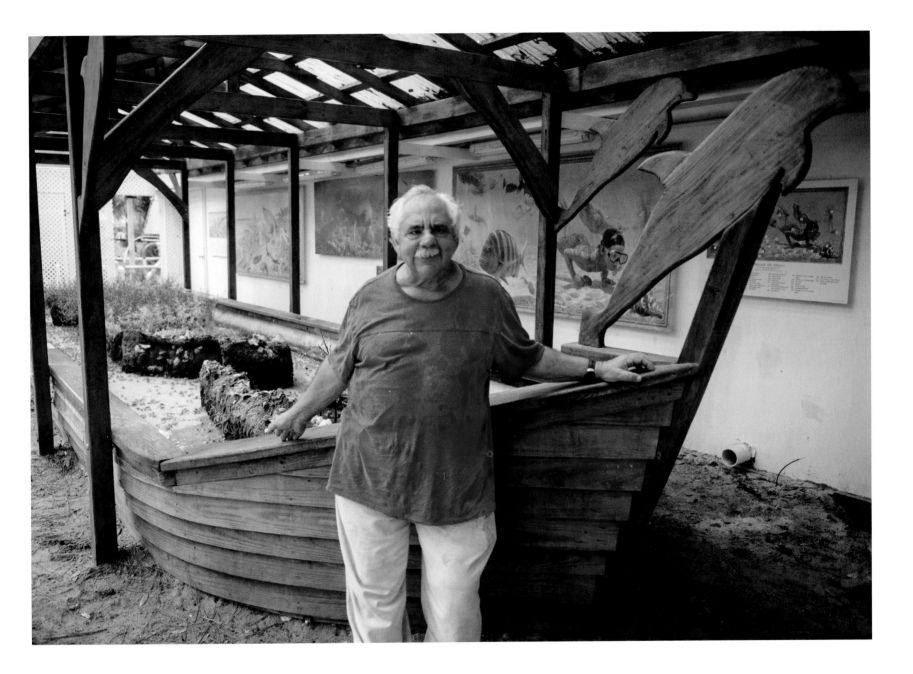

OPPOSITE: **Two banded sea stars** *(Luidia alternata)* NE,
**Small spine sea star** *(Echinaster spinulosus)* NE

Jack Rudloe stands in front of his ark full of little beach
crabs, just a small part of the education center in Panacea,
Florida, that he founded with his late wife, Anne.
"The little stuff is the most interesting of all," he says.

# CAMOUFLAGE ▶ ◀

"This squid was tiny, as I recall, perhaps thumb-size, but on the white background it's every bit as impressive as a leopard," Joel says. Both creatures rely on patterns for cloaking, whether in the light and shadow of an African savanna or on the speckled bottom of a seafloor. Camouflage can serve as protection from prey or stealth on the prowl.

**African leopard** *(Panthera pardus pardus)* VU

Bobtail squid *(Euprymna scolopes)* DD

"The plain truth is when we save species, we are actually saving ourselves.

**Empty deertoe mussel shell** *(Truncilla truncata)* NE

**Budgett's frog** *(Lepidobatrachus laevis)* LC

"This frog was growling like a mad cat and threatening to bite its handler as we shot the picture. It has sharp teeth and can actually draw blood. It's a large frog, the size of a baseball, so it's not one you want to irritate."

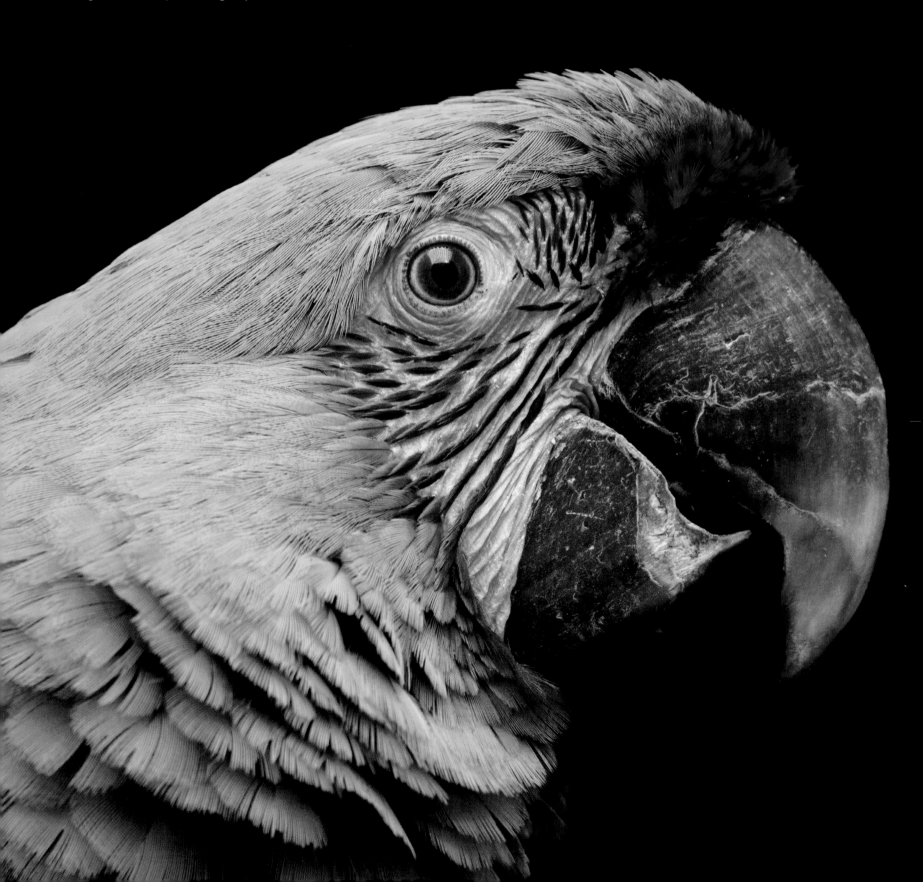

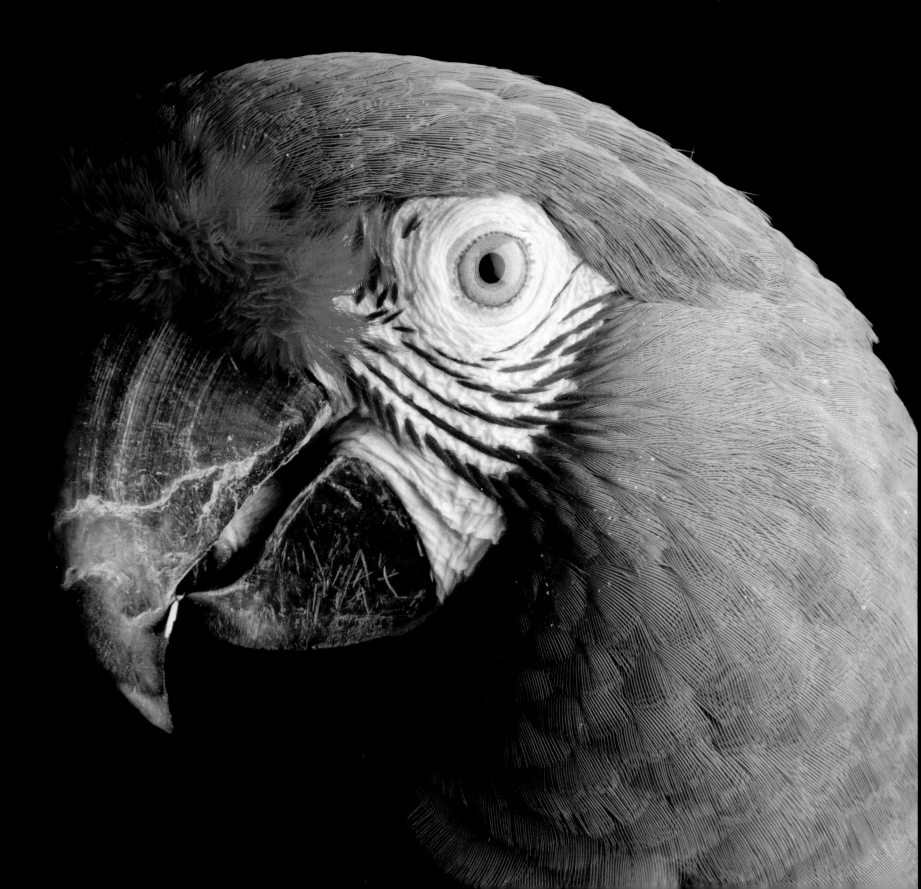

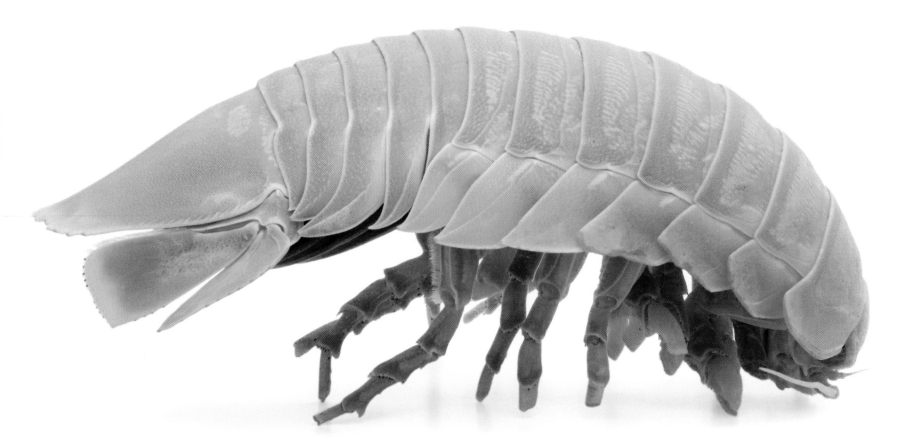

**Giant deep-sea roach** *(Bathynomus giganteus)* NE

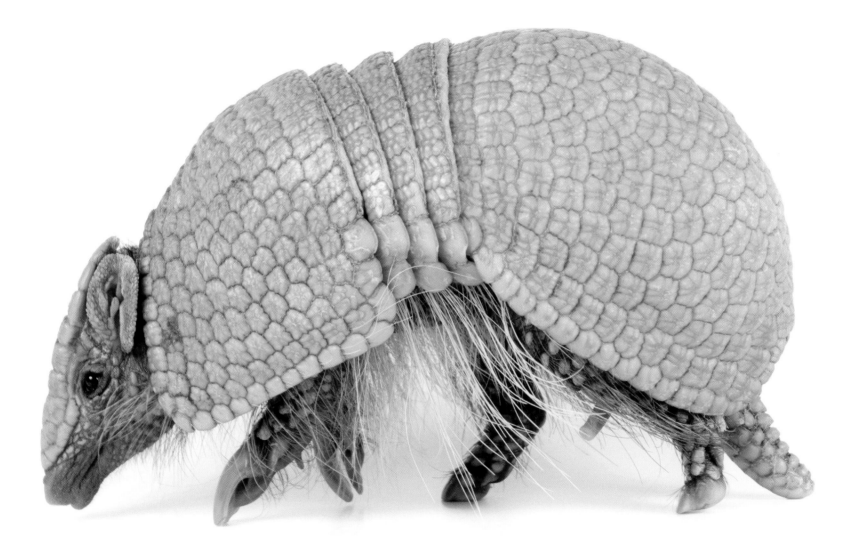

Southern three-banded armadillo *(Tolypeutes matacus)* NT

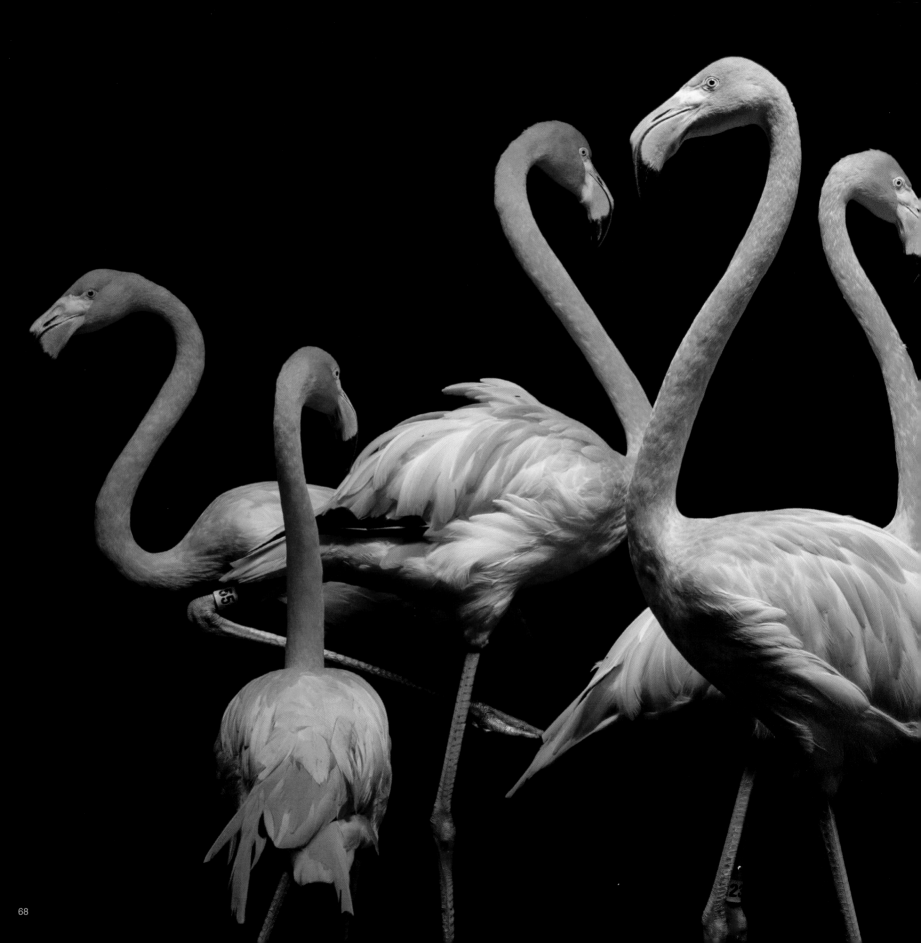

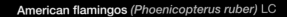

**American flamingos** *(Phoenicopterus ruber)* LC

"We walked the entire flock into a black velvet–lined stall.
From then on, the birds paid attention only to each other."

**Black-throated monitor**
*(Varanus albigularis ionidesi)* NE

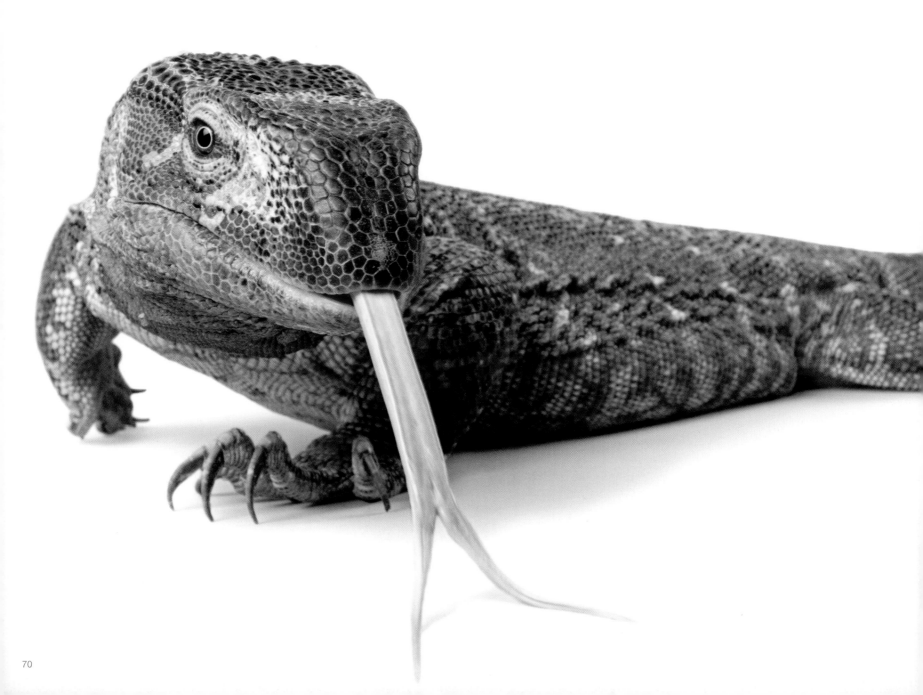

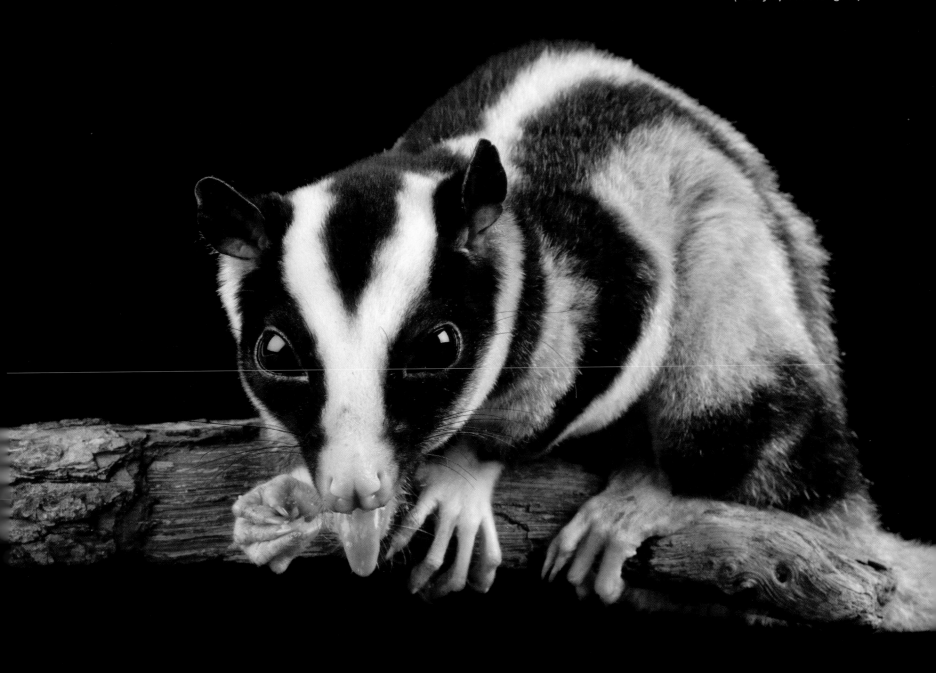

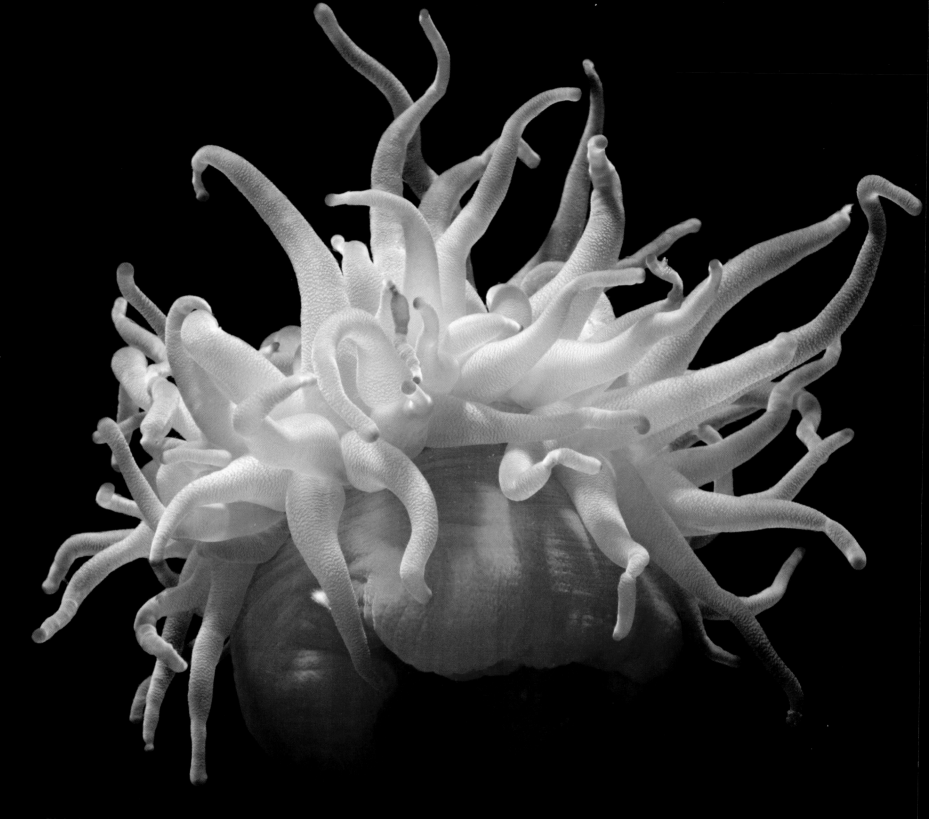

**Pink-tipped anemone** *(Condylactis gigantea)* NE

East African crowned crane
*(Balearica regulorum regulorum)* EN

Leopard cat *(Prionailurus bengalensis chinensis)* LC

# BEHIND THE SCENES

*Oklahoma City Zoo*

"They said it couldn't be done," Joel says of photographing an American bison named Mary Ann at the Oklahoma City Zoo in Oklahoma City. "They said the female bison was unruly, bossy, and dangerous, and we were just asking to get hurt." But after placing some enticing mulberry leaves on the floor for the photo shoot, the crew was able to position her exactly where Joel wanted.

"All these photos are about basic problem solving," Joel explains. To make the animal comfortable, the team adapted a space familiar to the bison—the stable she rests in at night. The plan worked. The bison's nature came through. "She was just a sweetheart," says Joel. ◆

*"Mary Ann walked in, chewed the leaves slowly, and looked right at me. She was totally cool.*

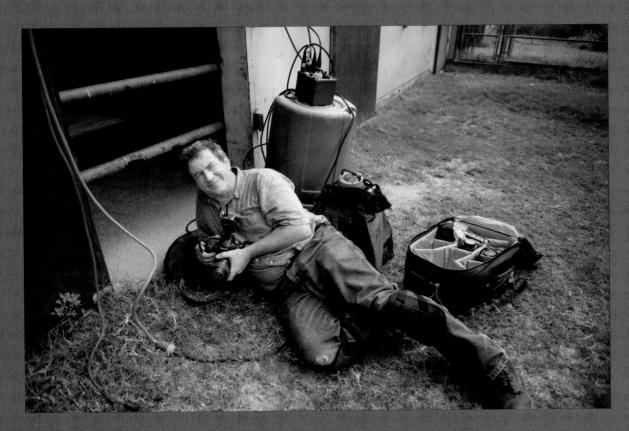

Joel gets ready to shoot the bison from below eye level (and from behind her corral bars) to capture the grandeur of an American bison. A patch of nontoxic white paint is just visible on the stall floor.

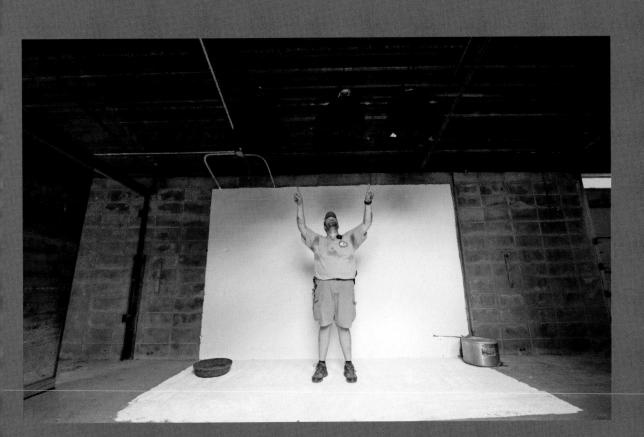

A zookeeper at the Oklahoma City Zoo points up to the obscured lights and cables that Joel used for the shoot. Concealing the equipment in the ceiling helped make the bison comfortable and less likely to startle.

The key to photographing Mary Ann, a spirited American bison, was to turn her own familiar stable into a studio. Joel and his team fastened all the lighting equipment they needed to the ceiling, so it was out of view and not in the way as the bison moved around. Mary Ann turned out to be the one ungulate Joel has worked with that was calm enough to allow him to photograph her against both black and white backgrounds.

American bison *(Bison bison)* NT

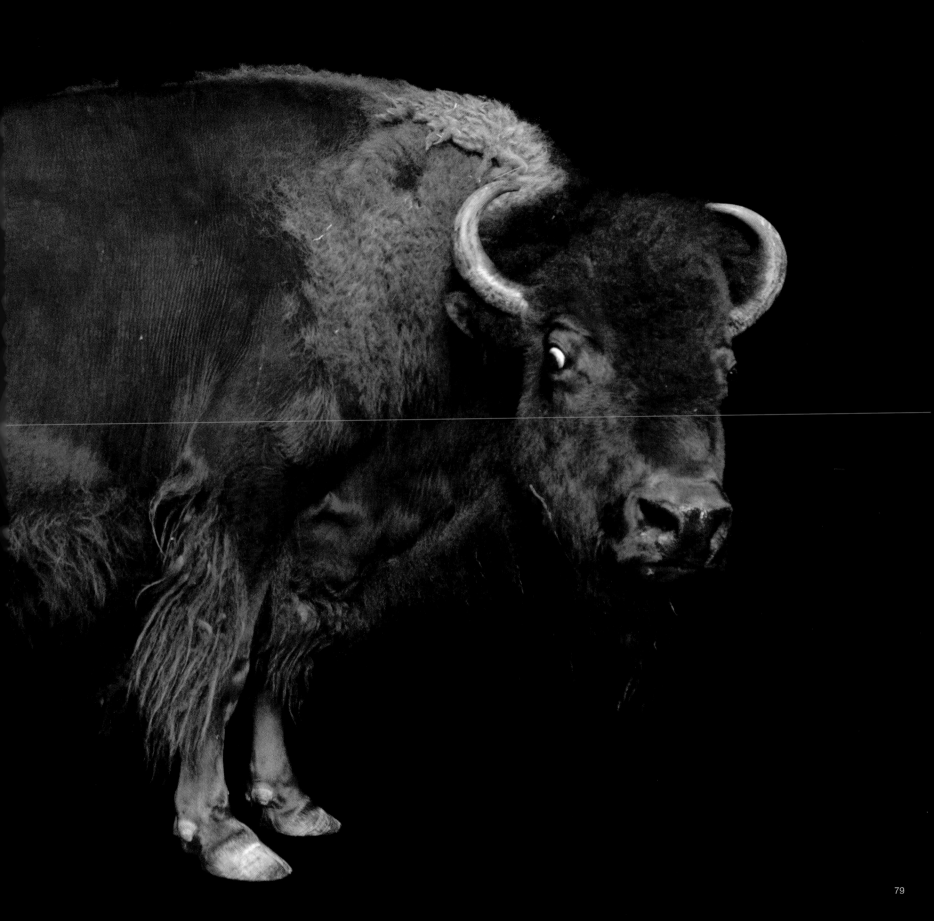

Eyes on butterfly wings, eyes on owls: At a glance, they are identical. Scientists think the eyespots evolved on this butterfly species' wings because they resemble owl eyes and fool potential predators. Although owls need not worry about predators, they can have other things to worry about: This great horned owl was nearly electrocuted by a power line and saved by Raptor Recovery, a rehabilitation center in Bellevue, Nebraska. He suffered some brain damage and so will remain under human care for the rest of his life.

**Owl butterflies** *(Caligo memnon)* NE

OPPOSITE: **Great horned owl** *(Bubo virginianus)* LC

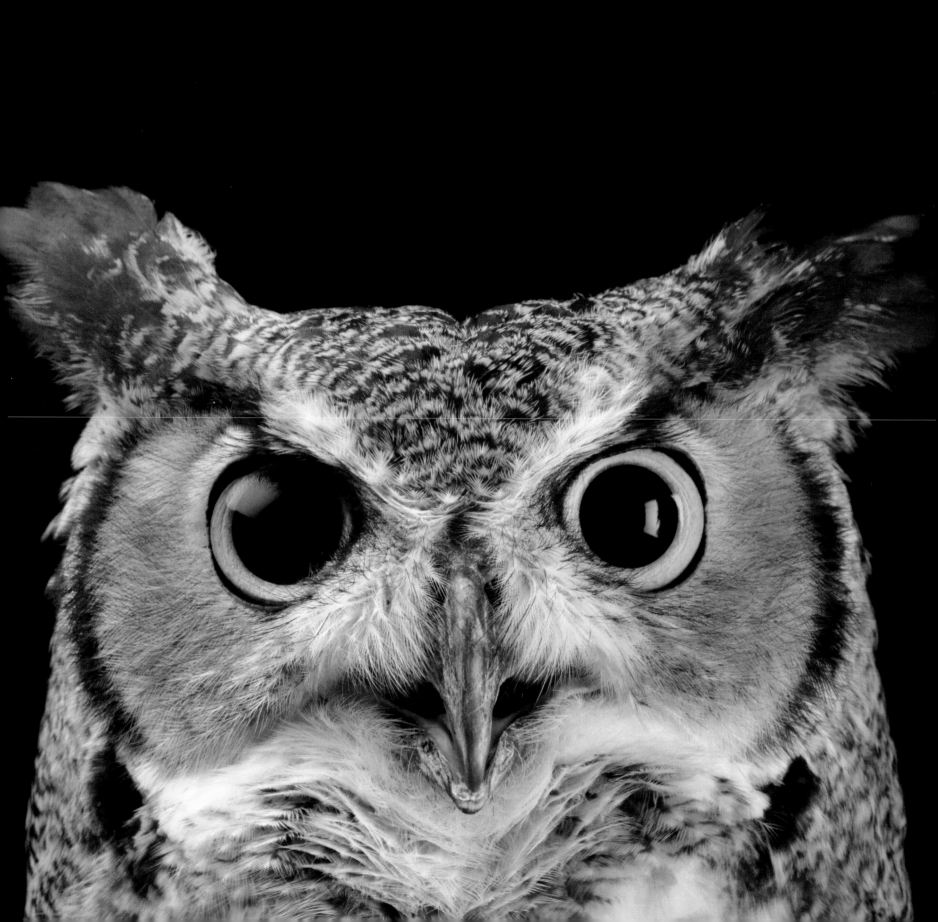

**Red-bellied lemur** *(Eulemur rubriventer)* VU

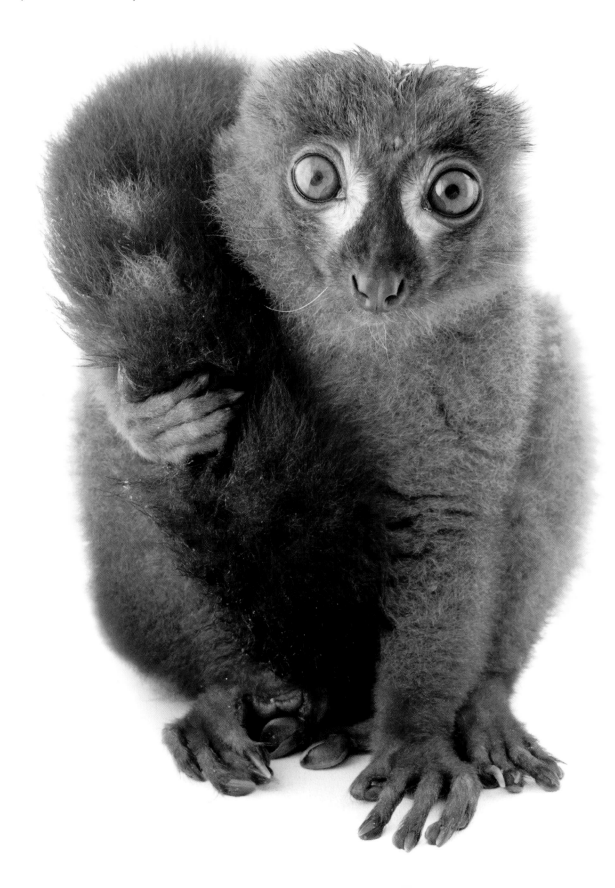

**Blue-eyed black lemur** *(Eulemur flavifrons)* CR

"Lemurs often wrap their tails up around their bodies when they're resting, chilly, or unsure of what the photographer is up to."

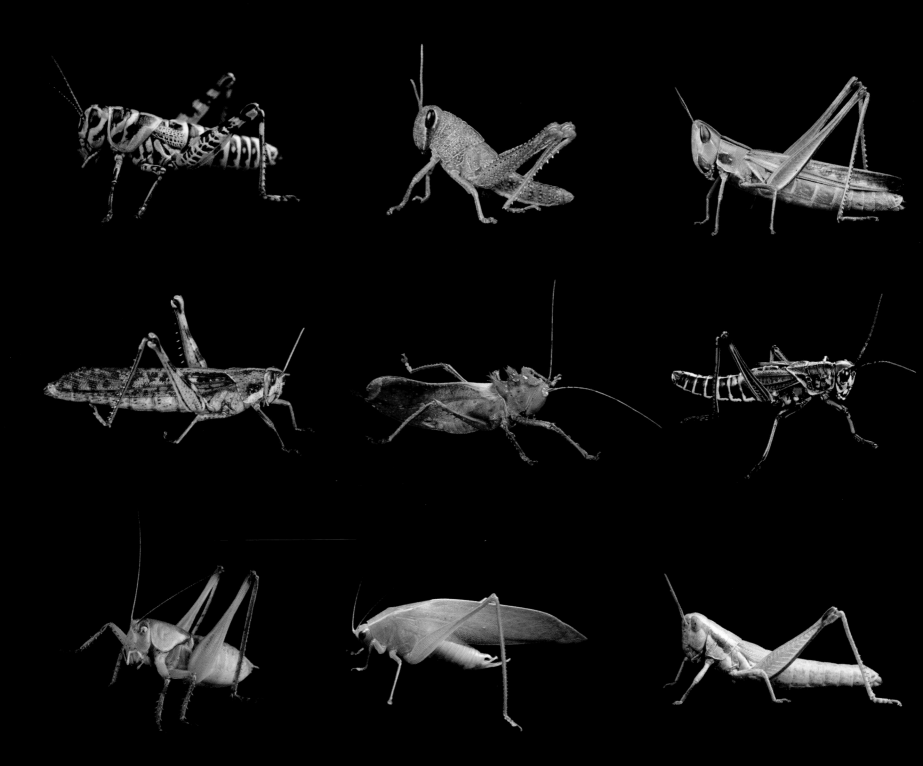

TOP ROW (L-R): **Rainbow grasshopper** *(Dactylotum bicolor)* NE, **Obscure bird grasshopper** *(Schistocerca obscura)* NE, **Red-legged grasshopper** *(Melanoplus femurrubrum)* NE MIDDLE ROW (L-R): **Gray bird grasshopper** *(Schistocerca nitens)* NE, **Dragon-headed katydid** *(Eumegalodon blanchardi)* NE, **Eastern lubber grasshopper** *(Romalea guttata)* NE BOTTOM ROW (L-R): **Haldeman's shieldback katydid** *(Pediodectes haldemani)* NE, **Katydid** *(Chloroscirtus discocercus)* NE, **Cudweed grasshopper** *(Hypochlora alba)* NE

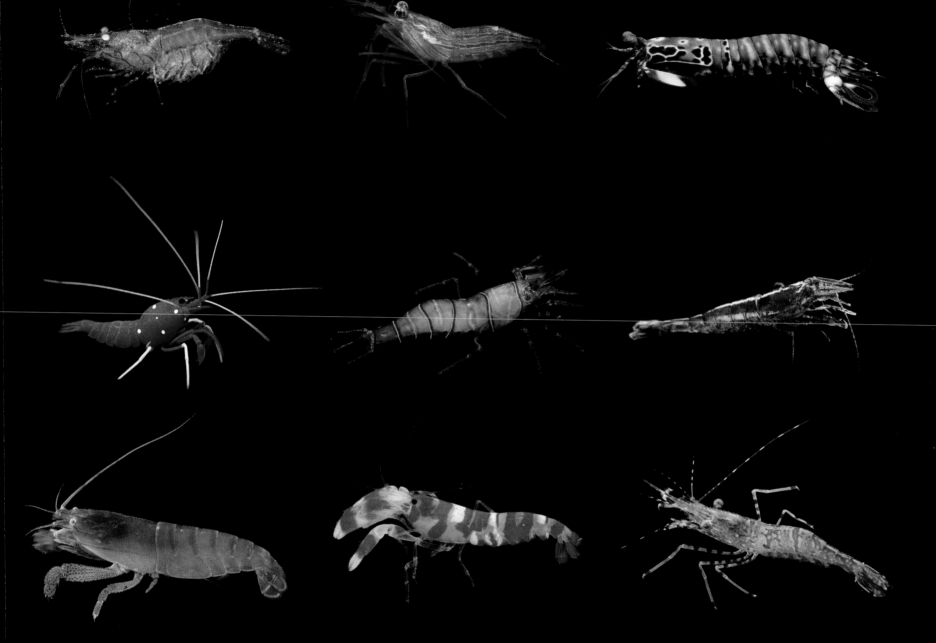

TOP ROW (L-R): Shore shrimp (*Palaemonetes* sp.), Peppermint shrimp *(Lysmata wurdemanni)* NE, Mantis shrimp *(Odontodactylus scyllarus)* NE MIDDLE ROW (L-R): Scarlet cleaner shrimp *(Lysmata debelius)* NE, Candy-striped shrimp *(Lebbeus grandimanus)* NE, Sand shrimp *(Crangon septemspinosa)* NE BOTTOM ROW (L-R): Blue wood shrimp *(Atya gabonensis)* LC, Red banded snapping shrimp *(Alpheus randalli)* NE, Coonstripe shrimp *(Pandalus hypsinotus)* NE

White-bellied pangolin and baby *(Phataginus tricuspis)* VU

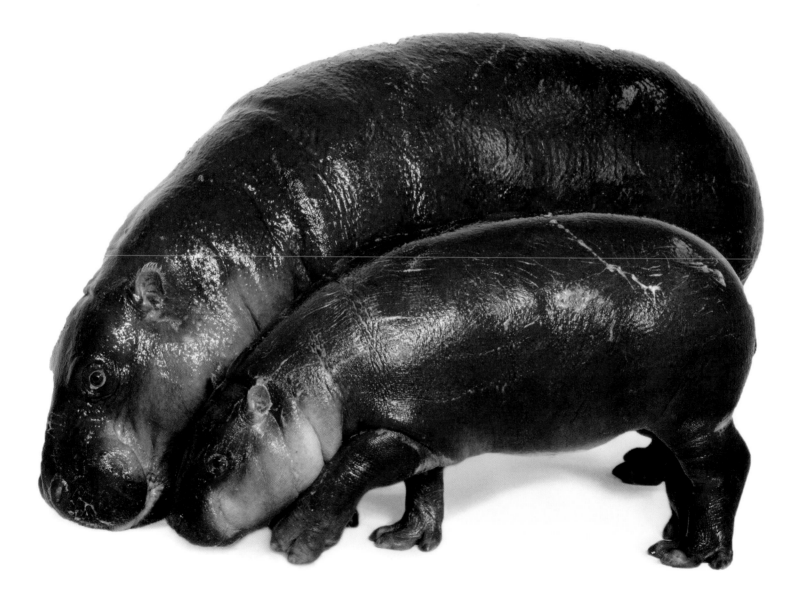

Pygmy hippopotamus and baby *(Choeropsis liberiensis)* EN

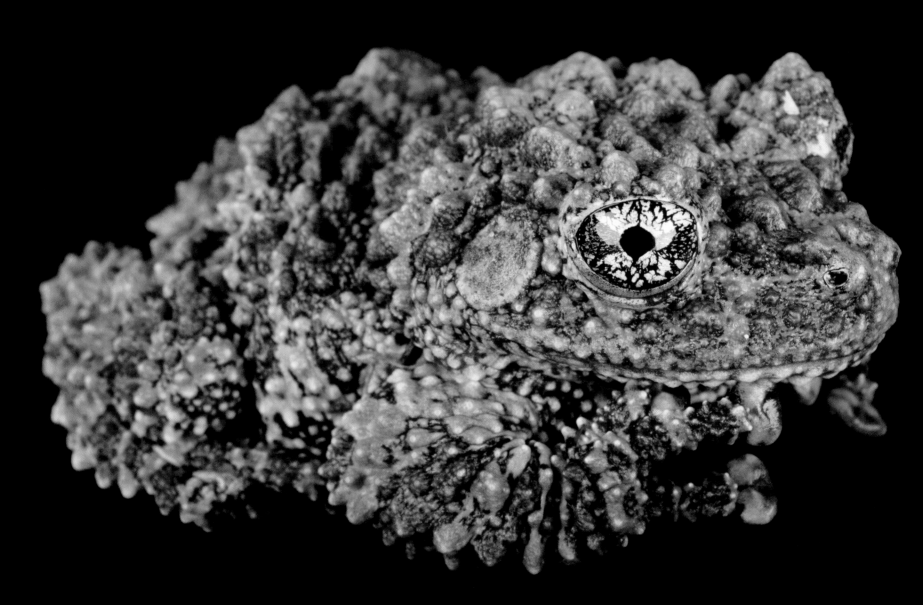

**Vietnamese mossy frog** *(Theloderma corticale)* DD

OPPOSITE: **Mexican hairy dwarf porcupine** *(Sphiggurus mexicanus)* LC

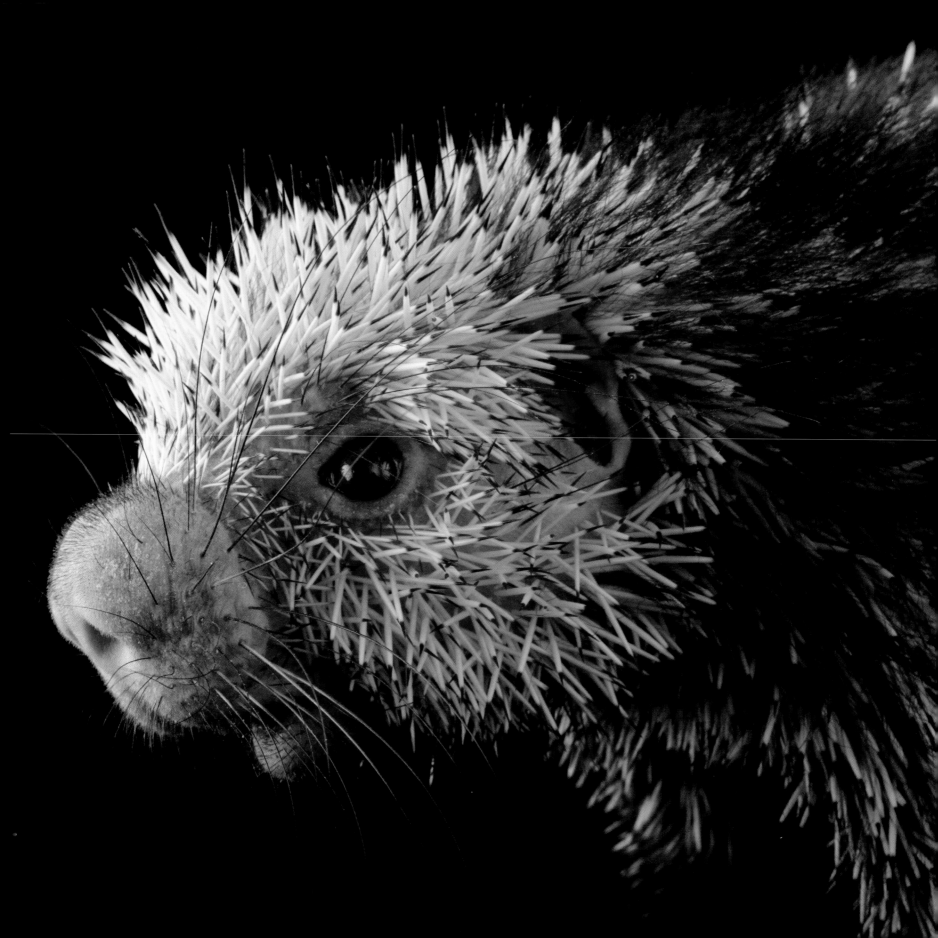

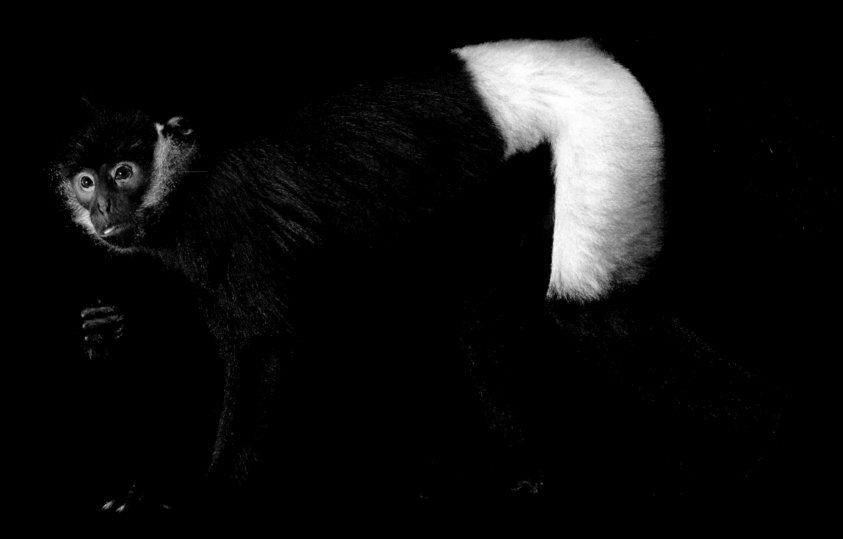

**Delacour's langur** *(Trachypithecus delacouri)* CR

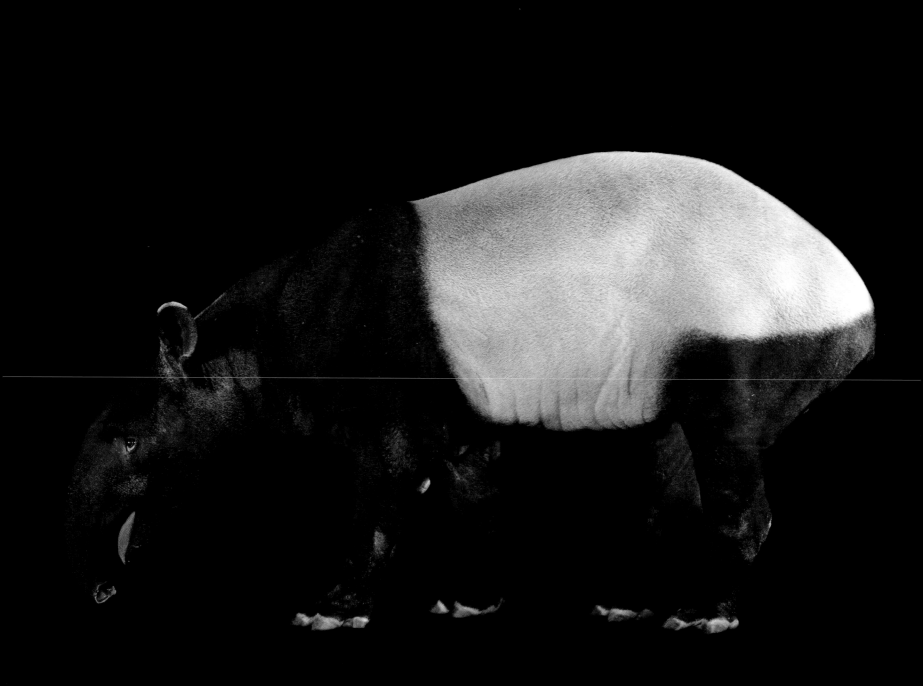

**Malay tapir** *(Tapirus indicus)* EN

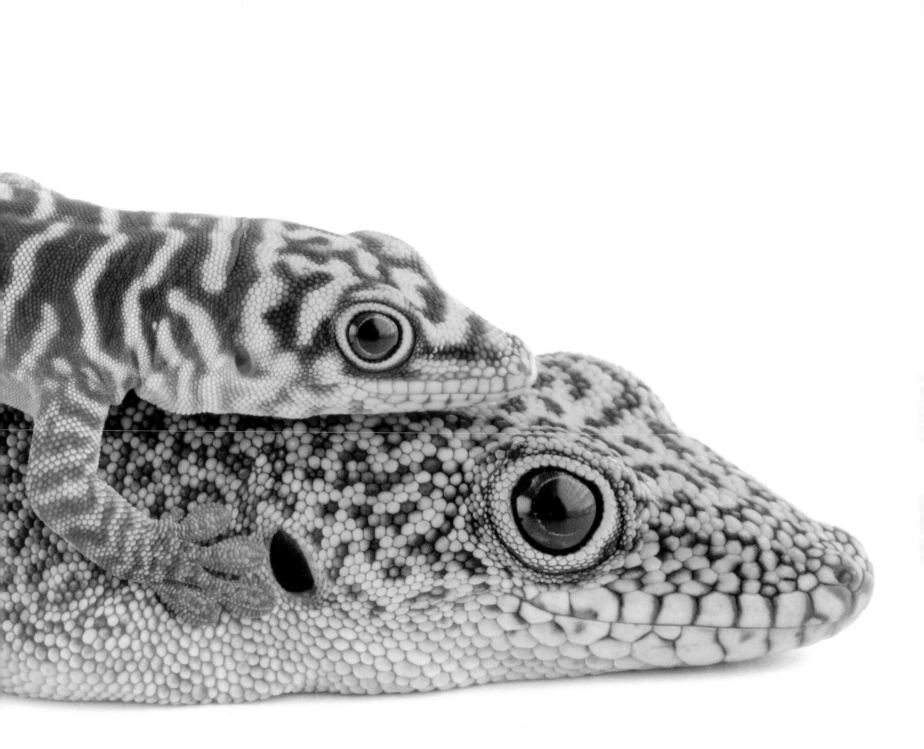

Standing's day gecko and hatchling *(Phelsuma standingi)* VU

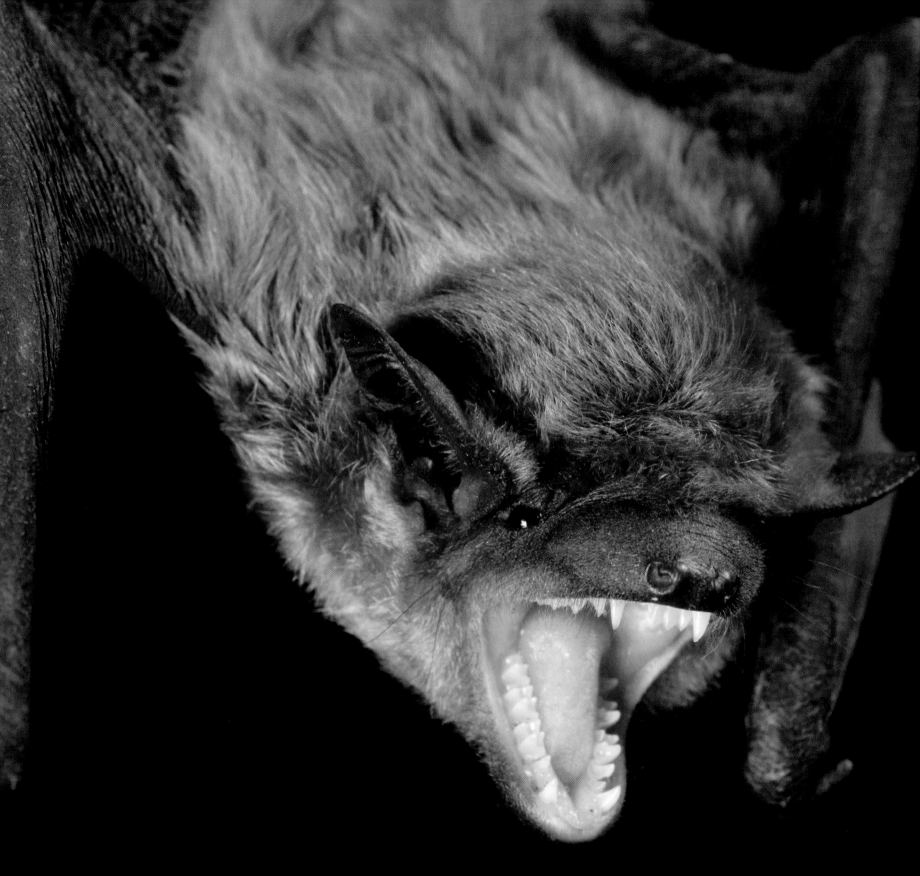

**Big brown bat** *(Eptesicus fuscus)* LC

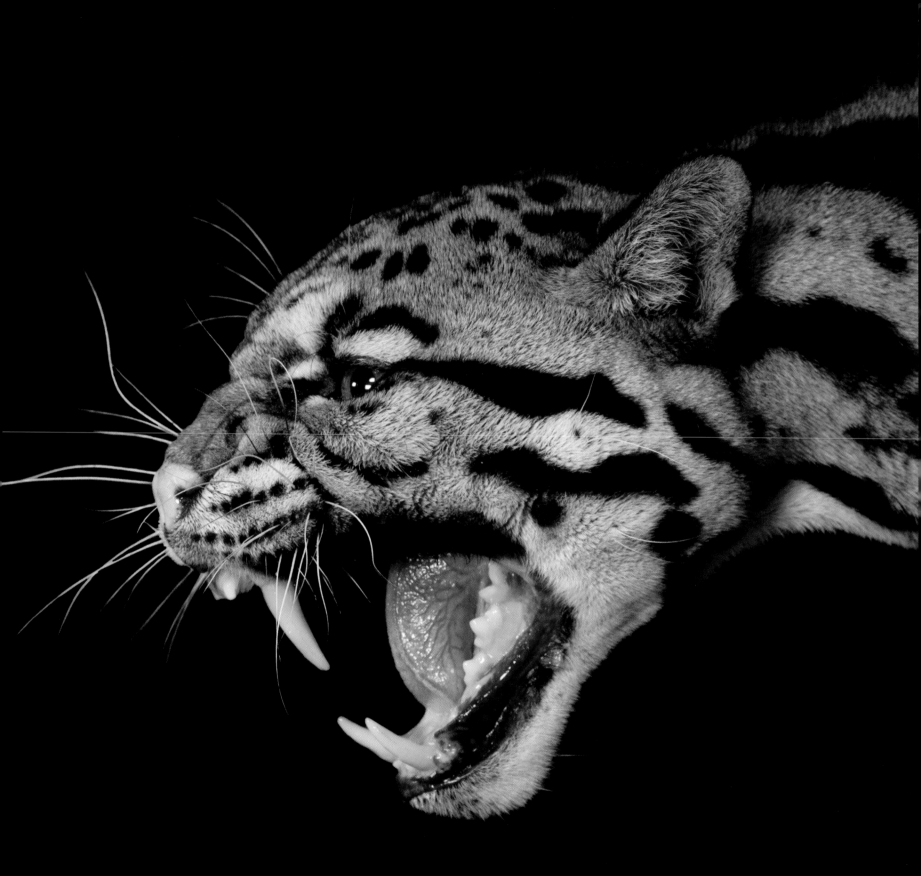

Clouded leopard *(Neofelis nebulosa)* VU

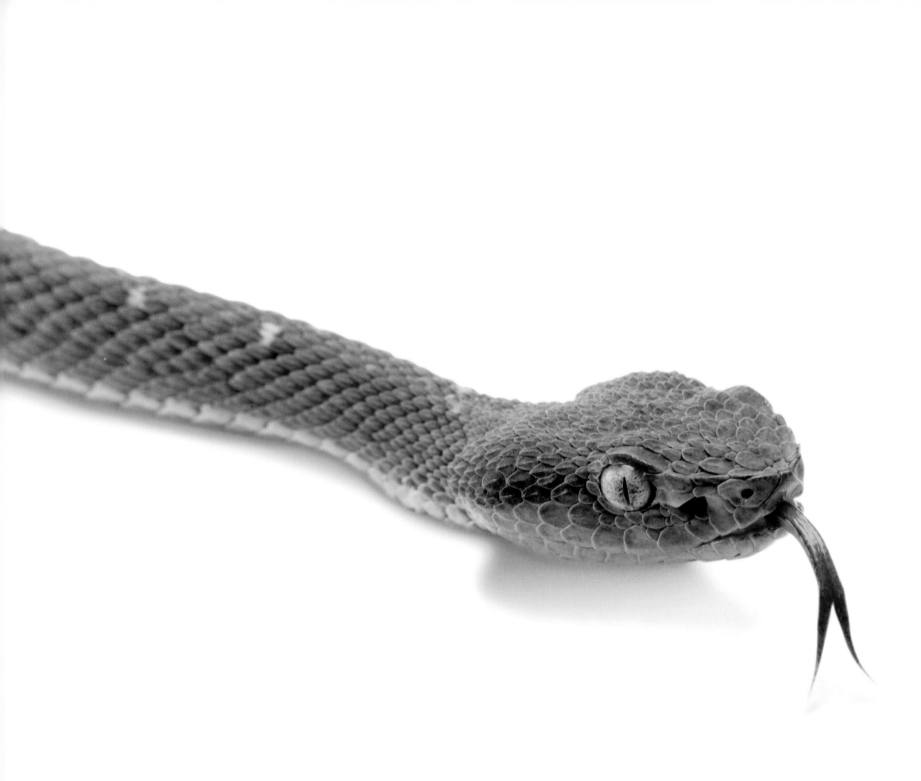

Side-striped palm pit viper *(Bothriechis lateralis)* LC

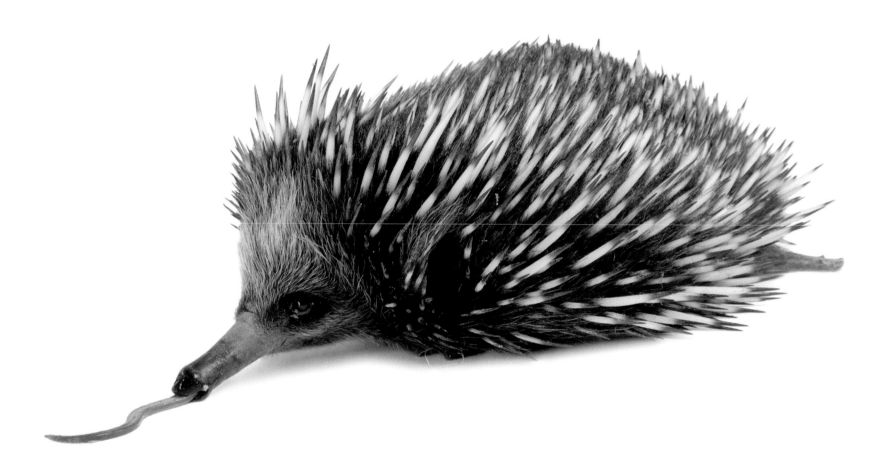

**Short-beaked echidna** *(Tachyglossus aculeatus)* LC

"The echidna may look like something from
another planet, but it's actually a mammal."

"*This is the one and only time I've photographed a two-headed animal. What were they thinking under that shell?*

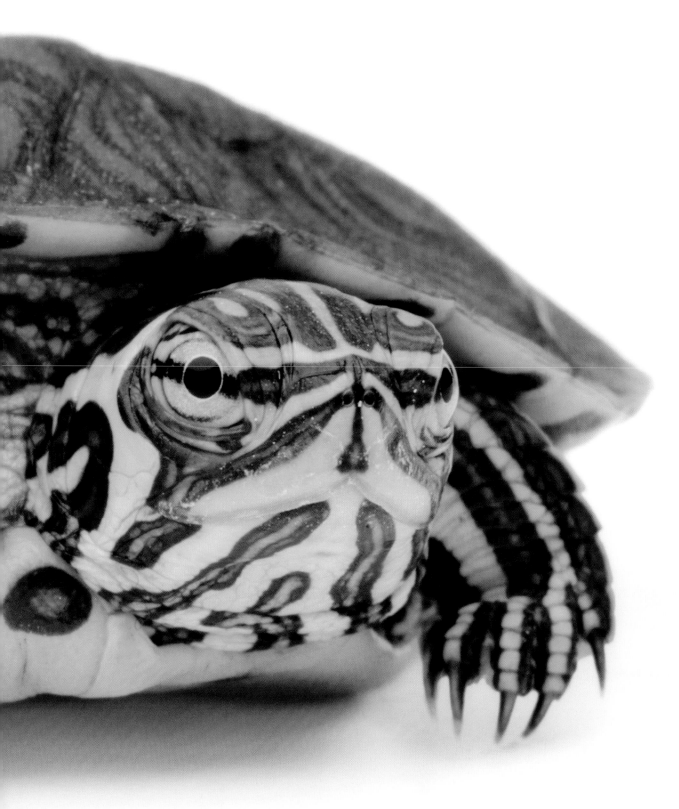

Yellow-bellied slider with two heads *(Trachemys scripta scripta)* LC

## A CONTINENT APART ▶◀

The hornbills of Africa and Asia and the toucans of
South and Central America are unrelated, but both have
large, curving bills, a case of convergent evolution—
similar characteristics that have evolved independently,
perhaps in response to similar environmental challenges.
The hornbill's casque, a sort of second bill on top of its
head, is made of the same material as your fingernails.

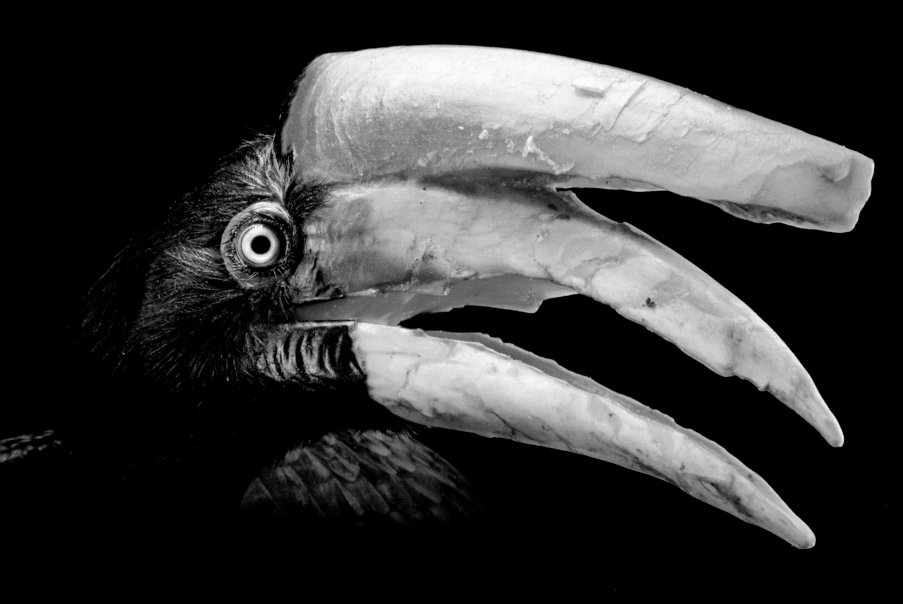

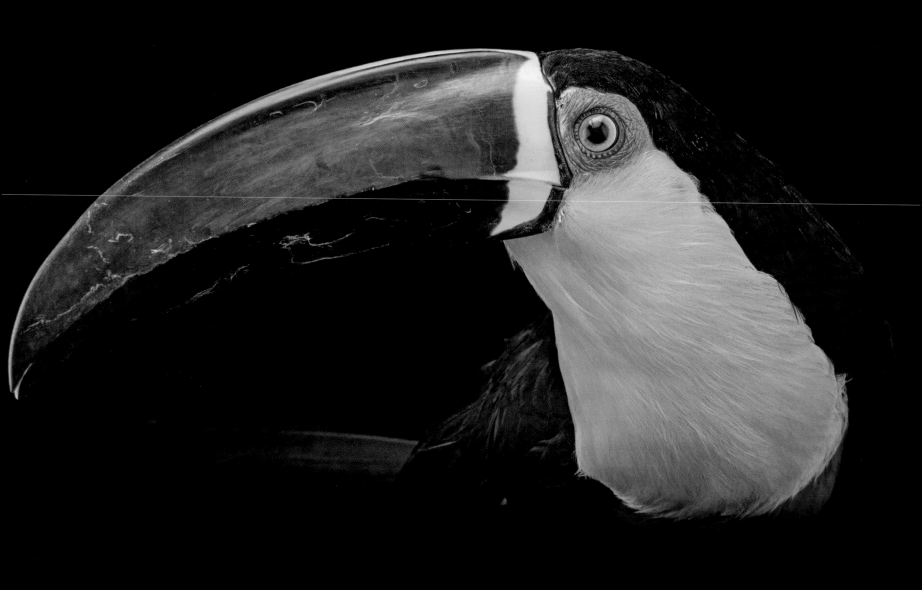

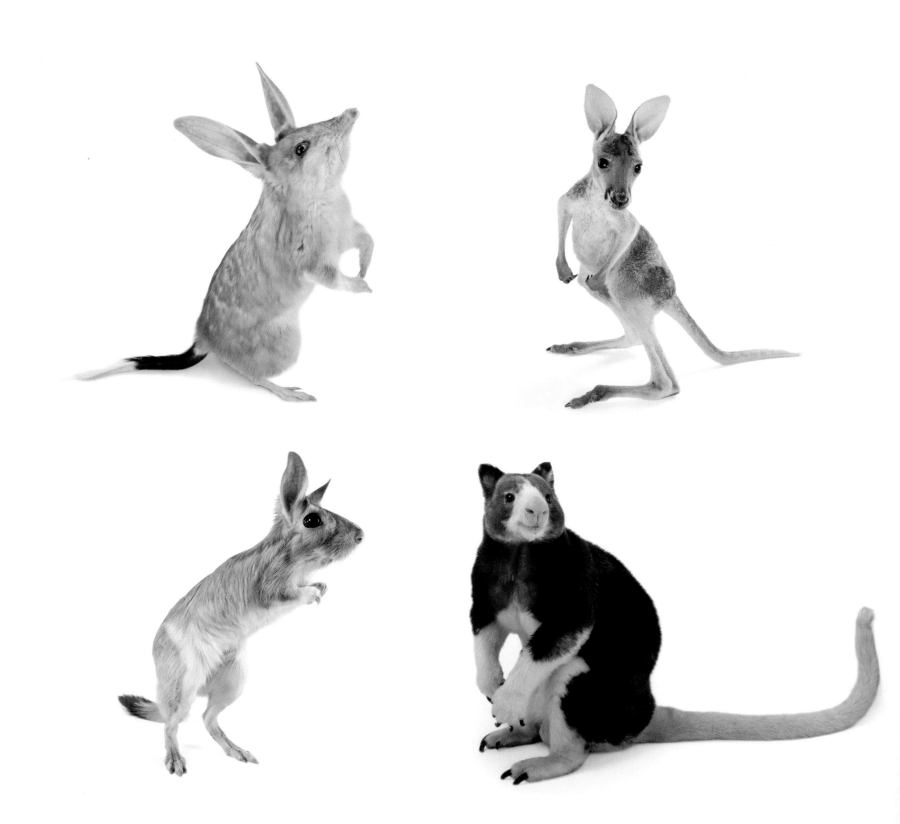

TOP ROW (L-R): **Greater bilby** *(Macrotis lagotis)* VU, **Red kangaroo** *(Macropus rufus)* LC
BOTTOM ROW (L-R): **Springhare** *(Pedetes capensis)* LC, **Matschie's tree kangaroo** *(Dendrolagus matschiei)* EN

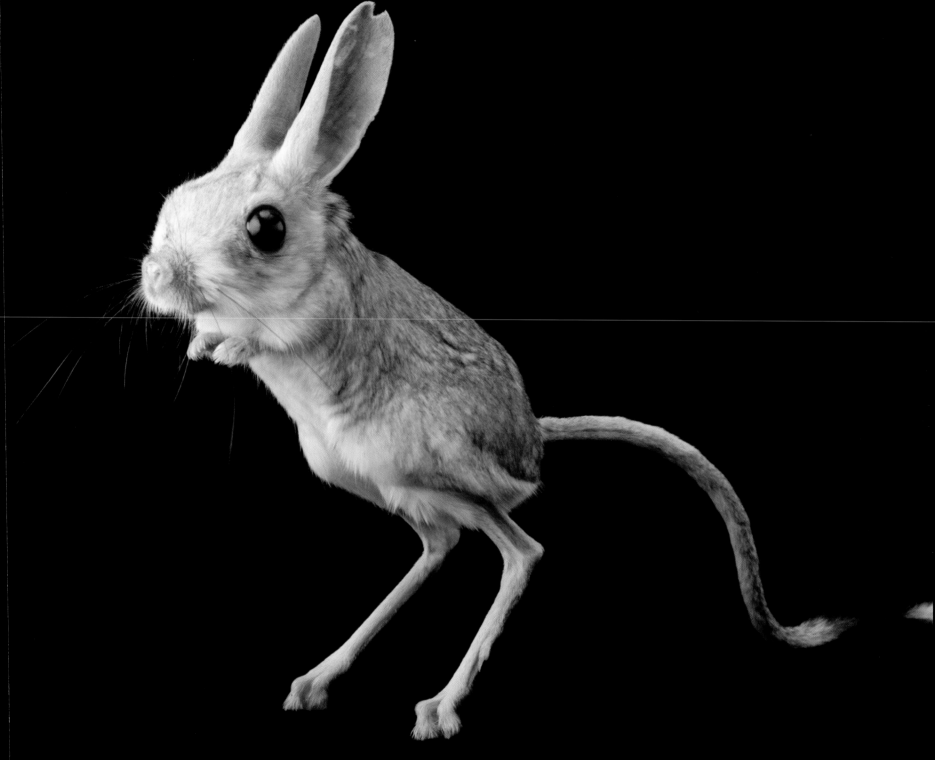

**Four-toed jerboa** *(Allactaga tetradactyla)* VU

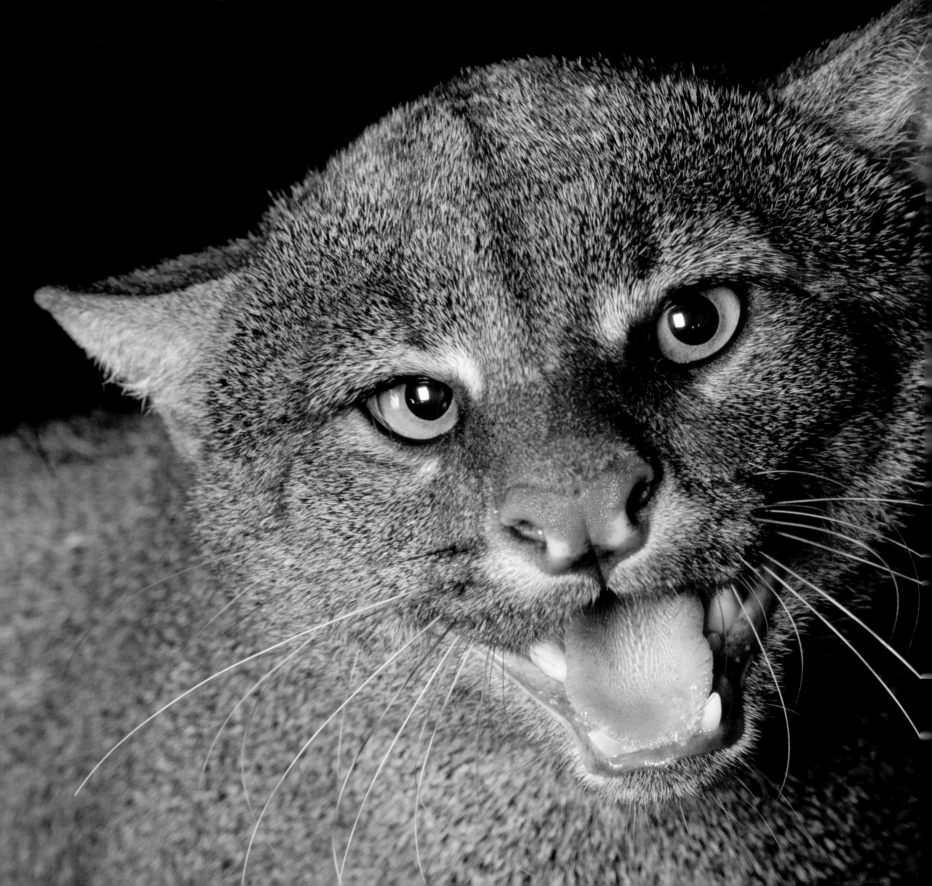

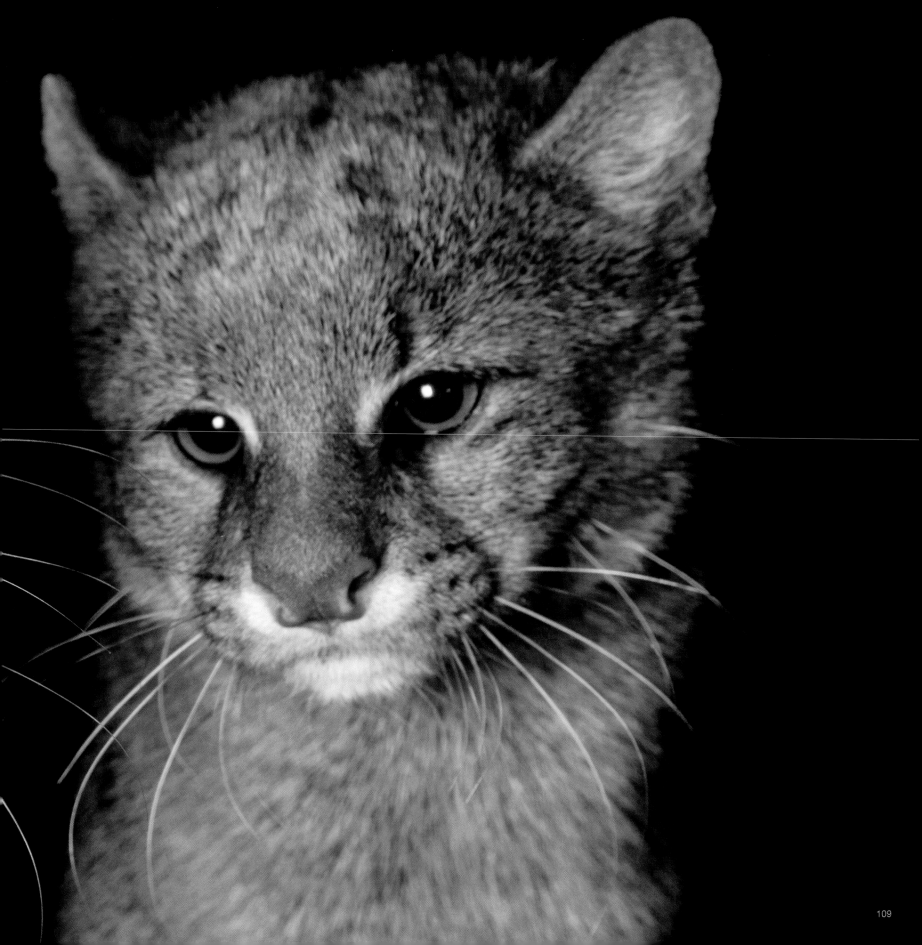

**Giant panda** *(Ailuropoda melanoleuca)* EN

"The panda sat for a long, long time eating big piles of bamboo without a care in the world. I could have photographed it all day, but I eventually had to go."

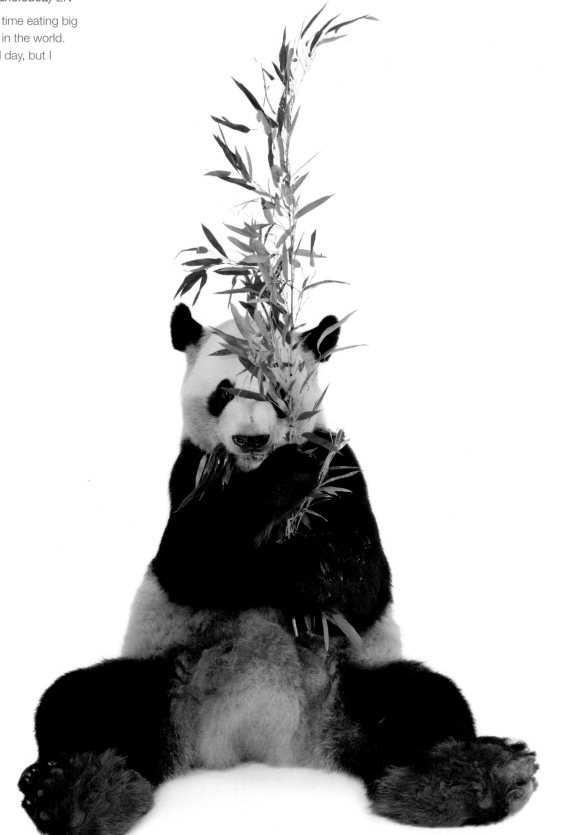

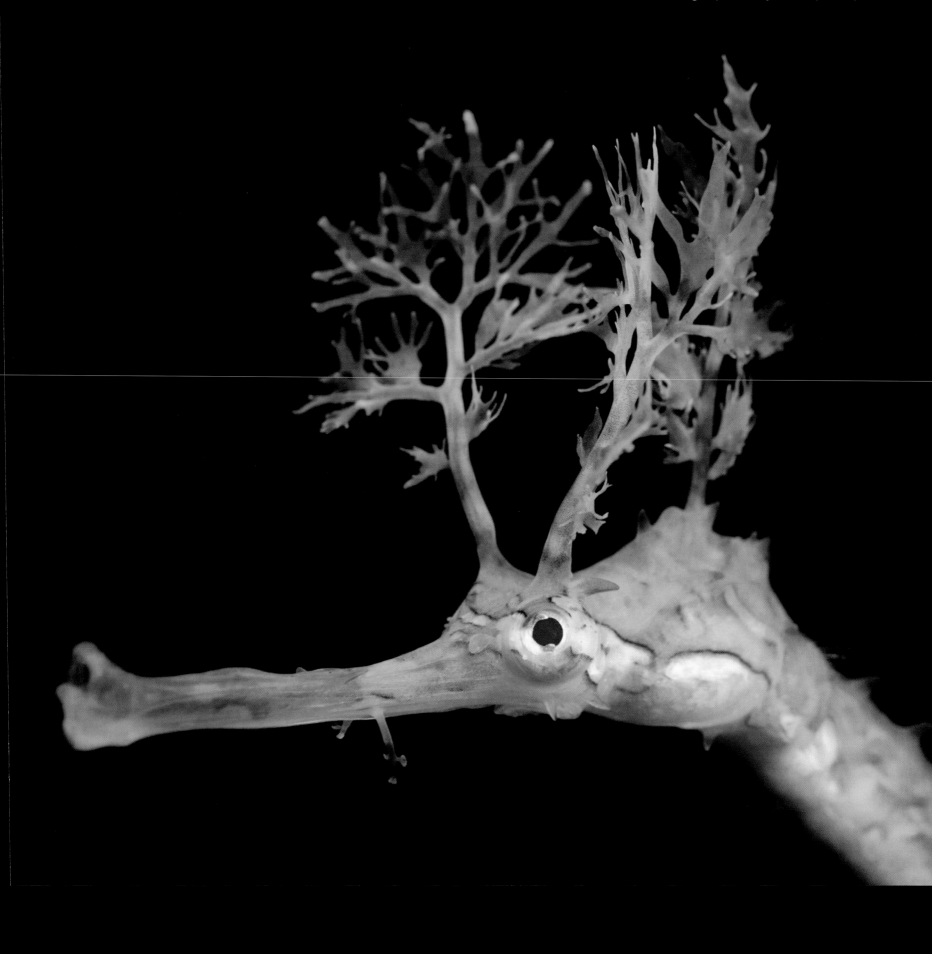

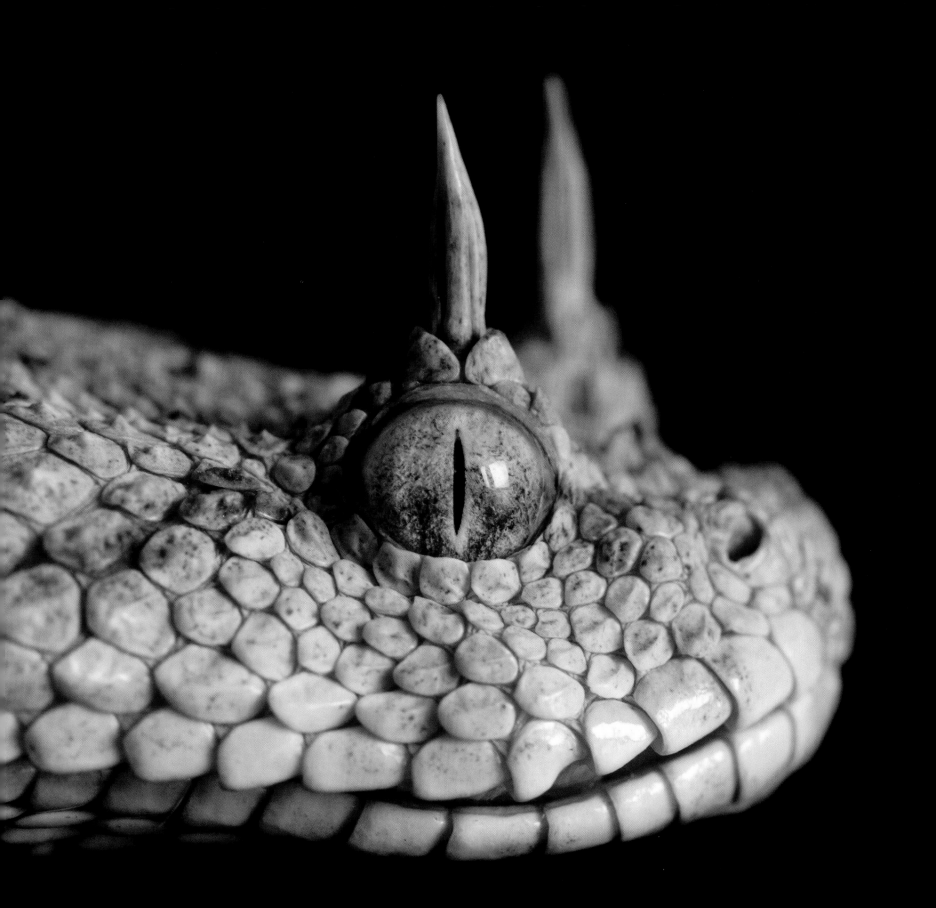

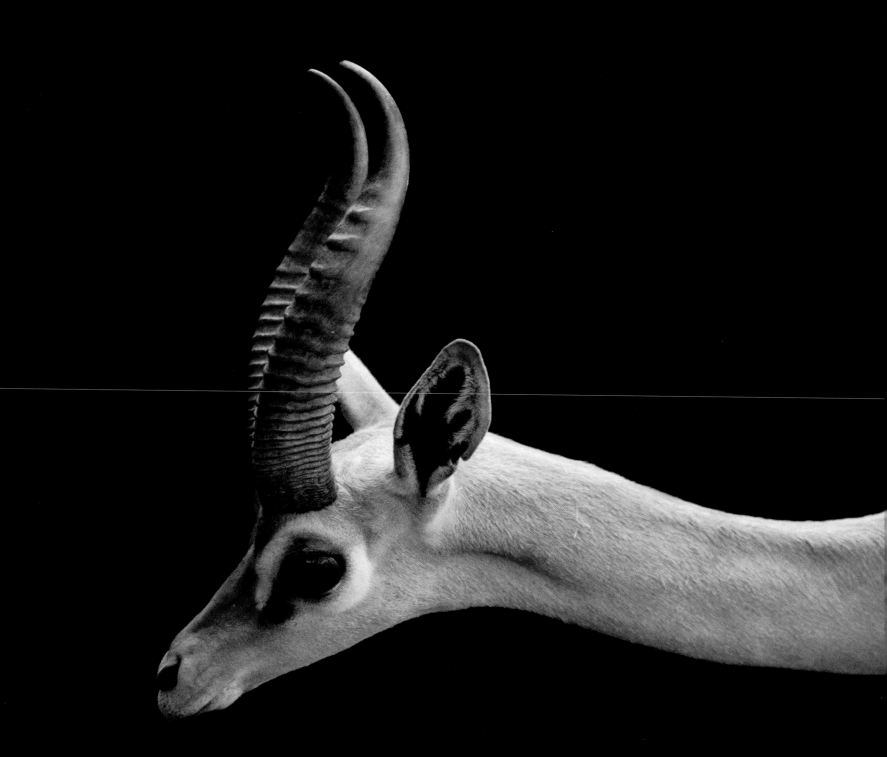

OPPOSITE: **Desert horned viper** *(Cerastes cerastes cerastes)* NE

**Southern gerenuk** *(Lictocranius walleri)* NT

**Virginia opossum and young**
*(Didelphis virginiana)* LC

Joel photographed this mother opossum and
her babies in his home studio. "The babies
wouldn't get off Mom, which made the picture
better. Mom just tolerated all of it, both the
photo shoot and the youngsters," Joel says.

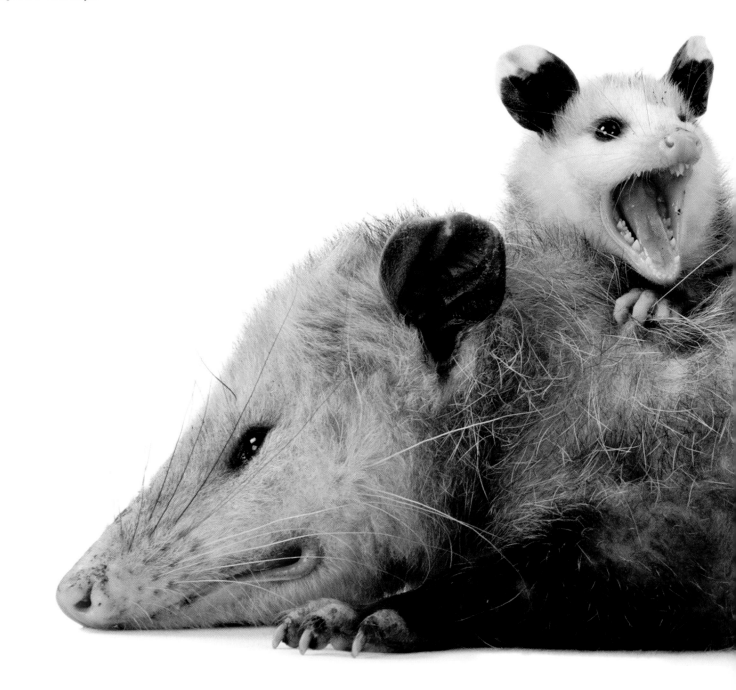

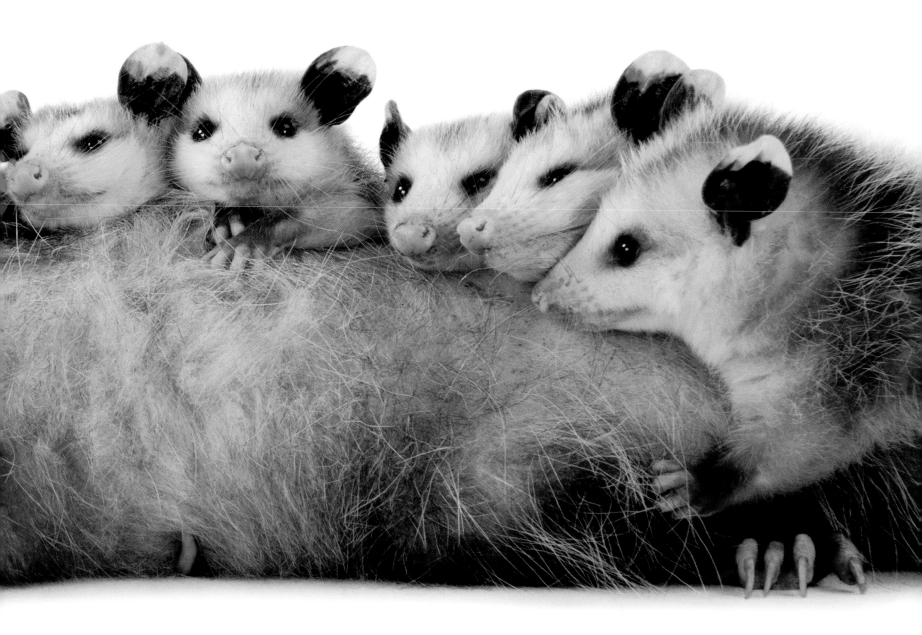

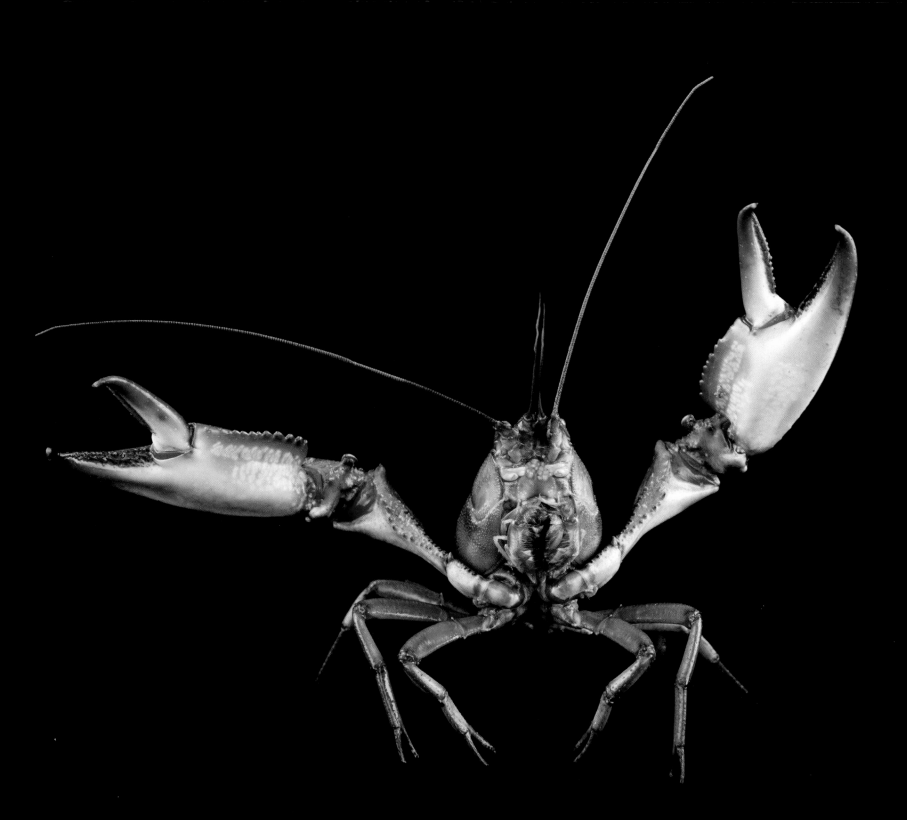

**Common yabby** *(Cherax destructor)* VU

Of the yabby, a kind of crawfish, Joel says, "His pincers
hurt." Of the mantis, "Lots of attitude, which helps it fend
off predators. Who would want to try and eat this?"

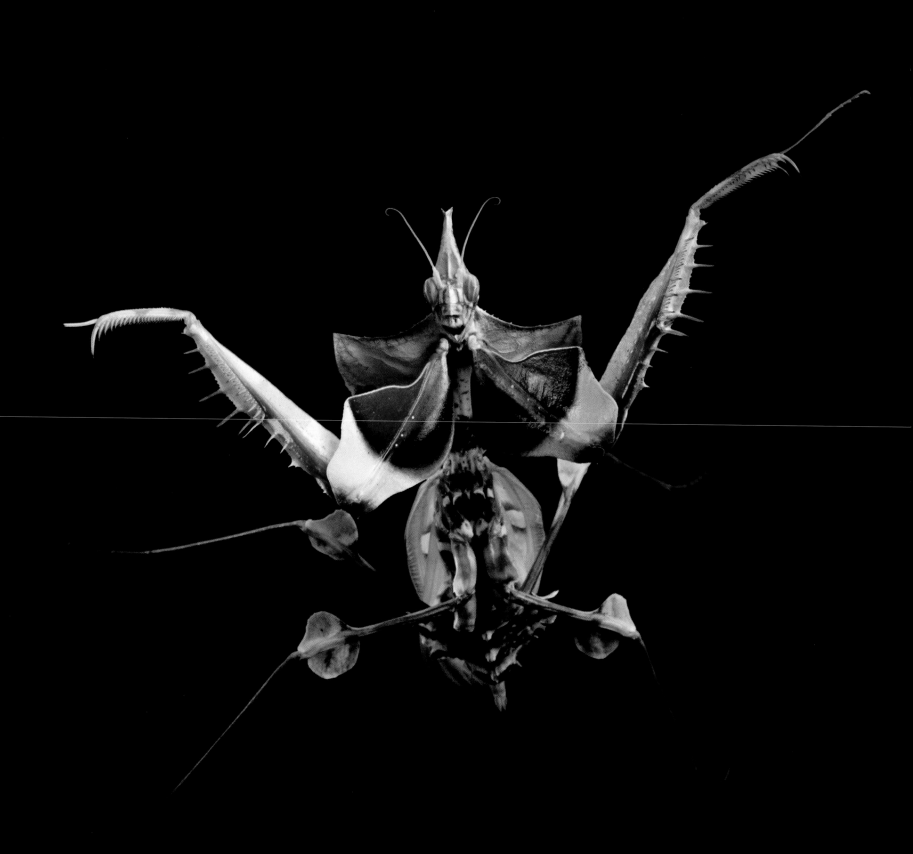

**Devil's flower mantis** *(Idolomantis diabolica)* NE

Caracal *(Caracal caracal)* LC

Silvery marmoset *(Mico argentatus)* LC

**HEADS OR TAILS** ▶◀

You're not seeing double: The tail mirrors the head of the Kenya sand boa, a powerful constrictor that grows to about two feet in length. The head-to-tail similarity may be a characteristic that successfully confuses predators.

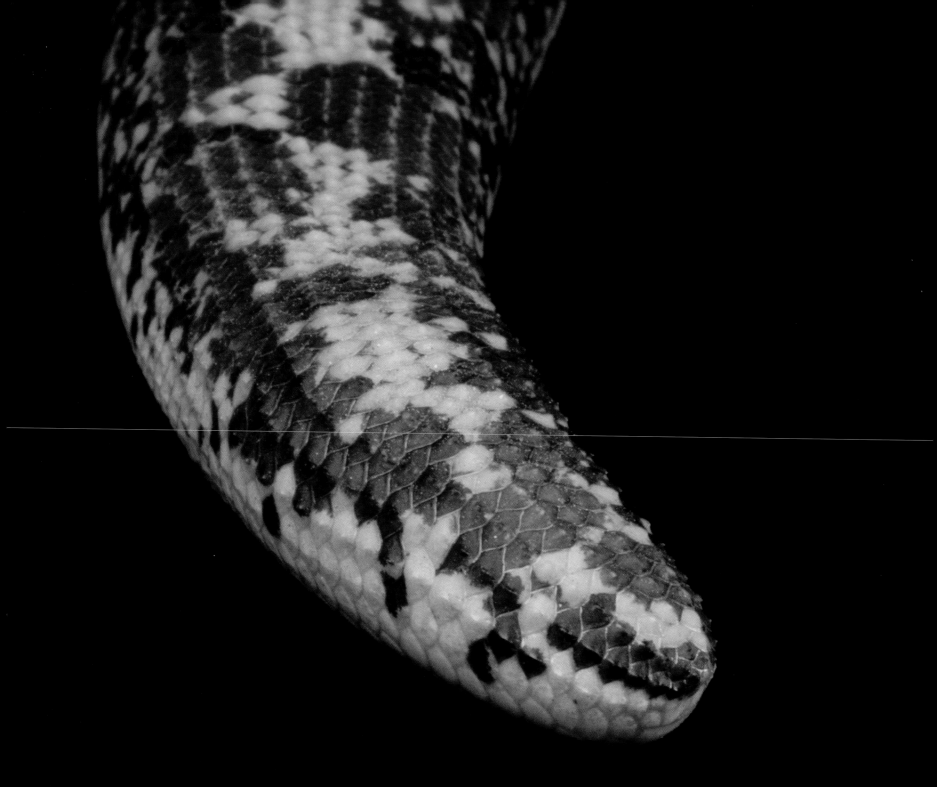

**Kenya sand boa** *(Eryx colubrinus loveridgei)* NE

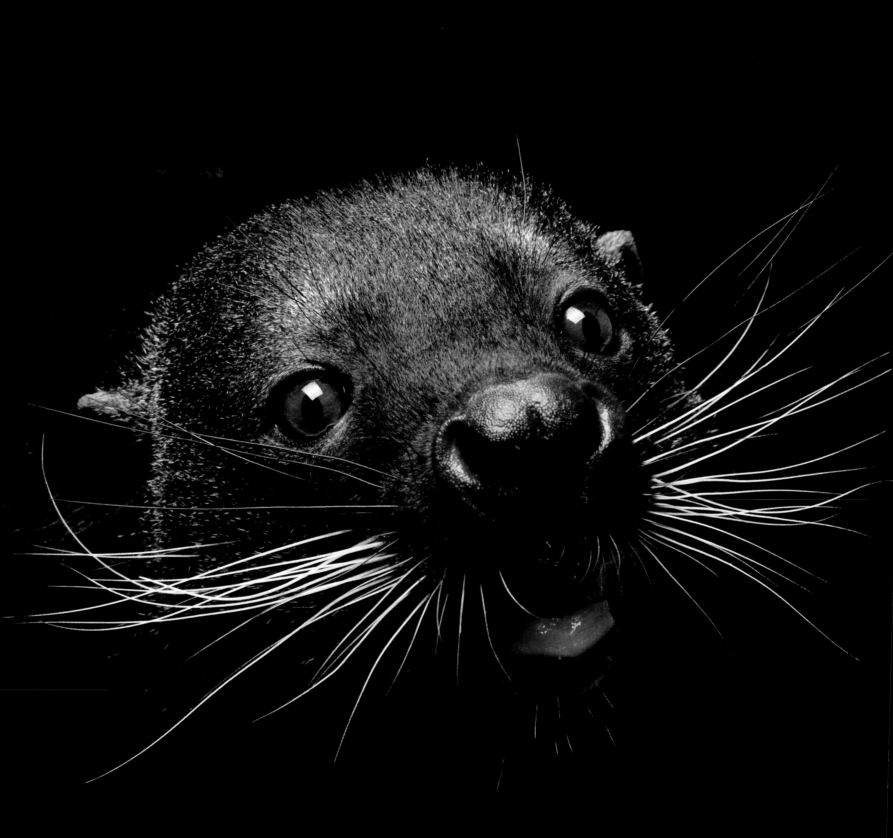

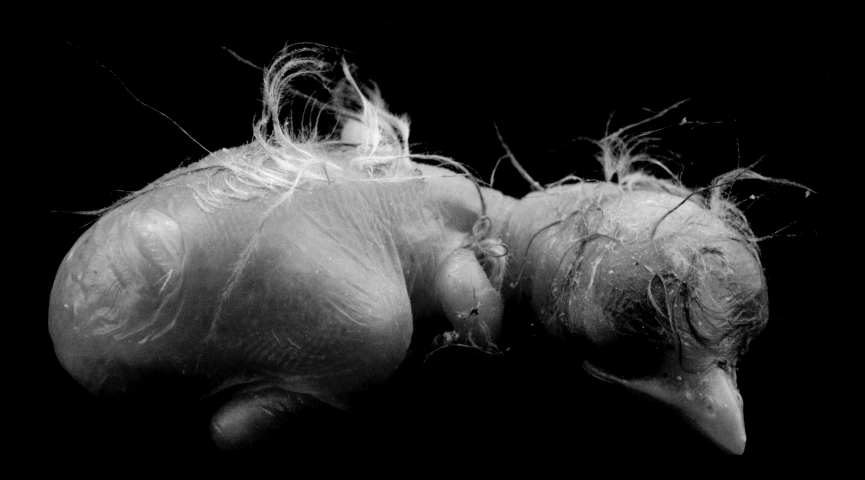

**Baby robin** *(Turdus migratorius)* LC

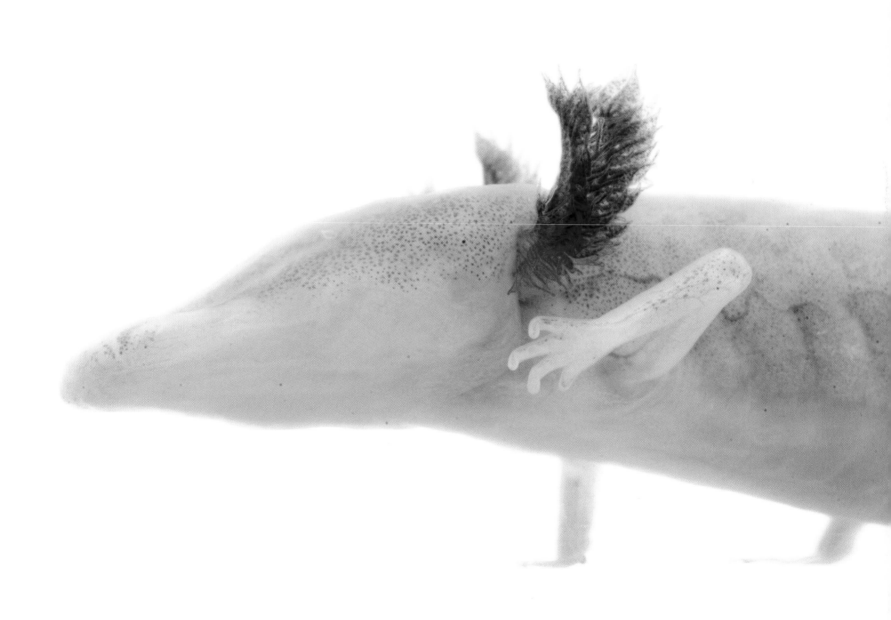

# HEROES

**J. R. Shute and Pat Rakes**
Conservation Fisheries
Knoxville, Tennessee

When biologist Pat Rakes found a yellowfin madtom *(Noturus flavipinnis)* hiding under a rock in Tennessee's Abrams Creek during a night swim, he recalls, "I was yelling through the snorkel." Then he called J. R. Shute, his partner and co-founder of Conservation Fisheries. Rakes had spotted the first wild-spawned yellowfin after nearly 10 years of reintroduction efforts. A trout reclamation project in the 1950s had brought the madtom species to the brink of extinction. In fact, until a population was found in a nearby tributary of the Little Tennessee River in the early 1980s, the species was considered extinct. And now it looked as if the fish were reestablishing themselves in their native habitat. "It was really exciting to go out and find them," says Shute.

The yellowfin madtom is just one of about 65 nongame fish species that Conservation Fisheries, a nonprofit based in Knoxville, Tennessee, has worked to save. It has reintroduced more than a dozen species back to their native waters. The organization is dedicated to preserving aquatic biodiversity in streams and rivers in the Southeast, "the hotbed of aquatic biodiversity," as Shute puts it, and home to more than 400 freshwater fish species.

Conservation Fisheries also works with local watershed groups to help educate young and old about the beauty and importance of local aquatic life. Participants put on snorkels to see up close what's living in local rivers. "Without putting your face in there, you don't even see these fish," Shute says.

"People often ask us, 'What good is that little fish?'" Rakes says, and he soon finds himself talking about what people can do to save the world's species, big and small. ◆

*" Any species that has been around for thousands or even millions of years is a lot more valuable than most of our possessions to which we assign great worth.*

—Pat Rakes

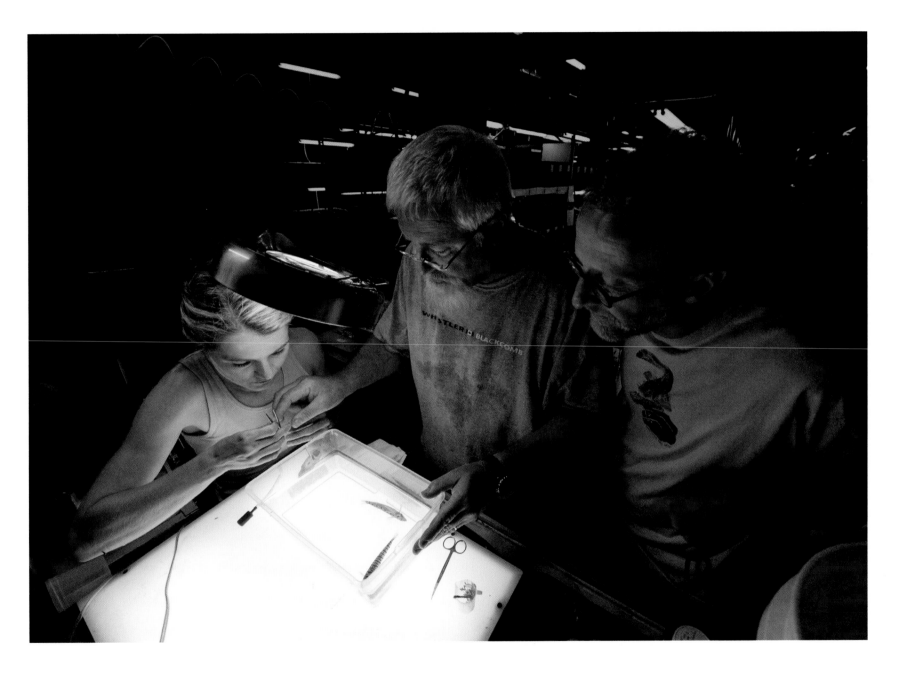

OPPOSITE: **Boulder darter** *(Etheostoma wapiti)* VU

J. R. Shute, center, and Pat Rakes, right, join hatchery data manager Melissa Petty at a light table in their 5,000-square-foot facility. The organization typically works with about 25 species at a time, and the group uses this table to collect genetic samples without sacrificing the fish.

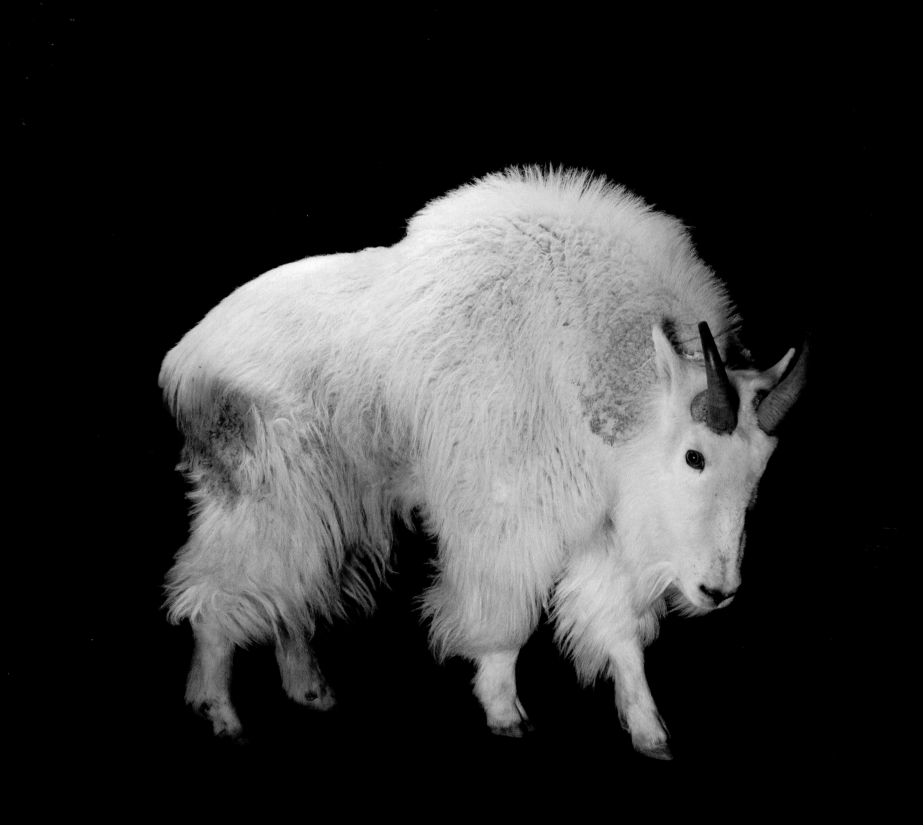

**Mountain goat** *(Oreamnos americanus)* LC

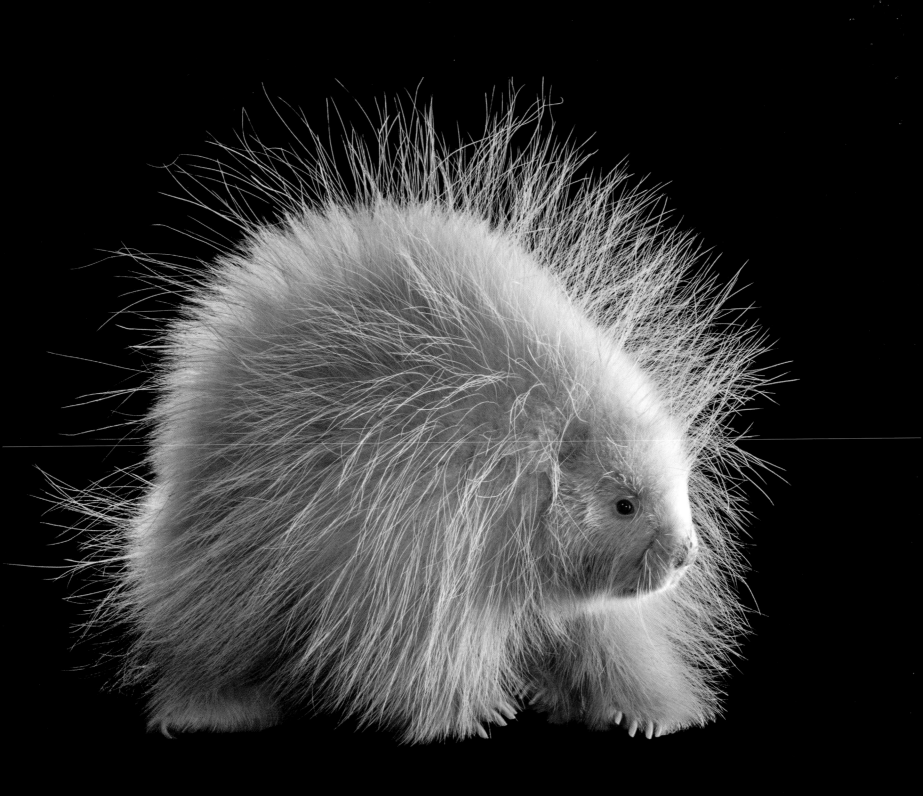

**Albino North American porcupine** *(Erethizon dorsatum)* LC

"This albino porcupine is named Halsey for the spot in Nebraska near where she was rescued after being hit on the highway. Today Halsey is thriving, despite a dental condition that prevents her from ever being returned to the wild."

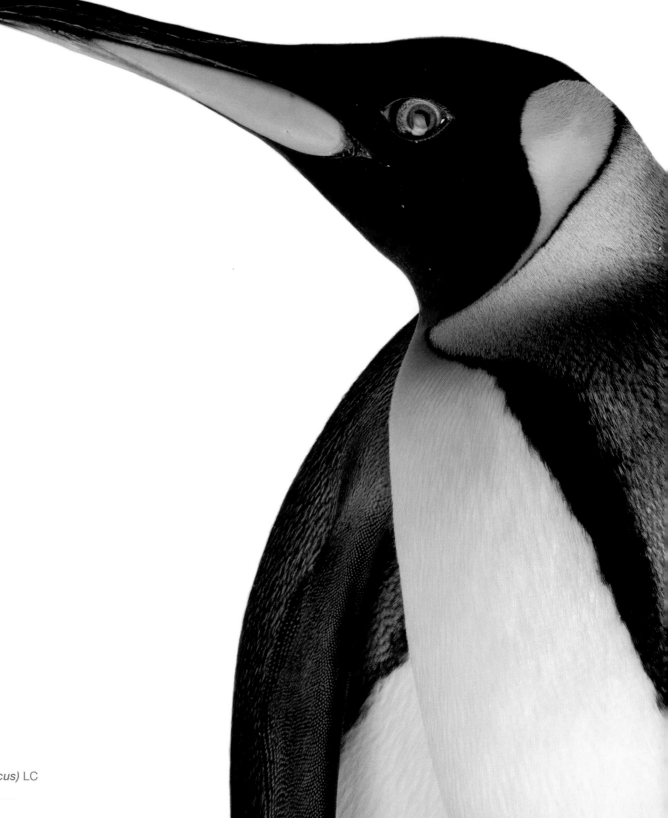

South Georgia king penguins
*(Aptenodytes patagonicus patagonicus)* LC

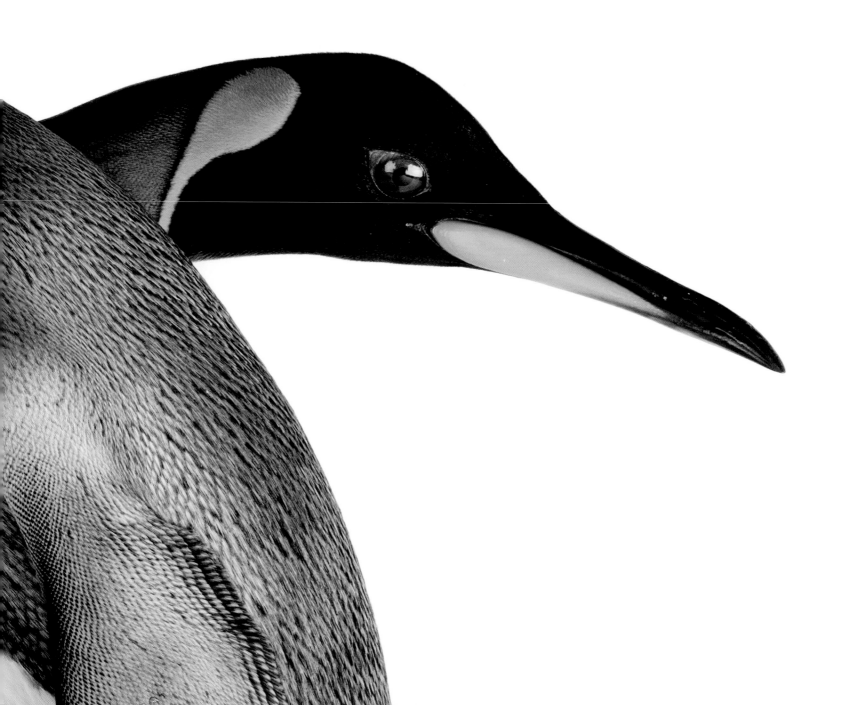

CHAPTER TWO ▶▶

# Partners

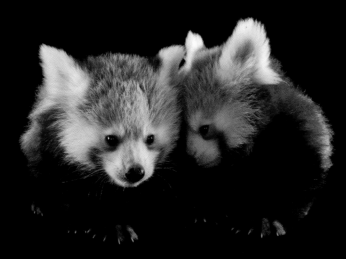

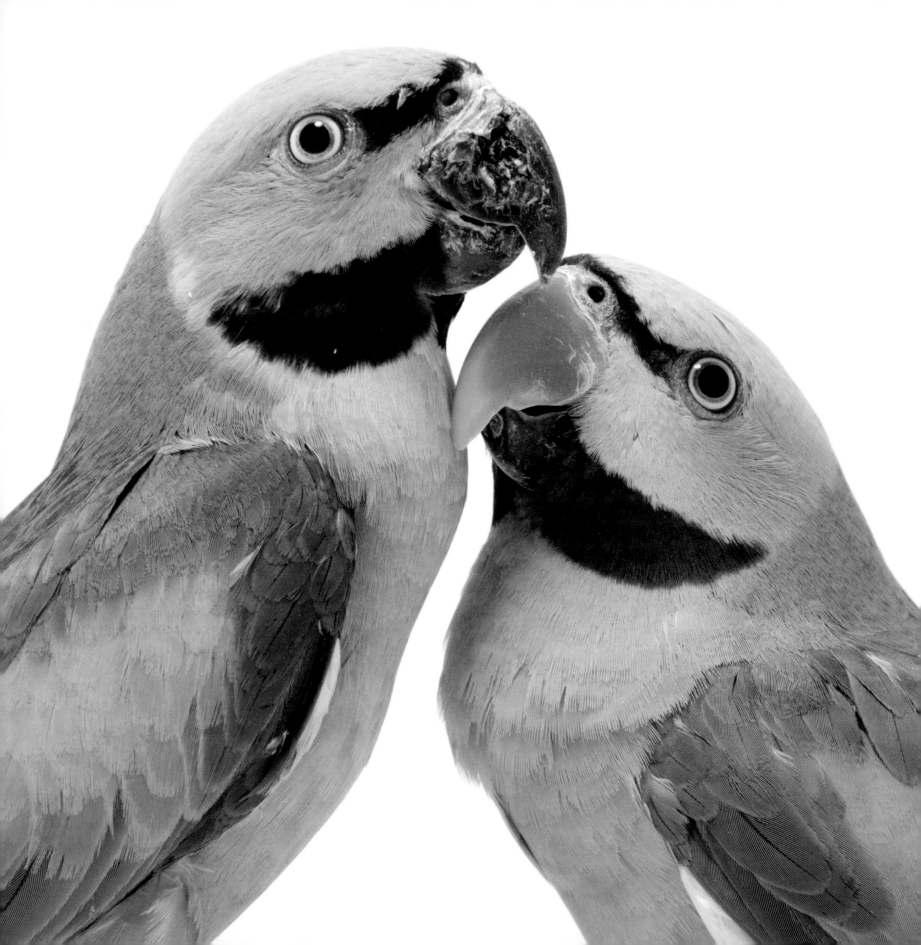

Hand in hand, side by side, two by two: There is some animal instinct to settle into pairs. First off, it almost always takes two to make more. For some, that union is fleeting and ephemeral. For others, it lasts a lifetime.

We humans identify with all: the short-lived brushes with one another, the devoted lifelong partnerships, and even the odd couplings that circumstance provides. Siblings, parent and child, best friends, lovers: In every sort of partnering that nature puts before our eyes, we see the beauty of relationship, of connection, collaboration, togetherness through strife and harmony. Here are two separate entities living through life together.

A pair of little blue penguins, down still fuzzy, seem to kiss and cuddle—and so do the Tabasara robber frogs from Central America in their own warty way. There are symbiotic partnerships essential to each species, such as the sharksucker: These small fish hitch rides on the bodies (or even mouths) of larger sharks. Sometimes they eat loose food from a shark's mouth, even cleaning up parasites that may harm their host. There are partnerships in number: the great star coral, the zebra paper wasps, the leafcutter ants. For them, partnership means community.

There are partners that look nearly identical, like African wild dogs, and partners that look so different from one another, you wouldn't guess they were a pair. Take the Guianan cock-of-the-rock. The female feathers up a drab brown while the male sports a topknot and gaudy orange array.

There are animals we've paired up in story: the owl and the pussycat, the birds and the bees, and (allow us our fun here) the beetles.

These are partnerships of kinship, of spirit, or of circumstance. Two by two, side by side, hand in hand, we build the ark and move through this world together. ◆

OPPOSITE: **Red-breasted parakeets, female, left, and male** *(Psittacula alexandri)* NT

PREVIOUS PAGE: **Red pandas** *(Ailurus fulgens fulgens)* EN

## THE OWL AND THE PUSSYCAT ▶ ▶

"This owl was very feisty. The oncilla, on the other hand, was as meek as a house cat and just sat and stared at me. Small spotted cats like this have been killed for many years by people wanting their fur, and that's one of the things that has led to their decline."

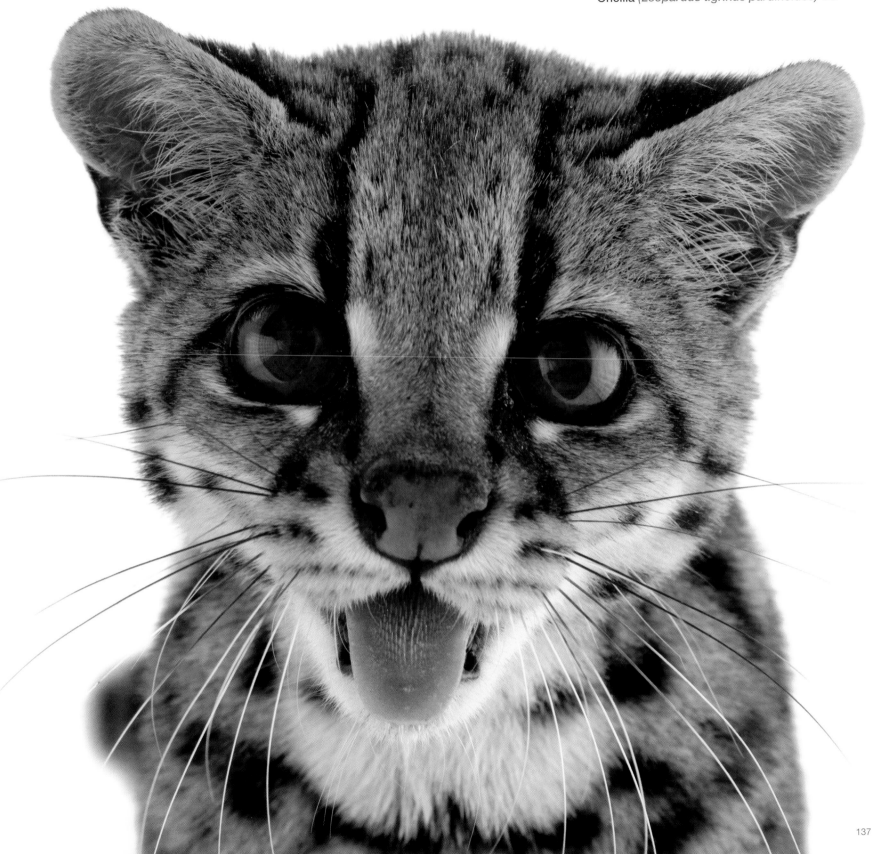

Hibernating arctic ground squirrels *(Spermophilus parryii)* LC

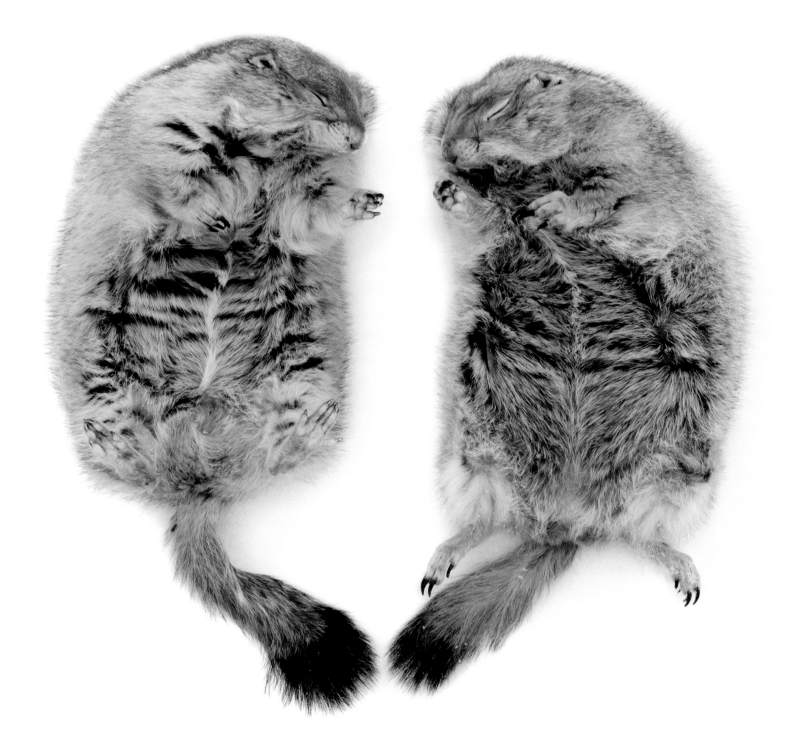

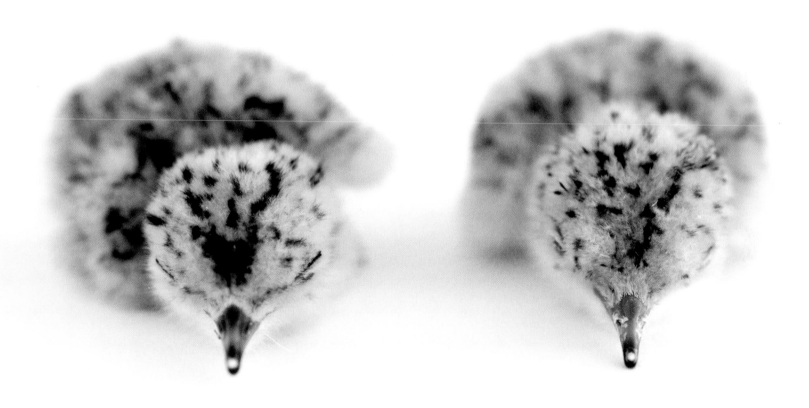

**Oblong-winged katydids** *(Amblycorypha oblongifolia)* NE

"Ordinarily, katydids are green. Among every few thousand eggs, one hatches in another color, such as pink, orange, or yellow. In the wild, these oddballs would stand out like a neon sign and be eaten immediately. But at the Audubon Nature Institute in New Orleans, they're safe, sound, and celebrated. The zoo hatches thousands of eggs annually in hopes of getting more color variants to put on display."

For centuries it has been presumed that the Nile crocodile and the Egyptian plover are a matched pair, the crocodile allowing the bird to pick debris from inside its mouth and thus clean its teeth. Closer observation shows this relationship to be a myth, but these two creatures can be seen together on African shorelines, the basking crocodiles tolerating the plovers as they wander nearby.

OPPOSITE: **Nile crocodile** *(Crocodylus niloticus)* LC

**Egyptian plover** *(Pluvianus aegyptius)* LC

**Little penguins** *(Eudyptula minor)* LC

"Fluffy, and best buddies. They didn't move
around much, but instead sat there and
groomed each other."

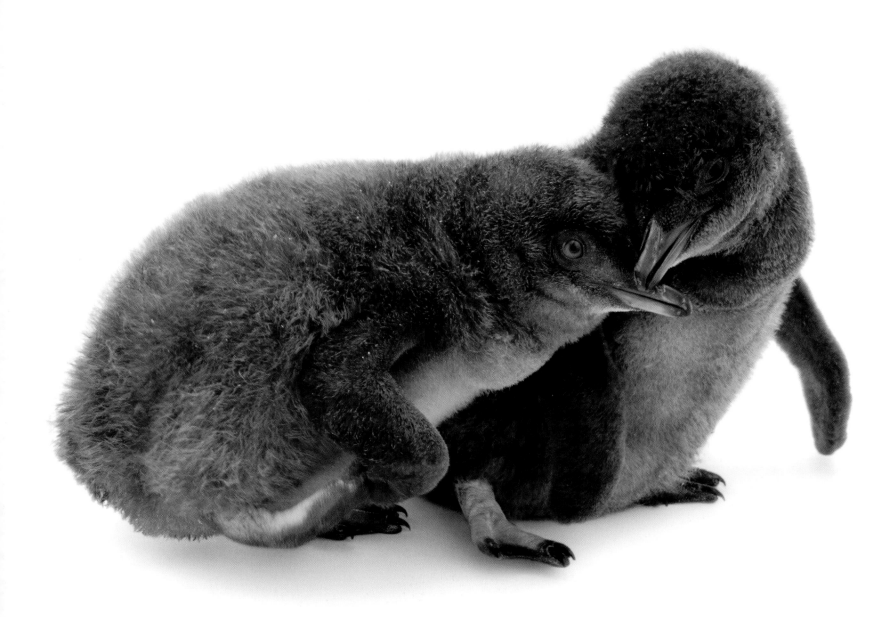

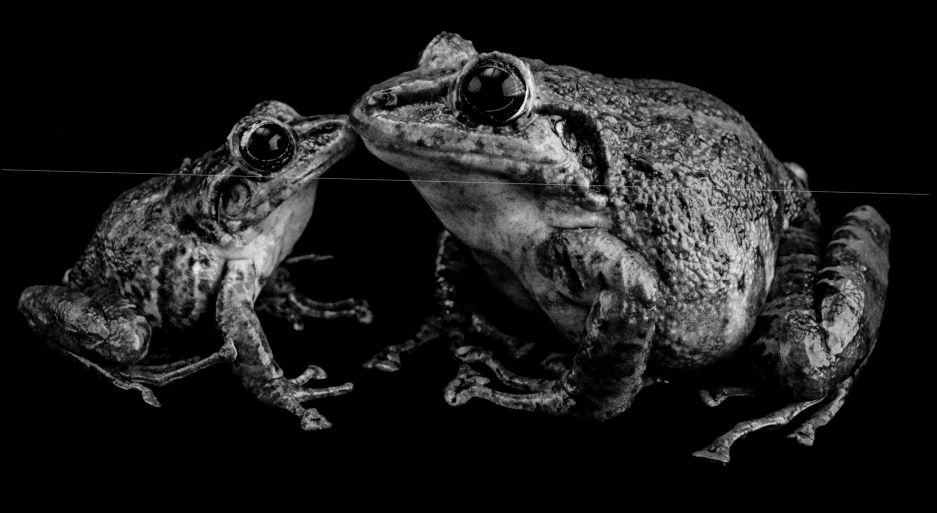

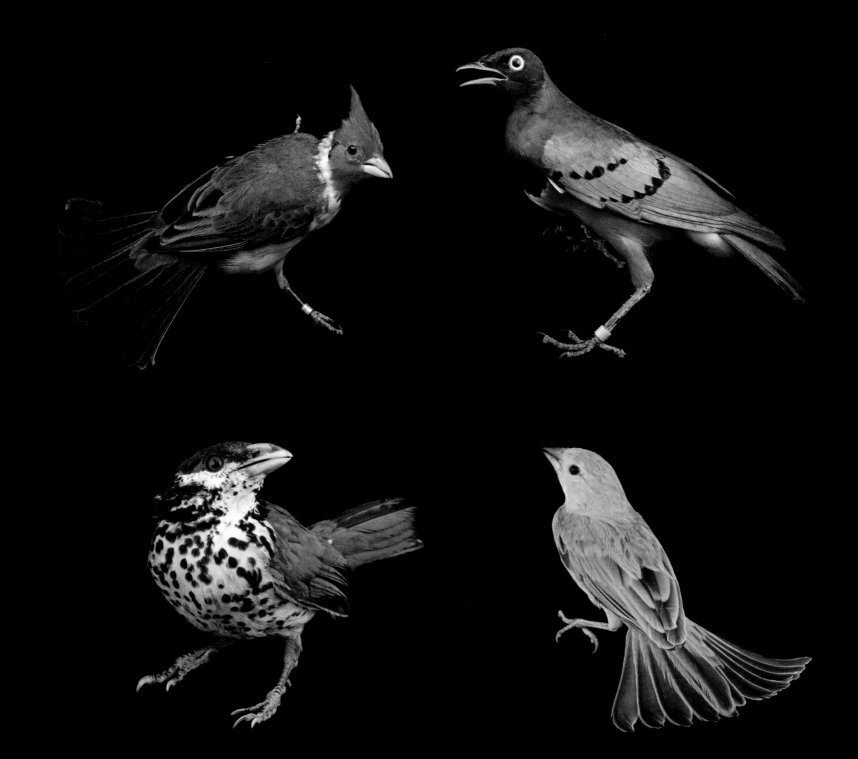

## THE BIRDS AND THE BEES ▶ ▶

TOP ROW (L-R): **Red-crested cardinal** *(Paroaria coronata)* LC, **Superb starling**
*(Lamprotornis superbus)* LC BOTTOM ROW (L-R): **White-eared catbird**
*(Ailuroedus buccoides)* LC, **Saffron finch** *(Sicalis flaveola)* LC

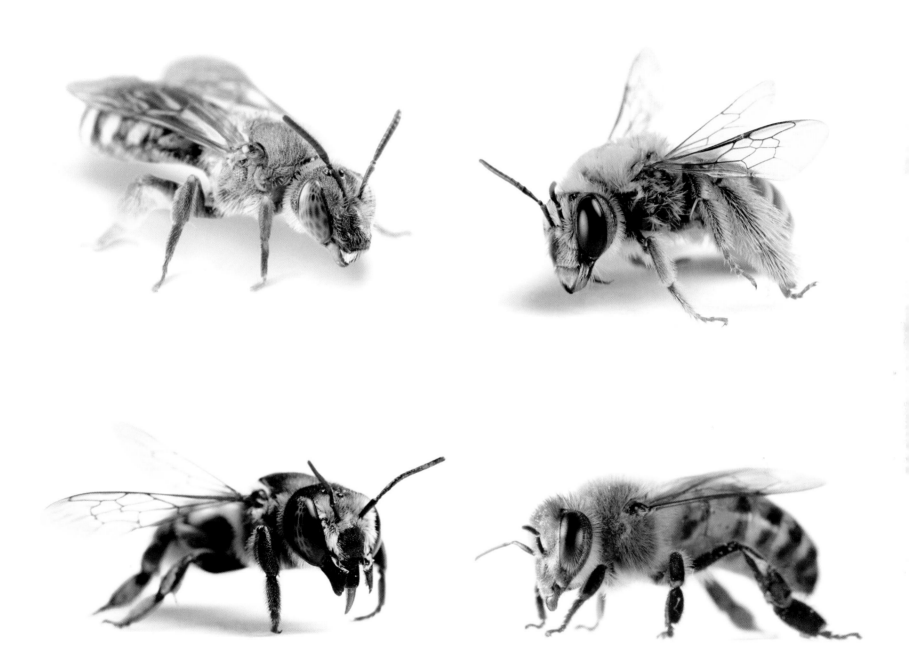

TOP ROW (L-R): **Metallic green bee** *(Agapostemon virescens)* NE,
**Long-horned bee** *(Tetraloniella* sp.) BOTTOM ROW (L-R): **Leafcutter bee**
*(Megachile parallela)* NE, **Honeybee** *(Apis mellifera)* NE

**Gray-tailed moustached monkeys**
*(Cercopithecus cephus cephodes)* LC

"This pair were orphaned and brought to
a wildlife rehab expert in Libreville, Gabon.
They are best friends, and they cling to
each other constantly, whether frightened,
playing, or sleeping."

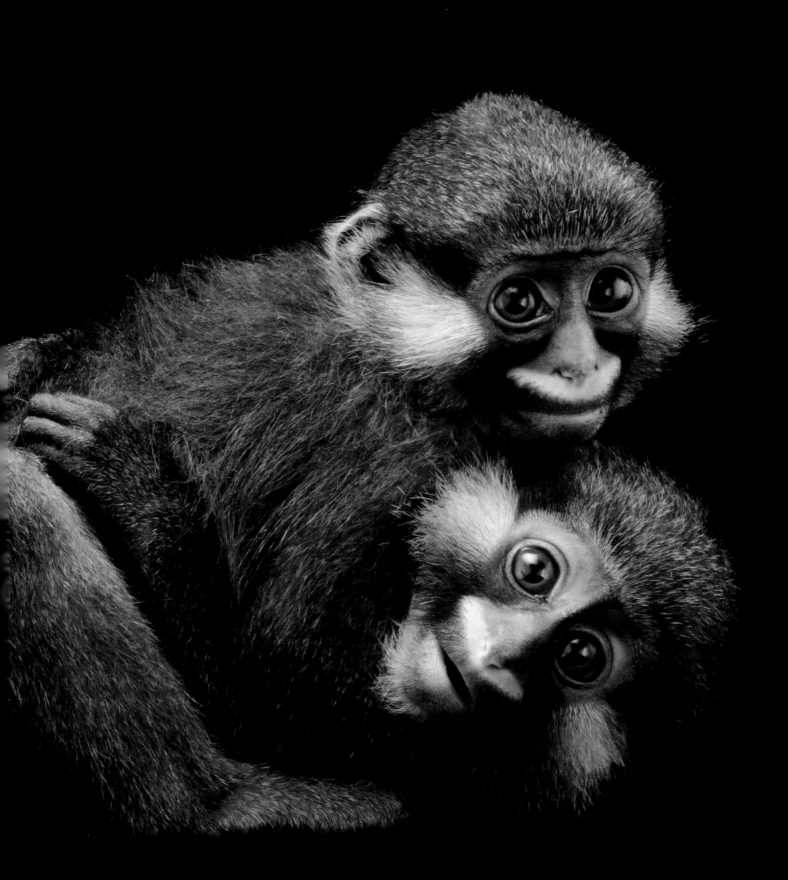

# HEROES

**Don and Ann Butler**

Pheasant Heaven

Clinton, North Carolina

D on and Ann Butler care for and breed pheasants on nine acres in Clinton, North Carolina. Known as Pheasant Heaven, their home is much more than just a refuge for 18 rare and endangered pheasant species. "It's also a heaven for us," Don says. The couple balances full-time careers with their conservation work. They've had particular success with the critically endangered Edwards's pheasant (Lophura edwardsi, page 353), a small blue-black pheasant with red legs and face. The birds haven't been seen in the wild in their central Vietnam range since 2000, and there are fewer than 500 in captivity.

Living and working so closely with their pheasants has also led to breeding breakthroughs. After years of poor reproductive success with the birds, the couple decided to diverge from the common wisdom of only pairing one Edwards's pheasant male with one female during breeding season. Instead, they placed multiple males and females together in a breeding colony—and those birds raised 50 nestlings the following season.

The Butlers share their knowledge as well as the beautiful birds they raise with zoos and other breeders. "Most pheasants are so skittish that it's hard to get a good picture of them," Joel says, recalling the success he had taking photos of the Butlers' birds. "The shooting tent I use calms them down, because they can't see me, just the front of the lens."

"It's rewarding that the birds feel so comfortable and safe with us," says Ann. Don adds a comment, speaking for them both: "These birds will not disappear in my lifetime if I can help it." ◆

*" Every animal, no matter how small or seemingly insignificant, has a role to play in the delicate balance of nature.*

—Don Butler

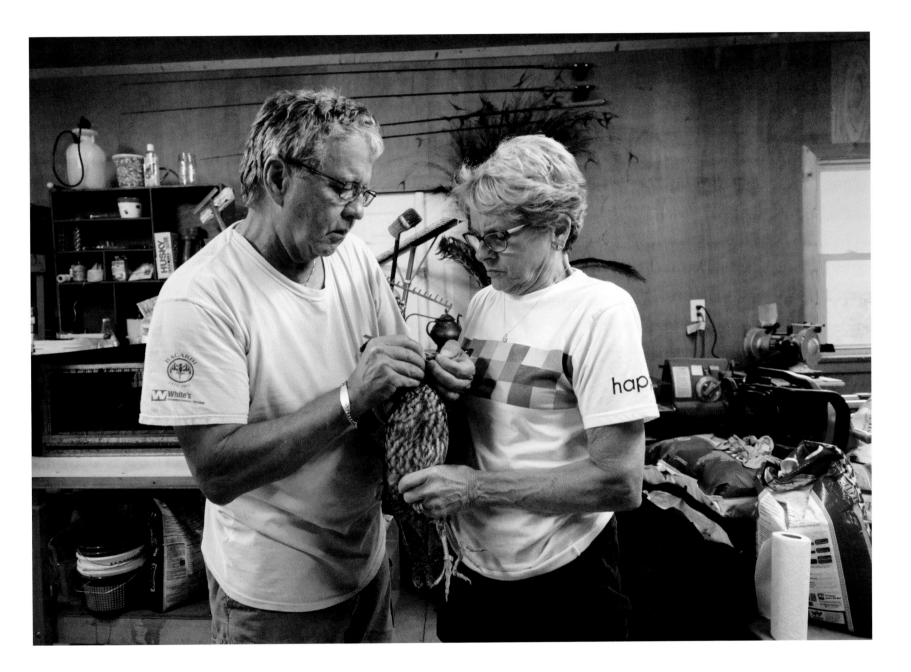

OPPOSITE: **Siamese firebacks** *(Lophura diardi)* LC

Don and Ann Butler perform a medical checkup of a female
Cabot's tragopan *(Tragopan caboti)*.

151

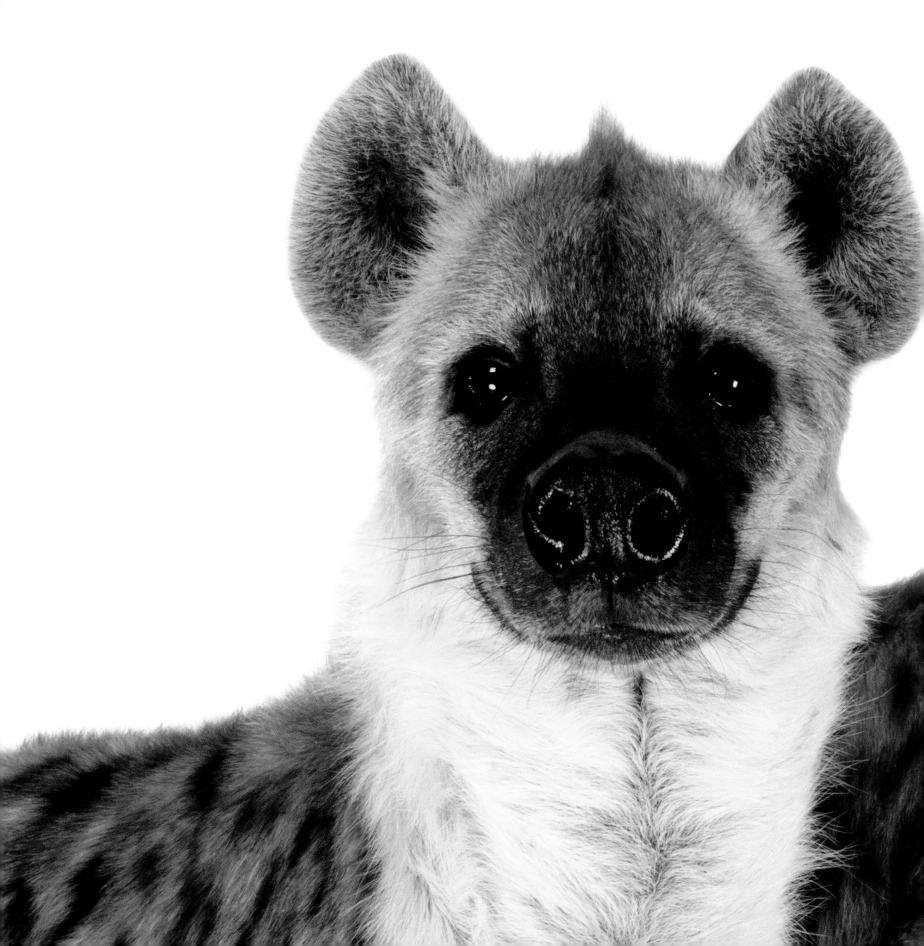

**Spotted hyenas** *(Crocuta crocuta)* LC

"These animals are extremely intelligent and intense.
They shredded my white paper background."

Sharksuckers or remoras—members of the Echeneidae family—
all have an oval sucking plate in place of a front dorsal fin and
use it to attach to host animals, especially sharks, such as this
coral catshark of the Indo-West Pacific. Some remoras simply
hitch a ride; others eat loose debris from their host's mouth and
gills. In some cases remoras actually clean up parasites, thus
benefiting the host as well.

**Coral catshark** *(Atelomycterus marmoratus)* NT

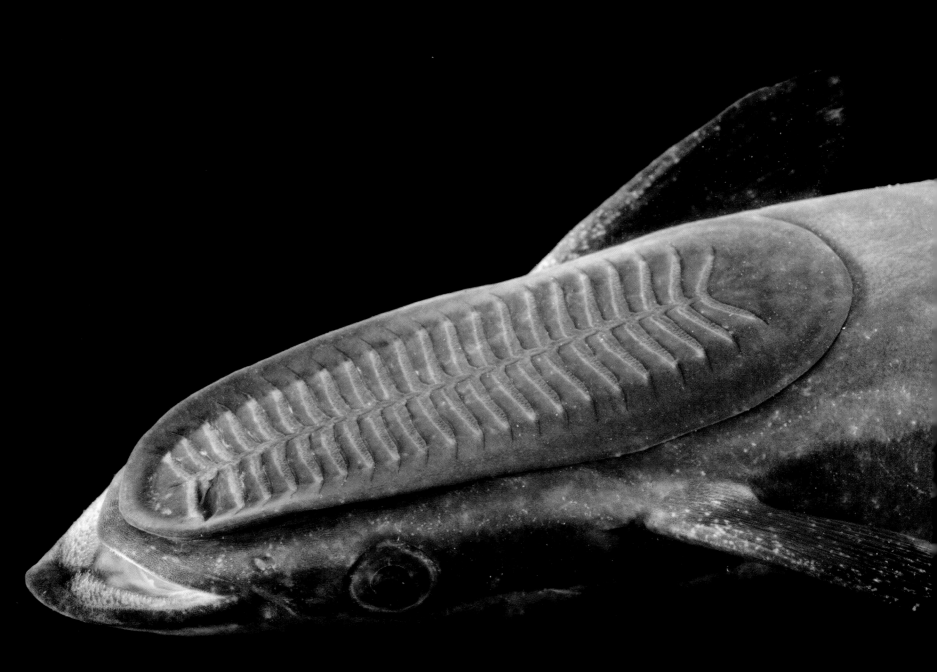

**Live sharksucker** *(Echeneis naucrates)* LC

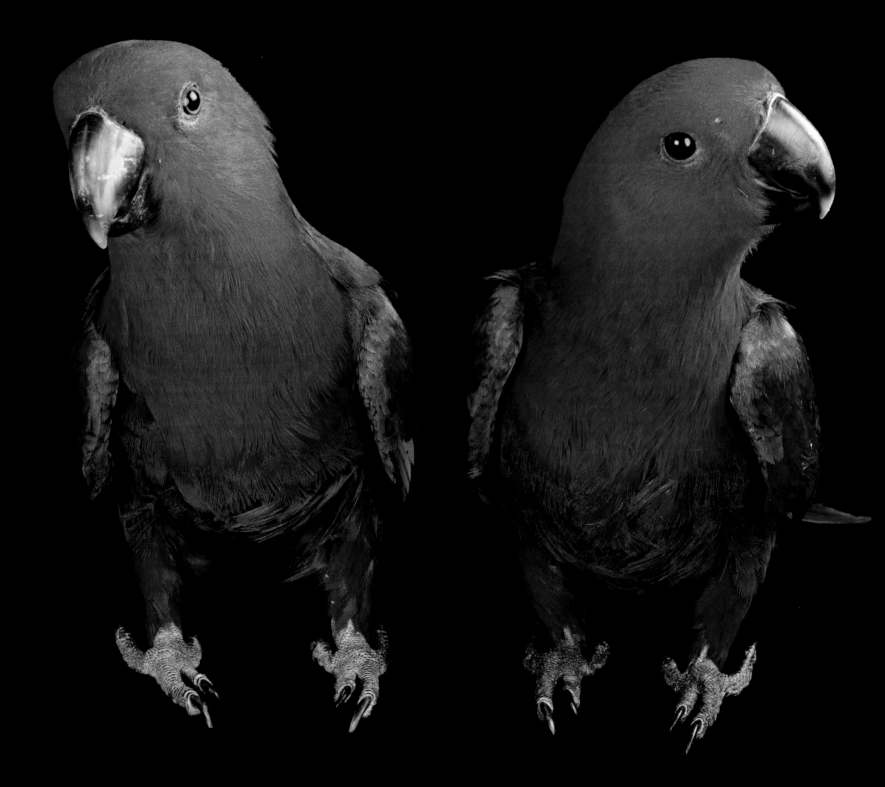

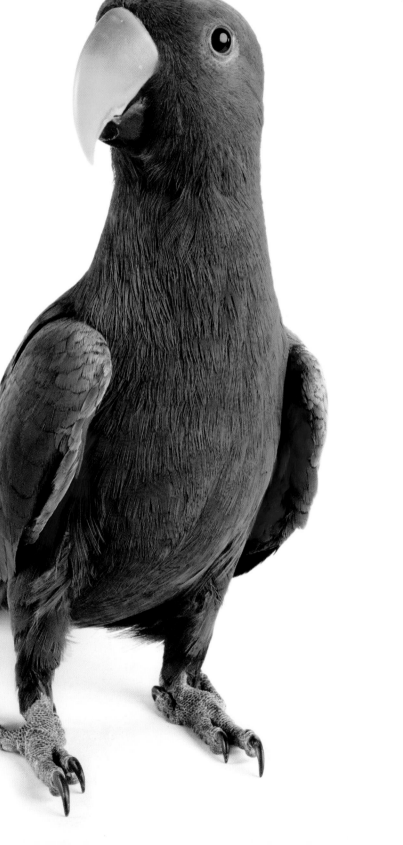

## WHEN COLOR MEANS GENDER ▶ ▶

Male and female eclectus parrots differ vividly in color—a phenomenon known as sexual dimorphism, which is more pronounced in this than in any other parrot species. Male eclectus parrots *(right)* are brilliant green, while females *(left)* are vivid red— unusual in the bird world, where males usually sport the brightest colors.

**Red-sided eclectus parrots, female** *(opposite)* **and male** *(Eclectus roratus polychloros)* LC

Panther chameleons, female *(on top)*
and male *(Furcifer pardalis)* LC

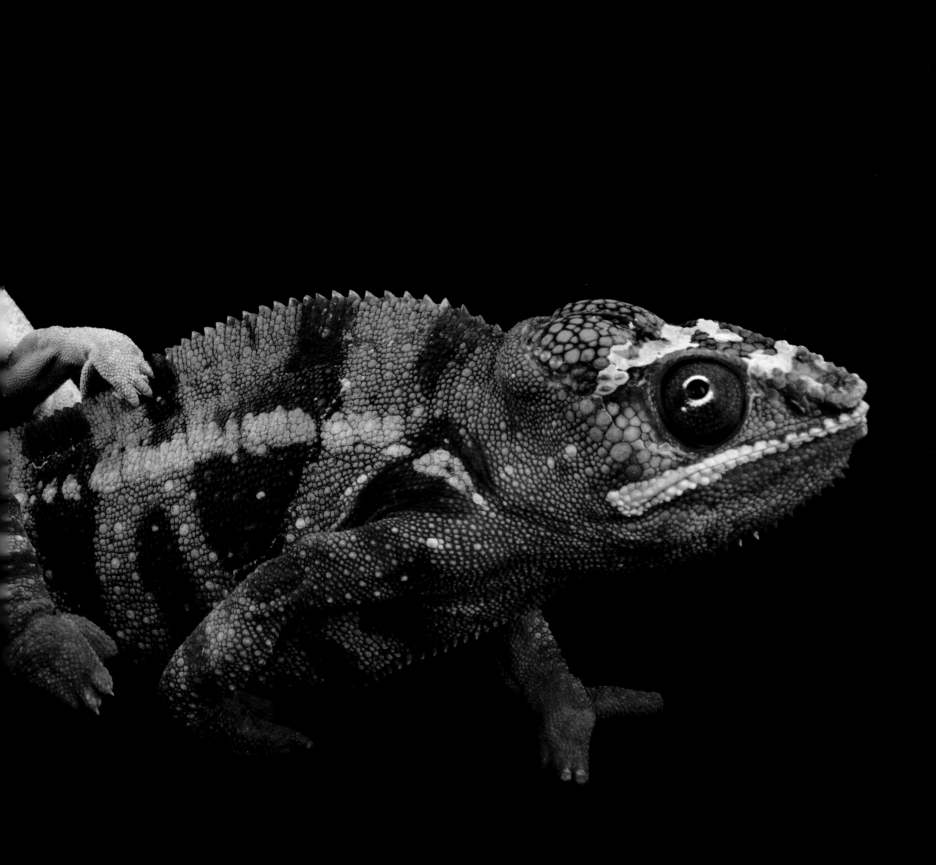

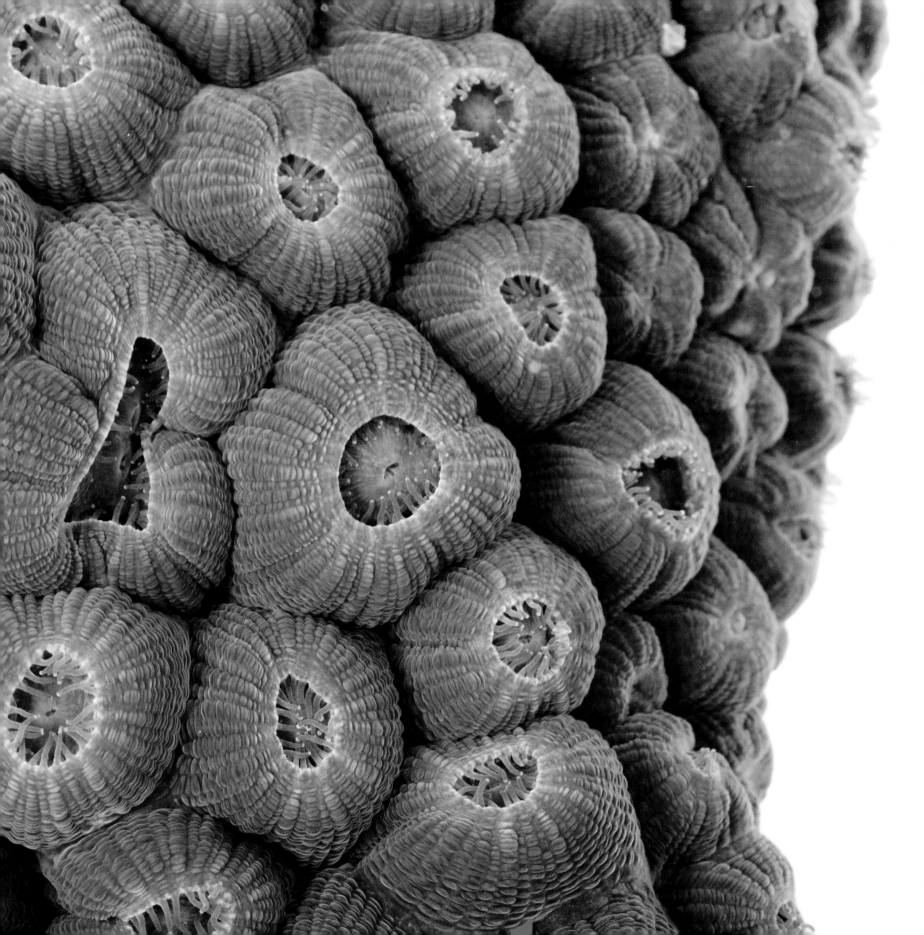

Tropical coral and paper wasps—these
animals are distinctly different, and yet
both species build colonies with structures
resembling each other in striking ways.

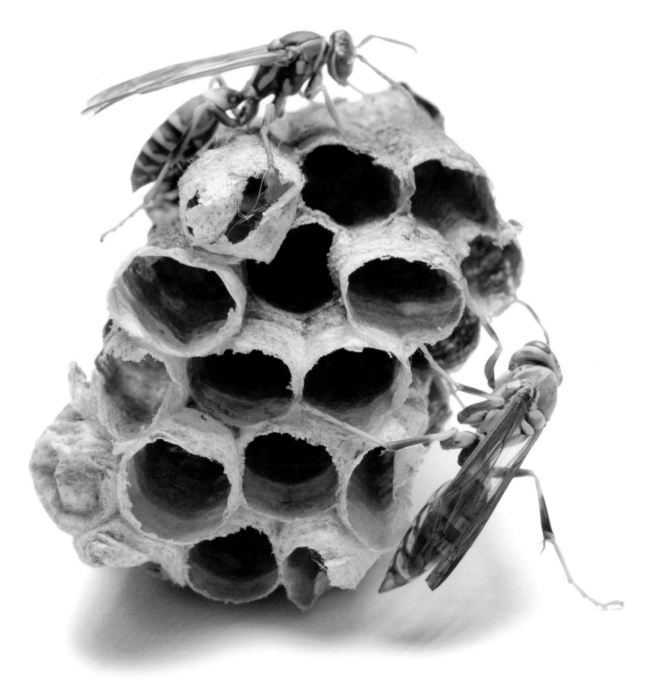

OPPOSITE: **Great star coral** *(Montastraea cavernosa)* LC

**Zebra paper wasps** *(Polistes exclamans)* NE

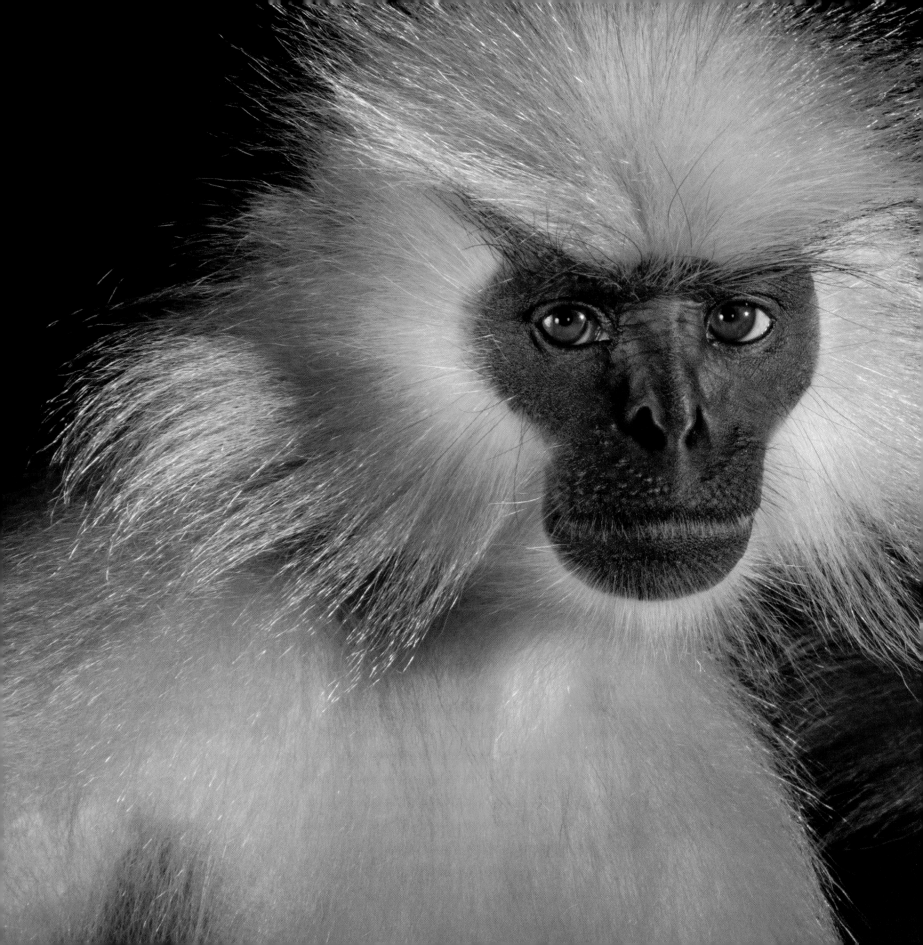

**Gee's golden langurs** *(Trachypithecus geei)* EN

"You're looking at this species' breeding program: that single female in the back, paired with the male in the foreground. There are two other males in human care. That's it: four animals."

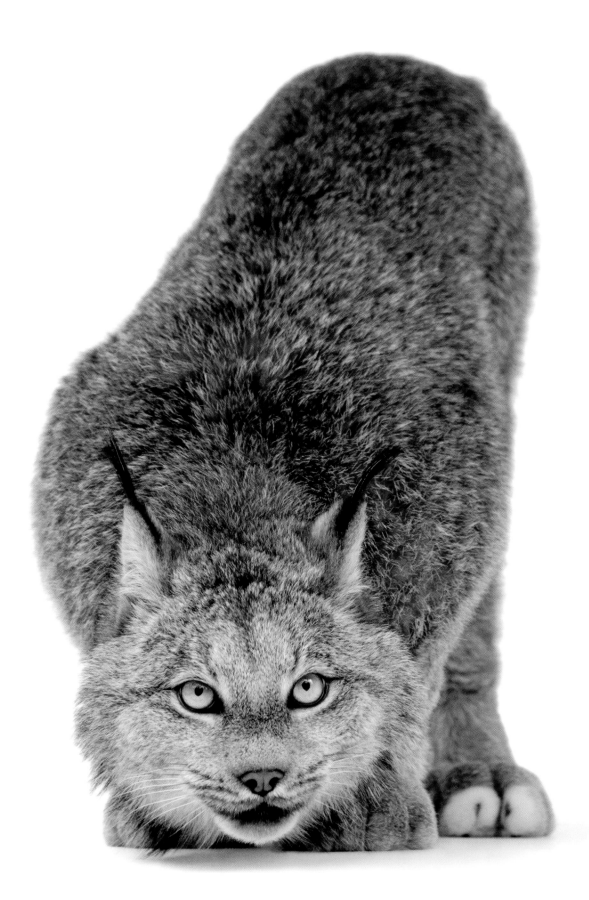

OPPOSITE: **Canada lynx** *(Lynx canadensis)* LC

**Choctawhatchee beach mouse**
*(Peromyscus polionotus allophrys)* LC

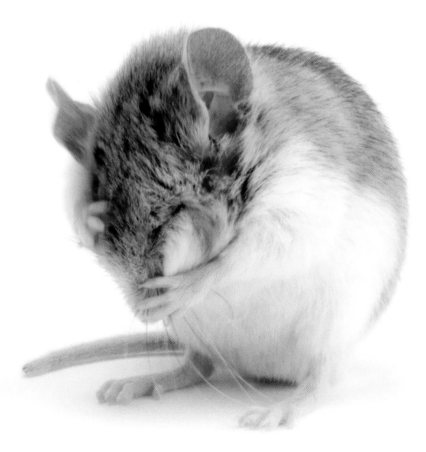

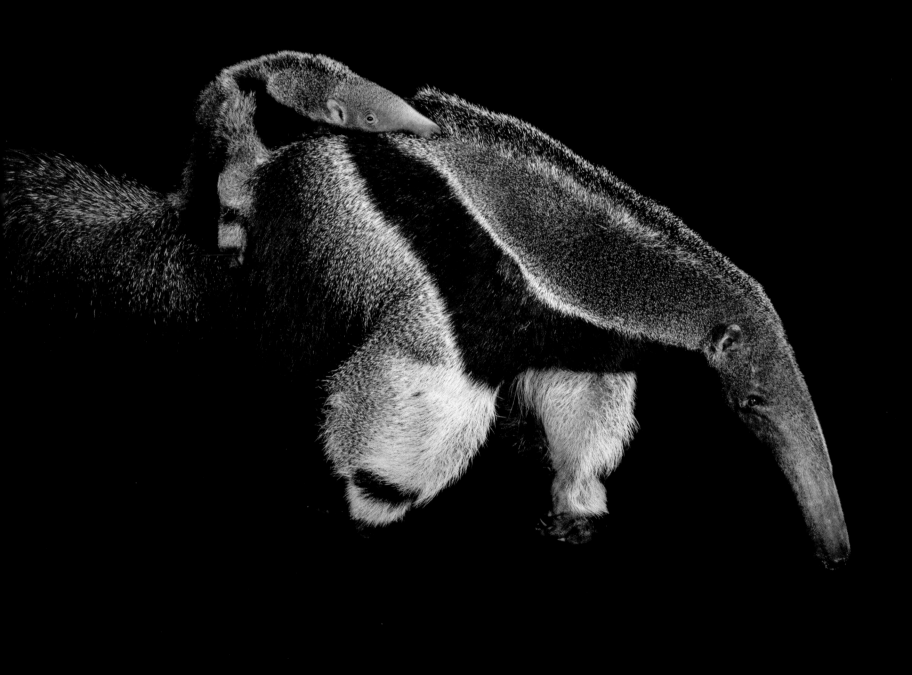

**Pileated gibbons** *(Hylobates pileatus)* EN

"Gibbons never, ever hold still. They are really tough to photograph without the photo cutting off an arm or a leg. They have some of the longest arms of any mammal, and at times they can literally race through the trees faster than a human can run."

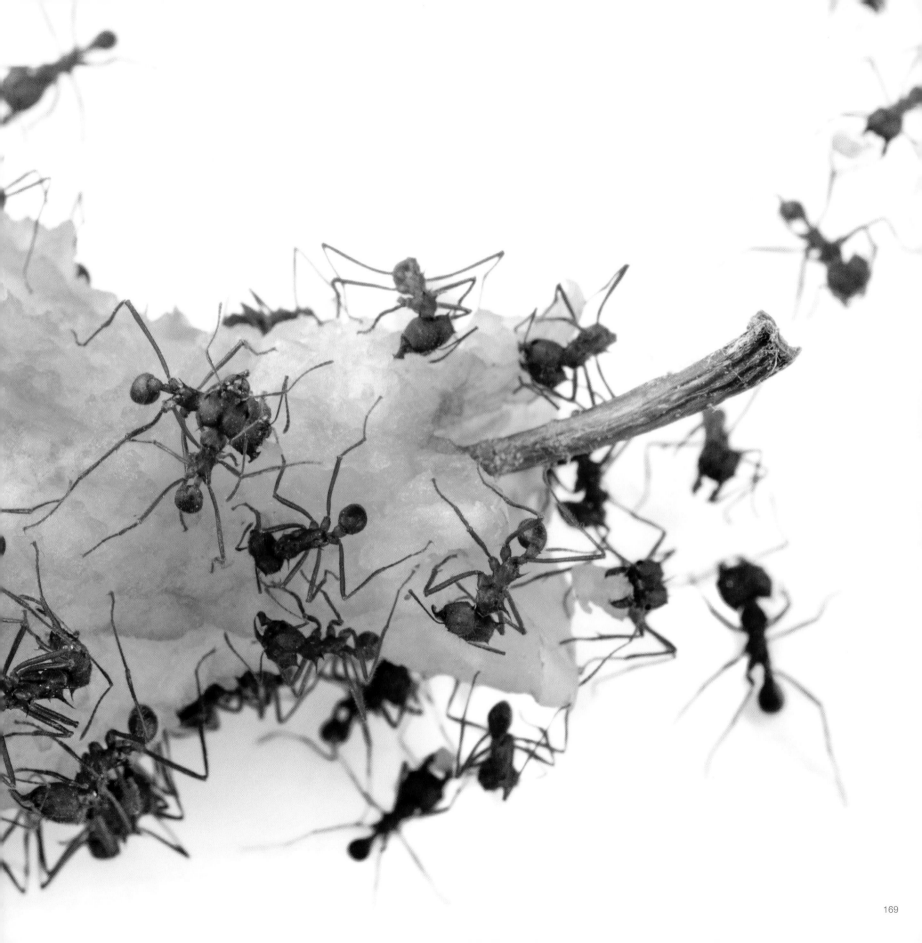

# BEHIND THE SCENES

## Assam State Zoo and Botanical Garden

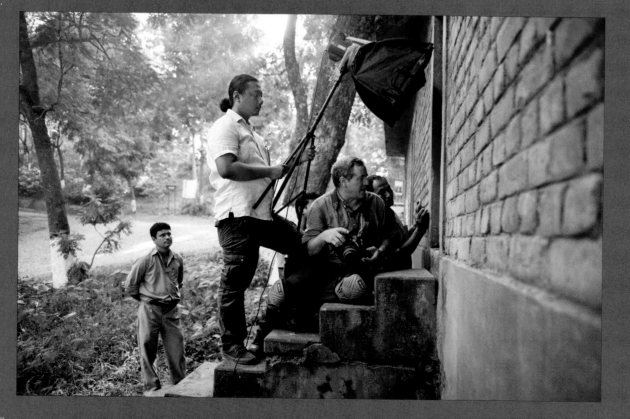

The Assam State Zoo in the northeast city of Guwahati, India, houses some 600 animals representing more than 80 different species. To avoid the heat and crowds, Joel set up his photographs in the early morning hours. One of the biggest puzzles ended up being how to get lighting outside the zoo buildings. The zoo's electricians (opposite, top) worked wonders, stringing power to wherever Joel was working. On the third day of shooting, a power surge fried the lights. Joel's photo assistant, Dhruba Dutta, came up with the solution: monolights—a system of multiple lights, each with its own power pack that could be placed independently, instead of all being wired back to a centralized system. ◆

> *"The logistics of pulling off a project of this scope is numbing at times. The travel, the long hours, the setup and teardown of our mobile photo studio . . . it wears me down just thinking about it.*

In the cool of the early morning, Joel takes pictures in the primate house. Later in the day, as they moved around, Joel and his team had to find ways to bring lighting to animals located outside. They found success by running wiring in from power poles along a nearby street and by using assistant Dhruba Dutta's lights after Joel's were cooked by irregular voltage. "Frying my lights was the best thing that ever happened to me," says Joel. "It was so freeing! I've never been the same since. The moment I got home, I bought a set of monolights."

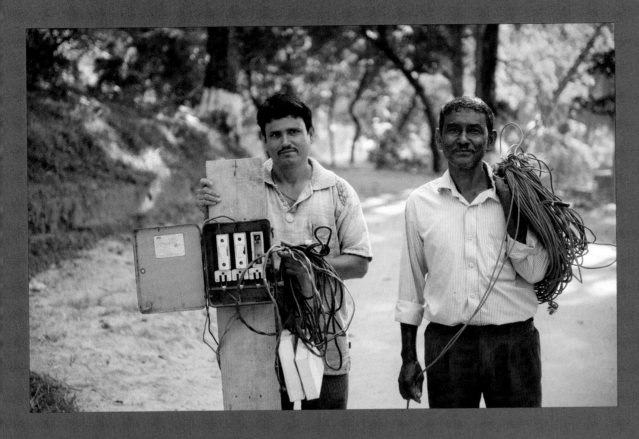

To bring power to Joel, these electricians put a ladder up against a power pole, climbed to the top, and then threw wires with bare ends directly on the high-voltage lines. "These guys showed up with a giant spool of wire—made up of different types of wire—and brought electricity," Joel says.

Visitors to the snake house watch Joel at work. Inside the photo tent, a lizard remained relaxed and calm while Dhruba Dutta (with white shirt, in front of the crowd) kept the onlookers at bay.

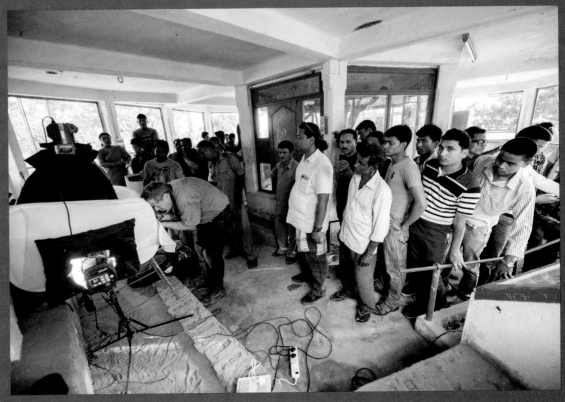

Himalayan griffon *(Gyps himalayensis)* NT

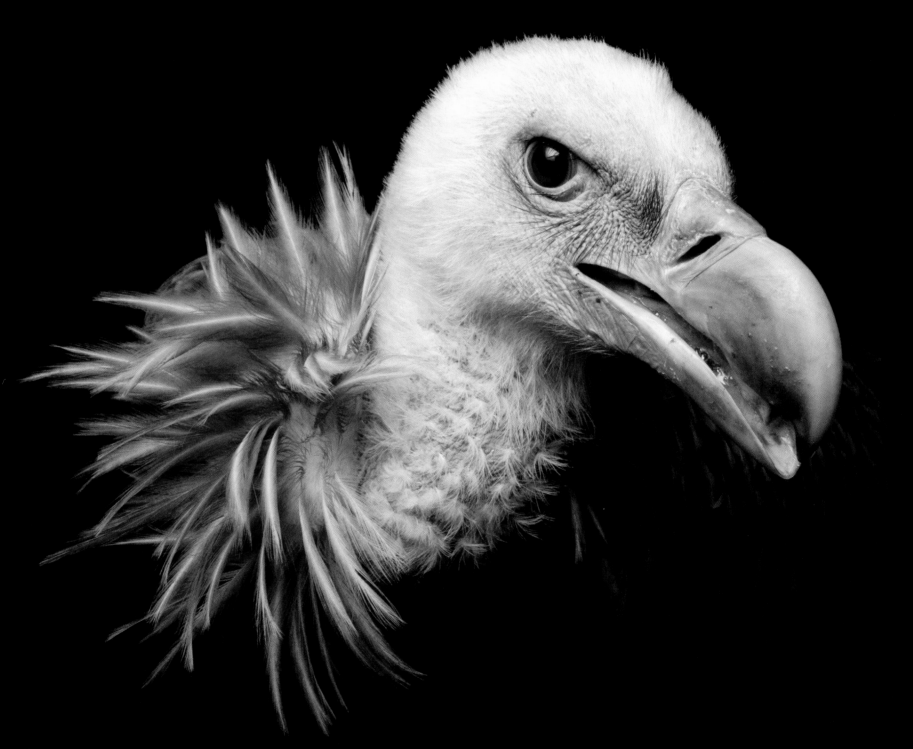

**Stump-tailed macaques**
*(Macaca arctoides)* VU

**Jaguars** *(Panthera onca)* NT

"They're sniffing the white paper, which, as I remember, they didn't tear up. I usually get my best photos when the animals first come out into a space and look around."

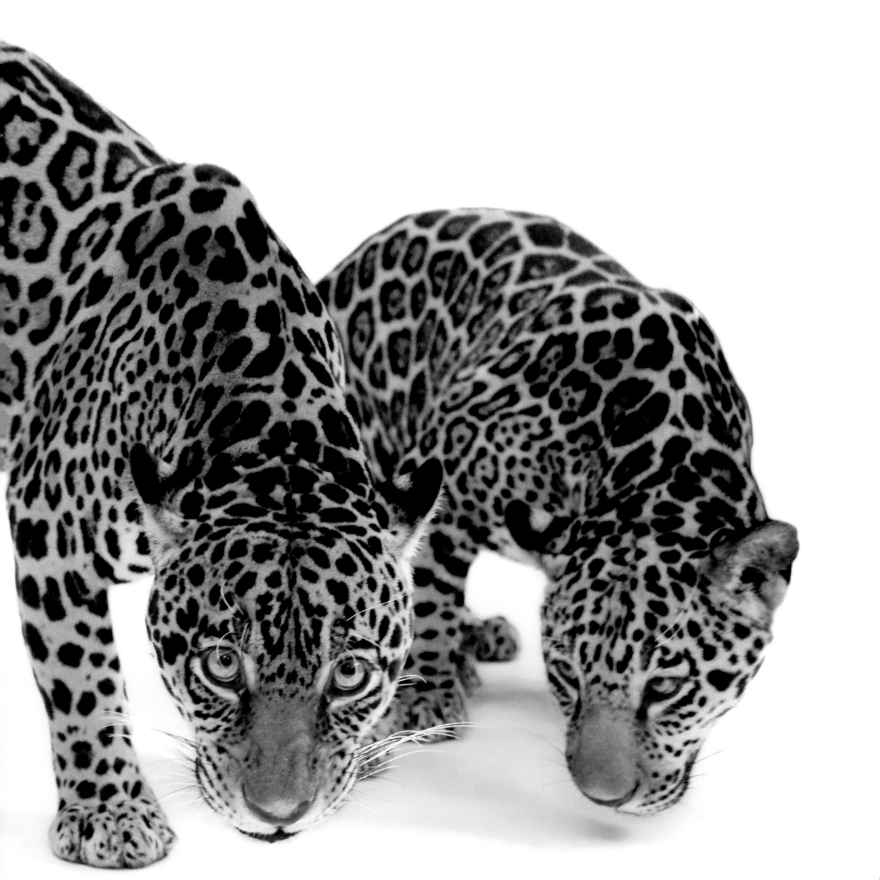

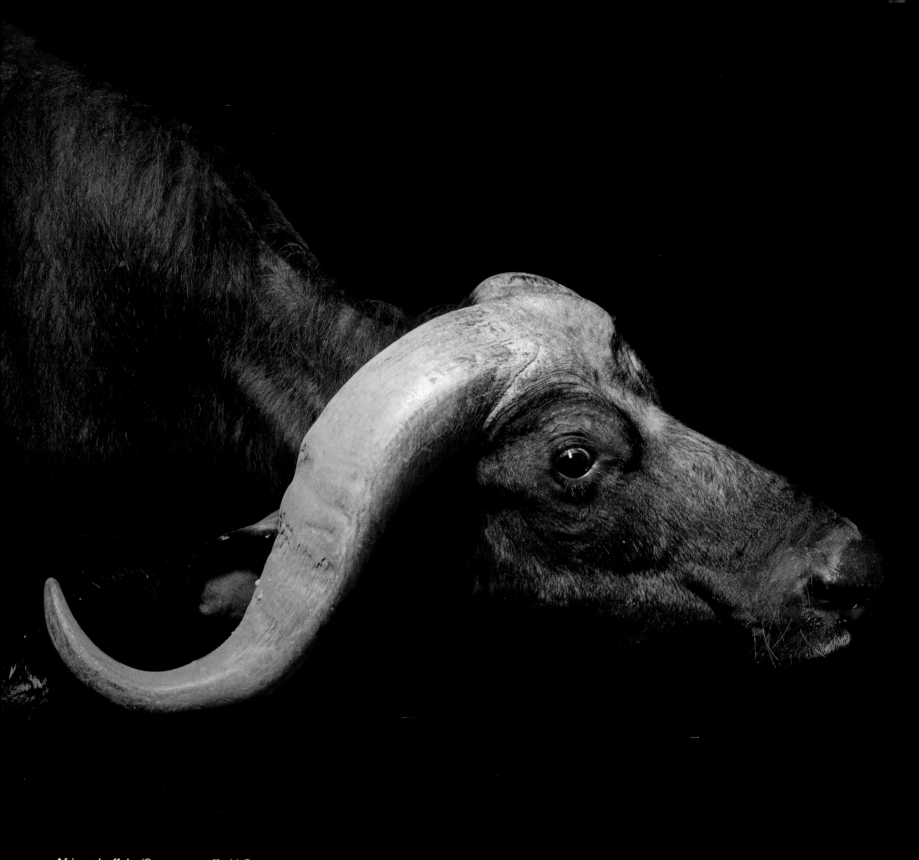

**African buffalo** *(Syncerus caffer)* LC

OPPOSITE: **Lilac-breasted roller** *(Coracias caudatus)* LC

When a large ungulate like this African buffalo walks around in tall grasses, it kicks up dirt and bits of green and any living things hiding in the grasses. So along comes an opportunistic bird, like this lilac-breasted roller, to snatch the insects flying around. The roller will even perch on a buffalo's head or horns for a better vantage point.

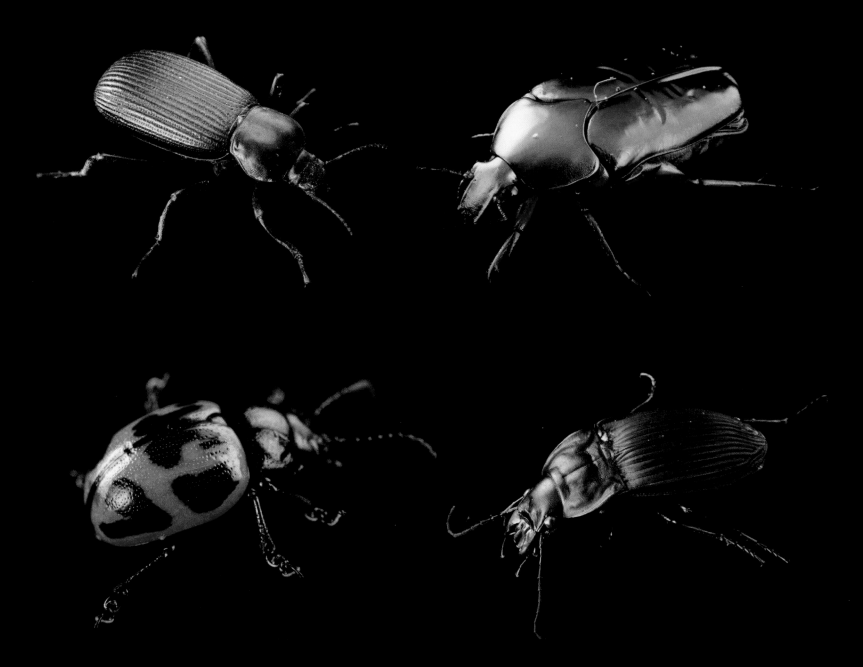

## MEET THE BEETLES ▶ ▶

OPPOSITE: **Tortoise beetle** *(Aspidomorpha citrina)* NE

TOP ROW (L-R): **Darkling beetle** *(Eleodes* sp.) NE, **Asian flower beetle** *(Agestrata orichalca)* NE BOTTOM ROW (L-R): **Milkweed leaf beetle** *(Labidomera clivicollis)* NE, **Notch-mouthed ground beetle** *(Dicaelus purpuratus)* NE

**African wild dogs** *(Lycaon pictus)* EN

"We separated the pack in order to get a small enough number that they would fit on my white paper. They were looking intensely at their pack mates on the other side of the room."

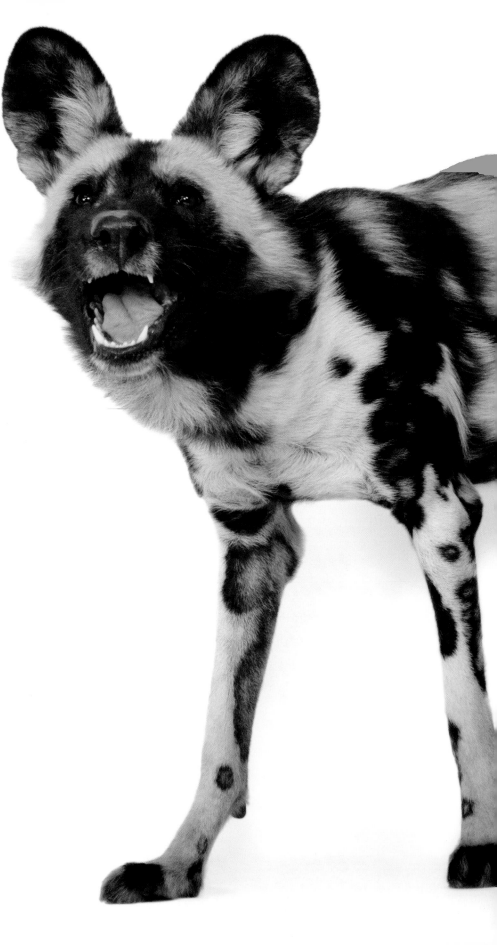

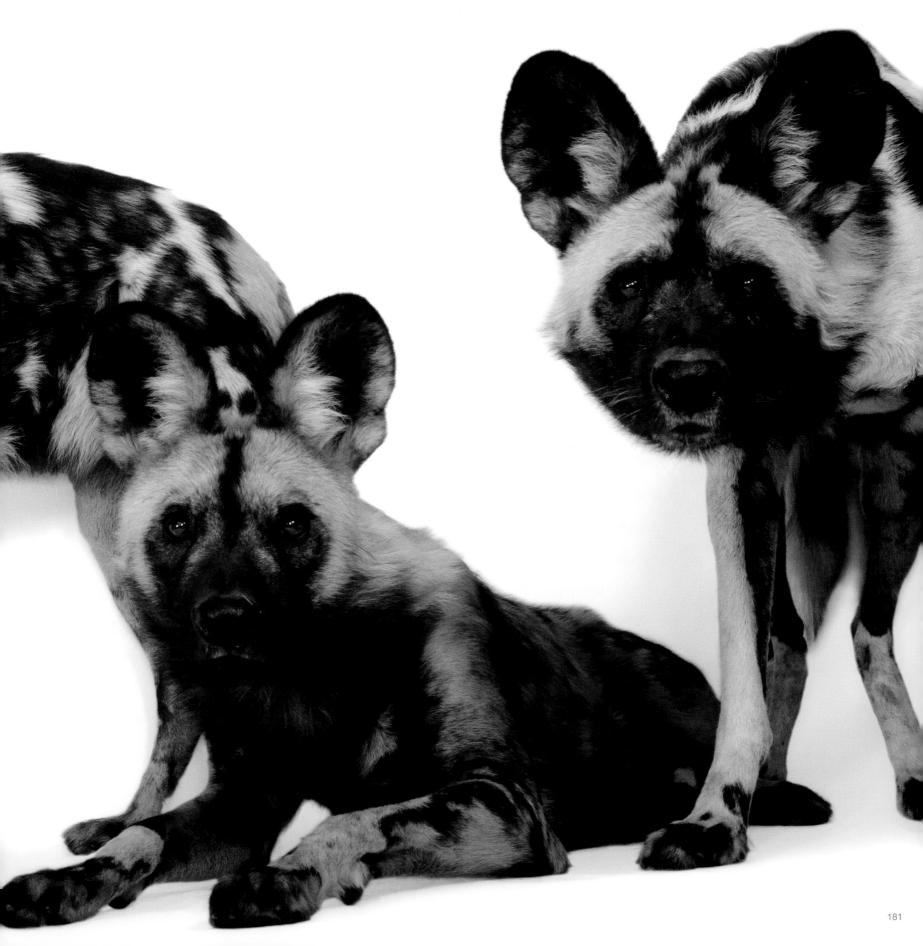

Guianan cock-of-the-rocks, male *(opposite)*
and female *(Rupicola rupicola)* LC

"*It amazes me that some of our most well-known species are the ones that are closest to extinction.*

**Lemur leaf frogs** *(Agalychnis lemur)* CR

"These frogs are coupled for mating, called amplexus in frog lingo. The male is smaller, on top, and stays attached to the female until she lays her eggs and he can fertilize them. It's his way of making sure his genetic material gets passed on—by being there, ready, at all times, even when sleeping."

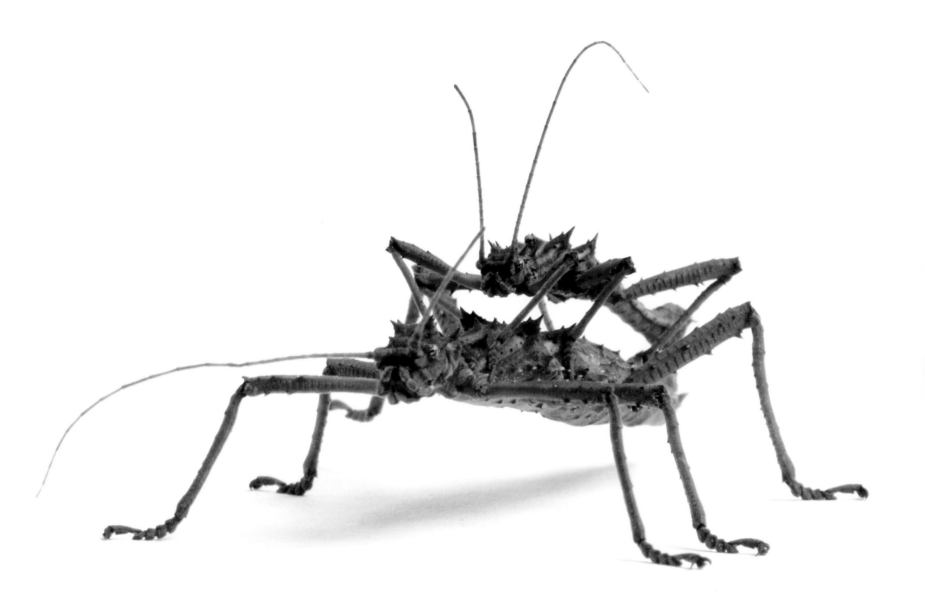

Sabah stick insects *(Aretaon asperrimus)* NE

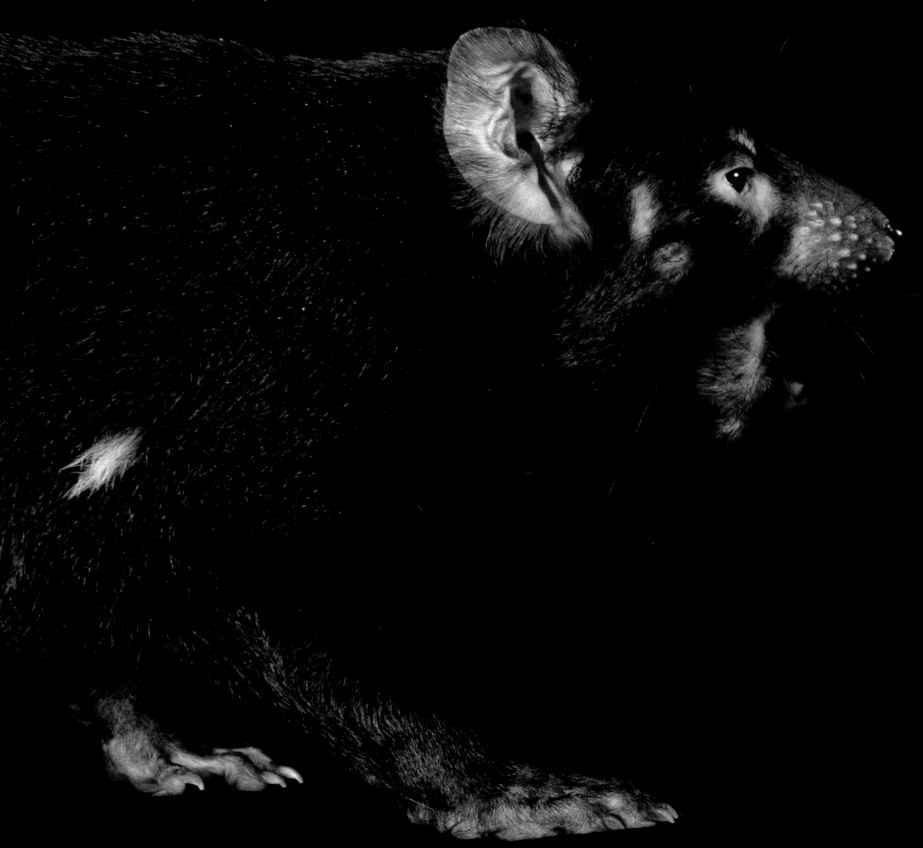

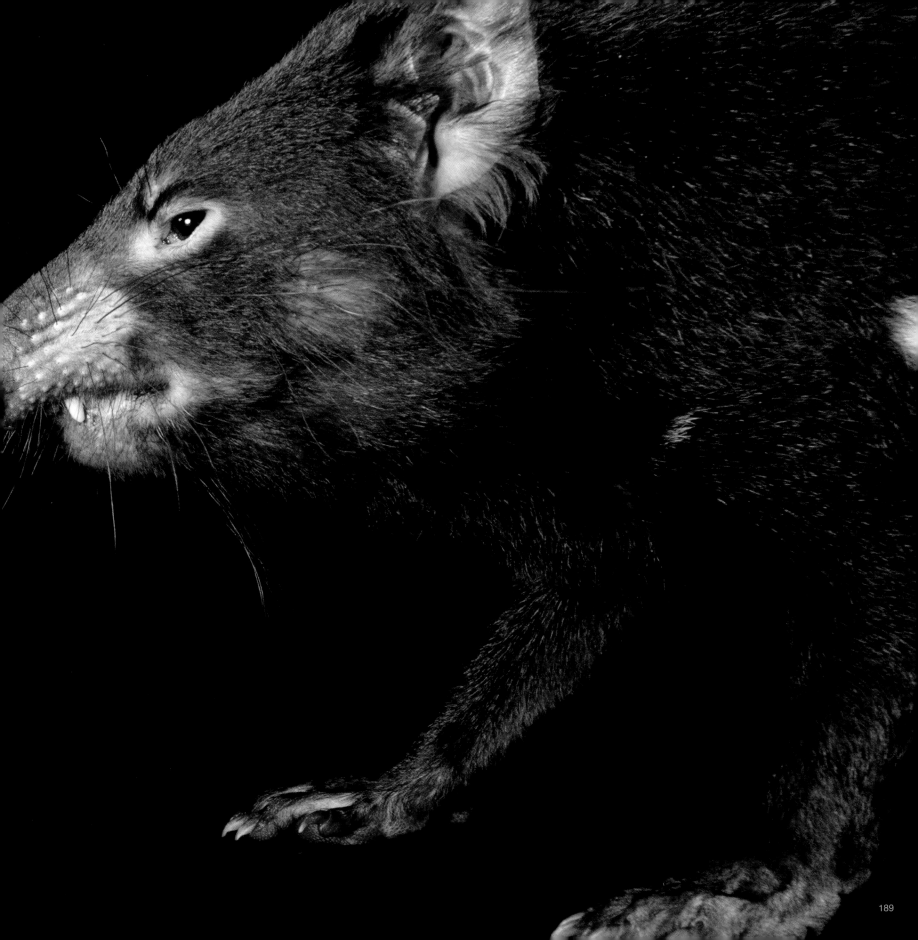

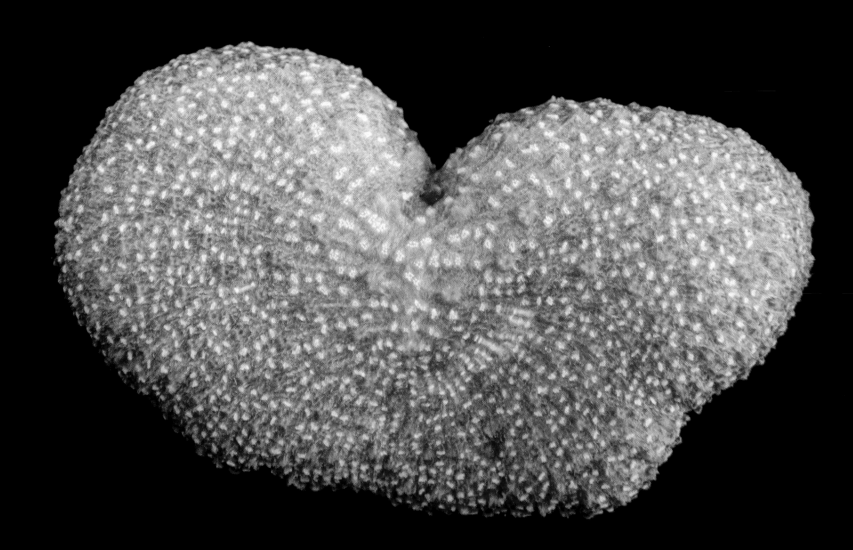

**Sea pansy** *(Renilla muelleri)* NE

**Sea whip** *(Leptogorgia virgulata)* NE

Celebes crested macaque *(Macaca nigra)* CR

OPPOSITE: **Sulawesi babirusas** *(Babyrousa celebensis)* VU

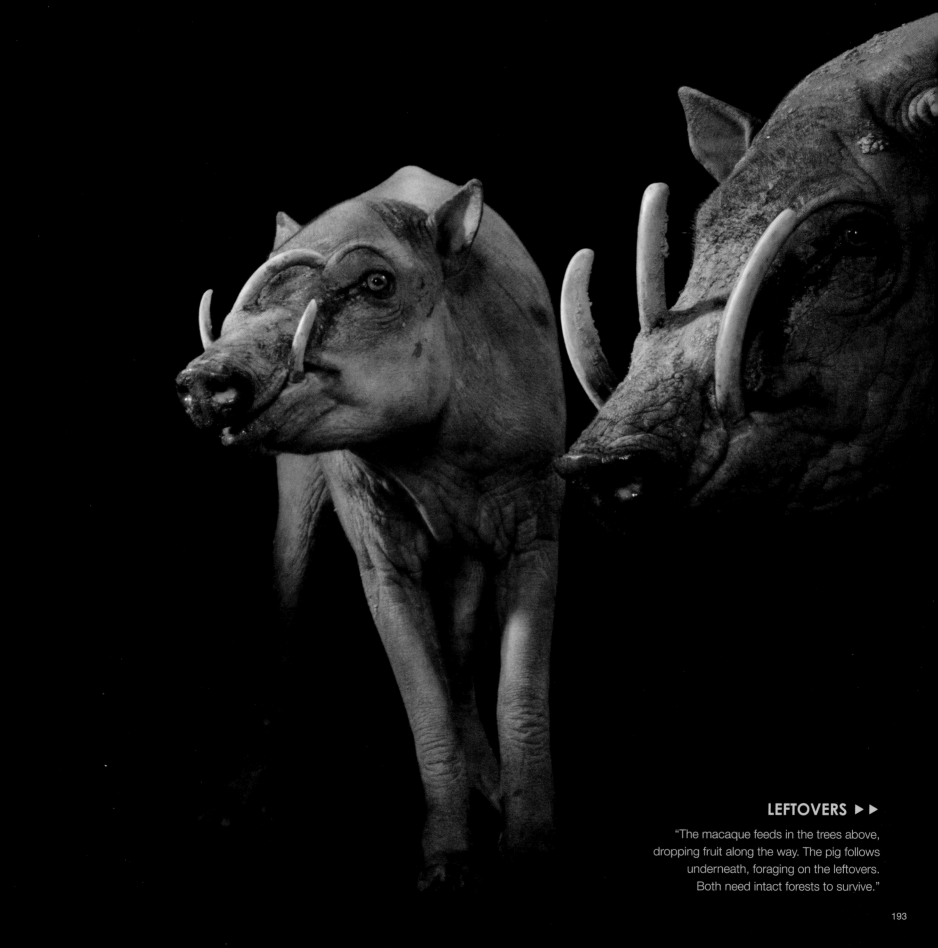

**LEFTOVERS** ▶ ▶

"The macaque feeds in the trees above,
dropping fruit along the way. The pig follows
underneath, foraging on the leftovers.
Both need intact forests to survive."

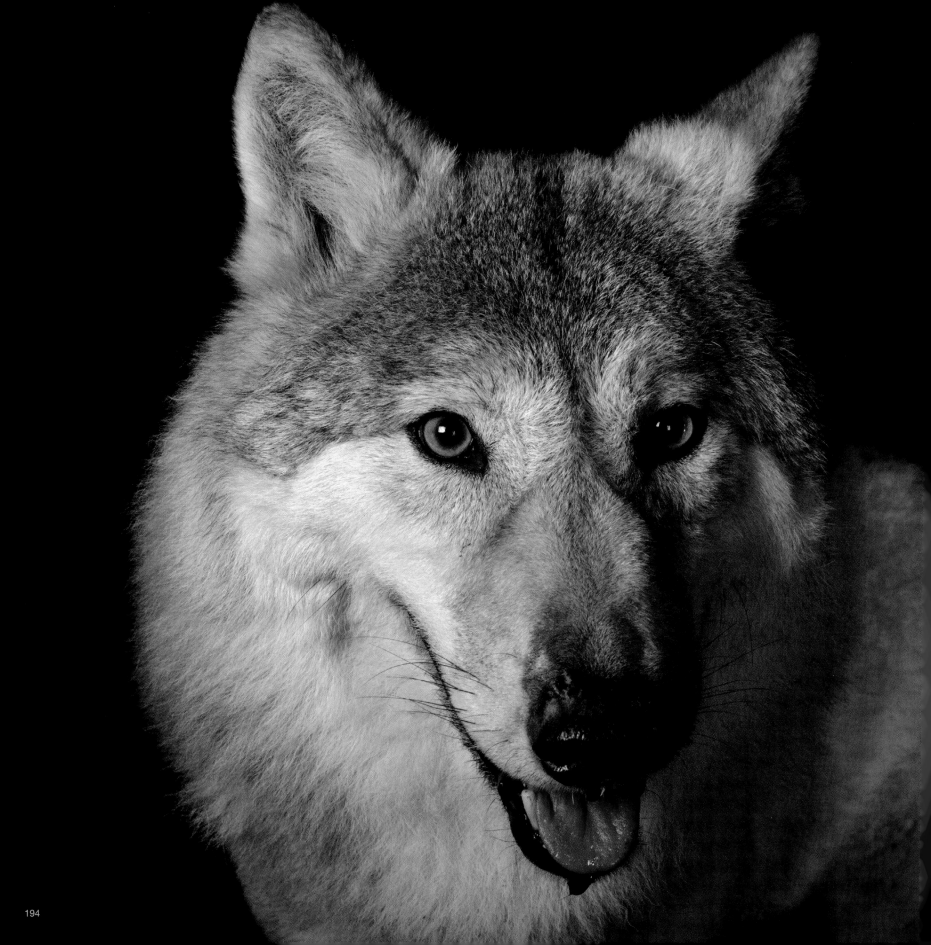

**Himalayan wolves** *(Canis himalayensis)* LC

"Taking pictures of these wolves was like photo-
graphing my pet dogs. They are super smart,
and they're only in it for the treats. When the
food runs out, they don't pay much attention to
me anymore, and the shoot's over."

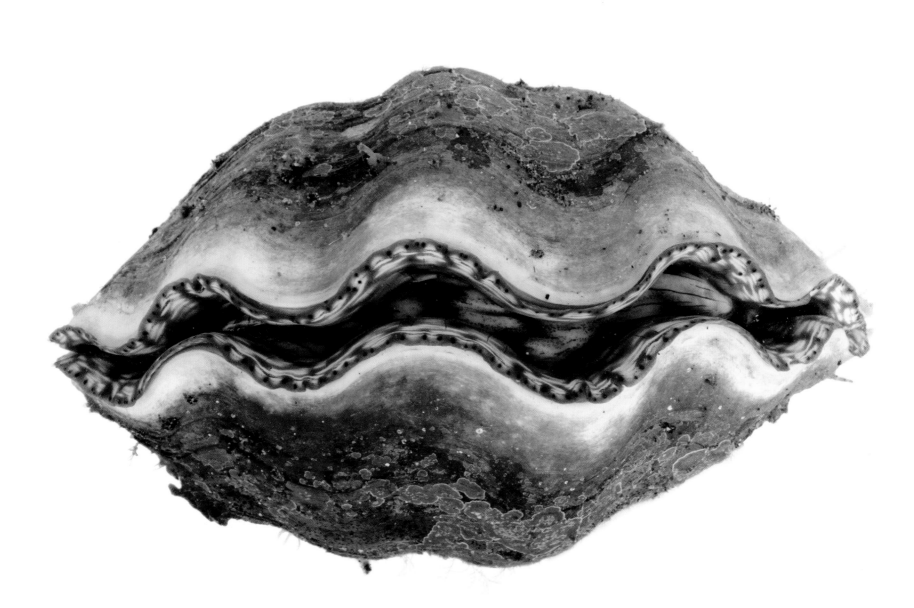

Southern giant clam *(Tridacna derasa)* VU

OPPOSITE: TOP ROW (L-R): **Rough pigtoe pearly mussel** *(Pleurobema plenum)* CR, **Deertoe mussel** *(Truncilla truncata)* NE, **Fanshell** *(Cyprogenia stegaria)* CR BOTTOM ROW (L-R): **Higgins' eye pearly mussel** *(Lampsilis higginsii)* EN, **Ribbed mussels** *(Modiolus demissus)* NE, **Three-ridge mussel** *(Amblema plicata)* LC

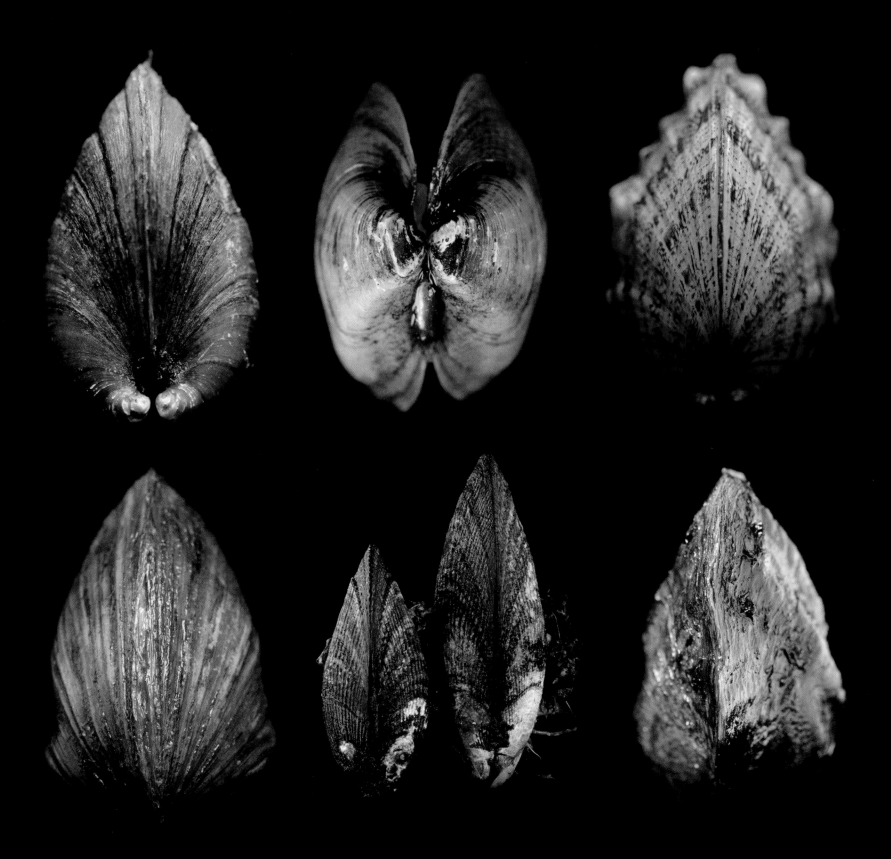

# HEROES

**Brian Gratwicke**
Tropical Research Institute
Smithsonian Institution
Gamboa, Panama

Brian Gratwicke, a conservation biologist for the Smithsonian's Tropical Research Institute, saves amphibians to help ensure Panama's rich biodiversity. Of the country's 214 amphibian species, many are struggling to deal with chytridiomycosis, a frog-killing fungus that scientists are racing to understand. At the same time, Gratwicke has been working quickly to establish captive breeding programs for the frogs at risk.

Researching possible cures for the fungus, his team analyzes the genes of frogs that survive an outbreak. They have also been testing the effect of probiotics on a colony of Panamanian golden frogs, to see if they can boost disease resistance. "Within any species you can have different disease outcomes, and if we can explain why some frogs live and some die, that will be the key to the kingdom," he says. Gratwicke and his team also focus on releasing healthy frogs into the wild. Today, the Smithsonian Tropical Research Institute field station in Gamboa is the largest amphibian conservation center of its kind in the world. "Now that we have the facilities, we are going to become frog farmers," he says.

As a young boy growing up in Zimbabwe, says Gratwicke, his favorite thing to do was to catch and identify pond fish—but amphibians were never far away. "If you are covered up to your waist in mud all day, you will come across tadpoles," he says. Though his work focuses on a particular subset, he advocates for all creatures. ◆

> *Frogs are nature's soundtrack. Each species has its own unique story to share if we are prepared to take the time to observe and listen.*
>
> —Brian Gratwicke

OPPOSITE: **Limosa harlequin frogs** *(Atelopus limosus)* EN

Brian Gratwicke holds a critically endangered
limosa harlequin frog, one of the many
species being bred at the Smithsonian Tropical
Research Institute field station in Gamboa, Panama.

**Red knots** *(Calidris canutus)* NT

"Red knots are dependent on one food during their northward migration: horseshoe crab eggs. Overfishing of the crabs has led to a dramatic decline in both knots and crabs."

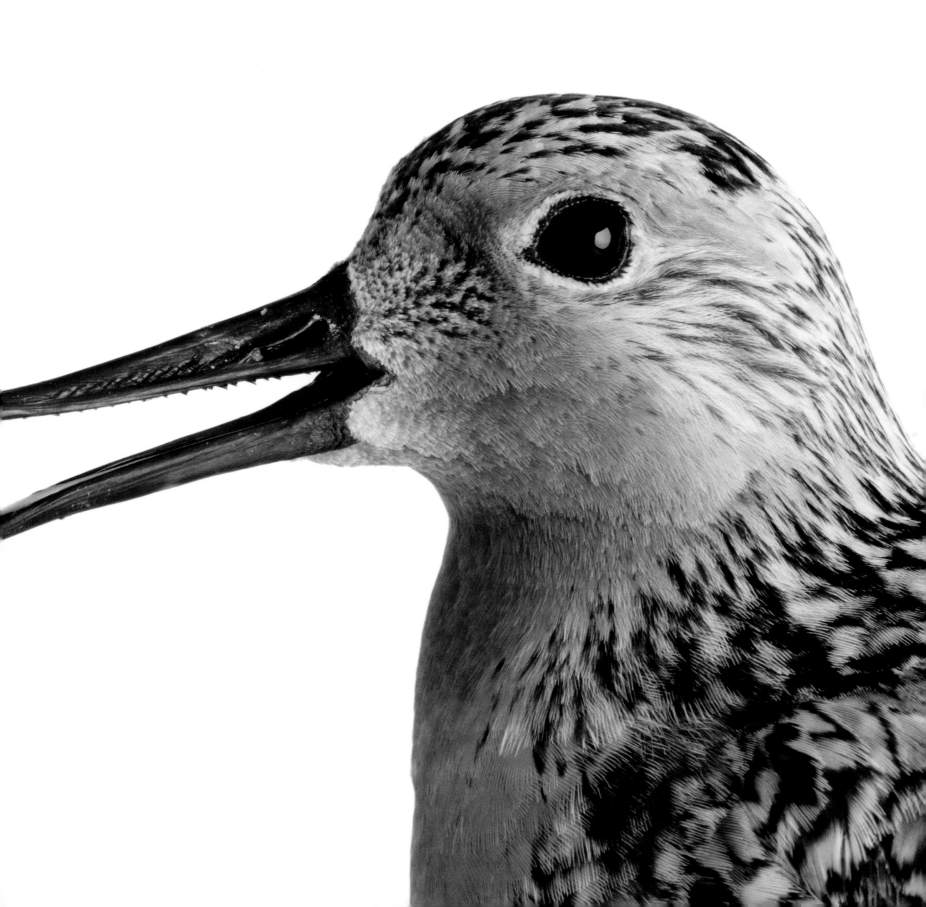

# CHAPTER THREE ◄►

# Opposites

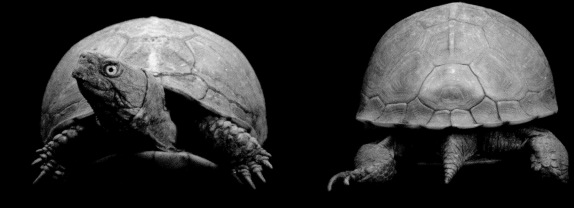

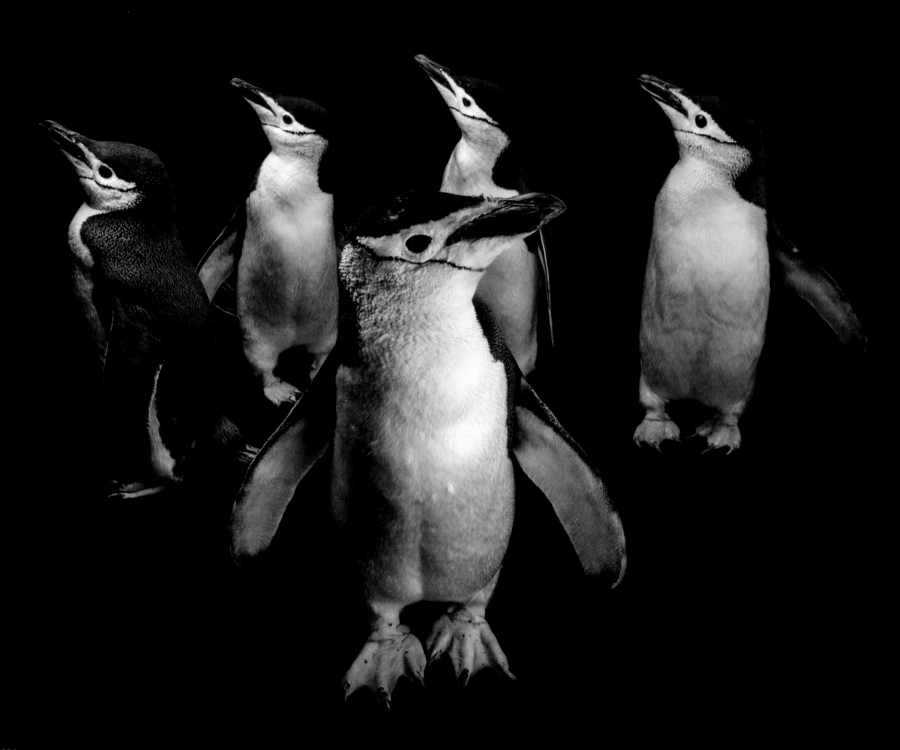

We gravitate toward that which we are not. The Other fascinates us. Intimate connections form between creatures because of their differences as well as their similarities. Connections form based upon competition, rivalry, parasitism, and predation—connections that are as deeply etched into identity as those arising out of harmony and sameness.

Some animals seem born to antagonize, like the common dwarf mongoose, a tiny carnivore not afraid to show teeth, or the betta, the Siamese fighting fish, both carnivorous and fiercely territorial. Africa's pin-tailed whydah appropriates food and nest sites from the red-cheeked cordonbleu. And then there are triangles, like the burrowing owl that takes over a prairie dog den and, to stay safe even down in the grasses, makes a call that sounds like a rattler to keep predators (and evicted prairie dogs) away.

Likewise, we humans enjoy organizing the world by its contrasts. Extremes at either end of the spectrum form fascinating bonds in our depiction of the animal world. The common garden snail oozes slowly; the cheetah, fastest land animal on Earth, can sprint up to 75 miles an hour. A millipede moves on hundreds of tiny legs, while the legless lizard—not a snake—manages life without any.

Nature displays contrasts without our even asking: The black and rufous sengi, one of 17 species of tiny African elephant shrews, sits closer in the evolutionary jigsaw puzzle to the elephant than to the shrew. A northern tamandua from Central America stands and throws his forelegs wide open; a Coquerel's sifaka from Madagascar curls up and pulls in. Saltwater fish and freshwater fish do not share the same habitat, but they share the same world.

As do we. Getting to know these animals, we see so many variations, details, and differences. That's the beauty of Earth's biodiversity, and that's why we want to keep all species alive. ◆

OPPOSITE: **Chinstrap penguins** *(Pygoscelis antarcticus)* LC
"I couldn't believe they all lined up like that, and then one stepped forward and looked the other way."
PREVIOUS PAGE: **Three-toed box turtles** *(Terrapene carolina triunguis)* VU

**Himalayan monal** *(Lophophorus impejanus)* LC

"This is one of the most gorgeous birds ever made,
photographed at Don and Ann Butler's Pheasant Heaven.
The lights I use are daylight-balanced and pure white,
yielding really vivid colors."

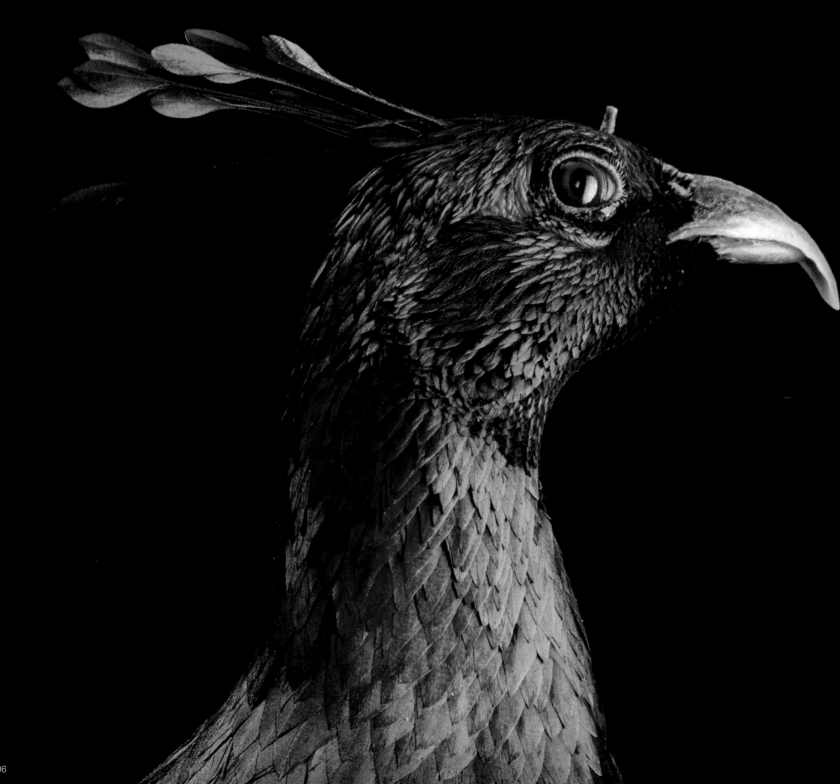

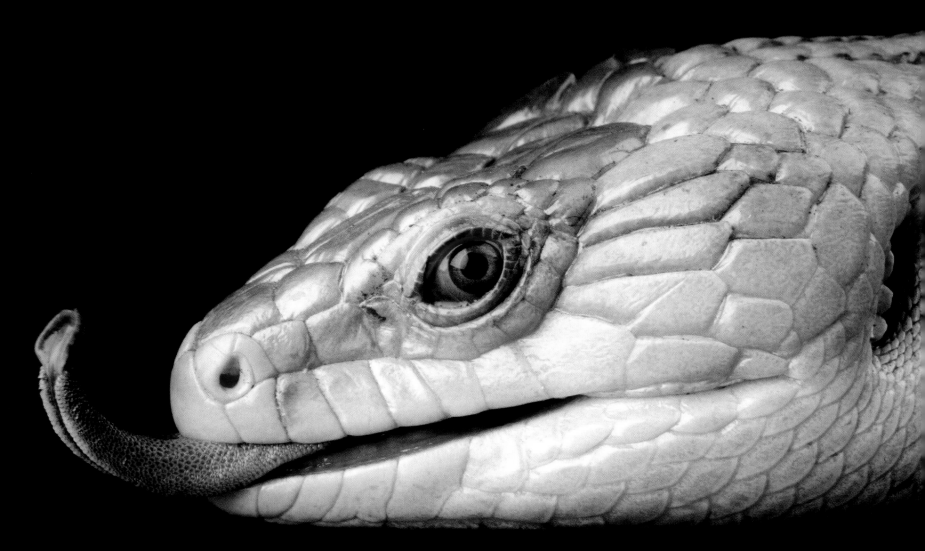

**Northern blue-tongued skink** *(Tiliqua scincoides intermedia)* NE

"This lizard was on the move, smelling both me and the black velvet backdrop with his tongue. The camera's flash froze the namesake tongue for all to see."

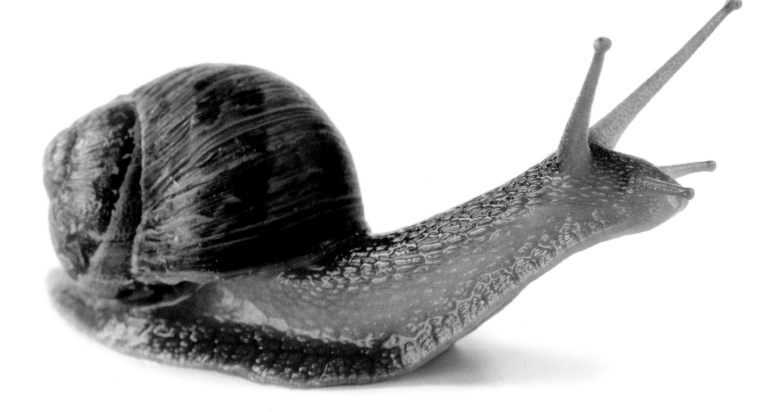

**Common garden snail** *(Helix aspersa)* NE

"There's nothing rare about this species,
but I find it remarkable nonetheless."

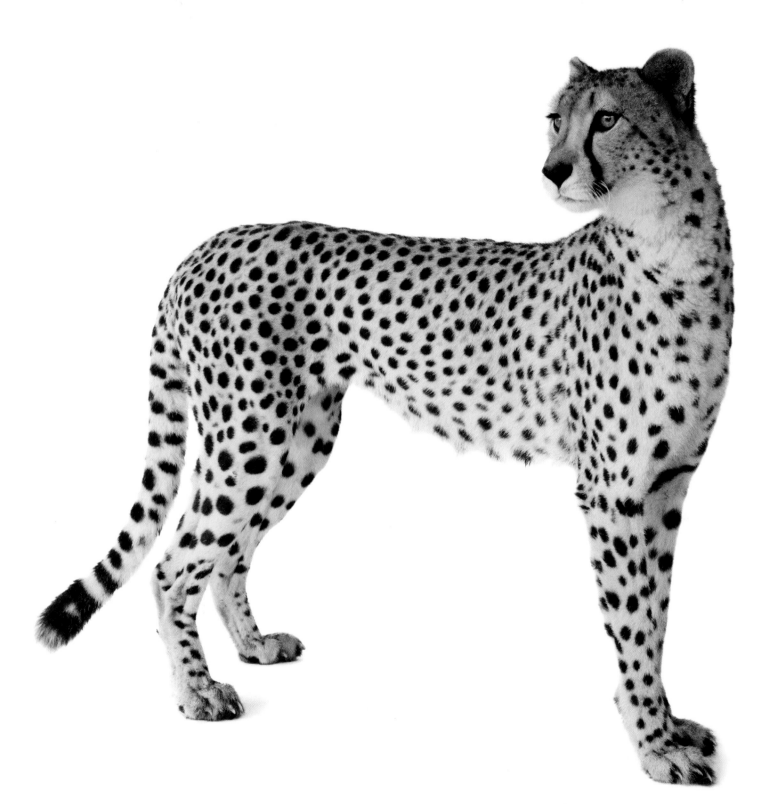

**Cheetah** *(Acinonyx jubatus)* VU

"This animal was so gentle, the keeper and I went right in the enclosure with it. If he looks majestic and serene, it's because he was."

Common dwarf mongooses
*(Helogale parvula)* LC

"*Mongooses never stop moving— always curious and investigating their surroundings.*"

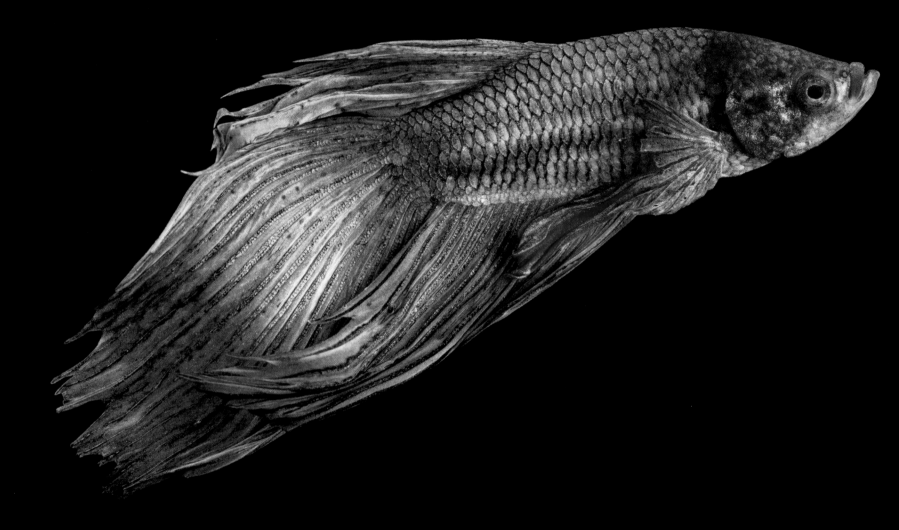

**Siamese fighting fish** *(Betta splendens)* VU

"Known for flaring their fins and fighting whenever they
see another male, these fish have been bred for longer
and longer fins for the pet trade."

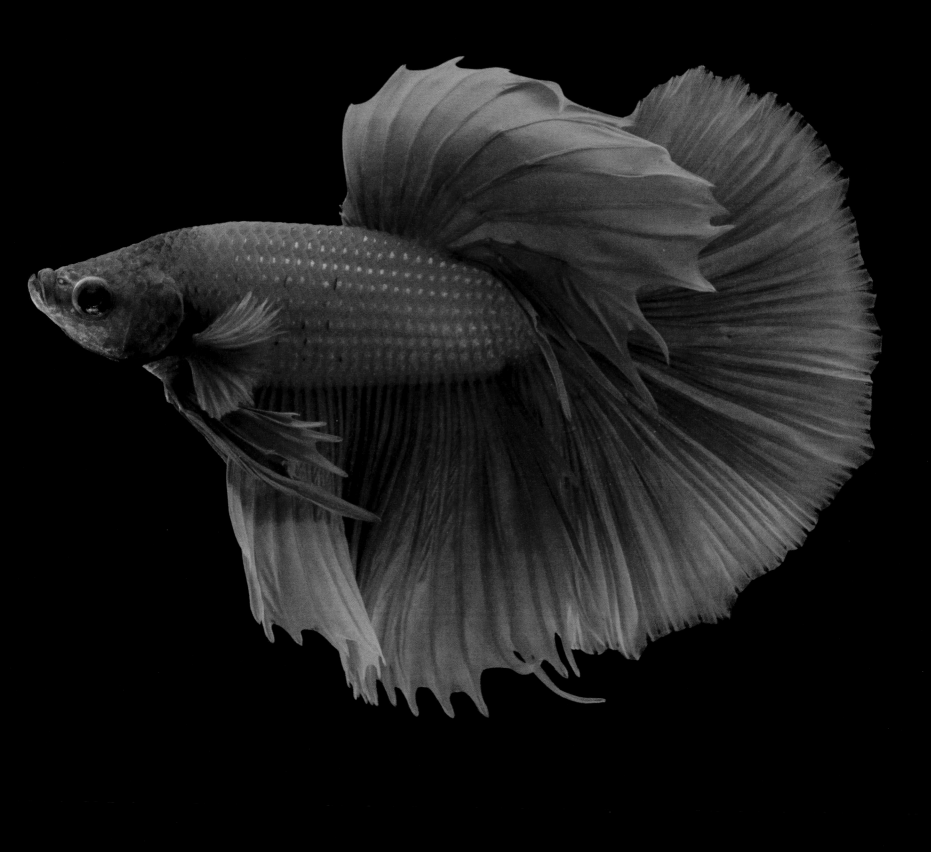

Gladiator meadow katydid *(Orchelimum gladiator)* NE

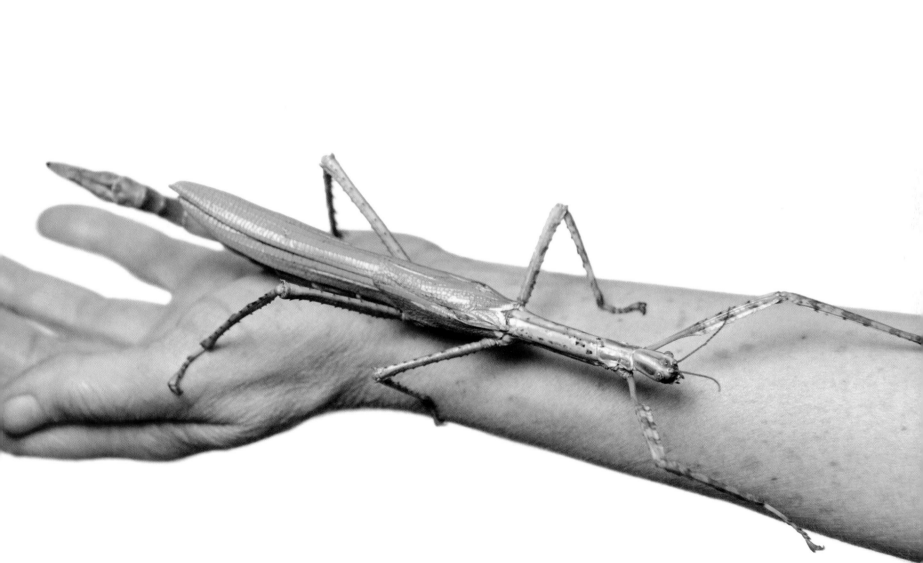

**Eastern goliath stick insect** *(Eurycnema goliath)* NE

"This is one of the largest insects in the world.
I don't like including human hands or arms in the frame,
but sometimes I must in order to show size."

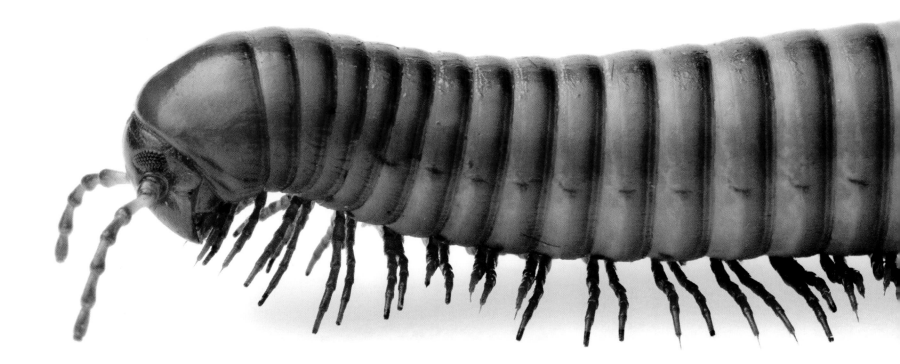

Millipede (*Diplopoda* sp.)

OPPOSITE: **European legless lizard** *(Pseudopus apodus)* NE

One of the characteristics that distinguishes the animal from the plant world is mobility, whether by fins, wings, or, in this case, legs. Millipedes have hundreds of legs— one species tops out at 750—while the legless lizard has only tiny vestigial legs that don't function anymore, so it slithers like the snakes that it resembles.

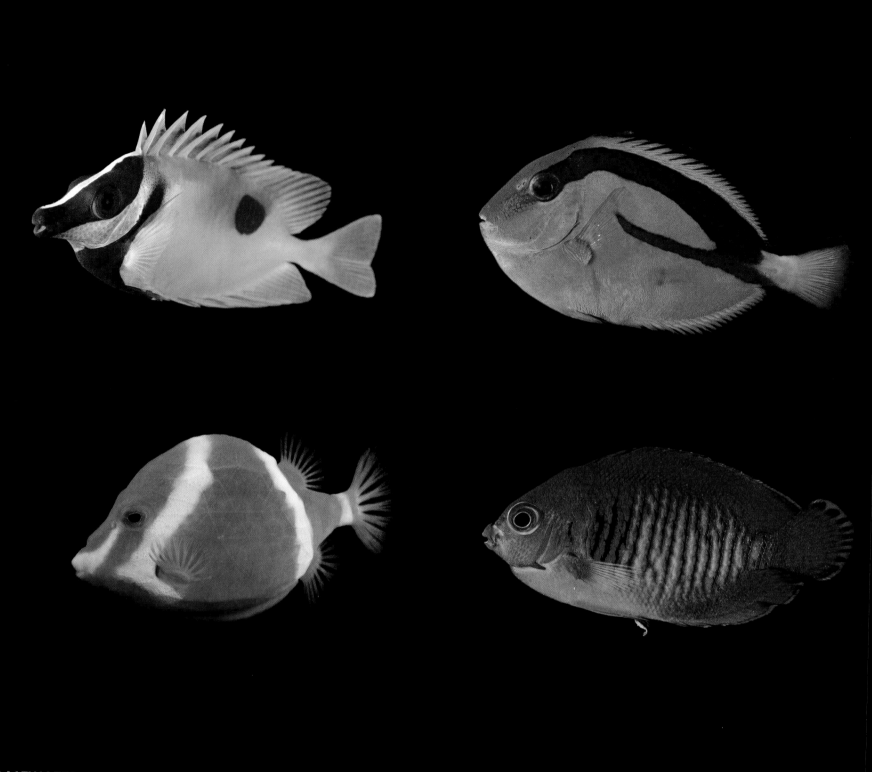

## SALTWATER AND FRESHWATER COLORS ◄ ►

Coral reefs are themselves awash in color, and the yellows and blues of saltwater reef fish *(this page)* blend in. Likewise, the fish that live in lakes, ponds, and rivers—such as these Colorado River species *(opposite)*—reflect the muddy hues of their own environment.

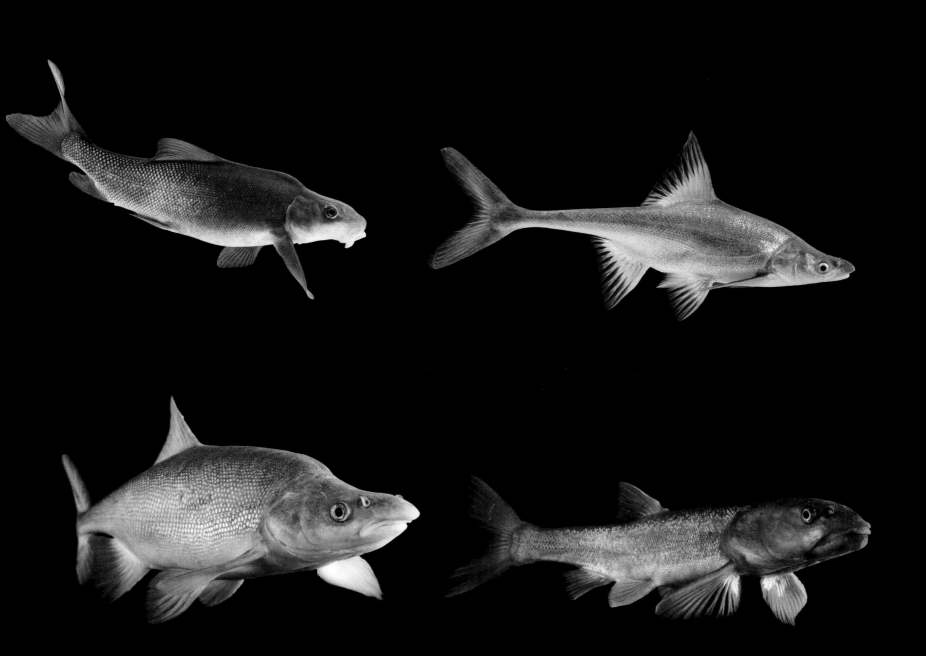

OPPOSITE PAGE, TOP ROW (L-R): Blotched foxface *(Siganus unimaculatus)* NE, Palette surgeonfish *(Paracanthurus hepatus)* LC BOTTOM ROW (L-R): White-barred boxfish *(Anoplocapros lenticularis)* NE, Two-spined angelfish *(Centropyge bispinosa)* LC THIS PAGE, TOP ROW (L-R): Razorback sucker *(Xyrauchen texanus)* CR, Bonytail *(Gila elegans)* CR BOTTOM ROW (L-R): Humpback chub *(Gila cypha)* EN, Colorado pikeminnow *(Ptychocheilus lucius)* VU

*"Snowy plover chicks at the Monterey Bay Aquarium huddle together for security and warmth. Except one—there's always one.*

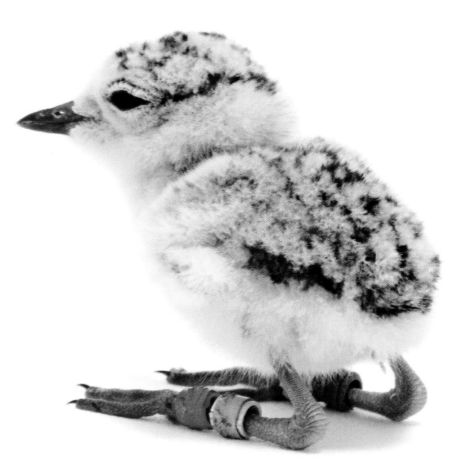

**Western snowy plover chicks**
*(Charadrius nivosus nivosus)* NT

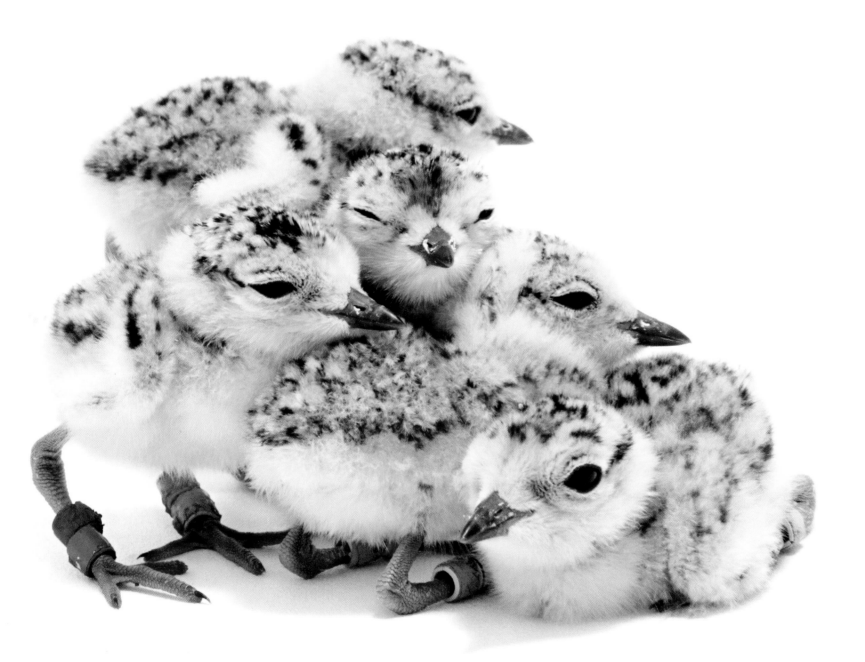

# HEROES

**Chris Holmes**
Houston Zoo
Houston, Texas

C hris Holmes wasn't exactly enamored with the first blue-billed curassow he saw, now some 20 years ago, when he was a teen volunteer at the Houston Zoo. "I didn't like him. He'd charge right up to the door of the cage and try to run out," says Holmes. "That bird is a big jerk," Holmes told his mentor. Trey Todd, assistant curator of birds at the time, responded with compassion for the critically endangered species, saying he wished someone would help it survive. "I never imagined it would be me," Holmes says today.

Native to northern Colombia, and deeply connected to Colombian culture, about 250 blue-billed curassows remain in the wild. The Houston Zoo has hatched more than 30 curassows, sending them to other zoos to start their own programs. Working closely with Colombian native Myriam Salazar from the Barranquilla Zoo, Holmes has helped develop a countrywide conservation program. And in 2014, with essential help from Colombians Rafael Vieira and Guillermo Galviz, the first captive birds hatched in their native country at the National Aviary of Colombia on Barú Island—"a major step forward," Holmes says.

Now Holmes's focus is to help conservationists and government officials breed and raise curassows in their homeland. "Traveling helps me understand the barriers to reintroduction and how to alleviate them," he says. At a Colombian workshop in December 2015, he helped develop a five-year conservation plan for the species.

From that first ornery creature to a career dedicated to the species, blue-billed curassows have won Chris Holmes's heart. He has a blue-billed curassow tattooed on his left bicep, and he doesn't call them jerks anymore. "It's easy to get infatuated by their personalities," he says. ◆

> " *This work has affected me personally as I realize how we are all connected.*
> —Chris Holmes

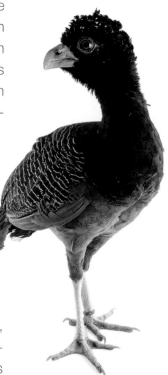

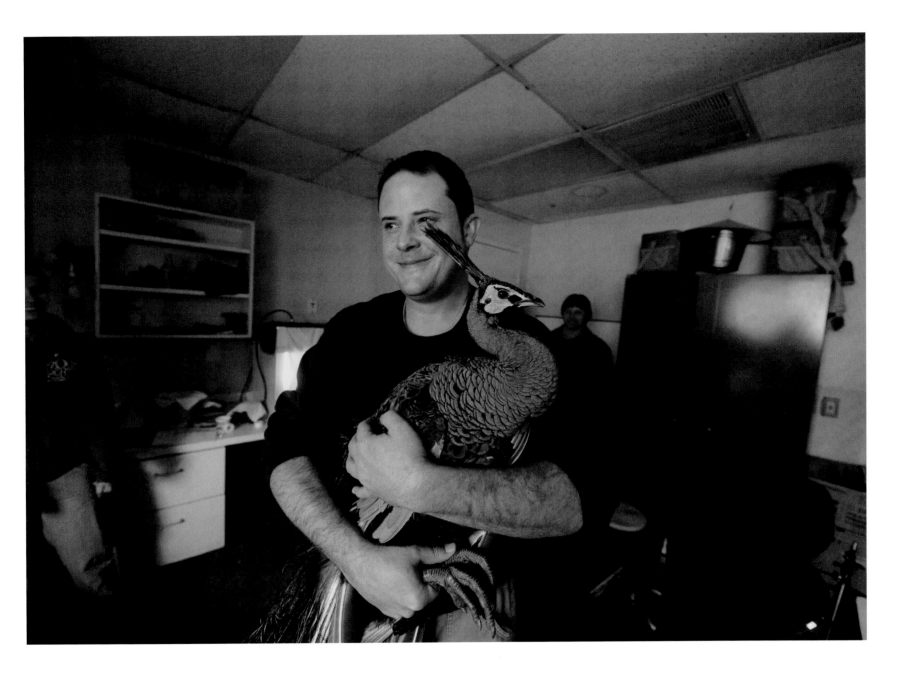

OPPOSITE: **Blue-billed curassow** *(Crax alberti)* CR

Chris Holmes carries a male green peafowl for a photo shoot with Joel. "We had a hard time fitting his tail in the tent," Holmes says. The green peafowl is the more endangered of the two peafowl species.

## ECOLOGICAL COOPERATION ◄ ►

Prairie dogs construct complex tunnel systems—some even call them towns—under the grasslands of the North American prairie. Other animals, including the burrowing owl and the rattlesnake, may appropriate their burrows. Their excavations aerate the soil and play a key role in this natural habitat. "Their towns are a huge boost to the prairie ecosystem," says Joel. "The equivalent of the coral reef in the ocean."

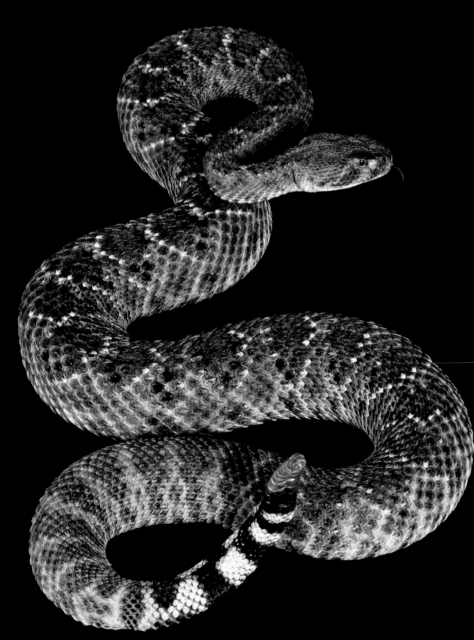
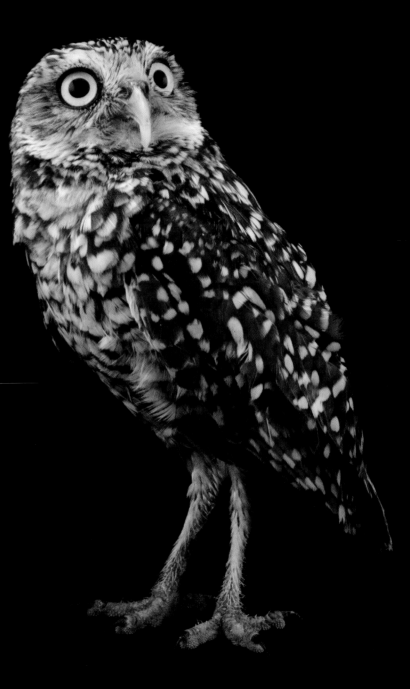

**Western diamondback rattlesnake** *(Crotalus atrox)* LC

**Burrowing owl** *(Athene cunicularia troglodytes)* LC

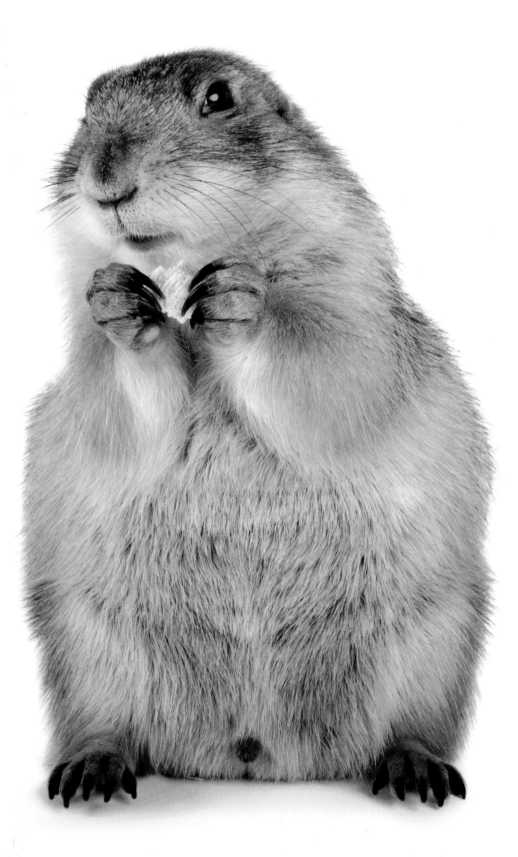

## SAME SPECIES, DIFFERENT COATS ◄ ►

Their coats may look different, but these two cats are both leopards of the same species. One has the typical leopard spots, useful as camouflage. The other has spots, too, visible only in certain light. It also has a condition called melanism, caused by a recessive gene that leads to the dark variant and is known to occur primarily in leopards and jaguars.

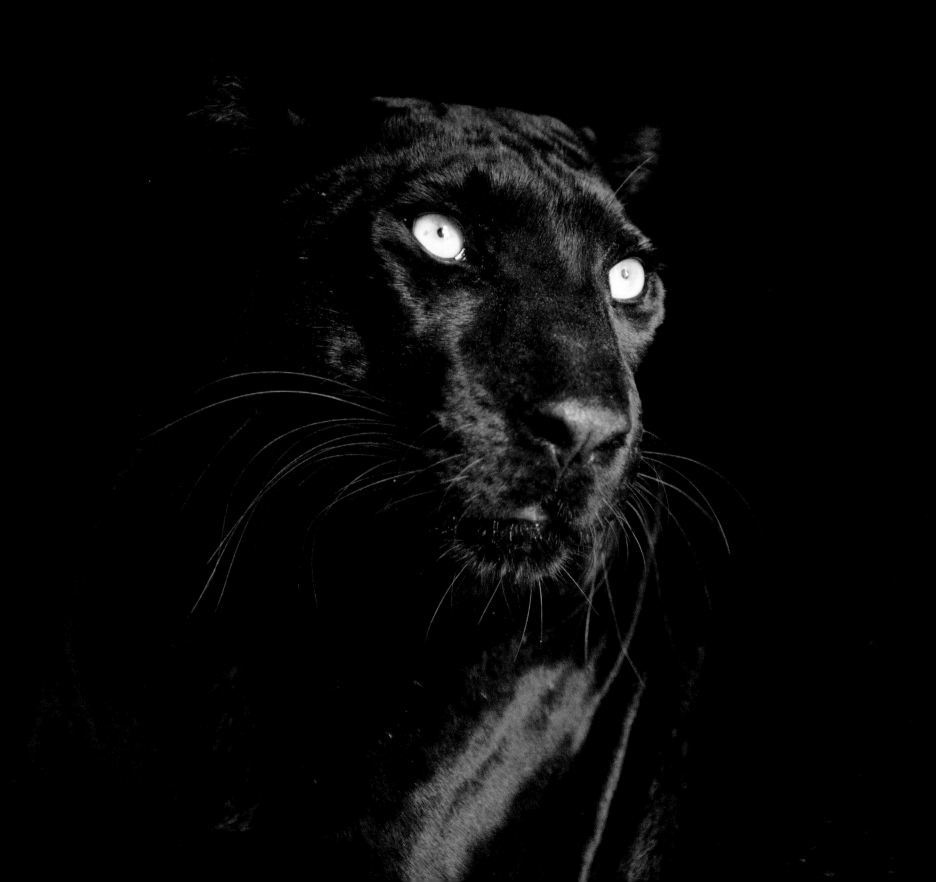

Common spider crab *(Libinia emarginata)* NE

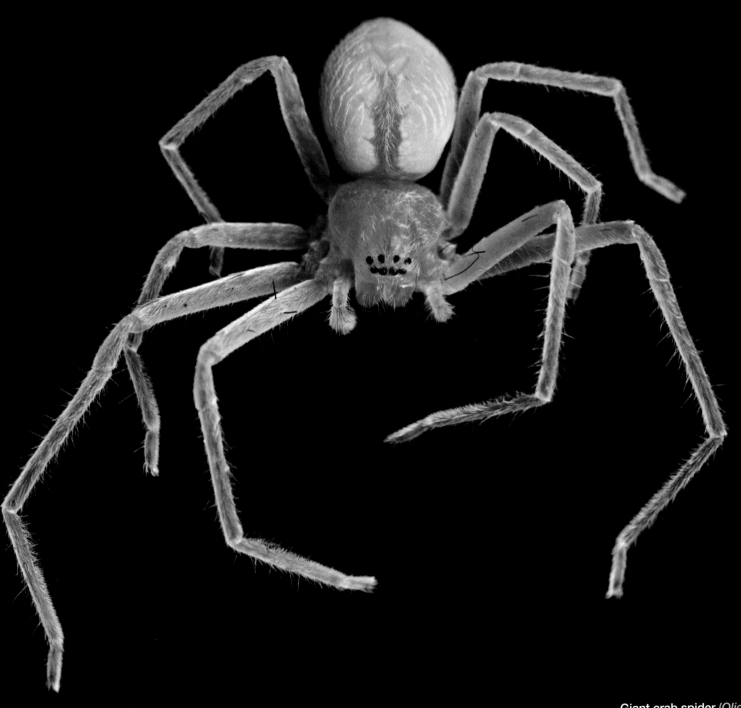

Giant crab spider (*Olios* sp.) NE

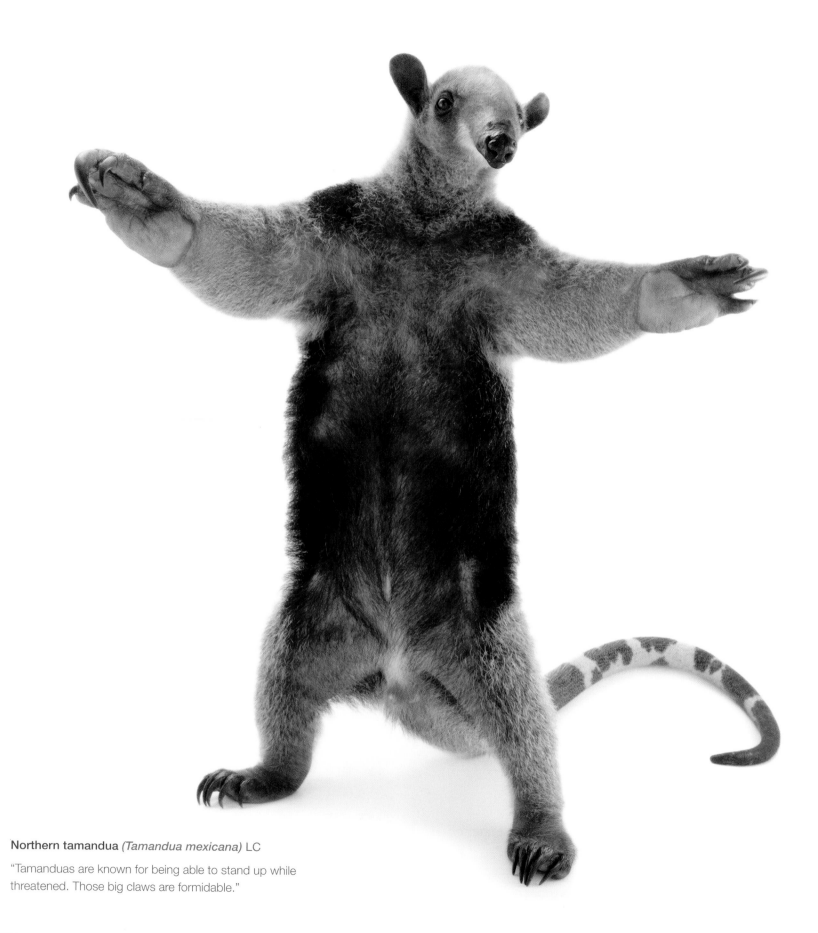

**Northern tamandua** *(Tamandua mexicana)* LC

"Tamanduas are known for being able to stand up while threatened. Those big claws are formidable."

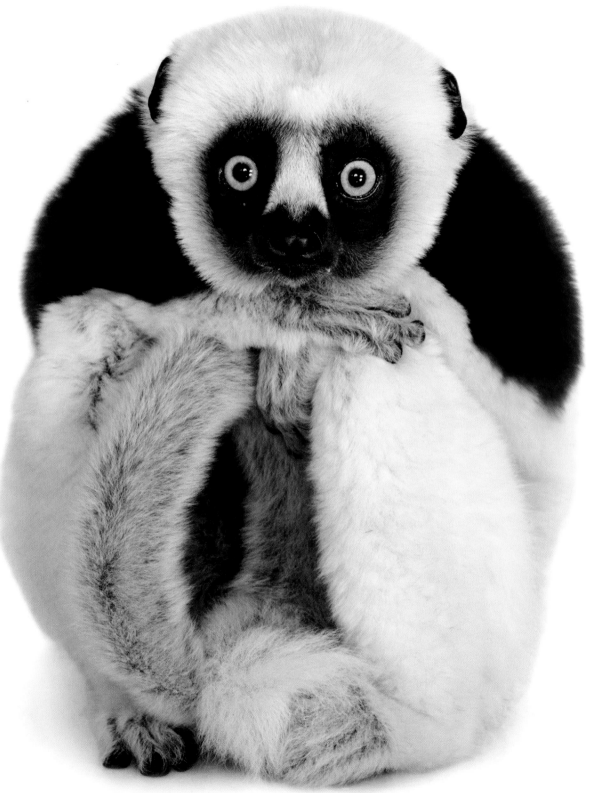

Coquerel's sifaka
*(Propithecus coquereli)* EN

TOP ROW (L-R): Spanish shawl nudibranch *(Flabellina iodinea)* NE, Regal goddess nudibranch *(Felimare picta)* NE, California aglaja nudibranch *(Navanax inermis)* NE MIDDLE ROW (L-R): California sea hare *(Aplysia californica)* NE, Hopkin's rose nudibranch *(Hopkinsia rosacea)* NE, Lettuce sea slug *(Tridachia crispata)* NE BOTTOM ROW (L-R): Warty nudibranch *(Dendro wartii)* NE, Lion's mane nudibranchs *(Melibe leonina)* NE

Leopard slug *(Limax maximus)* NE

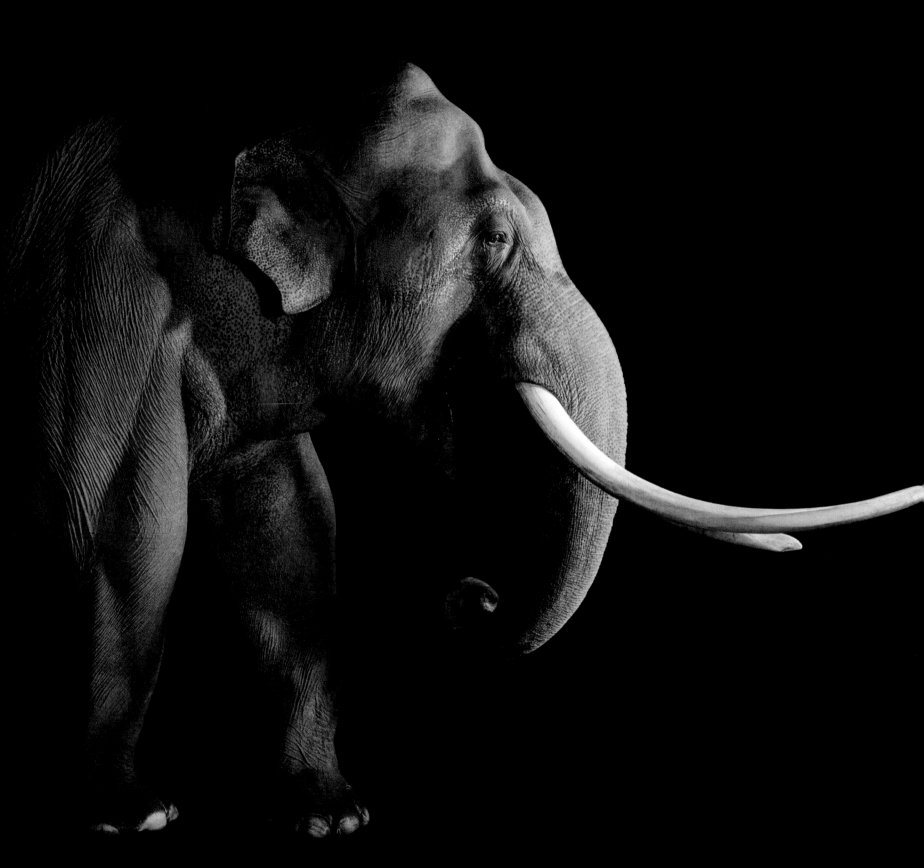

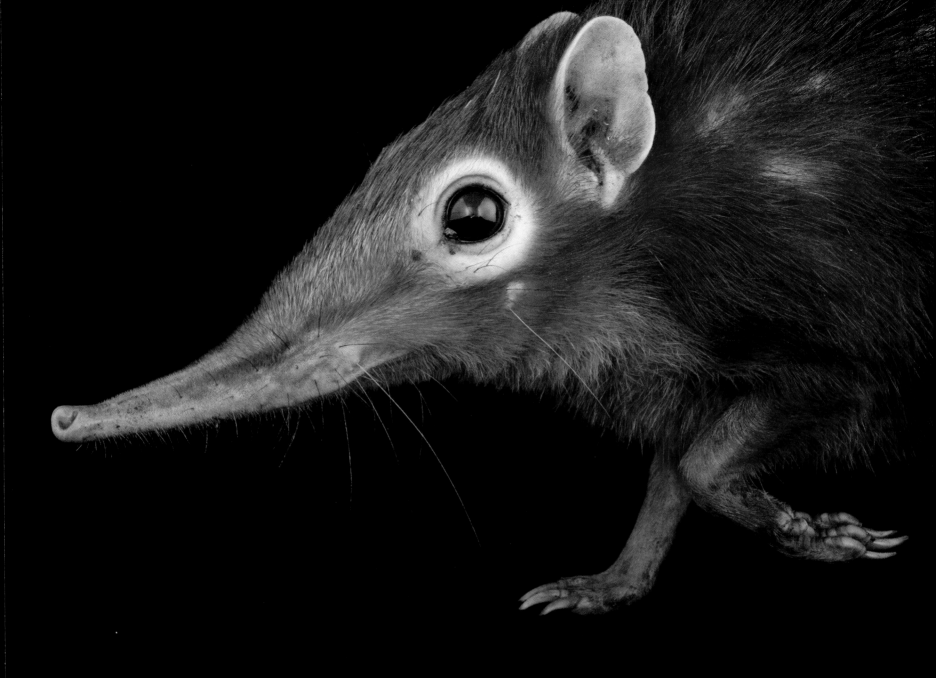

OPPOSITE: Asian elephant *(Elephas maximus)* EN

Black and rufous elephant shrew *(Rhynchocyon petersi)* LC

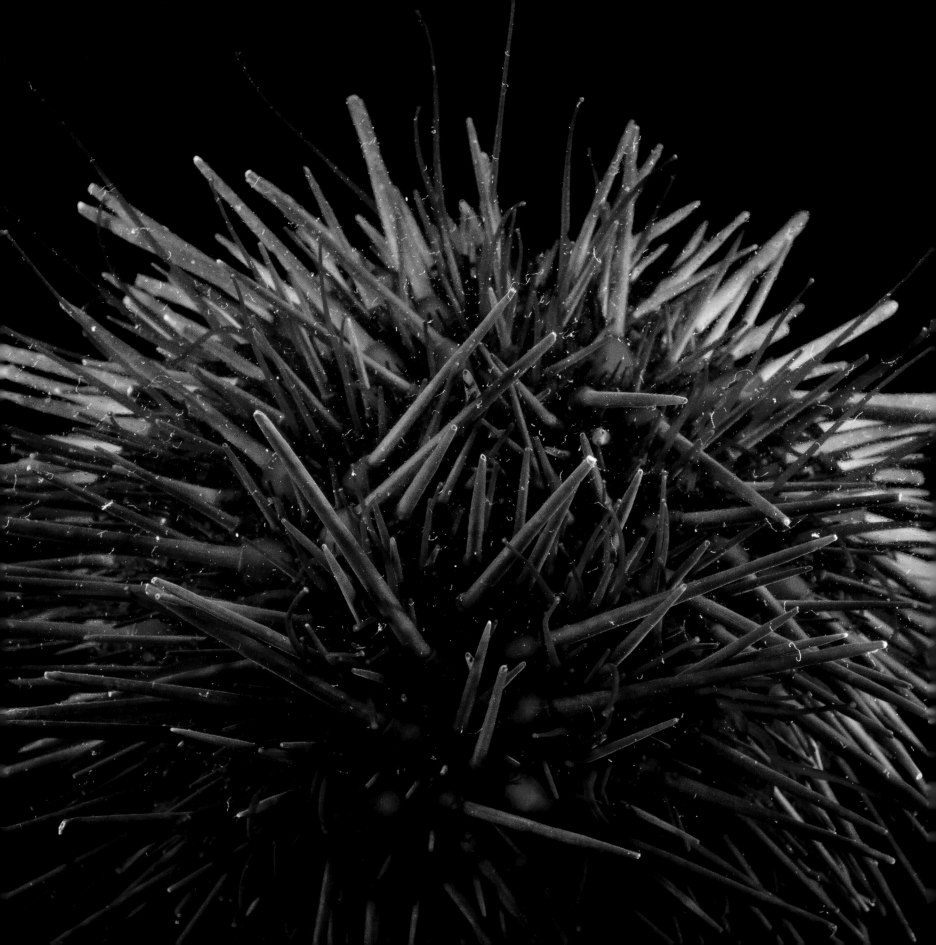

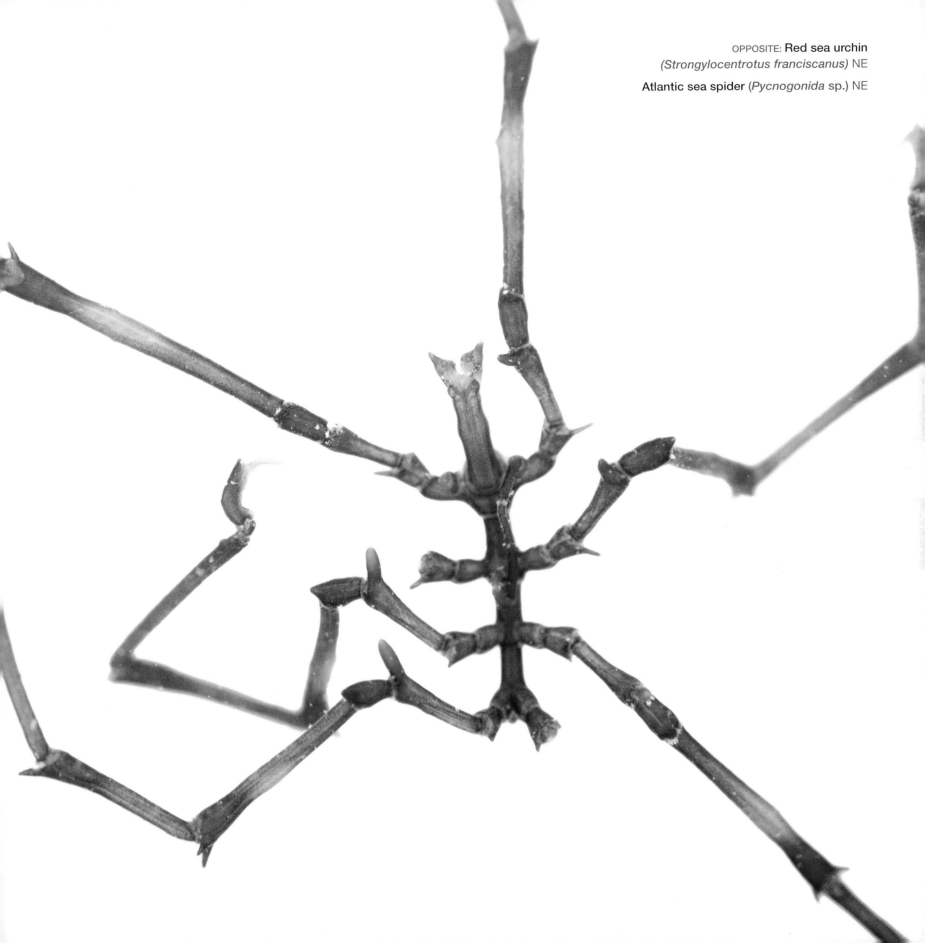

## INTRUDERS IN THE NEST ◄ ►

Watch out for the whydah *(this page)*: This African bird will lay its eggs in another bird's nest. Host species include the cordonbleu *(opposite)* as well as other seed-eating finches. The advantage of doing so? The nest owners raise the whydah chicks as their own.

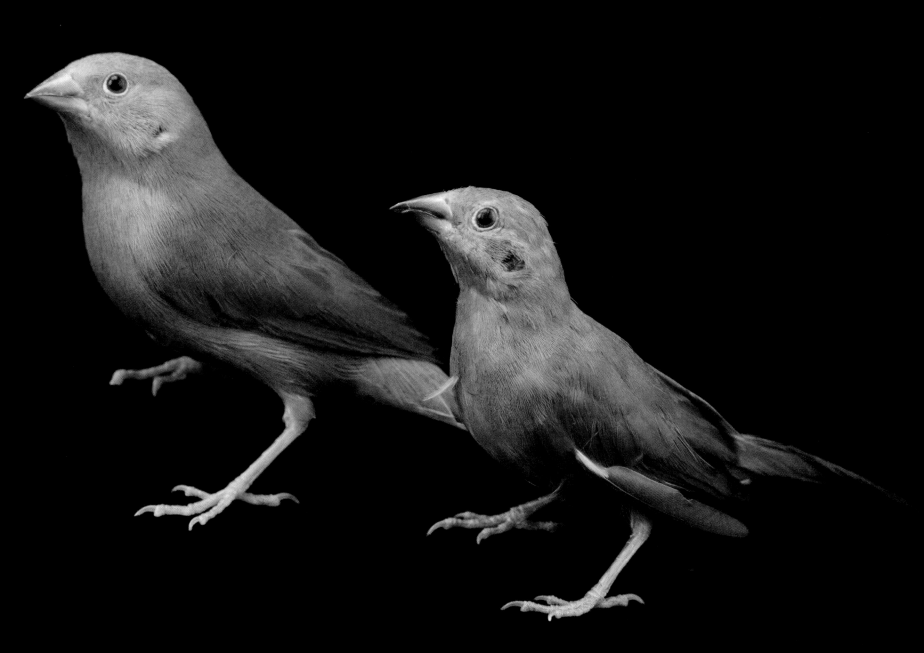

# BEHIND
# THE SCENES

*National Zoological Park, Dominican Republic*

Joel worked at the Dominican Republic's main zoo to photograph a number of species endemic to the Caribbean island of Hispaniola. As always, he relied on friends and conservationists to help arrange his visits and assist with the shoots. "My friend Eladio Fernandez arranged this trip," Joel says of the visit to Santo Domingo, the Dominican capital city. The visit gave Joel the chance to photograph the Hispaniolan hutia and the Hispaniolan solenodon (following pages). The shrewlike solenodon "looks ferocious," says Joel, and in this case appearances are not deceiving: The solenodon can use its lower incisors to deliver venomous saliva. ◆

> " *There are no average days when shooting for the Ark. Imagine going from something venomous, to the weirdest insect you've ever seen, to bottle-feeding a baby jaguar—that's just the first hour.*

Photographing a Ridgway's hawk, Joel uses a soft tent to contain and calm his subject and allow him to keep a close focus.

Joel's son Cole often assists on photo shoots, which does not always mean helping with cameras and lighting. "One of the perks of the job," says Joel. "Sometimes someone will hand you a bottle and tell you to feed a baby jaguar."

Joel and his team, including the black curassow they have just photographed, pause for a portrait at day's end. Most shoots involve plenty of assistance to pull off, mostly from zookeepers and volunteers.

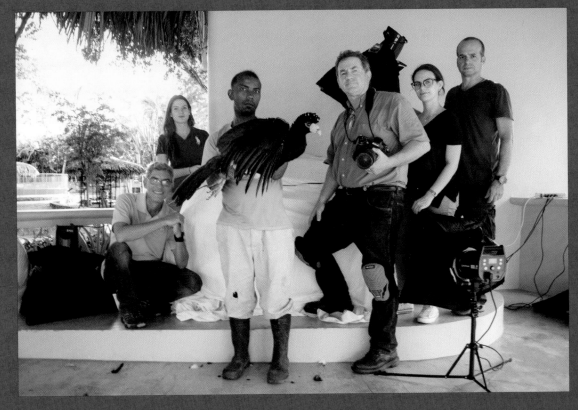

**Hispaniolan hutia**
*(Plagiodontia aedium)* EN

**Hispaniolan solenodon**
*(Solenodon paradoxus)* EN

**Forest red-tailed black cockatoo**
*(Calyptorhynchus banksii naso)* LC

> *All creatures great and small are valuable and magnificent, and all deserve a basic right to exist.*

**Banded leaf-toed gecko** *(Hemidactylus fasciatus)* NE

"This gecko crawled across my face in the middle of the night while I was sleeping in a tent in West Africa. In the dark I panicked, grabbed it, and threw it off. Then I turned on my headlight and saw that the tail was broken off and the gecko had run up to the ceiling. That's when I thought to put them both back together for the picture. The gecko will eventually grow another tail."

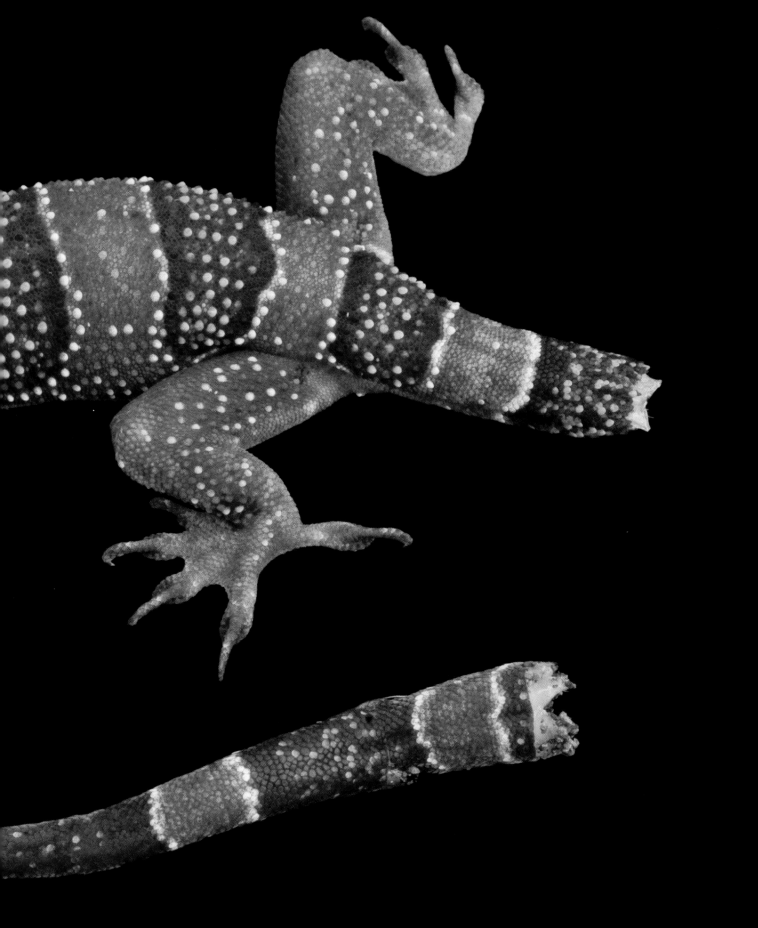

## POISONOUS STRAWBERRIES ◀ ▶

Though all the same species, these morphs show just a
portion of the variety of designs and colors found in the
strawberry poison dart frog, so named because some
of its species do sport a brilliant berry red. Because of
the abundance of morphs, most are named either for
the area they inhabit or for their color pattern. Some
variations are rare or endemic to a small place of origin.

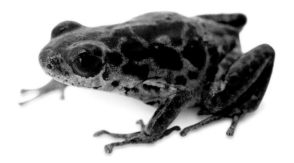
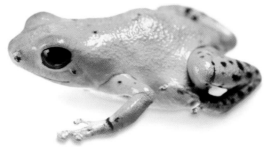
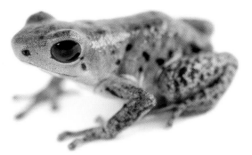

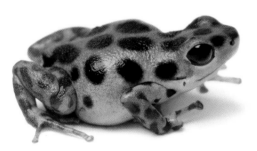
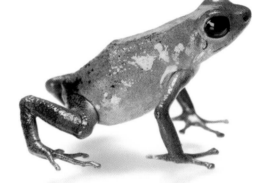
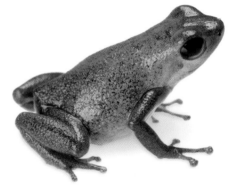

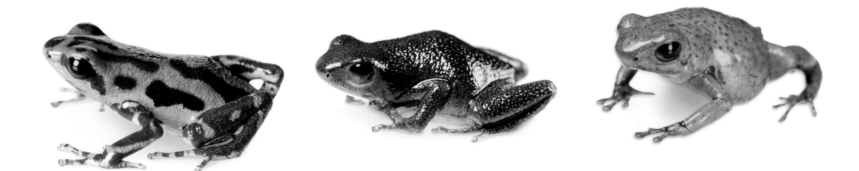

OPPOSITE AND THIS PAGE: **Morphs of the strawberry poison dart frog**
*(Oophaga pumilio)* LC TOP ROW: **Unnamed morphs** MIDDLE ROW: **La Gruta,
Almirante, Bruno morphs** BOTTOM ROW (L-R): **Rio Branco, Blue phase, Bri Bri morphs**

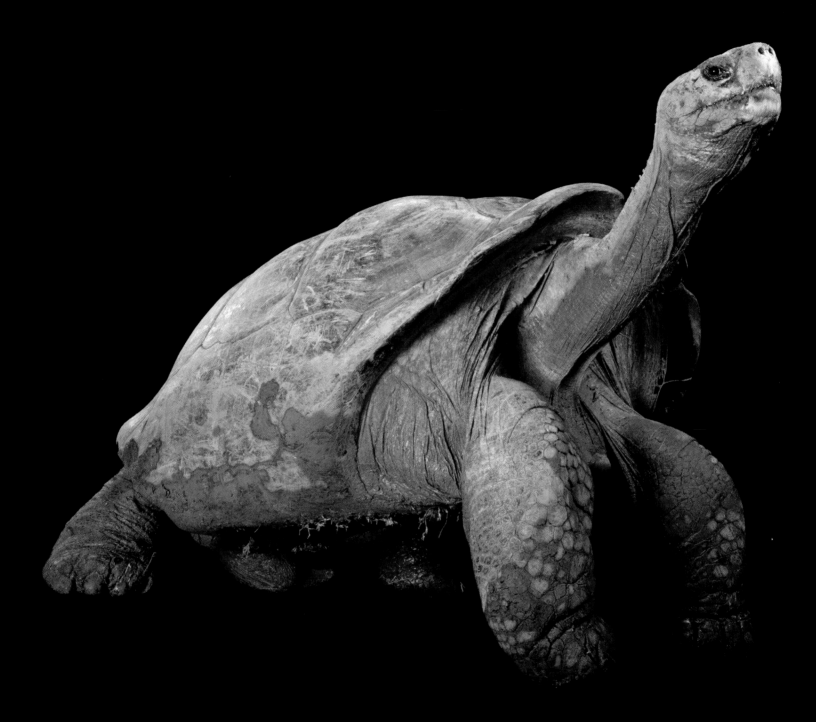

**Volcan Darwin tortoise** *(Chelonoidis vicina)* VU

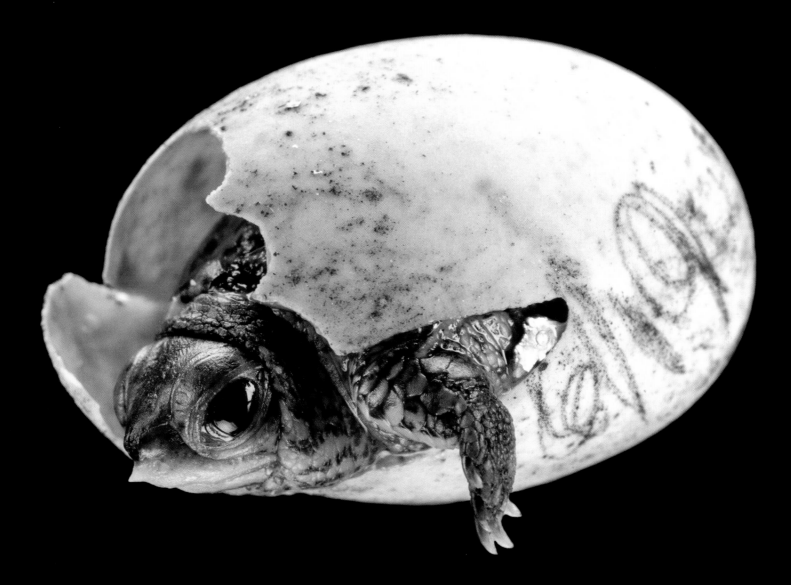

Aquatic box turtle *(Terrapene coahuila)* EN

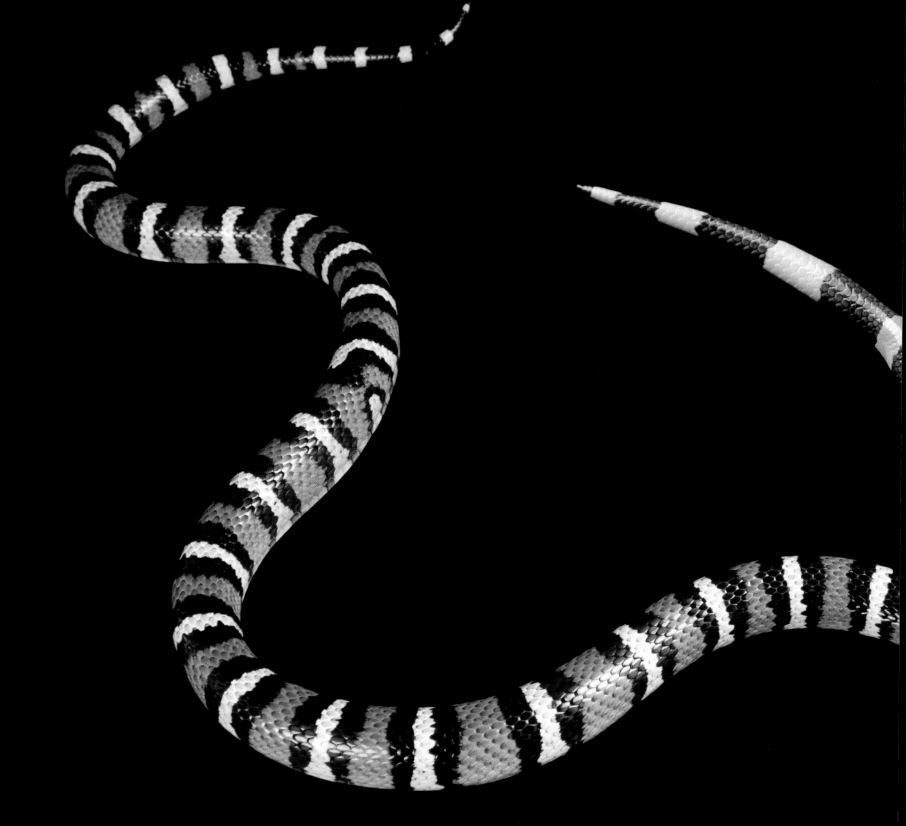

**Utah milk snake** *(Lampropeltis gentilis)* LC

OPPOSITE: **Eastern coral snake** *(Micrurus fulvius)* LC

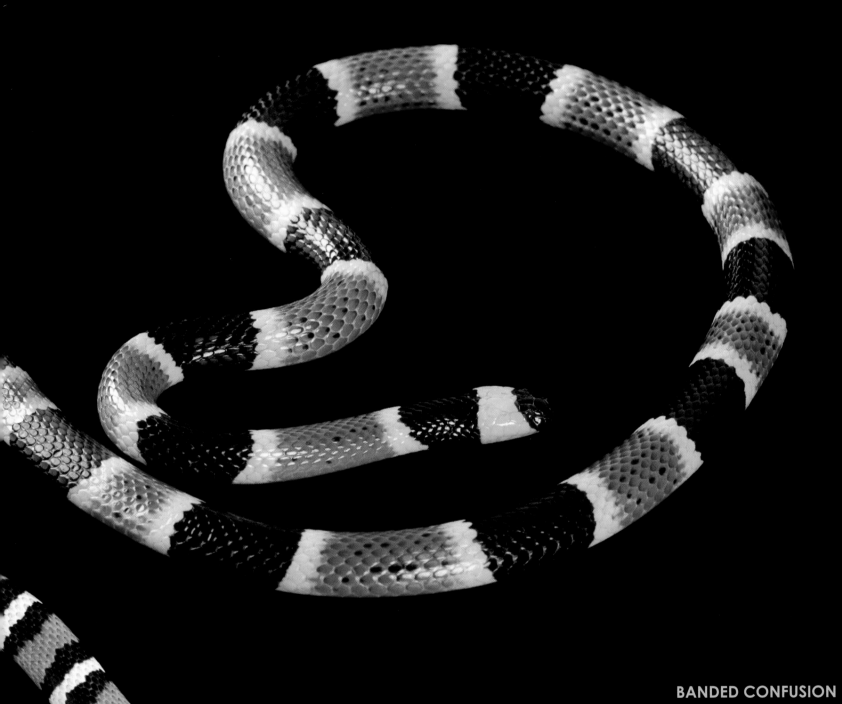

## BANDED CONFUSION ◄ ►

Mimicry in the animal world benefits the species involved, but in this case it can benefit humans wanting to avoid a lethal snakebite. The Utah milk snake *(opposite)* can be found far beyond the state it is named for, but rarely does it share territory with its venomous look-alike, the eastern coral snake *(above)*. Still, it's good to keep the rhyme in mind: Red touching yellow, kill a fellow. Red touching black, friend to Jack.

# HEROES

**Ludwig Siefert**
Uganda Carnivore Program
Western Uganda

In the 1990s the lions in Tanzania were dying, and wildlife veterinarian Ludwig Siefert began researching the threats facing them in neighboring Uganda. By monitoring lion prides, he and his team found that lions were being poisoned whenever the big cats threatened livestock. That was when the Uganda Large Predator Project was born.

As head of the project (now the Uganda Carnivore Program), Siefert mainly works in Queen Elizabeth National Park in western Uganda. Some 100,000 people live in and around the park's borders, and Siefert is dedicated to finding ways to reduce the conflicts between humans and the lions, leopards, and hyenas living near them. By holding community meetings to get feedback and make connections, the project found that "over 80 percent of those surveyed responded they would like to be involved in conservation," he says. Visitors to the park also learn about conservation efforts by taking wildlife tours. "They come away with a stronger connection to the individual lions and a better understanding of what it takes to conserve them," Siefert says.

The program's community-based projects might include helping to build stronger village fences or encouraging local school groups to go out on bird counts and then add their findings to international databases. Whether he's paying for radio collars and gas for vehicles out of his own pocket or starting a program that turns former adversaries into allies, Siefert is committed to Uganda's carnivores, holding promise for the charismatic mammals living close to human dwellings. ◆

" *The war against innocent and deliberate destruction could be won if many more would not just remain bystanders and onlookers.*

—Ludwig Siefert

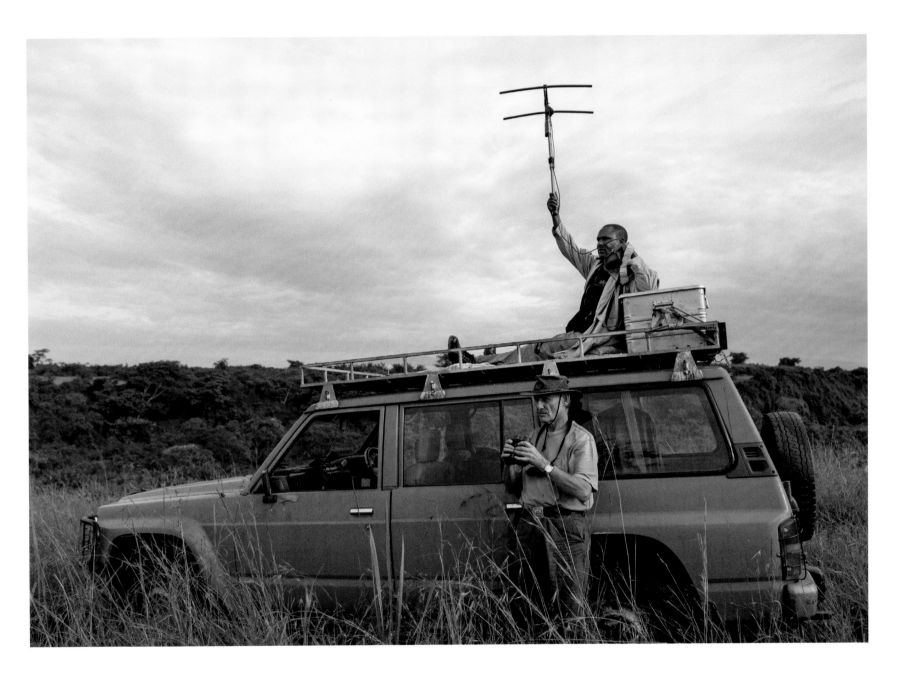

OPPOSITE: **African lion** *(Panthera leo)* VU

Ludwig Siefert and senior research assistant James Kalyewa use a wide range of monitoring techniques to track the movement of large predators in Uganda.

## SIBLING RIVALRY ◄ ►

Here, grackle siblings squawk off as Joel photographs them. In the natural world, sibling rivalry can be deadly. "Once a stronger sibling gains weight and strength, it can outcompete its nest mate for food, and sometimes even push it out of the nest to its death," says Joel.

Juvenile grackles *(Quiscalus quiscula)* LC

# CHAPTER FOUR ▲ ▼

# Curiosities

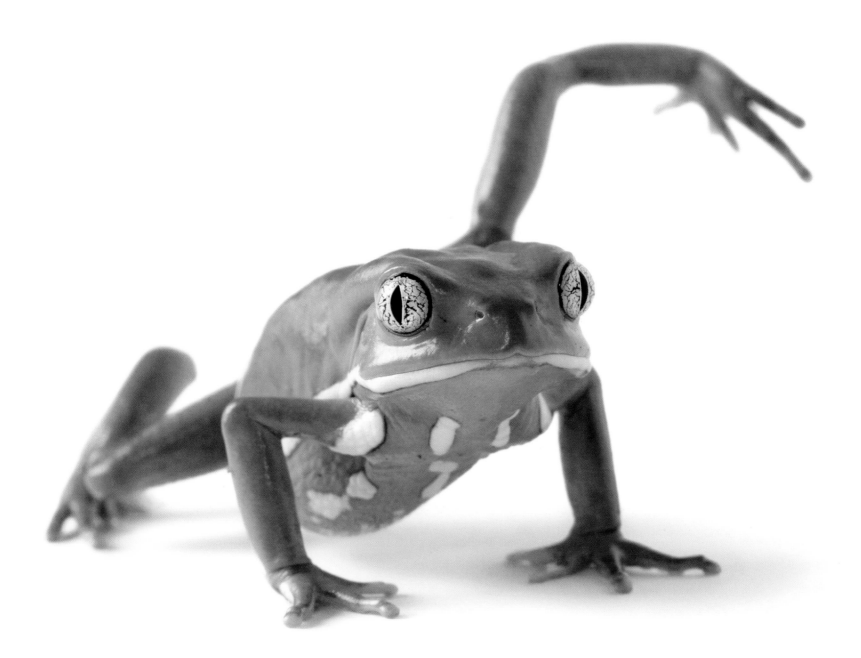

Some things just don't fit the mold—and we love them for it. "Outlier," "renegade," "individual," "nonconformist": All these words convey uniqueness, oddity, and devil-may-care finesse. There needs to be a place in the world for those who make it on their own. Often they find each other and partner up, but they never lose that pride in being inimitable, one of a kind.

In this chapter, we reserve the right to toss in anything left over, any animals that didn't pair up as mirrors or partners or opposites, and yet were so endearing and important we wouldn't leave them out of the Ark and we couldn't leave them out of the book.

There are the species that defy category: the echidna, or spiny anteater, and the platypus—monotremes, mammals that lay eggs, whose genetic readouts give us clues to animal evolution reaching back to dinosaur days.

There are the birds that push boundaries in all directions. The North American whooping crane, as tall as we are, curves its long neck down and doubles over in self-inspection. The South American horned screamer, which is most closely related to ducks and swans, squawks, flaps its wings, waggles its horn, fights with fierce leg spurs—and raises its young in a floating nest made of marsh plants woven together.

And there are species whose shapes and habits are so far from ours that we marvel at even calling them animals: resplendent starfish, spiny porcupinefish, prickly urchins—so strange it makes the tiny mud crab creeping over it seem like one of us.

The National Geographic Photo Ark says it loud and clear: Just look at the breadth, diversity, variability, and magic of the many forms of life that inhabit this planet. How marvelous and precious, even the least, even the weirdest of them. How worthy of our attention—and our care. ◆

OPPOSITE: **Waxy monkey frog** *(Phyllomedusa sauvagii)* LC
"This waxy monkey frog expresses dominance by lifting up one leg.
Didn't scare me, but it might work on other frogs."

PREVIOUS PAGE: **Fruit bat** (*Lissonycteris sp.*)**, Secretary bird** *(Sagittarius serpentarius)* VU

## PUSHING THE BOUNDARIES ▲ ▼

The echidna uses its tubular beak to probe the ground
and then sticks out its long tongue to catch termites,
ants, earthworms, and other prey. The platypus has a
bill like a duck, and the males have poisonous spurs on
their rear legs. Both these animals are monotremes—
the only egg-laying mammal species in the world.
Genetic analysis shows that the two animals diverged
from one another millions of years ago.

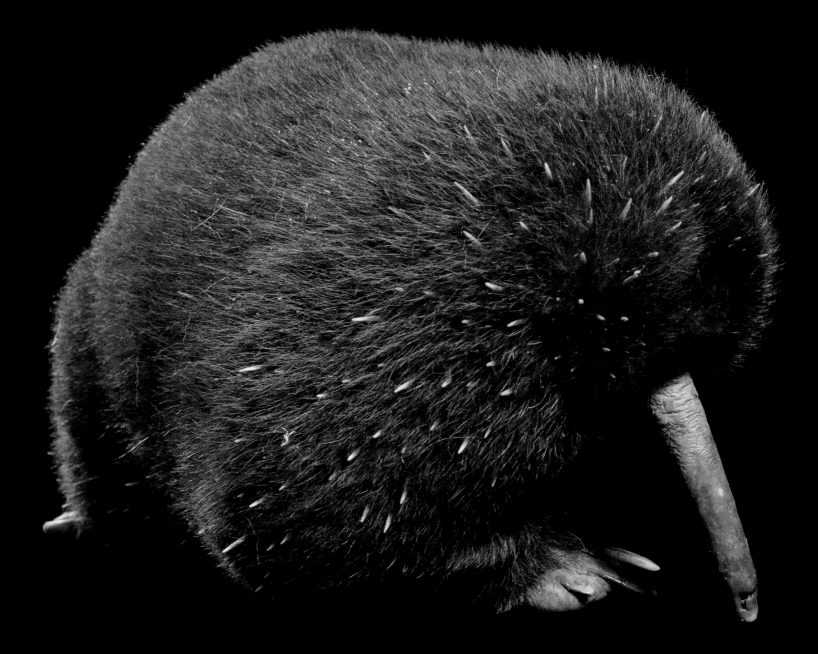

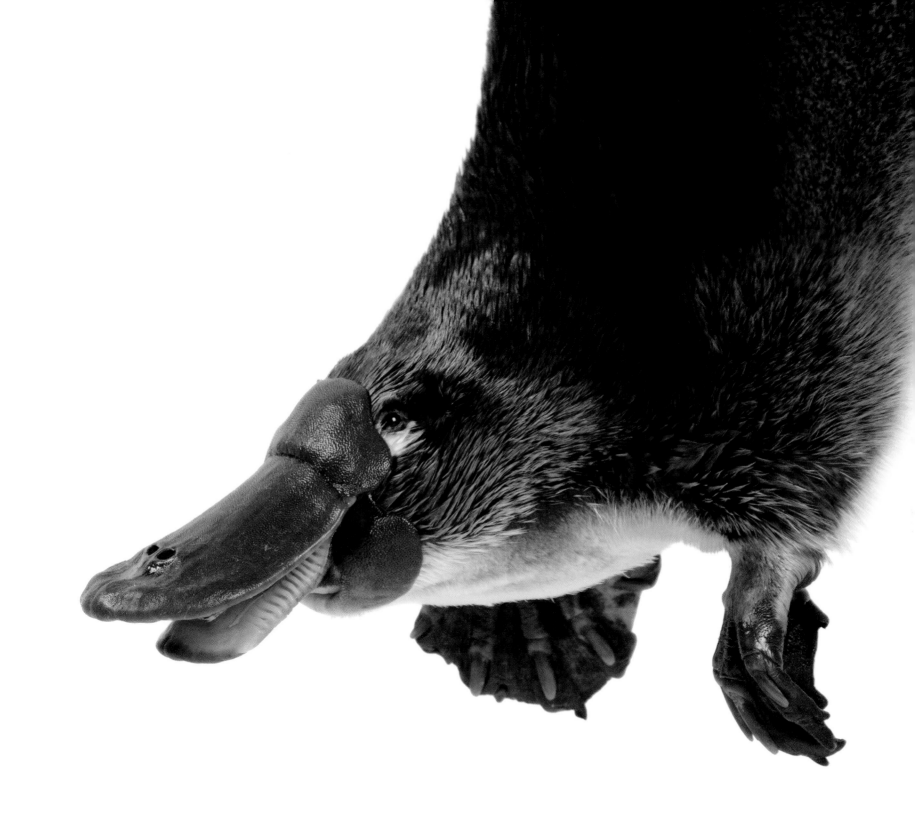

OPPOSITE: **Eastern long-beaked echidna** *(Zaglossus bartoni)* CR

**Platypus** *(Ornithorhynchus anatinus)* NT

**Domestic mutation of a red celestial eye goldfish** *(Carassius auratus)* LC

"Domestic goldfish have been bred by the Chinese over hundreds, if not thousands, of years. Today they have eyes that look up, bubbles around them, short bodies, enormous tails—you name it. All come originally from a rather bland-looking wild carp."

**Spectral tarsier** *(Tarsius tarsier)* VU

"This creature has huge eyes for moving about at night."

> **"** *The horn feels like a plastic bristle on a broom. It's made from cartilage.*

**Horned screamer** *(Anhima cornuta)* LC

"This bird was hand-raised and as tame as a pet chicken. My host picked it up, put it in my tent, and then put it back outside our cabin door, where it stayed, looking at us."

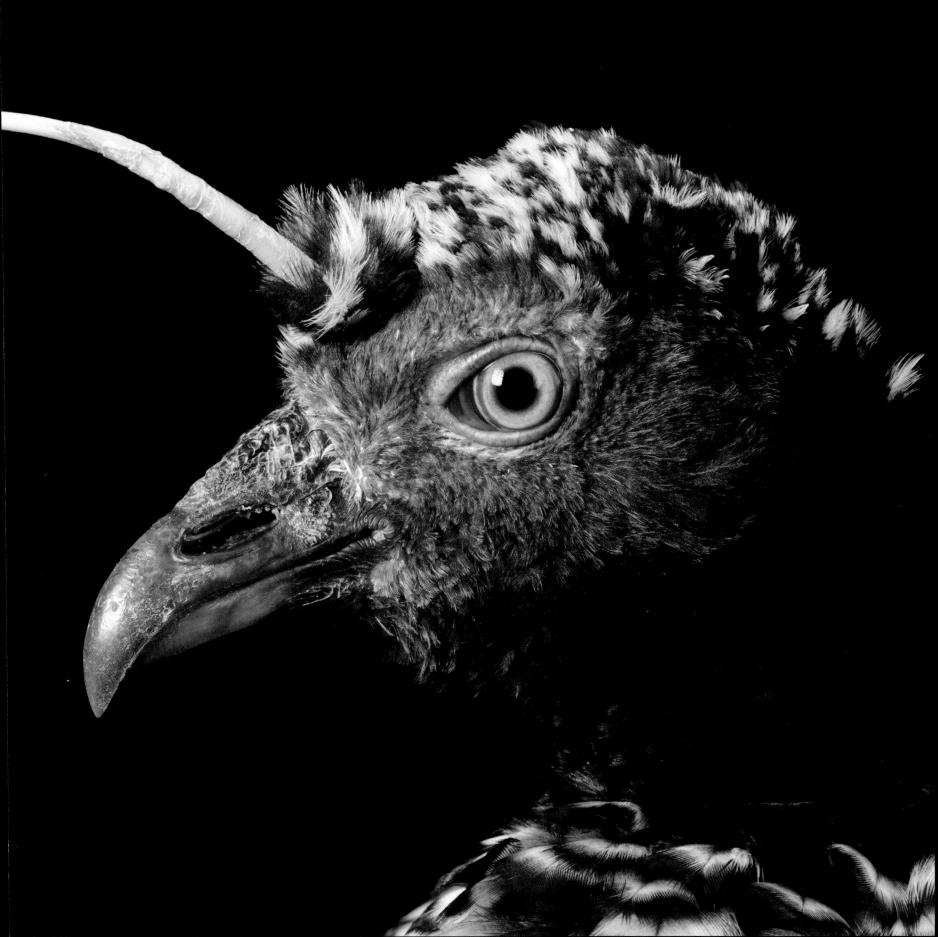

**African moon moth** *(Argema mimosae)* NE

"Moths sense chemical signals from other moths with
their antennae. It's one way they find each other to mate."

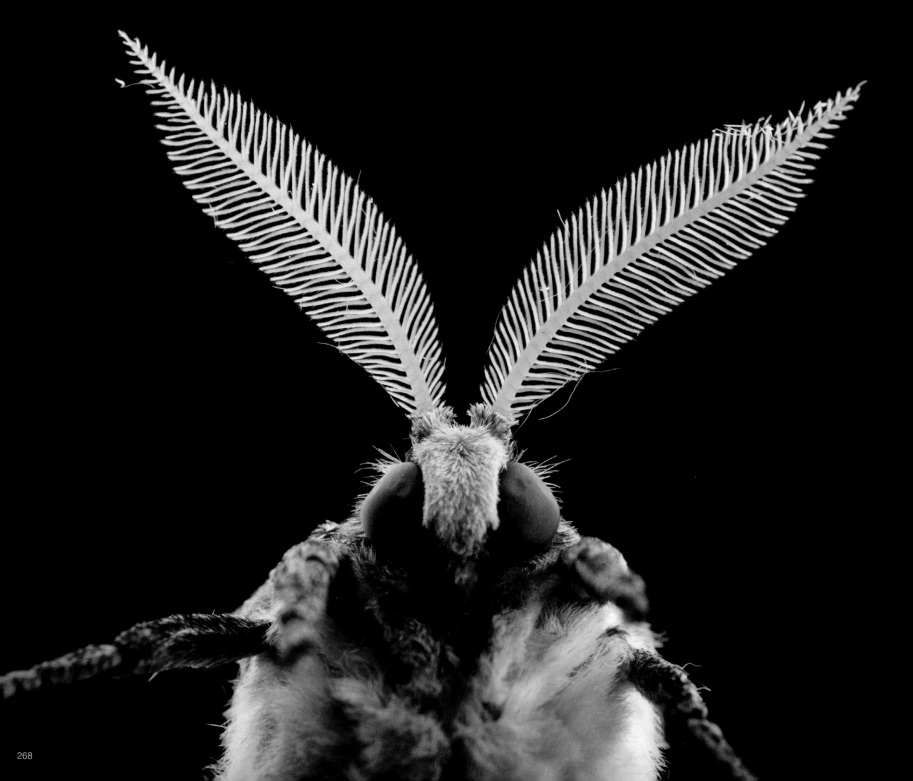

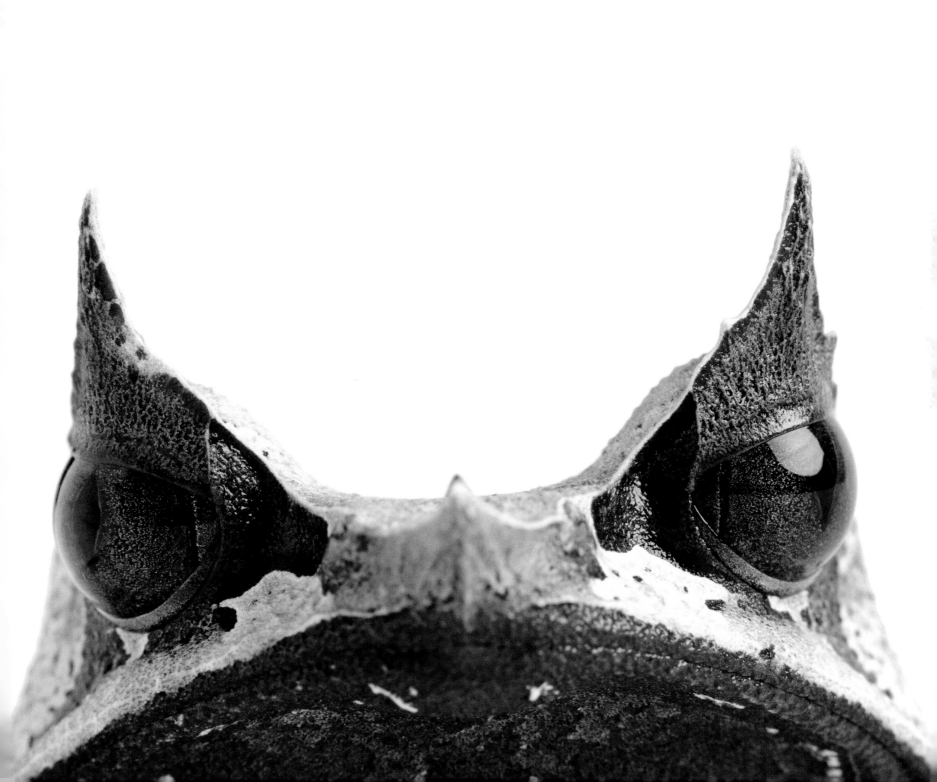

"The curly crest feels like plastic shavings to the touch."

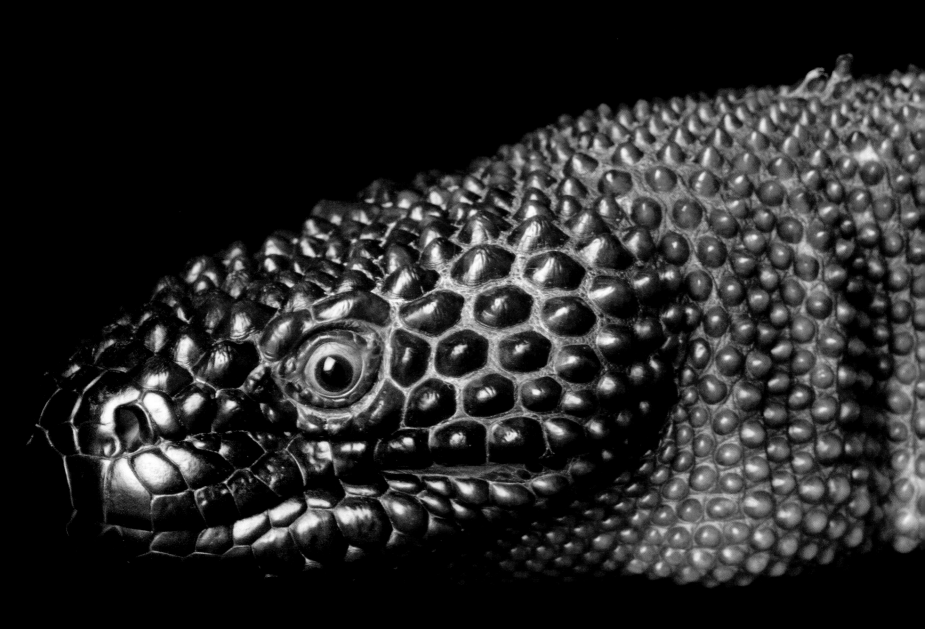

Rio Fuerte beaded lizard
*(Heloderma horridum exasperatum)* LC

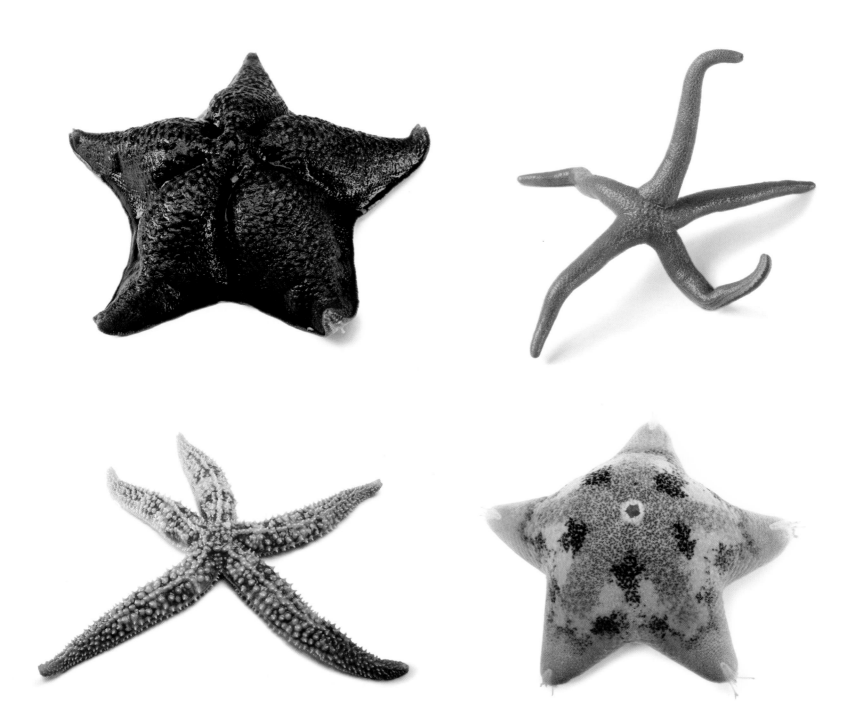

TOP ROW (L-R): **Bat star** *(Patiria miniata)* NE, **Pacific blood star** *(Henricia leviuscula)* NE BOTTOM ROW (L-R): **Rainbow sea star** *(Orthasterias koehleri)* NE, **Cushion starfish** *(Pteraster tesselatus)* NE

TOP ROW (L-R): **Purple sea star** *(Pisaster ochraceus)* NE, **Leather star** *(Dermasterias imbricata)* NE BOTTOM ROW (L-R): **Vermillion sea star** *(Mediaster aequalis)* NE, **Green and gold brittle star** *(Ophiarachna incrassata)* NE

Halloween pennant dragonfly
*(Celithemis eponina)* NE

# HEROES

**Tilo Nadler**

Endangered Primate Rescue Center
Cuc Phuong National Park, Vietnam

What Germany native Tilo Nadler saw on a trip to Vietnam more than 20 years ago changed his life forever. Many species of wildlife were being carried across nearby borders for the exotic pet trade. When government officials were able to seize the animals—including even the critically endangered white-cheeked gibbon—they often had no place to put them. Nadler responded by founding the Endangered Primate Rescue Center (EPRC), the first place in Indochina to care for these maltreated animals, confiscated from the black market trade. The rescued primates not only survive but thrive, eating fresh foods harvested in the surrounding forests.

Located on the edge of Cuc Phuong National Park, EPRC is now home to some 180 individuals representing 15 primate species, including 6 found nowhere else in captivity. Although there are currently no safe places where they could be released back into the wild, that doesn't diminish the spirit of Nadler, his family, and his staff. They work tirelessly to improve protection, eradicate poaching, and return their charges eventually back to the wild—or so they hope.

"The illegal hunting of wildlife here is unbelievable," Nadler says. He feels the urgency of his work. "The biggest problem is that there is no time for education on environmental issues. It takes 20 years to see the effects of an education program, and these species don't have even 10 years left." ◆

*It was not my work, not my profession, but what else could I do?*

—Tilo Nadler

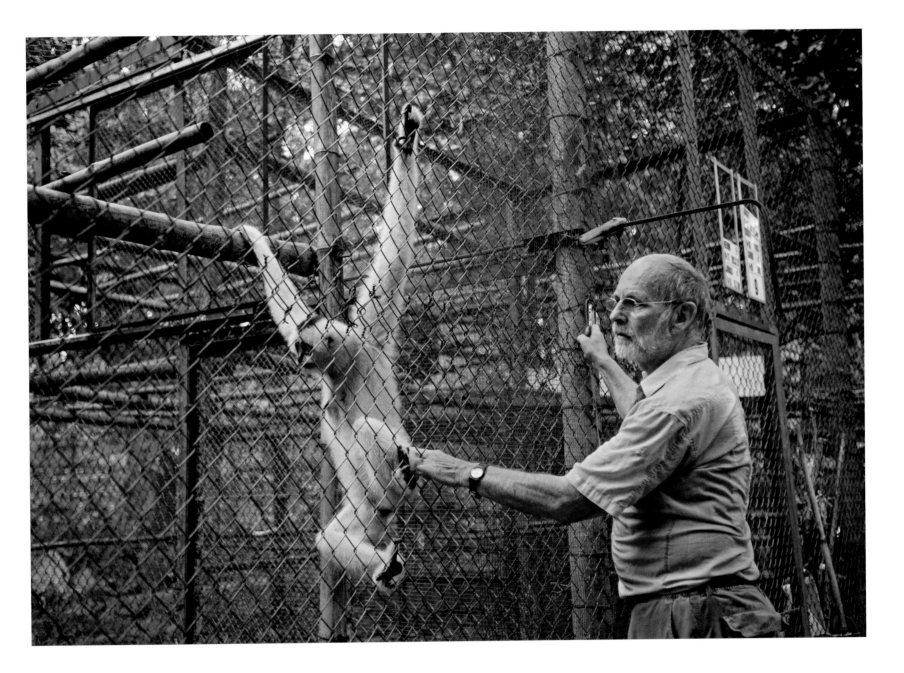

OPPOSITE: **Gray-shanked douc langur** *(Pygathrix cinerea)* CR

Tilo Nadler visits one of the 15 primate species—a rare yellow-cheeked gibbon *(Nomascus gabriellae)*—given shelter at the Endangered Primate Rescue Center in Cuc Phuong National Park, Vietnam.

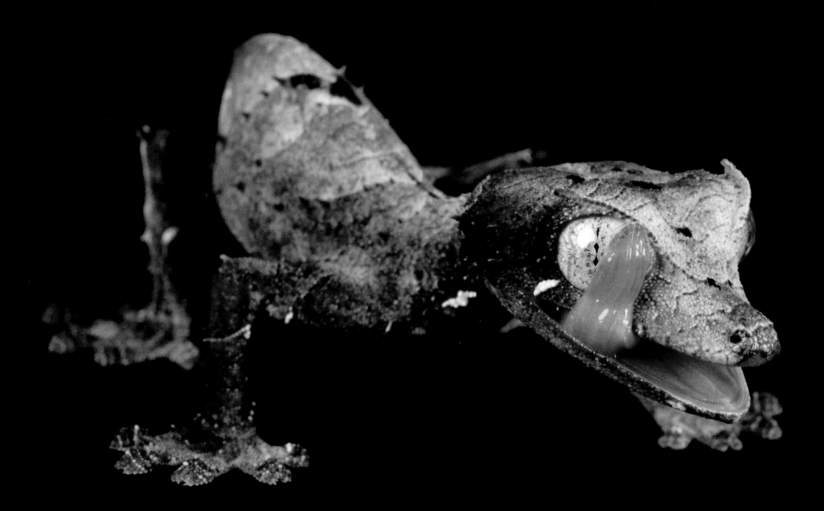

Satanic leaf-tailed gecko *(Uroplatus phantasticus)* LC

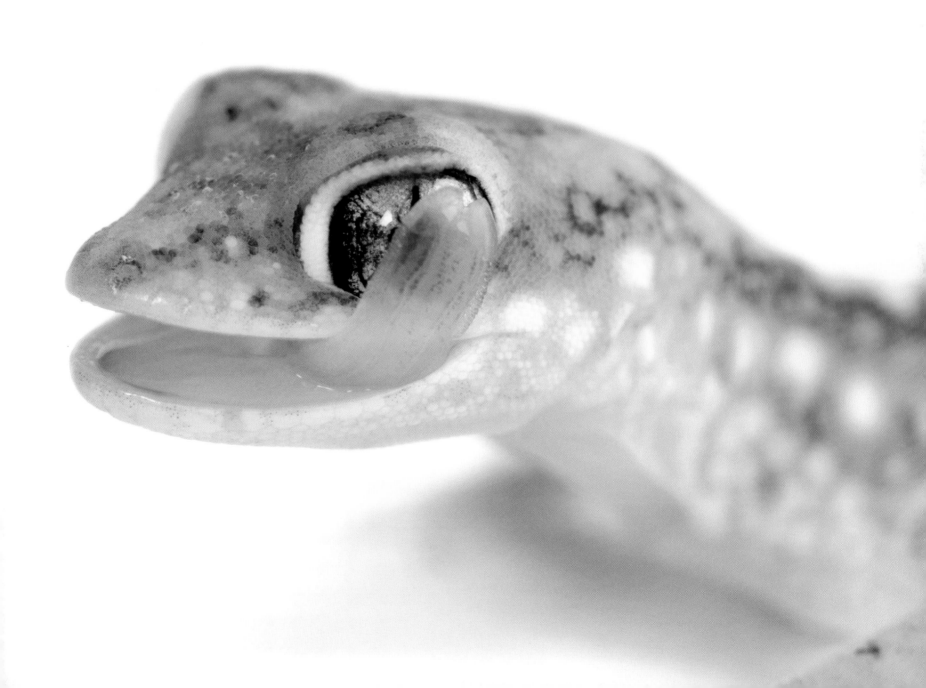

**Beaded gecko** *(Lucasium damaeum)* NE

"Geckos have no eyelids, and they lick their eyeballs just to clean them on a regular basis."

## HIDING AMONG THE SPOTS ▲ ▼

The light splotches on this baby tapir help it blend into the dark forest floor by mimicking the little beams of sunlight that reach the understory. This camouflage helps keep it safe while its mother is out foraging. The river ray's dappled coloration may also simulate shimmering light, making it harder for predators to see it from above.

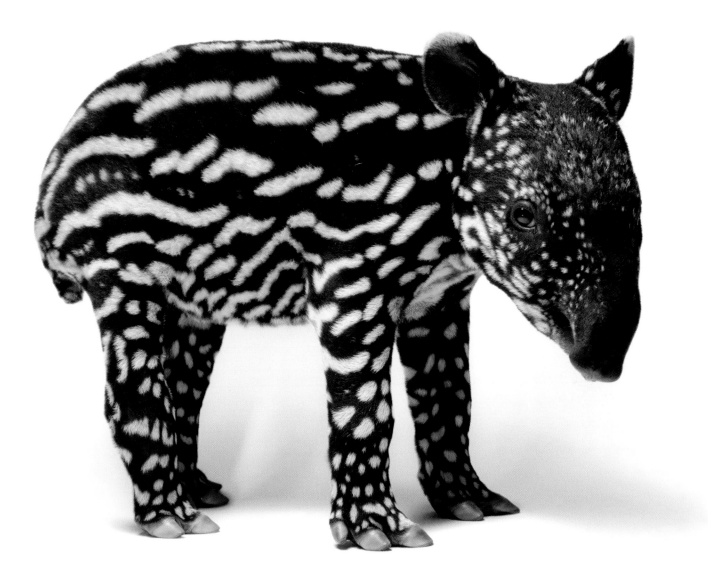

**Malay tapir** *(Tapirus indicus)* EN

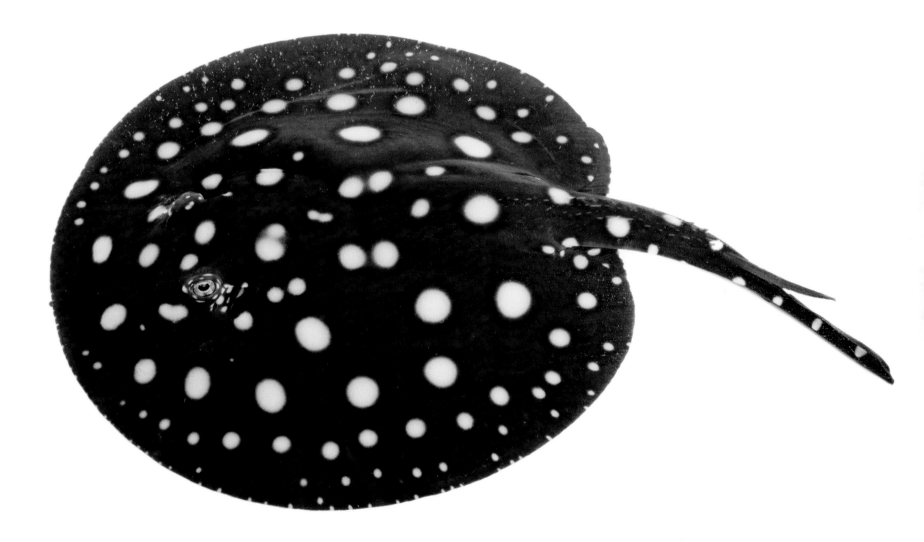

Rio Xingu River stingray *(Potamotrygon leopoldi)* DD

> " *Polluted waters and development along the riverbanks where they lay eggs threaten gharials.*

**Juvenile Indian gharials** *(Gavialis gangeticus)* CR

"This crocodilian is highly endangered, now that India's water is so polluted. The riverbanks where it lays its eggs are often trampled or developed by humans."

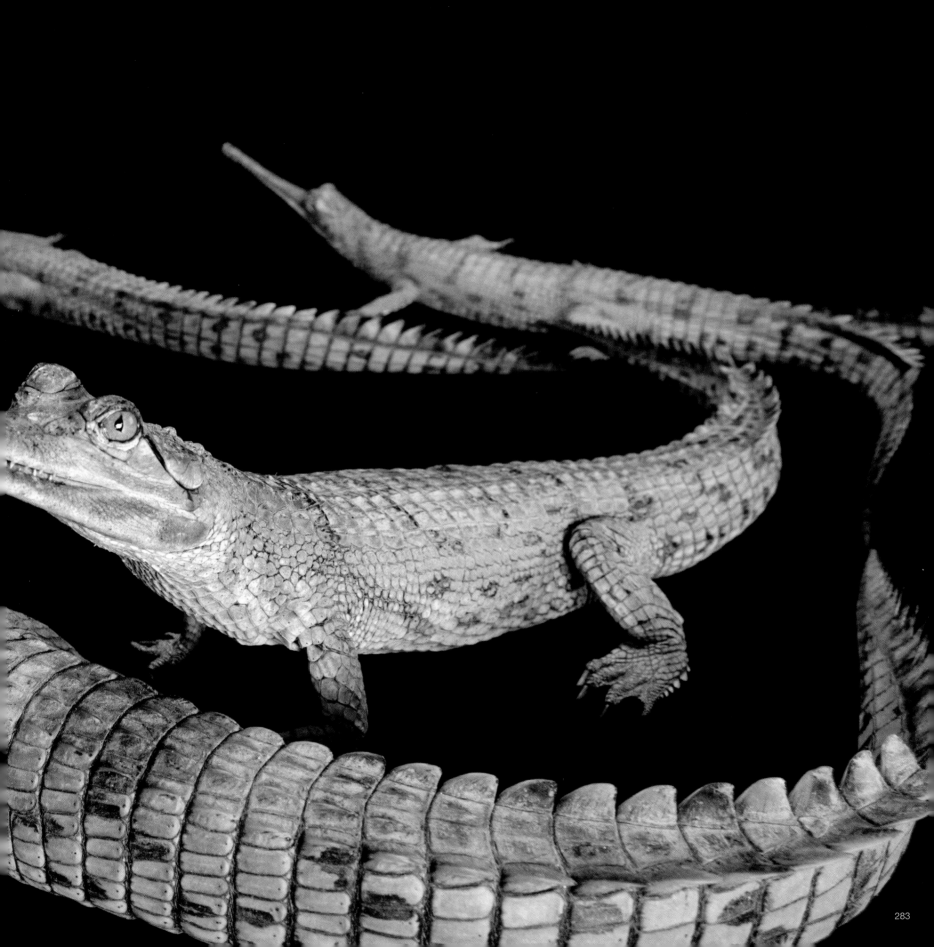

Red-headed uakari (*Cacajao calvus rubicundus*) VU

"A New World monkey, this fellow is one of the last males in captivity in this hemisphere."

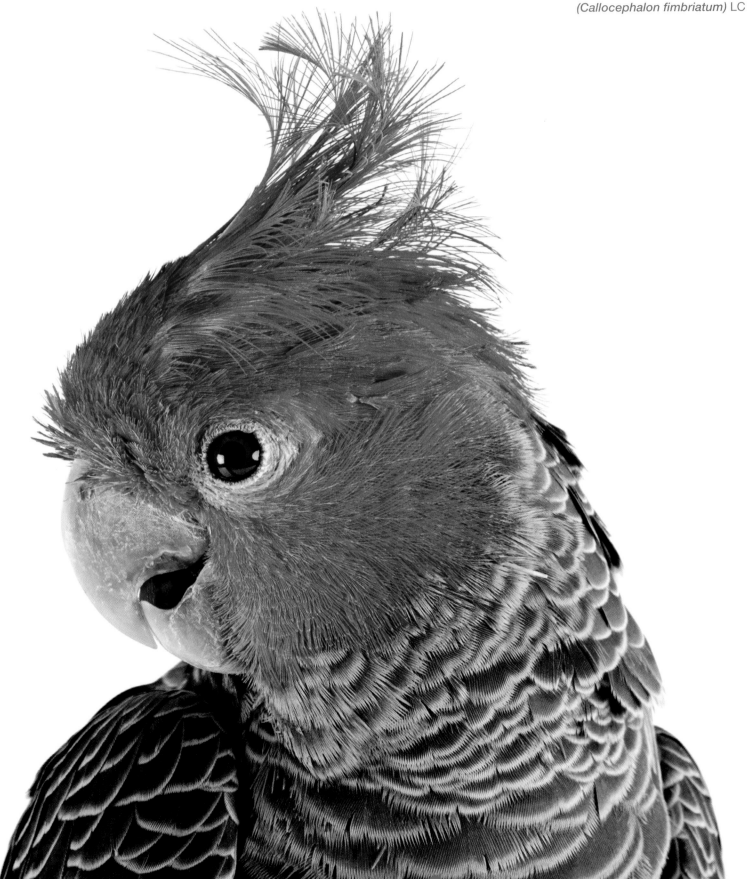

## DISTANT COUSINS ▲ ▼

Today you see a furry creature with a little button nose and whiskers and a massive animal with tusks and a distinctive trunk. But trace these two species back several million years along evolutionary lines, and they share a common ancestor—making the bush hyrax this African elephant's closest living relative.

**Whooping crane** *(Grus americana)* EN

"The whooping crane was saved from extinction thanks to habitat protection and captive breeding. This animal got down to fewer than two dozen individuals, and numbers in the hundreds today."

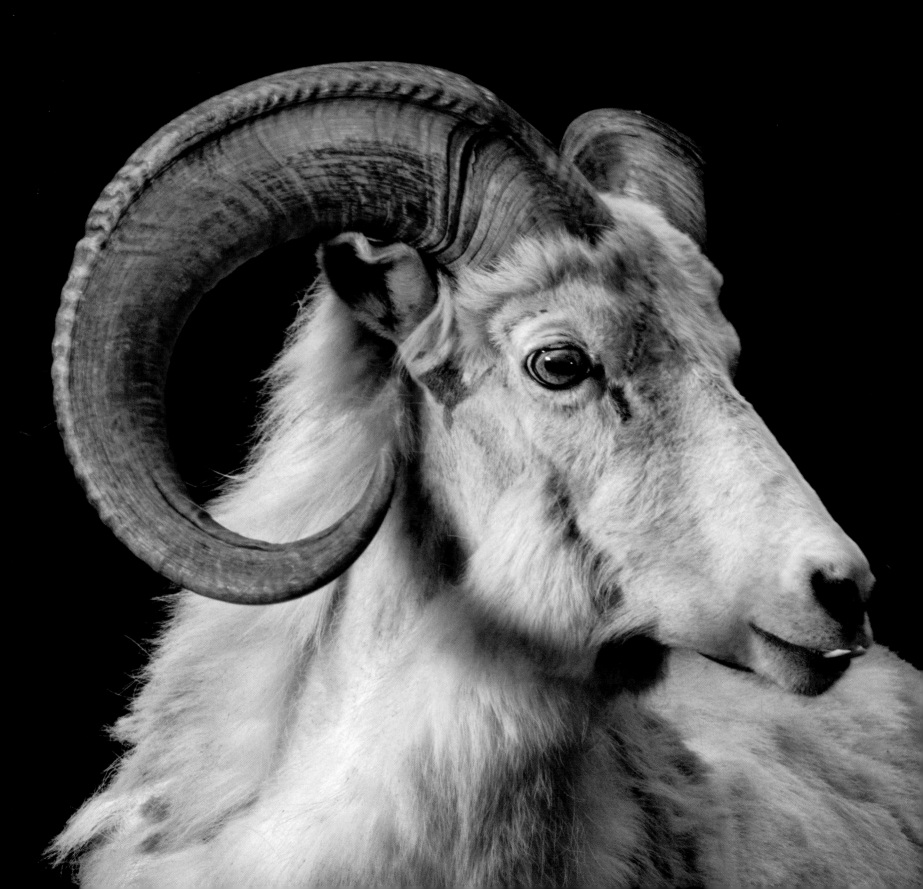

Dall's sheep *(Ovis dalli)* LC

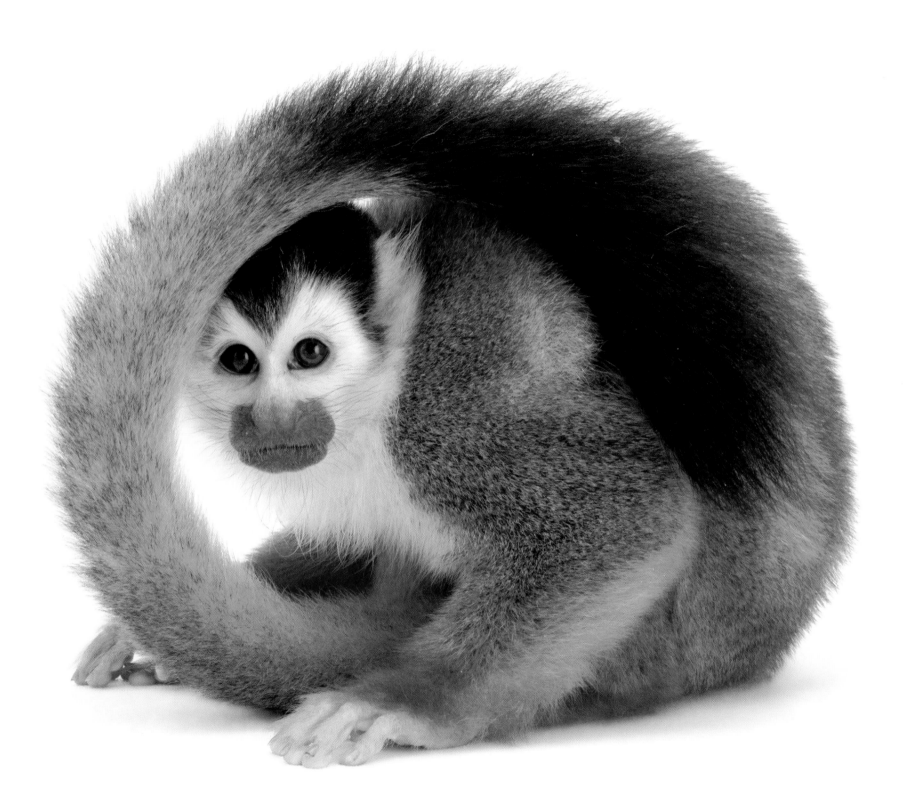

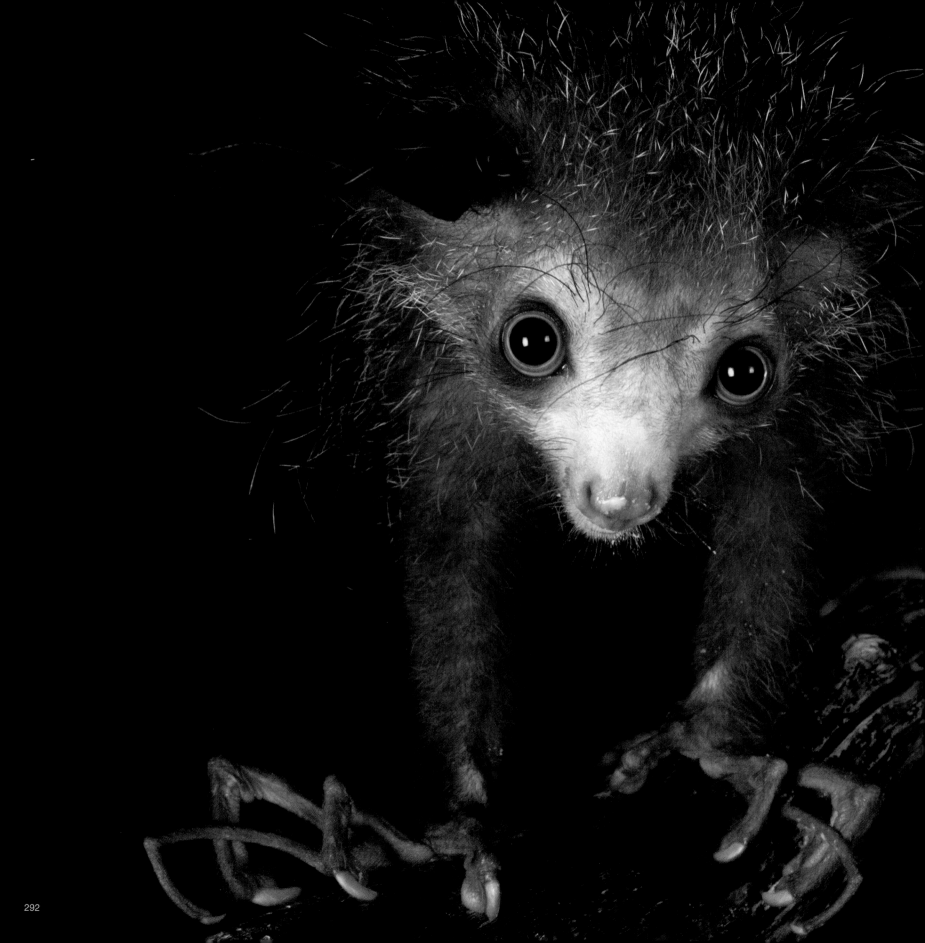

> *"How do we treat the least among us? That is the true measure of any society.*

**Aye-ayes** *(Daubentonia madagascariensis)* EN

"Nocturnal lemurs from Madagascar, these animals posed a special challenge. So as not to harm their eyes, we used infrared gels over the flashes, so they emitted light that was visible only to the camera. We were working in nearly total darkness, at least to humans. I'm still amazed we got anything in focus."

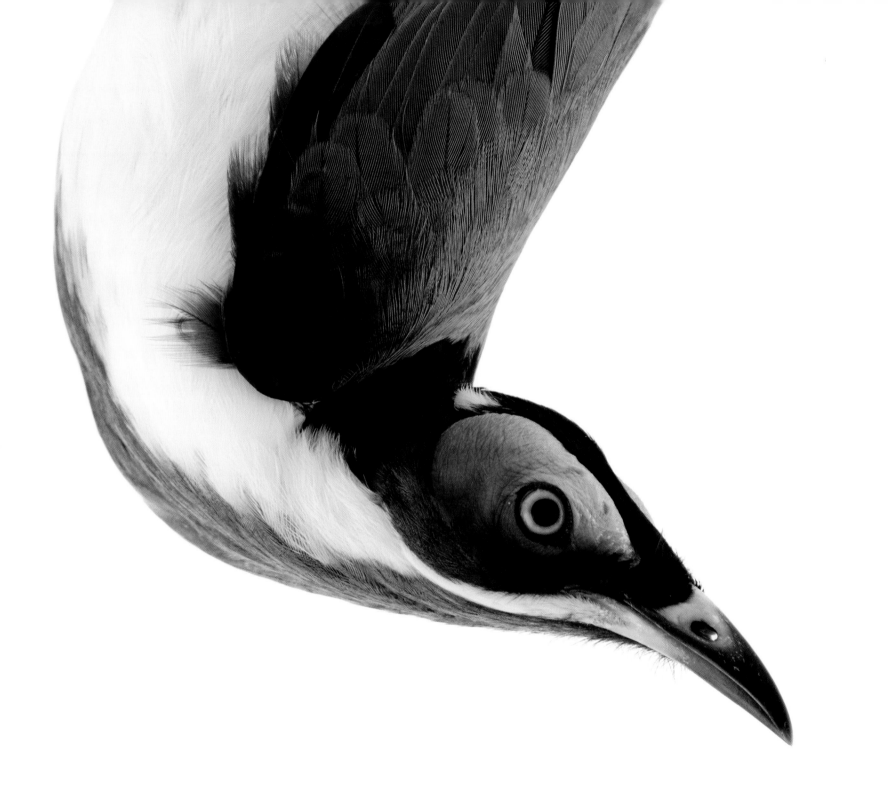

**Blue-faced honeyeater**
*(Entomyzon cyanotis griseigularis)* LC

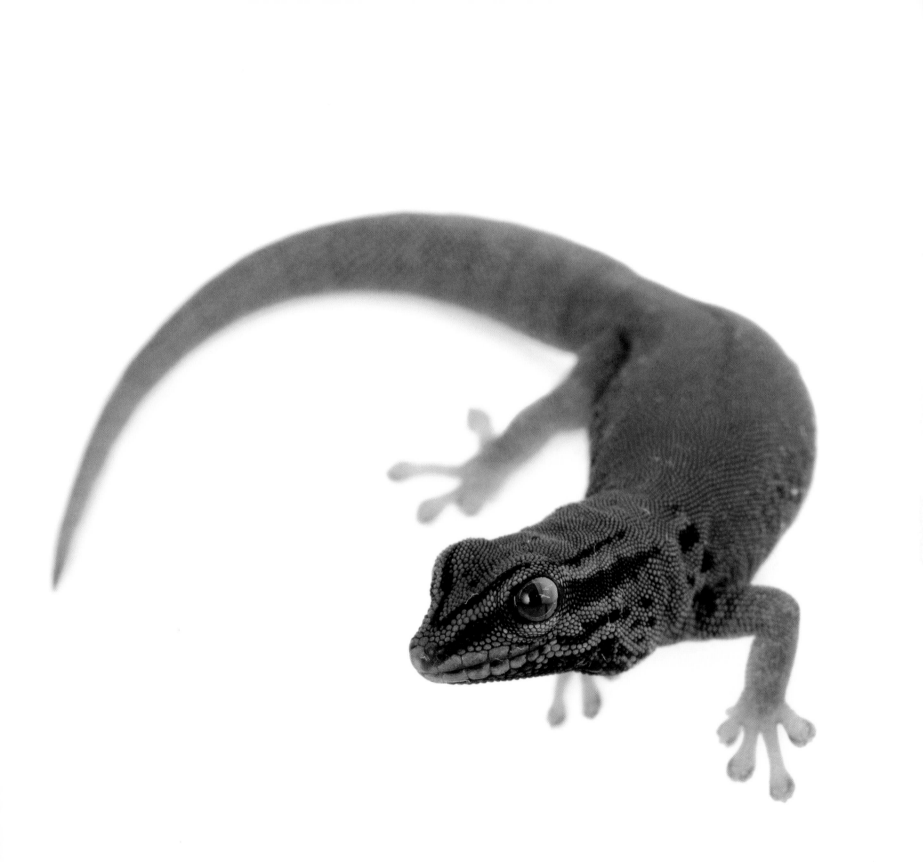

Turquoise dwarf gecko
*(Lygodactylus williamsi)* CR

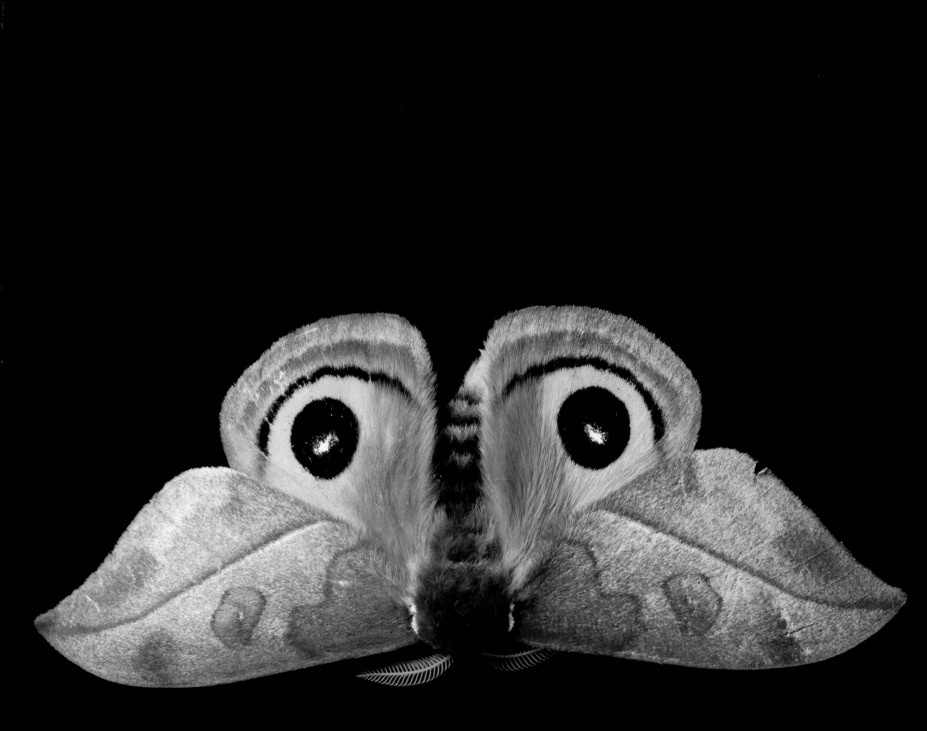

**Eyed Saturnian moth** (*Automeris* sp.)

OPPOSITE: **Wolf spider** *(Hogna osceola)* NE

**Giant Pacific octopus**
*(Enteroctopus dofleini)* NE

"One of the smartest animals to live
in the sea besides marine mammals.
Certainly the most intelligent
invertebrate we know of."

# BEHIND
# THE SCENES

## Singapore Zoo

**L**ocated near the Equator, the Singapore Zoo is hot and steamy and prone to thunderstorms. The zoo often receives lightning strikes, as Joel experienced firsthand when a bolt hit a metal building while he was standing close by. "Very exciting," he says. "We heard it sizzle for a split second before the thunder." Lightning aside, a well-prepared zoo staff assisted Joel in photographing some 150 species over 12 days—animals ranging from aquatic invertebrates to Asian elephants. The Photo Ark crossed the 6,000-species mark here, with the photo of a male proboscis monkey. Wildlife Reserves Singapore, which operates the Singapore Zoo and three other parks—Jurong Bird Park, Night Safari, and River Safari—works to save animals through wildlife protection and by breeding critically endangered species. ◆

*"Increasingly, zoos are serving as conservation centers. They're the real arks now, and the only things that stand between many rare species and extinction.*

Joel feeds Asian elephants in their huge outdoor pen, which includes a pond to play in.

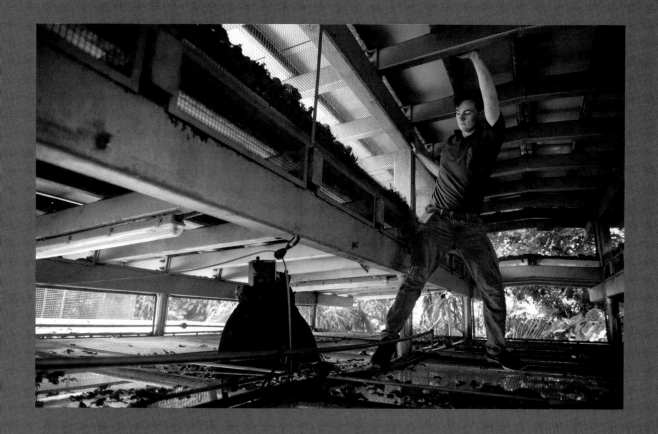

Joel's son Co
session from
where he rigg
dials the inten
down, depend
he stays there

A Malay civet *(Viverra tangalunga)* makes itself at home on a white PVC board.

Glass catfish *(Kryptopterus vitreolus)* NE

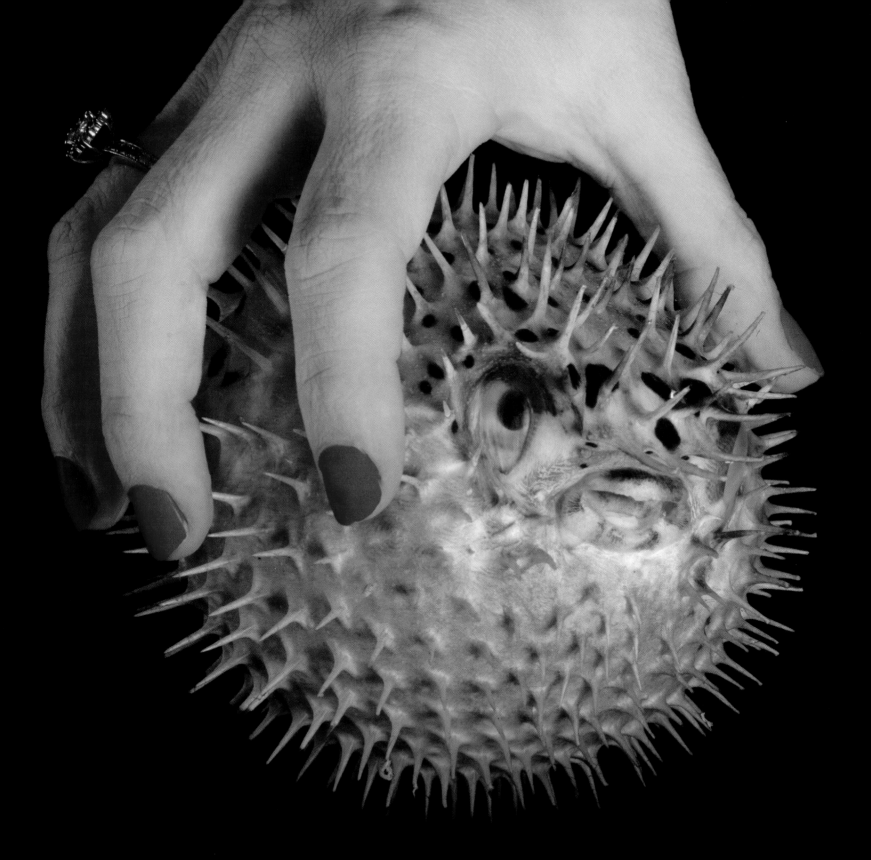

Long-spine porcupinefish *(Diodon holocanthus)* LC

Black-fingered mud crab *(Panopeus herbstii)* NE

Slate pencil urchin *(Eucidaris tribuloides)* NE

Asiatic lion
*(Panthera leo persica)* EN

# GOING WHITE ▲ ▼

ALBINO ANIMALS, TOP ROW (L-R): **Nelson's milk snake** *(Lampropeltis polyzona)* NE, **Eastern gray kangaroo** *(Macropus giganteus)* LC
BOTTOM ROW (L-R): **Green frog** *(Lithobates clamitans)* LC, **Monocled cobra** *(Naja kaouthia)* LC OPPOSITE: **Leucistic red-tailed hawk, lacking in pigment but not albino** *(Buteo jamaicensis)* LC

"Millions of years of evolution are on display for all to see. Now all we have to do is pay attention.

**Golden snub-nosed monkeys**
*(Rhinopithecus roxellana)* EN

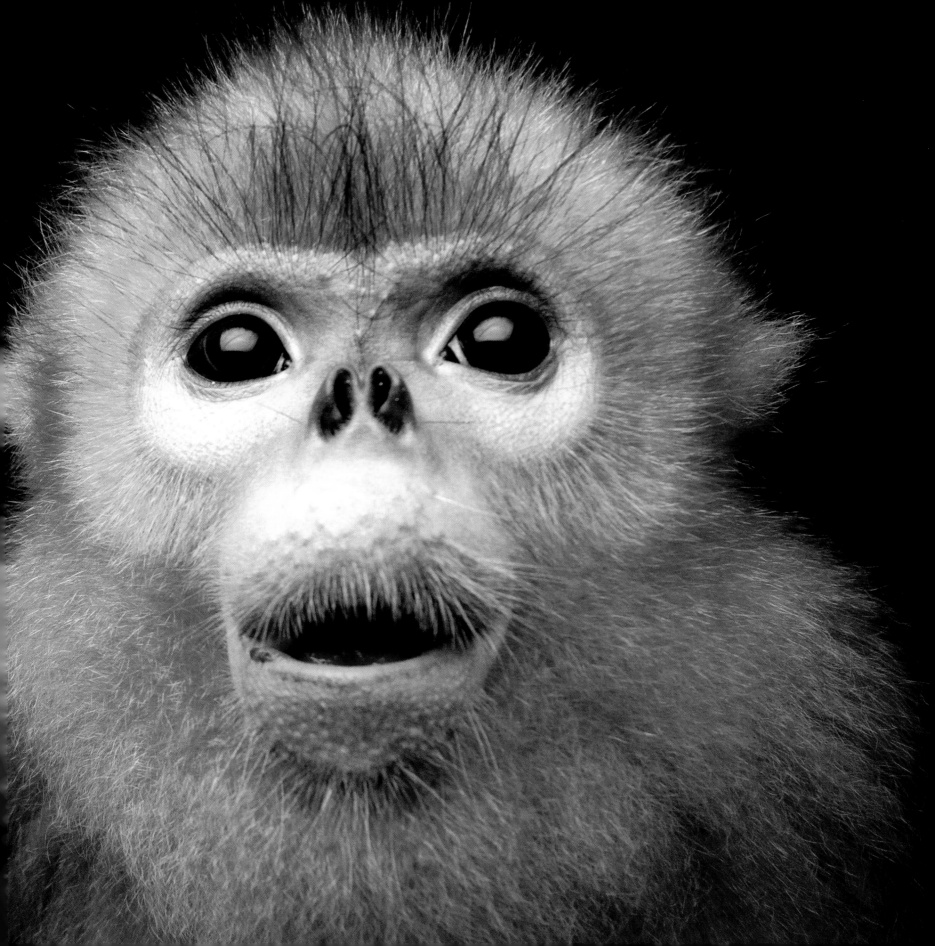

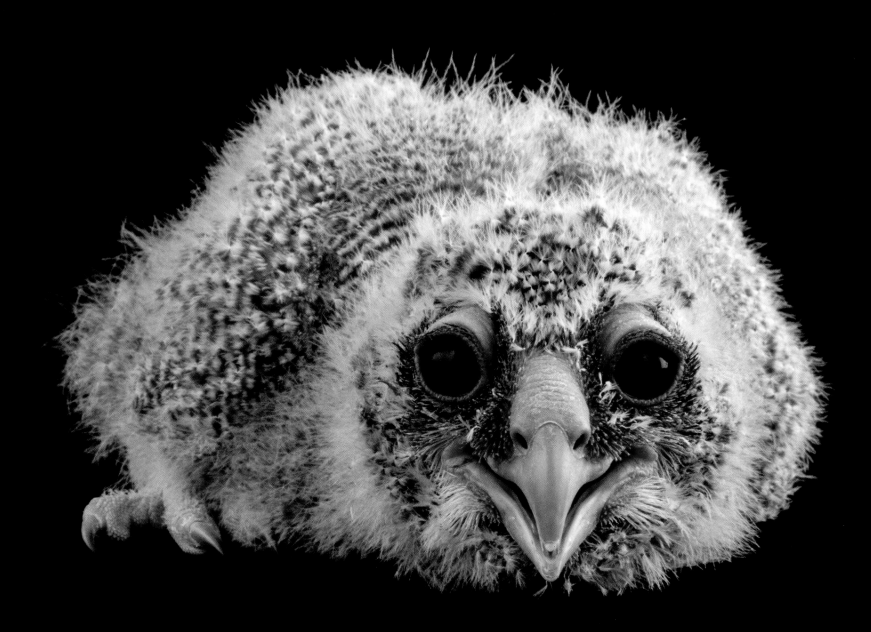

Verreaux's eagle-owl chick *(Bubo lacteus)* LC

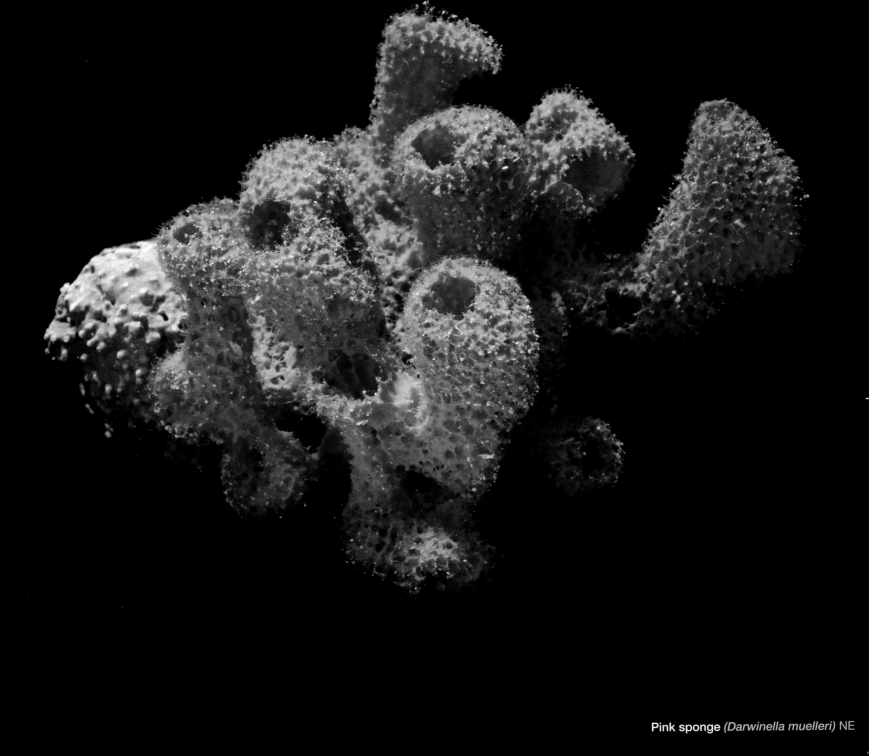

**Pink sponge** *(Darwinella muelleri)* NE

Ostrich *(Struthio camelus australis)* LC

OPPOSITE: **Grant's zebra** *(Equus quagga boehmi)* LC

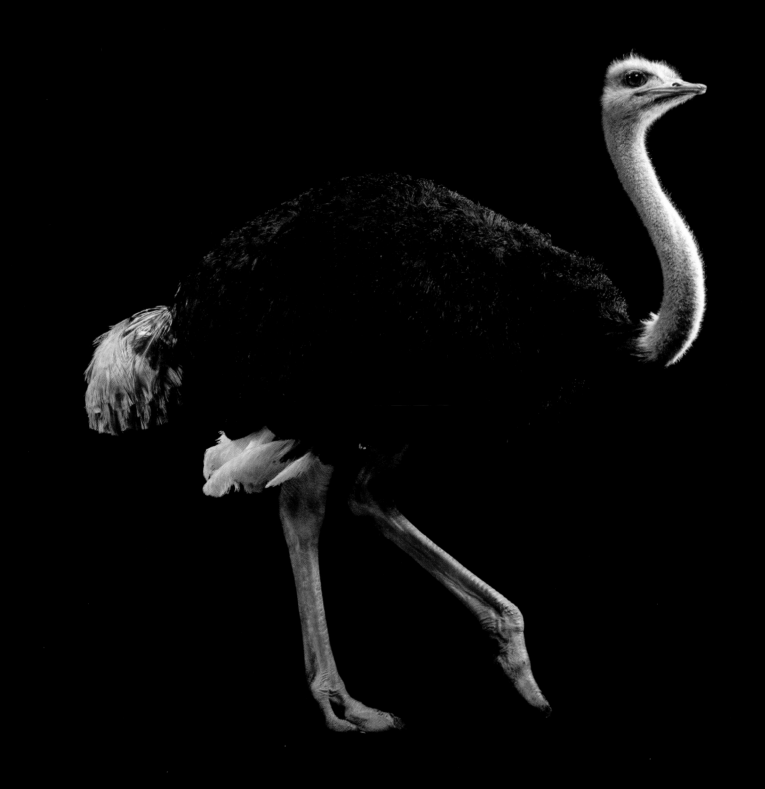

Relationships develop on the African plain. Ostriches stand tall and can spot threats from far away, which gives zebras more time to graze. Zebras can hear things approaching that may be camouflaged or that the ostrich may have missed. The keen eyesight of ostriches and the sensitive hearing of zebras can work together to help both species avoid predators.

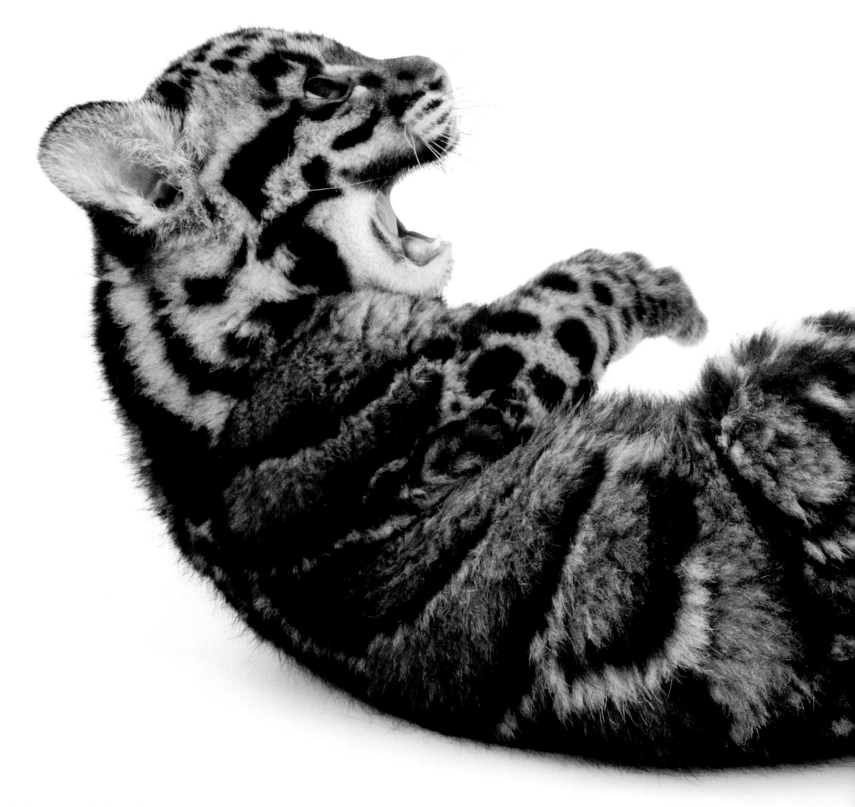

**Clouded leopard cub** *(Neofelis nebulosa)* VU

"*The animals I photograph are passive and aggressive, shy and show-offy, silly and playful. In other words, they're just like us.*

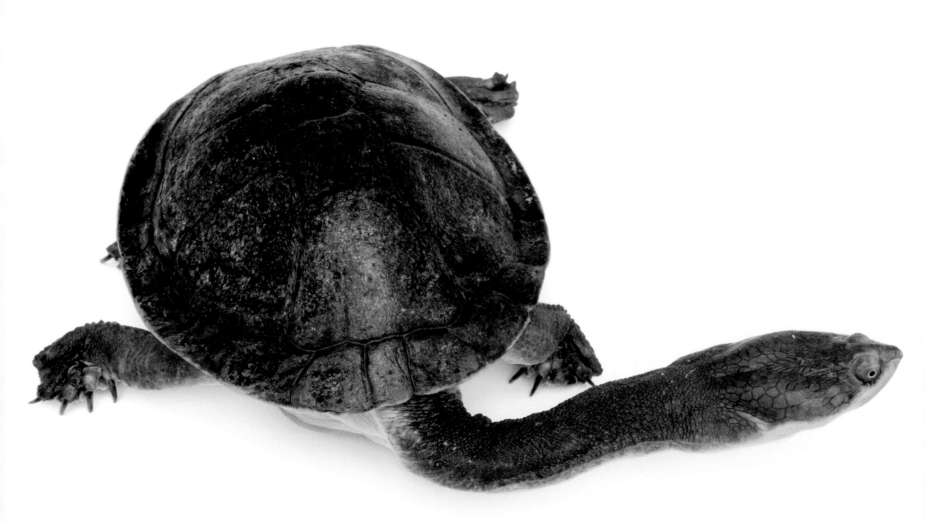

**Giant snake-necked turtle** *(Chelodina expansa)* NE

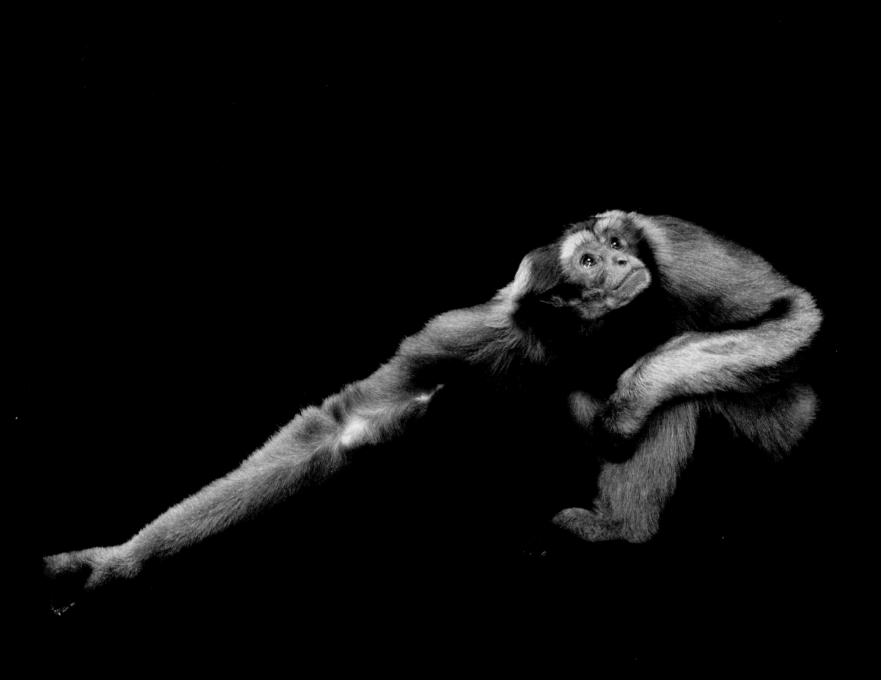

**Müller's gray gibbon** *(Hylobates muelleri)* EN

"Long reaches can improve survival. Gibbons use their long
arms for locomotion and feeding. The snake-necked turtle
thrusts its long neck out at fish like a spear."

319

> **"** *This was the very first species brought on board the Photo Ark more than a decade ago.*

**Naked mole rat** *(Heterocephalus glaber)* LC

"As I describe in my introduction, the Photo Ark began with an image of this creature, photographed at the Lincoln Children's Zoo. This is a different individual but the same species, and so it holds a place of honor."

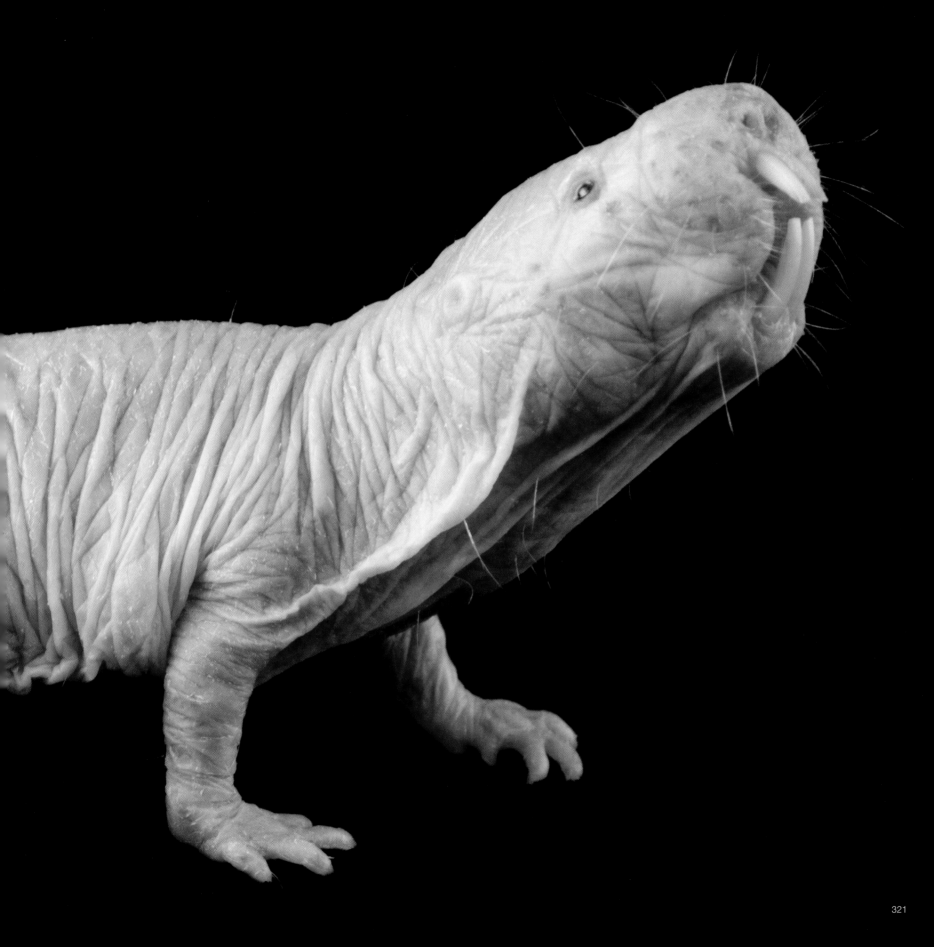

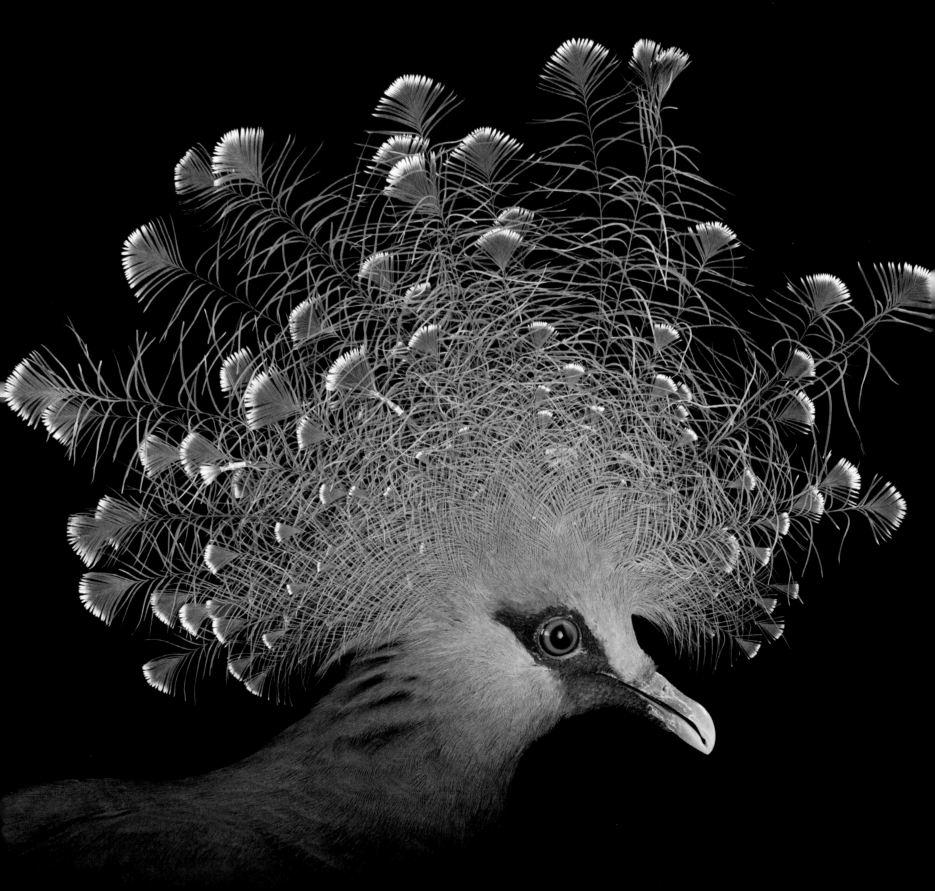

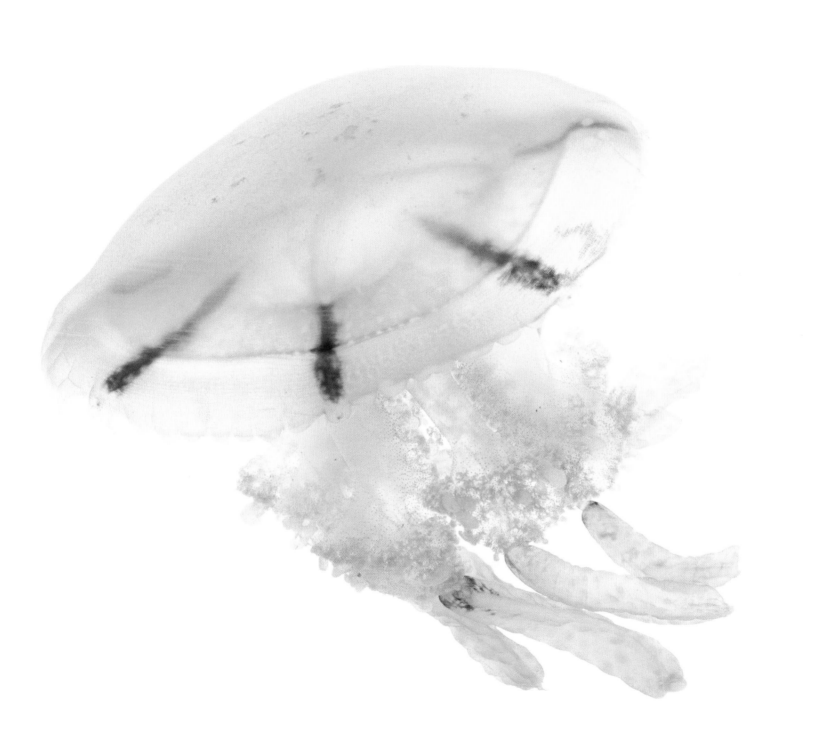

Spotted jellyfish *(Mastigias papua)* NE

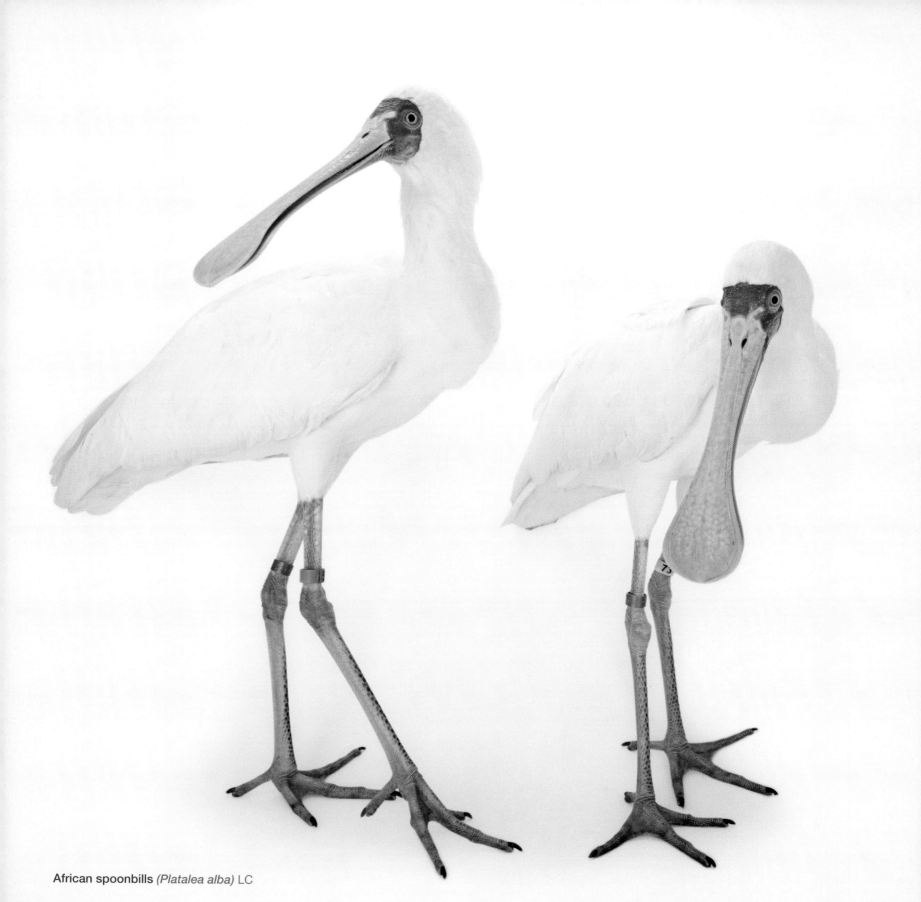

**African spoonbills** *(Platalea alba)* LC

Orange spotted filefish
*(Oxymonacanthus longirostris)* VU

**Silvery gibbon** *(Hylobates moloch)* EN

Frilled lizard *(Chlamydosaurus kingii)* LC

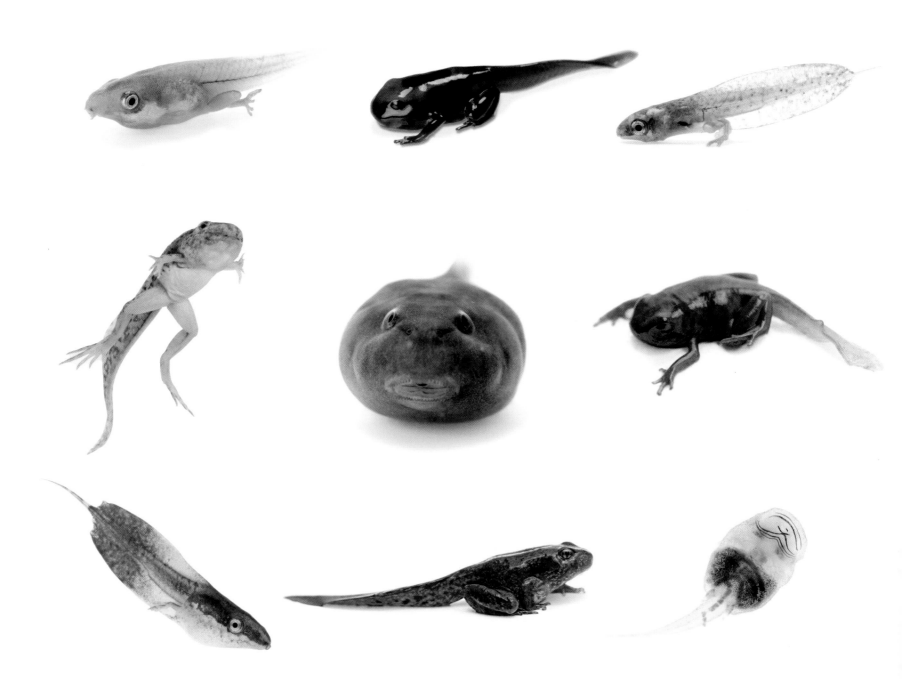

THIS PAGE AND OPPOSITE: **Tadpoles** TOP ROW (L-R): **Hylomantis hulli** *(Agalychnis hulli)* LC, **Dyeing poison frog** *(Dendrobates tinctorius)* LC, **Shreve's Sarayacu tree frog** *(Dendropsophus sarayacuensis)* LC MIDDLE ROW (L-R): **Chiricahua leopard frog** *(Rana chiricahuensis)* VU, **San Lucas marsupial frog** *(Gastrotheca pseustes)* EN, **Diablito** *(Oophaga sylvatica)* NT BOTTOM ROW (L-R): **Hourglass tree frog** *(Dendropsophus ebraccatus)* LC, **Southern mountain yellow-legged frog** *(Rana muscosa)* EN, **Pebas stubfoot toad** *(Atelopus spumarius)* VU OPPOSITE: **Blue poison dart frog tadpole, still inside the egg** *(Dendrobates tinctorius "azureus")* LC

# HEROES

**Betsy Finch**
Raptor Recovery
Bellevue, Nebraska

When someone finds an injured raptor in Nebraska, Betsy Finch gets the call. Her organization, Raptor Recovery, and its network of some 50 trained volunteers is the only one in the state licensed to rehabilitate raptors. Betsy founded the organization in 1976, and says now the "rehabilitation center is a little oasis in the middle of agricultural land." The organization has worked with 12,600 birds during its 40-year history.

"Ninety-five percent of the birds we get are injured directly or indirectly as a result of human activities, and most of the injuries we see are from collisions," Finch says. When a golden eagle came in with a badly broken wing, staff members noticed a problem with his eye that complicated his months-long rehabilitation. A collision had exposed bone, and the injury required a number of surgeries and months of careful care. "We don't give up on birds very easily," Finch says. The eagle was left with one wing shorter than the other and had to learn how to fly again. It was successfully released almost a year after its treatment began.

Thanks to a 2013 partnership with Fontenelle Forest, a nature center and protected lands near Omaha, Raptor Recovery has solid financial footing. It is now able to tend to the birds that need help and share them with the public frequently. The work of Fontenelle Forest's Raptor Recovery reaches thousands of people a year. "It's fun to see the faces of people when they see the birds up close," says Finch. She believes that by getting to know the wild raptors that she and her organization have cared for, people will become more passionate about protecting habitats in general. "That's vital for everything." ◆

> " *Every person can do one thing, even if it is small, to help wildlife.*
>
> —Betsy Finch

OPPOSITE: **Snowy owl** *(Bubo scandiacus)* LC

Betsy Finch holds an extremely nearsighted peregrine falcon whose poor eyesight got it into trouble once it fledged from its nest on a downtown Omaha skyscraper.

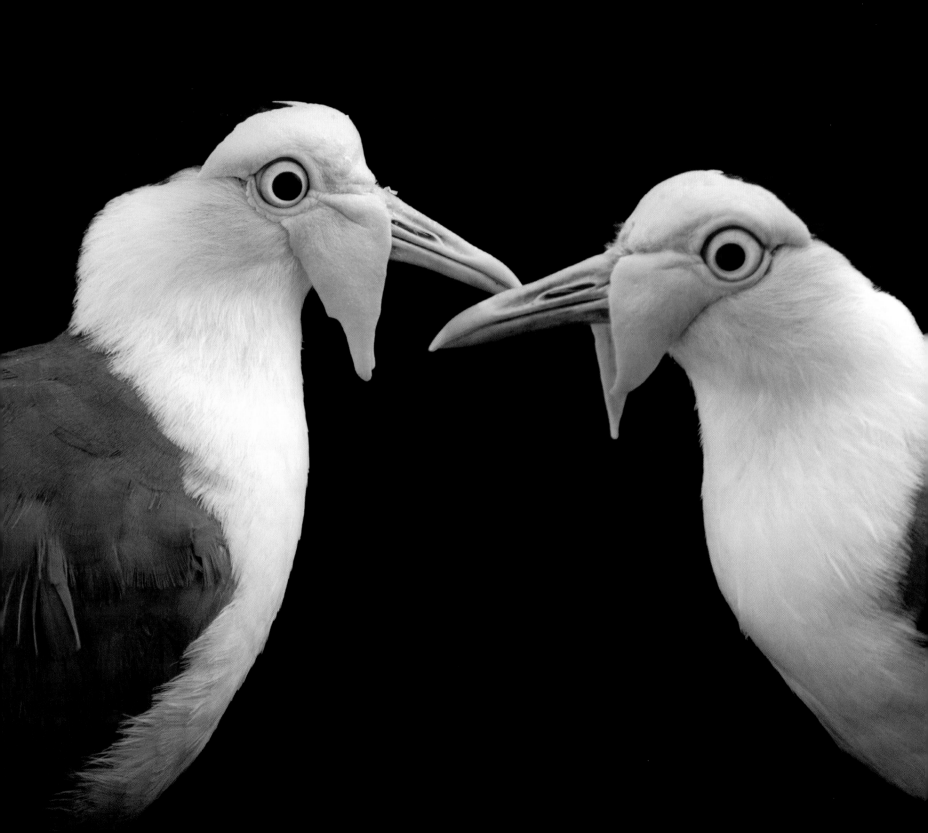

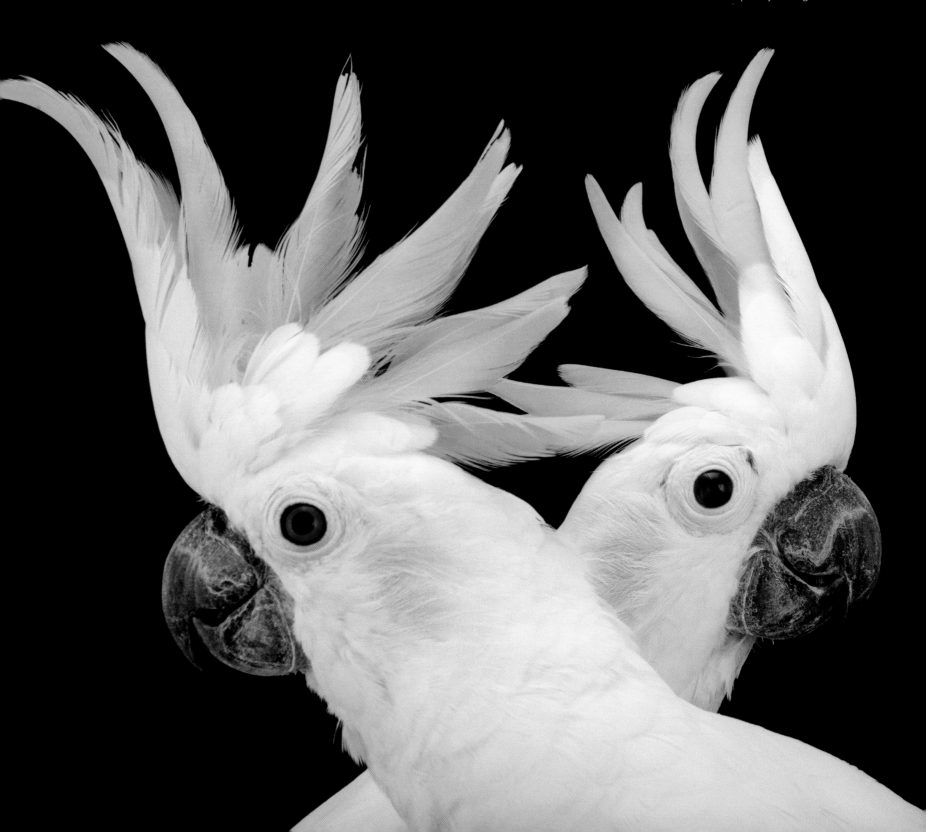

**Lesser sulphur-crested cockatoos**
*(Cacatua sulphurea citrinocristata)* CR

"This mated pair groomed each other
frequently during the shoot."

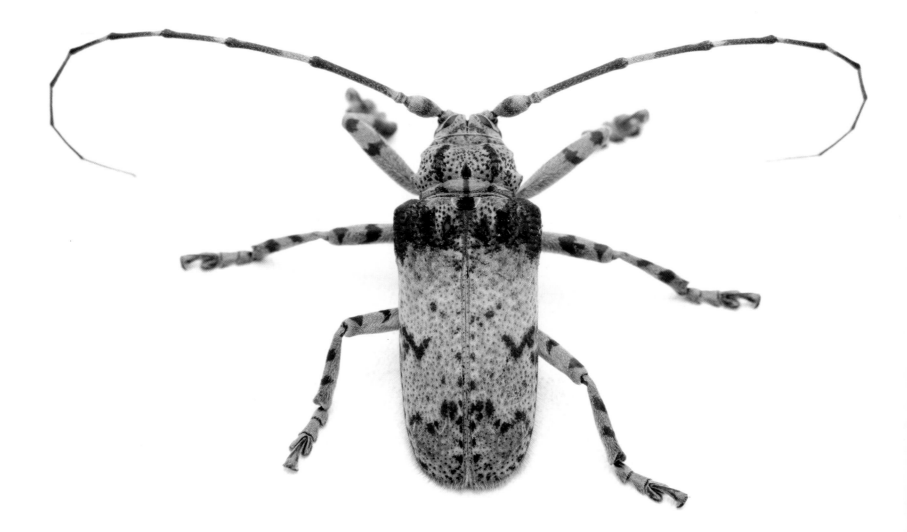

**Longhorn beetle** *(Moechotypa marmorea)* NE

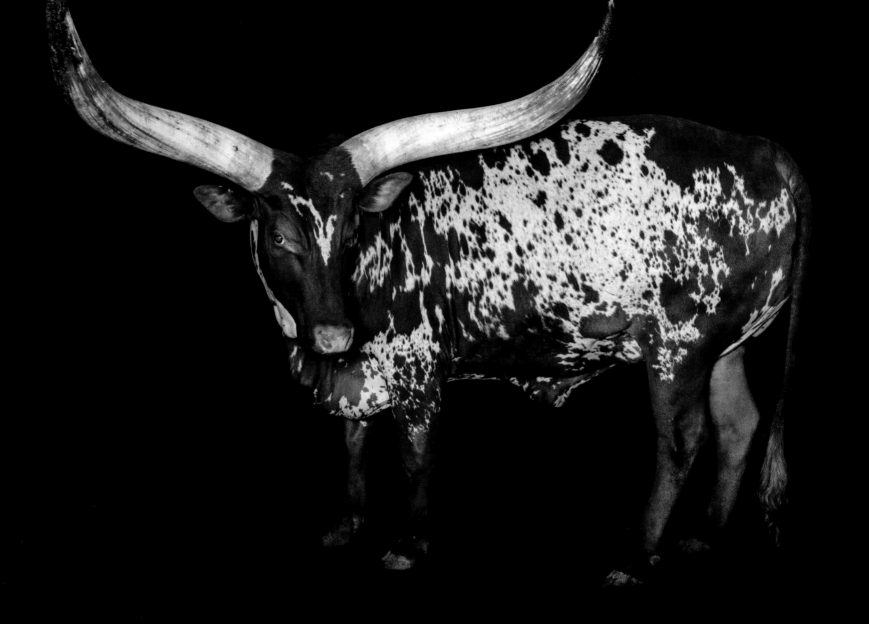

**Ankole/Watusi cow** *(Bos taurus "watusi")* NE

"This cow had horns so big it had learned how to go through doorways in its barn by carefully turning its head sideways and working its way in."

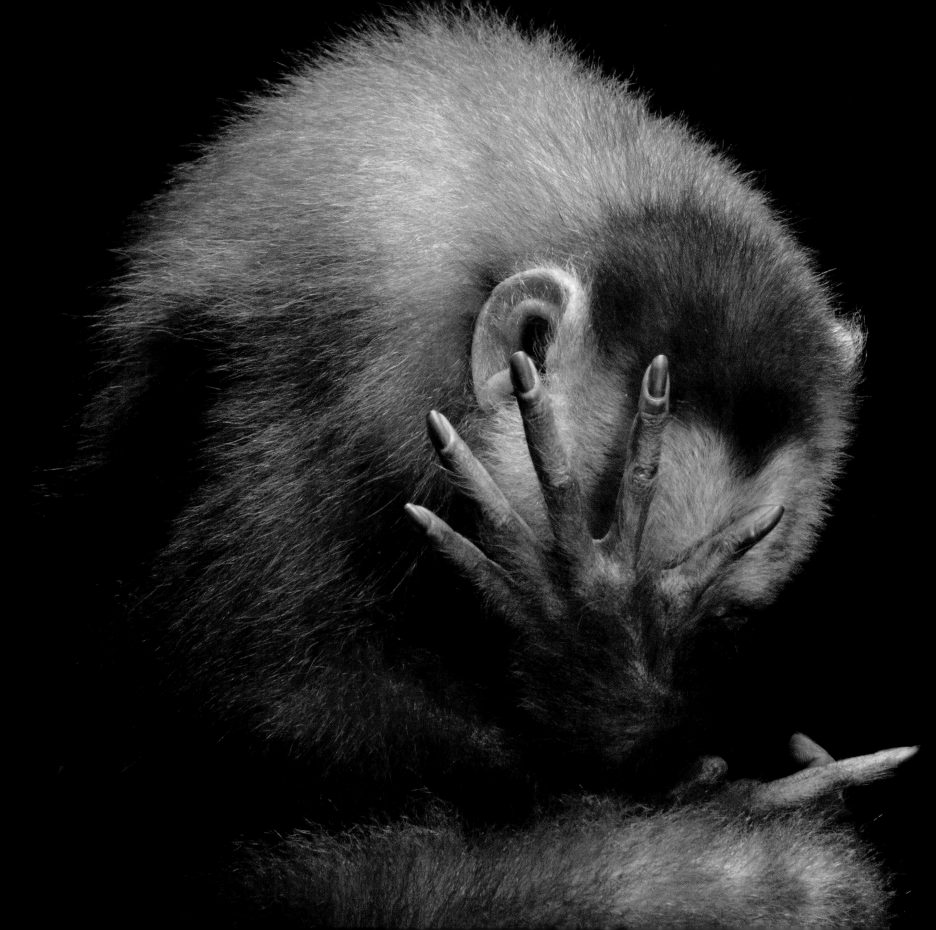

> " *I've always loved the way this primate's hands look so much like ours.*

**Varied capuchin** *(Cebus versicolor)* EN

CHAPTER FIVE ▲▲

# Stories of Hope

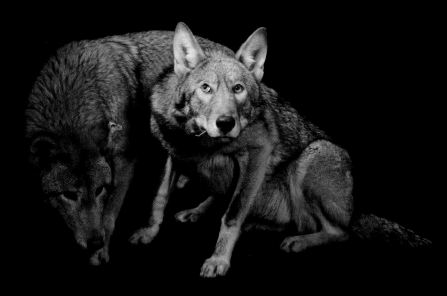

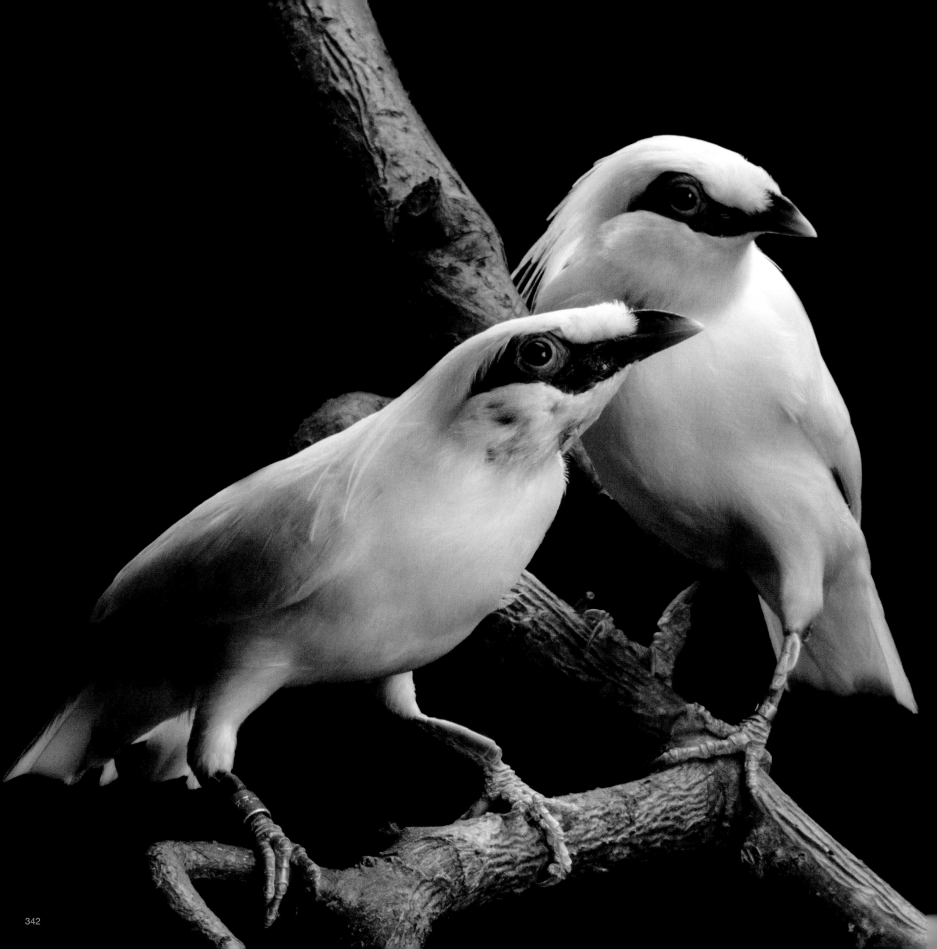

Some call it the "sixth extinction"—a global sweep of disappearing species so far-reaching it rivals the ice ages and the meteoric event believed to have exterminated the dinosaurs. And this time, we humans are both cause of and, one hopes, solution to the problem.

We saw down forests for timber, clear land for planting, and plumb the soil for its mineral riches, thus destroying natural communities. We spew exhaust and influence the chemistry of the atmosphere, thus warming the planet, changing local climates and habitats, interrupting migration paths, and depleting food sources. We covet the beautiful and the powerful, thus trapping or killing magnificent animals for our own pleasure.

And now we step back, look at what we are doing, and ask how we can change our ways. Of all the animals, we humans have had the greatest impact on the planet. Knowing what we do, we may still have the opportunity to lighten our footprint, heal the planet, and save its rich diversity of species. That's what the Photo Ark is all about.

In this last chapter, we feature species once on the brink of extinction that are benefiting from human care. None of these stories carry the sure promise of ending happily ever after, but all signify what can be done when human beings pay attention, learn from nature, work hard, and do all they can to preserve the biodiversity of our planet.

It is tricky to define "success" in this complicated realm of threatened and endangered species. Just as the International Union for Conservation of Nature has categories from "near threatened" to "extinct in the wild" and downright "extinct," any discussion of species saved by human intervention must include some definitions too.

Our efforts to save the American bald eagle (*Haliaeetus leucocephalus,* page 75), for example, have been so successful that there are more and more breeding individuals in the wild,

OPPOSITE: **Bali mynah** *(Leucopsar rothschildi)* CR

The Bali mynah, collected intensively for the pet trade, would be extinct if it weren't for intensive captive breeding programs and releases back into the wild.

PREVIOUS PAGE: **Red wolves** *(Canis rufus gregoryi)* CR

The U.S. Fish and Wildlife Service introduced captive-bred red wolves to a small range in eastern North Carolina in 1987. Hybridization with coyotes or red wolf-coyote hybrids is the primary threat to the species in the wild, but it hangs on.

and it appears as if the species is now able to make it on its own. The successful resurgence of the California condor (*Gymnogyps californianus,* page 352) is not quite so secure, although populations reseeded in California, Arizona, and Mexico seem to be reproducing. At this point, though, more often a species that came to human attention as it was facing extinction now enjoys a stable, or maybe even growing, population because it is being cared for in a zoo, wildlife center, aquarium, or by private breeders. A few of these heroic caretakers are featured in this book, and many more are doing the same valiant work around the world.

A species maintained thanks to human care is not the same as a species returned to healthy numbers in the wild. Some beloved creatures—orangutans, gorillas, tigers, leopards—prevail under human care but still face desperate situations in the wild. Some had habitats that were small to begin with, and human development has shrunk them even further. That's why conservation efforts to revive natural communities around the world are so important: so that the creatures now breeding primarily in zoos can return to homes in the wild.

Some, especially the less charismatic species that do not find their way into zoos or aquariums, may persist in tiny numbers in the wild because they inhabit restricted areas such as wildlife preserves or national forests. By protecting small bits of habitat, from forest to desert, jungle to ocean and coral reef, we do what we can to maintain the natural surroundings for the sake of those who live there. Of course animals know no boundary lines, and many travel age-old migration pathways without regard for any borders we draw through governmental decree. For the sake of both the animals and ourselves, we need to go beyond designating protected areas, as valuable as they may be, and do whatever we can to improve the health of the whole planet.

In this chapter, you will find stories that inspire—examples of animals still here and rebounding. Some are making their way in the wild; others still depend on human caretakers.

The golden lion tamarin (*Leontopithecus rosalia,* pages 348–349), a monkey native to the Brazilian Atlantic coast rain forest, once faced extinction, due primarily to centuries-old

deforestation but also due to capture for the pet trade. In the 1990s, researchers estimated that as few as 200 individuals lived in the wild. Tamarins raised in captivity since then have bred, and their young have been reintroduced into four locales. The golden lion tamarin population in the wild is now estimated above 1,000. Reforestation efforts help support that population, now considered stable in the wild.

The Guam rail (*Hypotaenidia owstoni,* page 379), a flightless, fast-running bird native only to the Pacific island of Guam, dropped fast in number during the 20th century. About 2,000 lived on the island in 1981, but none by the end of that decade, likely because they fell prey to feral cats and a snake introduced to the island. Breeders in Guam and zookeepers in the United States have kept the rails alive and breeding. Reintroductions in areas cleared of cats and snakes have not yet succeeded, but these efforts will continue.

The addax (*Addax nasomaculatus,* page 356), called in French the "white antelope," is a desert ungulate that once roamed in herds throughout the Sahel and Sahara regions. A cascade of effects pushed it toward extinction. Widespread drought has meant shrinking grazing territory, and increased human populations hunt this species for meat. Zoos, ranches, and private breeders now care for at least 1,600 individuals; Morocco, Tunisia, and Algeria have declared it protected, and Algeria and Egypt have banned gazelle hunting in general. Reintroductions are under way, and perhaps it is not too late to save this graceful species.

Stories of hope can be told, but many are tentative at best. Let us do all we can to make sure that in the coming century—in the lifetime of our children's children, and beyond—there will be many more such stories to tell. This is the ultimate goal of the National Geographic Photo Ark: to get people to stop and look, to think about the future, and to put their concerns into action. We are building this ark and keeping it afloat together. Here are a few of the creatures we are saving by doing so. ◆

**St. Vincent parrot** *(Amazona guildingii)* VU

This parrot, endemic to the small Caribbean island of St. Vincent, had been struggling against extinction. But conservation work and a public education campaign seem to have halted its decline.

**Kirtland's warbler or jack pine warbler**
*(Dendroica kirtlandii)* NT

The rarest songbird in North America, the Kirtland's warbler nests only in young jack pine trees, 10 feet tall or shorter. Fire suppression efforts severely limited its habitat, but in 1980 a controlled fire got out of hand and spurred the germination of new jack pines. Planting efforts by scientists have also given the songbird room to rebound.

**Golden lion tamarins**
*(Leontopithecus rosalia)* EN

Reintroduced populations of golden lion
tamarins in protected woodlands offer hope for
the long-term survival of this Brazilian species.
A third of all wild golden lion tamarins come
from captive breeding efforts.

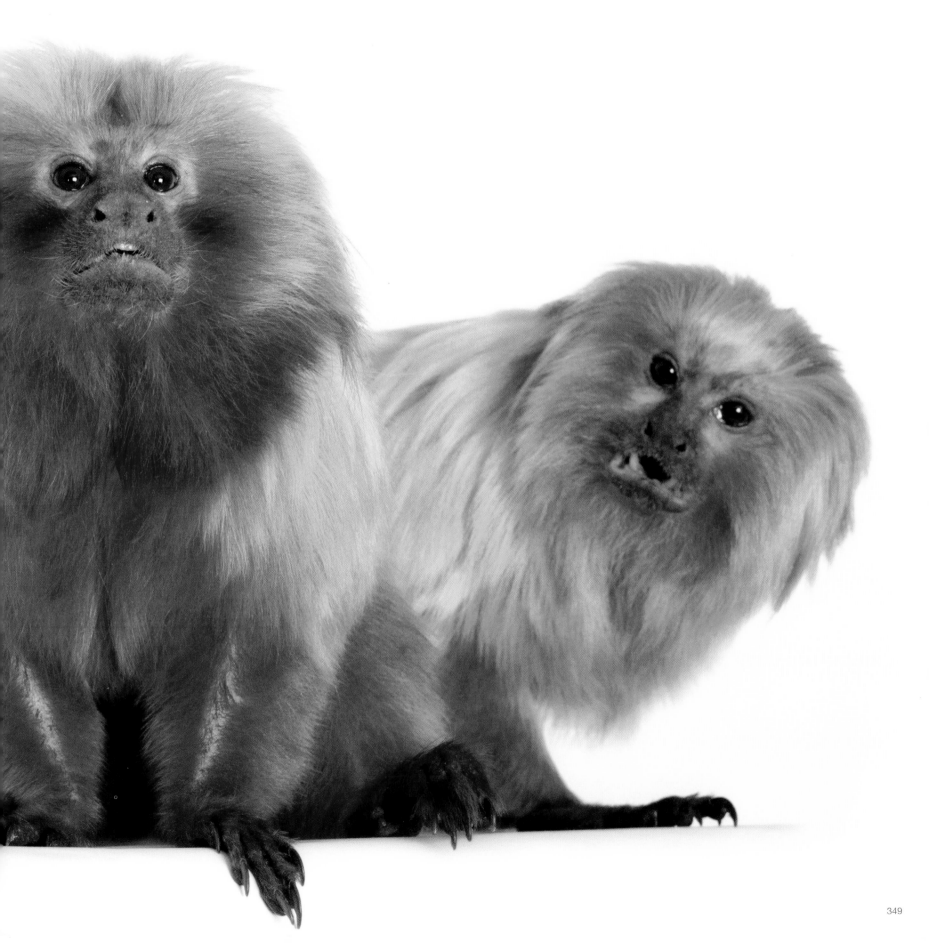

**Black-footed ferret** *(Mustela nigripes)* EN

By 1979 scientists considered the black-footed ferret extinct. This small mammal had fallen victim to efforts in North America to control prairie dogs (its main meal) as well as a flea-borne plague that wipes out the prairie dogs. Captive breeding and reintroductions have led to a few hundred ferrets living in the wild.

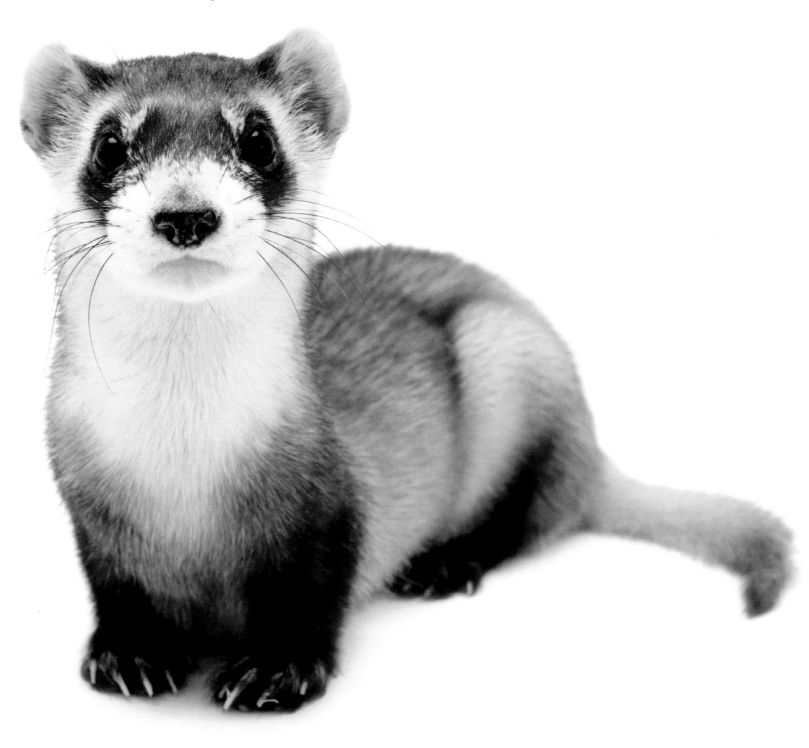

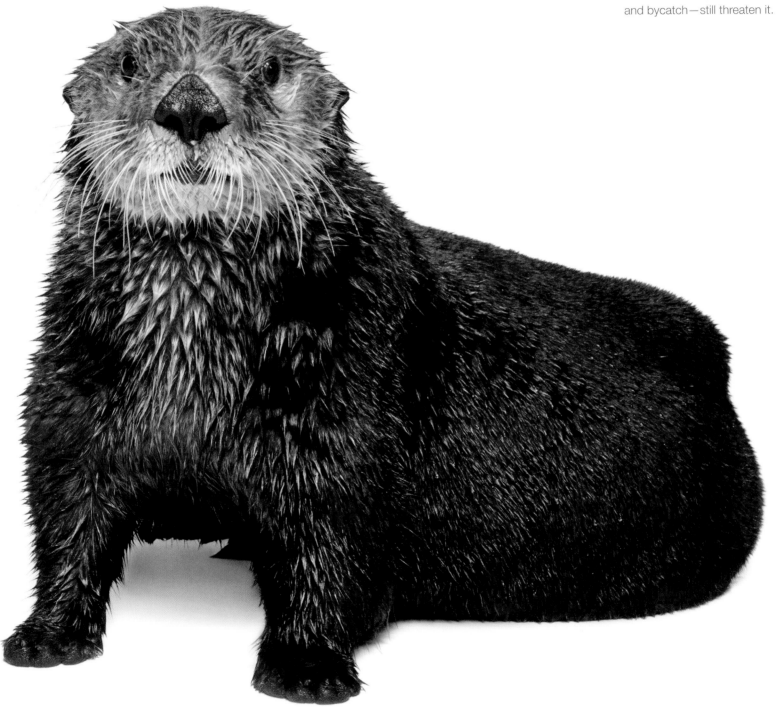

**Northern sea otter** *(Enhydra lutris kenyoni)* EN

A small Alaskan population of sea otters survived the ravages of the commercial fur trade. Today, the U.S. Fish and Wildlife Service manages this subspecies. Predation by killer whales and human threats—oil spills, hunting, and bycatch—still threaten it.

**California condor** *(Gymnogyps californianus)* CR

You can see the California condor flying free in some Southwest skies after an intensive breeding program reintroduced this vulture to locations in California, Arizona, and Mexico. Its numbers dropped to less than two dozen by 1981, but the population is now building.

**American burying beetles**
*(Nicrophorus americanus)* CR

Populations of the American burying
beetle east of the Appalachians were in
severe decline as early as the 1920s.
A captive breeding program at the
St. Louis Zoo has produced
thousands of offspring and
set them back into
the wild.

**Juvenile addax** *(Addax nasomaculatus)* CR

The addax was believed lost to hunting and habitat destruction in its home range in the African country of Niger until tracks were seen a few years ago in nearby Mauritania, raising hopes that the species was hanging on. In the meantime, reintroductions in Tunisia and managed populations in zoos and with private breeders worldwide offer hope for the survival of this species.

**American alligator** *(Alligator mississippiensis)* LC

By the 1970s the American alligator was on the brink of extinction, hunted for its meat and leather. Education programs and strict regulations saved its skin, literally. Today, the reptile has rebounded, and the species is no longer endangered.

**South Island takahē** *(Porphyrio hochstetteri)* EN

Endemic to New Zealand, this flightless bird was limited to a small population in the Murchison Mountains of Fiordland by the middle of the 20th century. Captive breeding programs have had some limited successes, and the species is being introduced to offshore islands that are free of invasive mammalian predators.

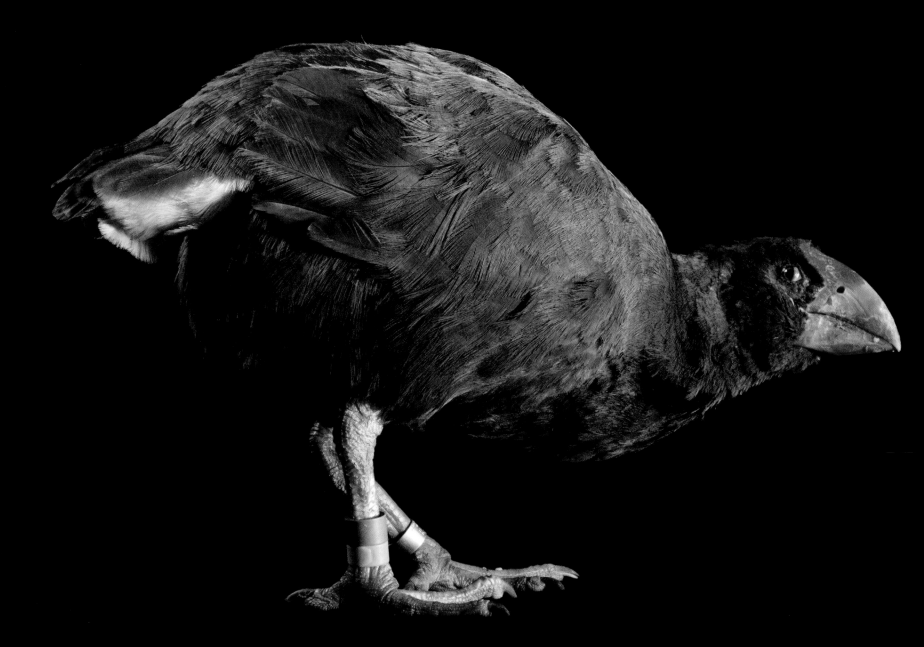

**Forsten's lorikeet** *(Trichoglossus forsteni)* NT

This brightly colored bird is native only to five Indonesian islands. Habitat destruction and the introduction of non-native rats and snakes were taking a toll on its population, but thanks to conservation efforts, its numbers are now holding steady.

# BEHIND THE SCENES

## Lincoln Children's Zoo

W hen Joel decided he needed to work close to his Lincoln, Nebraska, home for a while, he called his friend John Chapo, president and CEO of the Lincoln Children's Zoo, and asked if he could take a few portraits. Located a mile from Joel's home, the zoo became the birthplace of the Photo Ark. Curator Randy Scheer made the unlikely suggestion of a naked mole rat for Joel's first shoot. Ever since then he has worked with Joel on every shoot at the zoo—"and has never complained," says Joel with a smile. "Randy's been kicked, bitten, scratched, and scarred, but he does it all for the animals. The animals know him," says Chapo. "Just watch the storks start their courtship dance when he shows up." ◆

> " *These shoots are about people too— those compassionate enough to give their lives caring for animals. They're building living arks to last a century, if not longer.*

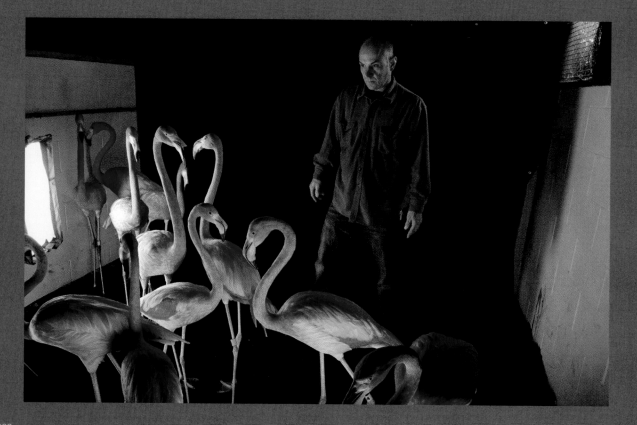

Animal curator Randy Scheer assists Joel with a flock of flamingos *(see pages 68–69)*. "They squabbled and honked constantly," says Joel. "Seems they love each other but can't stand each other. They're a social, flocking bird, but they really act like they hate their neighbor at times."

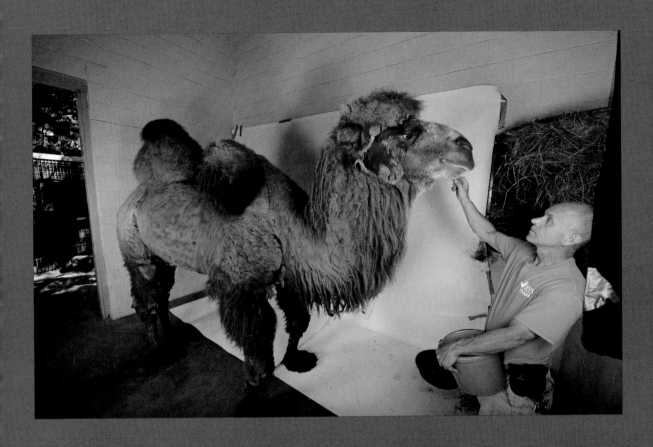

Randy Scheer helps pose Kalif, the Bactrian camel. Scheer has been bitten and bruised by Kalif, but the camel remains his favorite animal of all time.

Joel gets ready to make a portrait of a Gila monster as Randy Scheer looks on. Although Scheer was a tough first curator to work with, Joel says, "Randy absolutely put me on the right path for this project. He taught me how to do these portraits quickly and make it as stress-free as possible for the animals. I couldn't have had a better boss, actually."

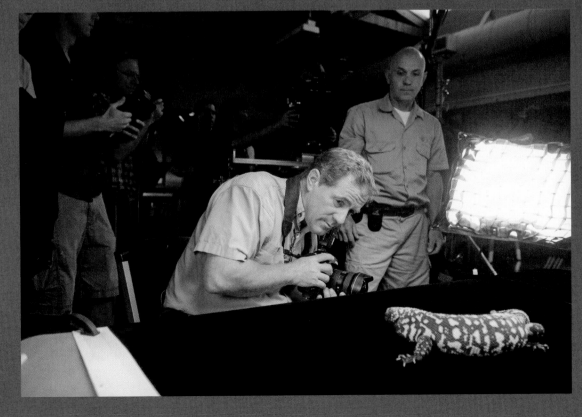

**Domestic Bactrian camel** *(Camelus bactrianus)* CR

Wild Bactrian camels *(Camelus ferus)* are critically
endangered, facing pressures from hunting and
competition with domestic livestock. This camel, a
domesticated form of its wild cousin, made its home
at the Lincoln Children's Zoo and formed a special
bond with curator Randy Scheer. Kalif succumbed to
old age in December 2015. The zoo's president,
John Chapo, says, "Randy hurts when they hurt.
He misses them greatly when they're gone."

**Vancouver Island marmot**
*(Marmota vancouverensis)* CR

This species of marmot inhabits the alpine
meadows of Canada's Vancouver Island, but in
2003 only 30 were recorded in the wild. Thanks
to captive breeding, reintroduction, and other
protection efforts, these rodents are starting to
recover, with an estimated 300 marmots living
in the wild in 2015.

**Grizzly bear** *(Ursus arctos horribilis)* LC

Grizzly bears, a subspecies of brown bears, have solid populations in Canada and Alaska. In 2007, the U.S. Fish and Wildlife Service took the Yellowstone grizzly population off the list of threatened species. These animals can tolerate humans much more than the other way around, it seems. In areas where they aren't shot, they do well.

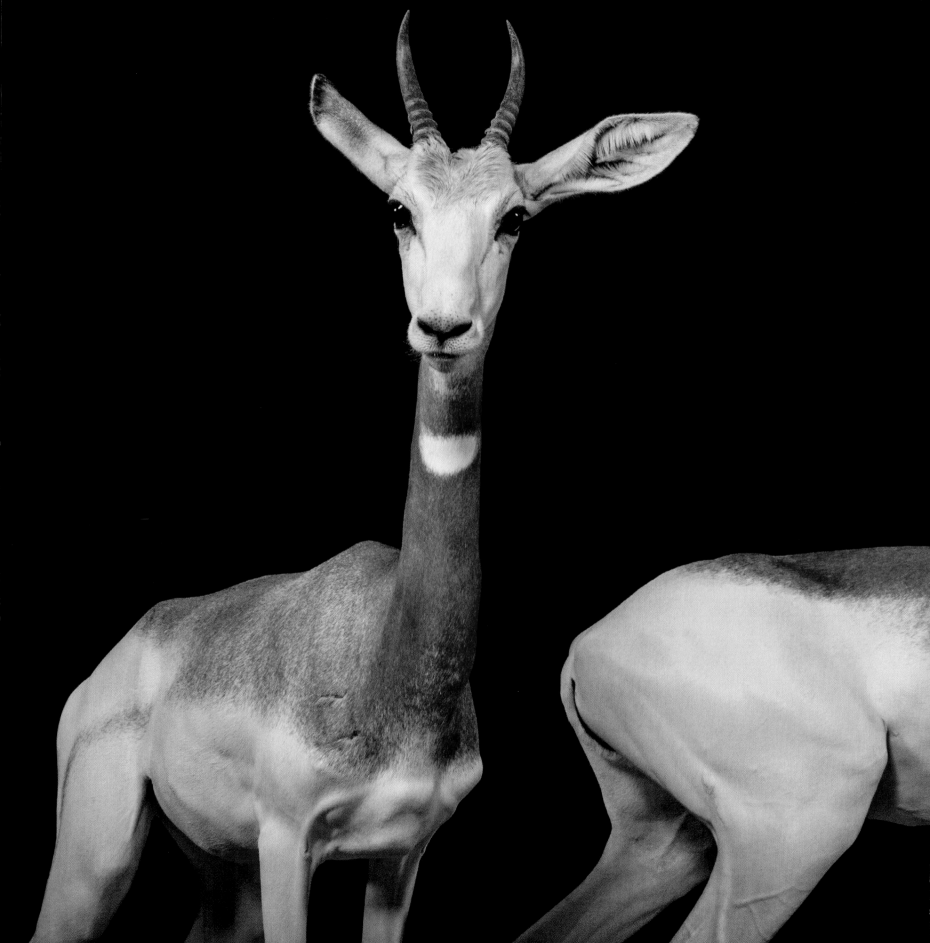

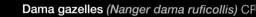

**Dama gazelles** *(Nanger dama ruficollis)* CR

This graceful gazelle has disappeared from
much of its range in the Sahara and Sahel
regions of Africa, a victim of hunting and
habitat loss, and yet it was selected as the
mascot of Niger's national soccer team.
Captive breeding programs are working to
build populations.

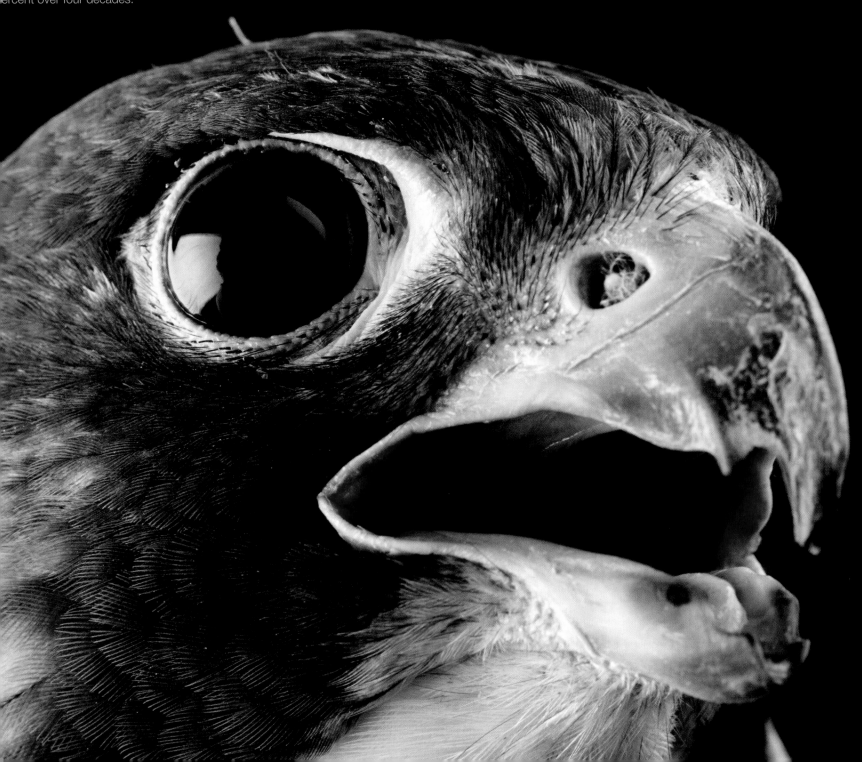

**Blue-throated macaw** *(Ara glaucogularis)* CR

For some birds, it doesn't pay to be colorful. Capture for the pet trade caused rapid declines of this Bolivian species by the 1980s, but successful conservation efforts and a near-total cessation of the trade has given hope to the species.

**Nenes** *(Branta sandvicensis)* VU

This goose, endemic to the Hawaiian Islands, suffered a severe decline in numbers from predation by both humans and introduced species. But a reintroduction project has released more than 2,400 nenes to the wild, and the population continues to grow.

" *This doesn't have to end here. You can save species if you try. Each of us can have a real and lasting impact.*

**Przewalski's horse** *(Equus ferus przewalskii)* EN

Although it looks like a domestic horse, subtle differences mark the Przewalski's horse as distinct. It's the last surviving subspecies of the wild horse. It was thought to be extinct in the Asian steppes, but breeding programs and reintroductions have kept this species alive. A huge semiwild herd lives in central France, in a remote protected area often used for reintroducing human-bred individuals back into the wild.

A few farming families living in the Western Cape of South Africa saved this species from extinction in the mid-1900s. Since then, private landowners have raised bonteboks on their land, giving this species a stronger future.

**Yellowfin madtoms** *(Noturus flavipinnis)* VU

When formally described by scientists, this species was presumed extinct. Thanks to the efforts of Conservation Fisheries *(see pages 126–127),* the species has regained a foothold in the upper Tennessee River drainage system, the region it calls home.

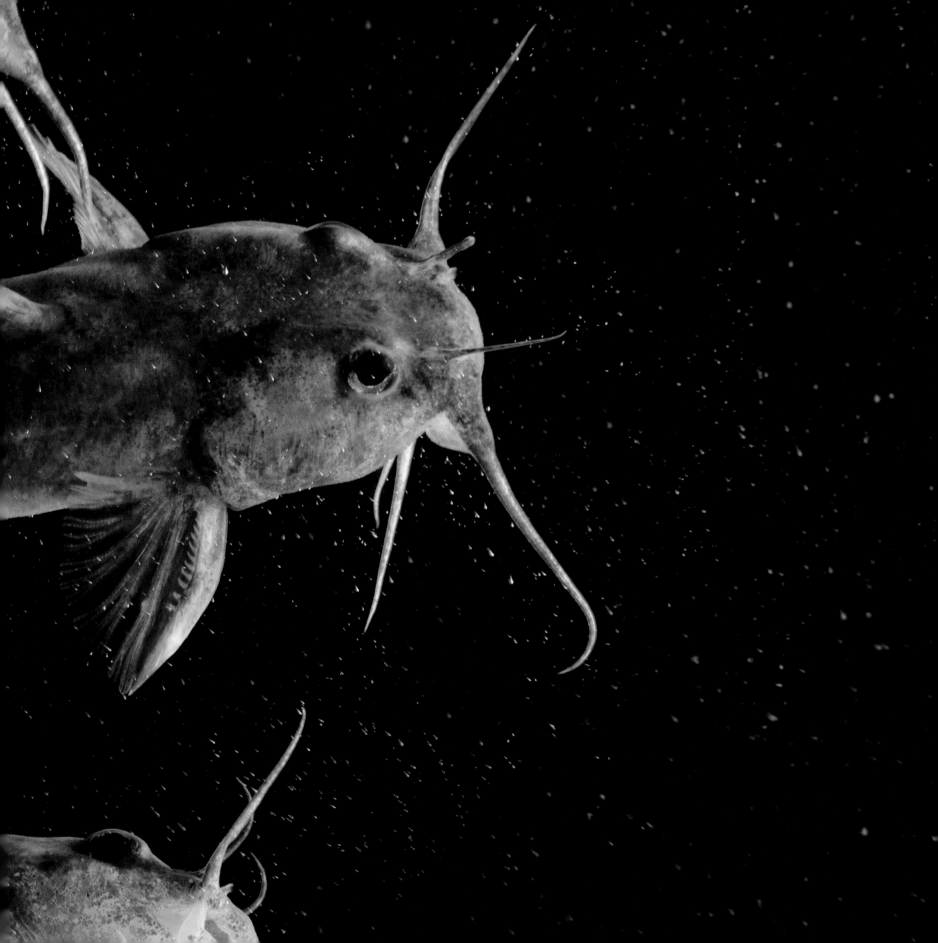

**Brown pelican** *(Pelecanus occidentalis)* LC

Pesticide poisoning brought these powerful seabirds close to extinction. Declared an endangered species in the United States in 1970, the brown pelican was delisted in 2009. Today, more than half a million brown pelicans grace the coastal regions.

**Florida panther** *(Puma concolor coryi)* LC

In 1995 only about 30 Florida panthers were left in the wild. To increase the population's genetic diversity, scientists released nine female panthers from Texas into southern Florida, leading to a healthier and more diverse population.

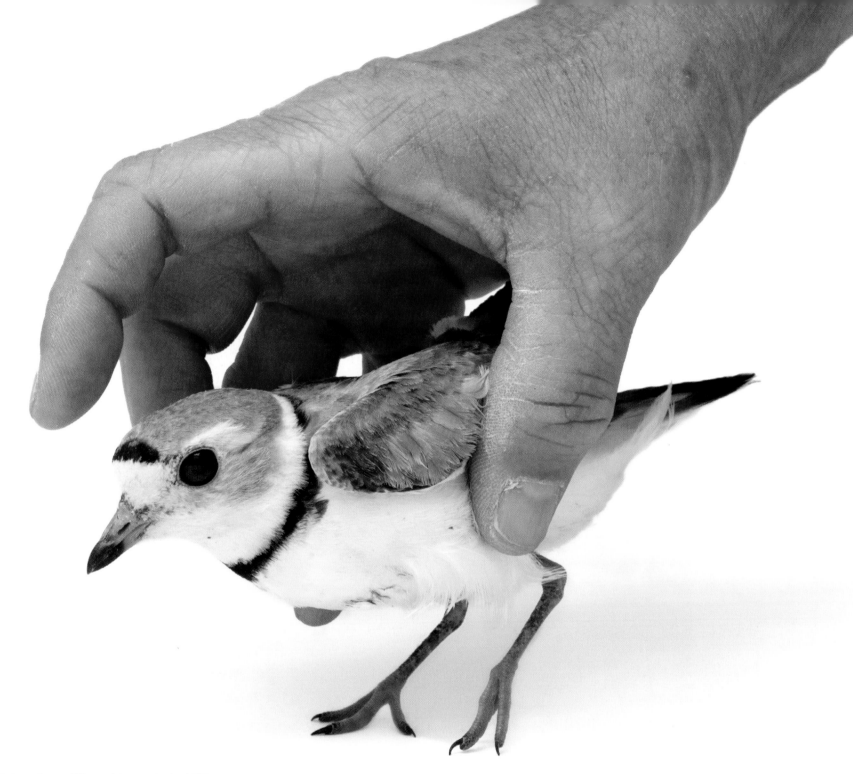

**Piping plover** *(Charadrius melodus)* NT

This shorebird nests in open stretches of sand and gravel. Unfortunately, its nesting spots often include busy beaches, roadsides, and even active gravel mines. Conservation programs since the 1990s have stemmed this bird's decline, though.

**Guam rail** *(Hypotaenidia owstoni)* EW

Endemic to the Pacific island that shares its name, this small, flightless wading bird is extinct in the wild, but the species has been saved by zoos and private breeders. Recently, conservationists introduced small populations on two islands close to Guam.

**Spix's macaws** *(Cyanopsitta spixii)* CR

With its dusty blue head and vivid blue wings and body, the Spix's macaw faced intense pressure from trapping for the pet trade. It hasn't been seen in the wild since 2000, but some 100 individuals can be found in breeding programs or private hands.

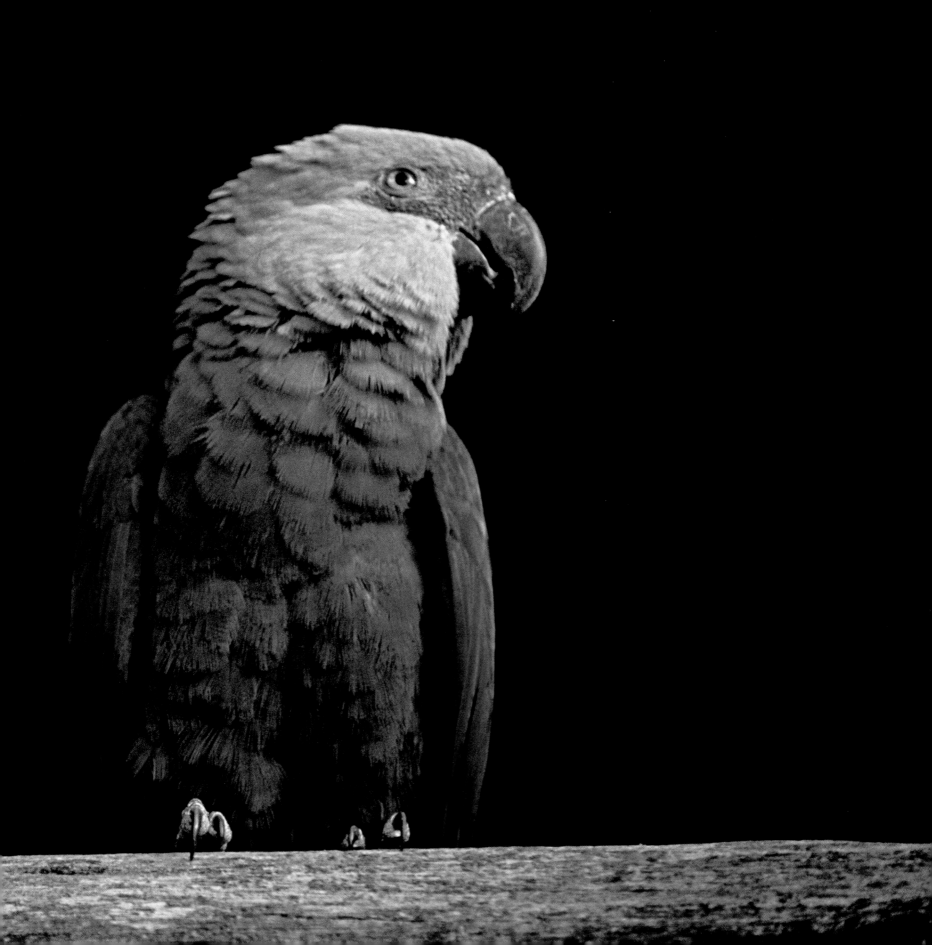

**Amur leopard** *(Panthera pardus orientalis)* CR

Conservation efforts are having some success in protecting the Amur leopard, a critically endangered subspecies living in the Russian Far East and the rarest big cat in the world. "Because they're the boss in their own ecosystems, they're not fearful of much, and they come right up to investigate me and my camera . . . located safely on the outside of their enclosures."

**Sumatran tiger** *(Panthera tigris sumatrae)* CR

Illegal trade in tiger parts, habitat fragmentation, and conflict with humans have all dealt serious blows to this tiger subspecies, one of the least numerous in the world. Only about 250 individuals live in the wild today on the Indonesian island of Sumatra. Without zoos, all tigers would be extinct in their native ranges within the next 50 years.

**Kakapo** *(Strigops habroptilus)* CR

This kakapo, named Sirocco, is imprinted on humans, and so he spends part of his time in the wild on a predator-free island in New Zealand and part of his time touring different zoos and nature centers. "He's a tremendous ambassador in terms of his educational value."

**Sumatran orangutan** *(Pongo abelii)* CR

Logging and development of the Sumatran forests, which turn rain forest into plantations, threaten this critically endangered orangutan species. "This orangutan was quite tame, and I remember being in the room with her as she posed on white seamless paper. I kept wondering what she was thinking behind those eyes."

**Mexican gray wolf**
*(Canis lupus baileyi)* LC

This subspecies of the common wolf recently faced extinction, with only a small wild population remaining in Mexico. Now, thanks to breeding and reintroduction efforts, its numbers are increasing in the United States as well.

# Making *the* Photographs

So just how do we make these photos? We start with the animal in front of a black or white background, and in nice light. Smaller animals are usually quite easy; they're moved into a space that has black or white on the walls and underfoot. Most often, this means they go into our soft cloth shooting tents. Once inside, they see only the front of my lens. For larger, more skittish animals like zebras, rhinos, and even elephants, we install a background and may use only natural light. We seldom put anything under their feet that could scare them or cause them to slip. In those cases, we either don't photograph the animal's feet, or we later use Photoshop to darken the floor to black.

The majority of Photo Ark participants have been around people all their lives and are calm when we work with them. Still, we want the photo shoots to go as quickly as possible, and so we don't stop to clean up dirt or debris they may deposit on the backgrounds. For that, we later use Photoshop and touch up the final frames.

The goal is to end up with a clear, focused portrait of the animal with nothing but pure black or white around them. To eliminate all distractions. To get viewers to care. ◆

Black and white liners inside this cloth photo tent allow small animal portraits to be fast and safe.

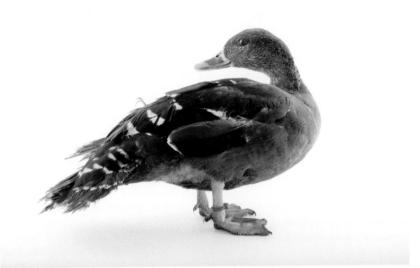

**Before:** Our number one goal is to make photographs quickly to reduce stress on the animals. This means cleaning up the backgrounds digitally after the shoot.

**After:** The finished product, after dirt, poop, and a background seam have been removed electronically.

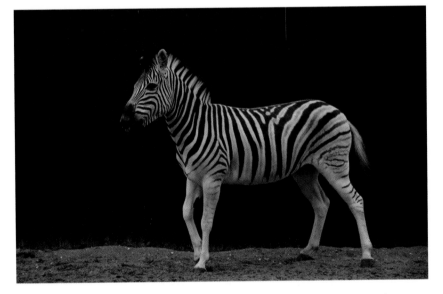

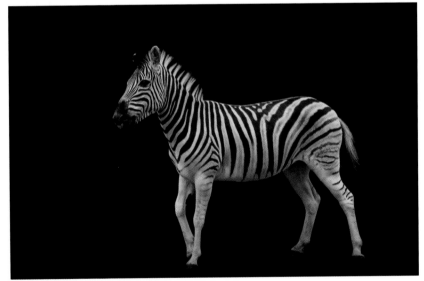

**Before:** For nervous or large animals, we install a black wall covering in their view far in advance of the shoot day.

**After:** Darkening the ground using Photoshop eliminates having to put anything under a skittish animal's feet during the shoot.

# About *the* Photo Ark

For many of Earth's creatures, time is running out. Species are disappearing at an alarming rate. That's why National Geographic and renowned photographer Joel Sartore are dedicated to finding solutions to save them. The National Geographic Photo Ark is an ambitious project committed to documenting every species in captivity—inspiring people not just to care but also to help protect these animals for future generations. Once completed, the Photo Ark will serve as an important record of these animals' existence and a powerful testament to the importance of saving them. For more information on how you can support this project, visit *natgeophotoark.org.* ◆

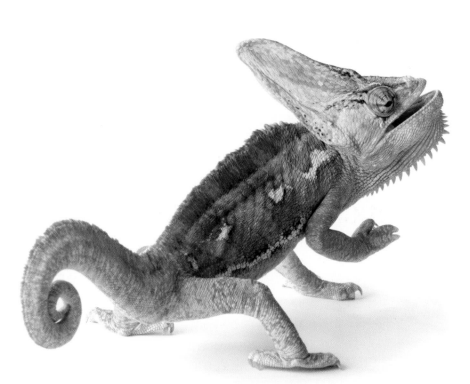

**Veiled chameleon**
*(Chamaeleo calyptratus)* LC

# About *the* Author *and* Contributors

**JOEL SARTORE** is a photographer, author, teacher, conservationist, National Geographic Fellow, and regular contributor to *National Geographic* magazine. His hallmarks are a sense of humor and a midwestern work ethic. Joel specializes in documenting endangered species and landscapes around the world. He is the founder of the Photo Ark, a 25-year documentary project to save species and habitat. In addition to the work he has done for *National Geographic,* Joel has contributed to *Audubon* magazine, *Sports Illustrated,* the *New York Times, Smithsonian* magazine, and numerous book projects. Joel is always happy to return from his travels around the world to his home in Lincoln, Nebraska, where he lives with his wife, Kathy, and their three children.

**HARRISON FORD** is vice chair of Conservation International and a passionate advocate for nature. He has served with the board of Conservation International for 25 years. He is dedicated to raising awareness among government and business leaders that there is a direct connection between international conservation failures and the consequent threats to national and economic security. He believes, "Human well-being depends on nature to sustain us. Nature doesn't need people . . . people need nature . . . to survive . . . to thrive."

**DOUGLAS H. CHADWICK** is a wildlife biologist who has studied mountain goats, grizzly bears, wolverines, and harlequin ducks in the Rockies. Chad is also a journalist whose travels on behalf of *National Geographic* have taken him from the heights of the Himalaya to the Congo Basin and Great Barrier Reef. He has written 13 books and hundreds of magazine articles. He is a founding board member of the Vital Ground Foundation, a conservation land trust protecting wildlife habitat in the western United States and Canada, and serves on the advisory board of the Liz Claiborne Art Ortenberg Foundation, which funds conservation projects around the globe.

# Acknowledgments

How to thank a cast of literally thousands in this amount of space? Impossible. So instead, let me just say this: I'm grateful to the staff at zoos, aquariums, private breeders, and wildlife rehab centers for allowing me access to the animals they care for, with quiet dignity and diligence, for years on end. It's important that you support organizations like this in your own hometown; far too often, they are fighting on the very front lines of the extinction crisis.

I'm grateful to the many partners who have invested in the Photo Ark, from private donors to the staff at the National Geographic Society, Defenders of Wildlife, Conservation International, the Oceanic Preservation Society, and the National Audubon Society, to name just a few.

I'm grateful to those who have worked on this project unfailingly for years, from our scientific adviser Pierre de Chabannes to the staff of Joel Sartore Photography, and to my wife, Kathy, daughter, Ellen, and son Spencer, for tolerating my being gone at least half the year for as long as they can remember. And to son Cole, who has been with me on the road more than anyone else.

And finally, I'm grateful to my parents, John and Sharon Sartore, who instilled in me a love for nature and taught me to value hard work. They gave me a flying start.

My deepest thanks to all of you.

–J.S.

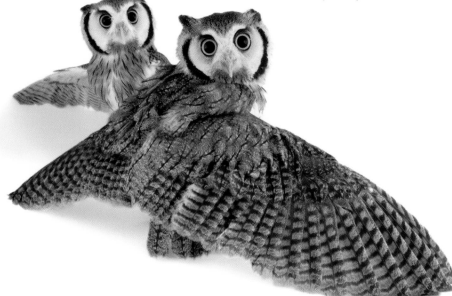

**Northern white-faced owls**
*(Ptilopsis leucotis)* LC

# Index *of* Animals

Here we list, in the order they appear in the book, the common name of each species, the place where the photograph was taken and, as possible, the website of that location.

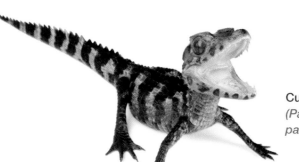

**Cuvier's dwarf caiman**
*(Paleosuchus palpebrosus)* LC

**56: Small spine sea star,** Gulf Specimen Marine Lab and Aquarium, Panacea, Florida | *www.gulfspecimen.org*

**58: African leopard,** Houston Zoo, Houston, Texas | *www.houstonzoo.org*

**59: Bobtail squid,** Monterey Bay Aquarium, Monterey, California | *www.montereybayaquarium.org*

**60-61: François' langurs,** Omaha's Henry Doorly Zoo & Aquarium, Omaha, Nebraska | *www.omahazoo.com*

**62: Deertoe mussel,** Missouri State University, Springfield, Missouri

**63: Budgett's frog,** National Aquarium, Baltimore, Maryland | *www.aqua.org*

**64: Great green macaw,** Tracy Aviary, Salt Lake City, Utah | *www.tracyaviary.org*

**65: Military macaw,** Denver Zoo, Denver, Colorado | *www.denverzoo.org*

**66: Giant deep-sea roach,** Virginia Aquarium, Virginia Beach, Virginia | *www.virginiaaquarium.com*

**67: Southern three-banded armadillo,** Lincoln Children's Zoo, Lincoln, Nebraska | *www.lincolnzoo.org*

**68-9: American flamingos,** Lincoln Children's Zoo, Lincoln, Nebraska | *www.lincolnzoo.org*

**70: Black-throated monitor,** Kansas City Zoo, Kansas City, Missouri | *www.kansascityzoo.org*

**71: Common striped possum,** Omaha's Henry Doorly Zoo & Aquarium, Omaha, Nebraska | *www.omahazoo.com*

**72: Pink-tipped anemone,** Gulf Specimen Marine Lab and Aquarium, Panacea, Florida | *www.gulfspecimen.org*

**73: East African crowned crane,** Kansas City Zoo, Kansas City, Missouri | *www.kansascityzoo.org*

**74: Leopard cat,** private collection

**75: Bald eagle,** George Miksch Sutton Avian Research Center, Bartlesville, Oklahoma | *www.suttoncenter.org*

**78-9: American bison,** Oklahoma City Zoo, Oklahoma City, Oklahoma | *www.okczoo.com*

**80: Owl butterflies,** Audubon Butterfly Garden & Insectarium, New Orleans, Louisiana | *www.audubonnatureinstitute.org*

**81: Great horned owl,** Raptor Recovery, Bellevue, Nebraska | *www.fontenelleforest.org*

**82-3: Asian arowana,** Tennessee Aquarium, Chattanooga, Tennessee | *www.tnaqua.org*

**84: Red-bellied lemur,** Duke Lemur Center, Durham, North Carolina | *lemur.duke.edu*

**85: Blue-eyed black lemur,** Duke Lemur Center, Durham, North Carolina | *lemur.duke.edu*

**86: Rainbow grasshopper,** Spring Creek Prairie, Denton, Nebraska

**86: Obscure bird grasshopper,** Spring Creek Prairie, Denton, Nebraska

**86: Red-legged grasshopper,** Spring Creek Prairie, Denton, Nebraska

**86: Gray bird grasshopper,** Cincinnati Zoo, Cincinnati, Ohio | *www.cincinnatizoo.org*

**86: Dragon-headed katydid,** Omaha's Henry Doorly Zoo & Aquarium, Omaha, Nebraska | *www.omahazoo.com*

**86: Eastern lubber grasshopper,** Audubon Nature Institute, New Orleans, Louisiana | *www.audubonnatureinstitute.org*

**86: Haldeman's shieldback katydid,** Dallas Zoo, Dallas, Texas | *www.dallaszoo.com*

**86: Katydid,** Gamboa, Panama

**86: Cudweed grasshopper,** Spring Creek Prairie, Denton, Nebraska

**87: Shore shrimp,** Sedge Island Natural Resource Education Center, Sedge Islands Marine Conservation Zone, Barnegat Bay, New Jersey | *www.njfishandwildlife.com/sedge.htm*

**87: Peppermint shrimp,** Columbus Zoo and Aquarium, Powell, Ohio | *www.columbuszoo.org*

**87: Mantis shrimp,** Monterey Bay Aquarium, Monterey, California | *www.montereybayaquarium.org*

**87: Scarlet cleaner shrimp,** Nebraska Aquatic Supply, Omaha, Nebraska | *www.nebraskaaquatic.com*

**87: Candy-striped shrimp,** Alaska SeaLife Center, Seward, Alaska | *www.alaskasealife.org*

**87: Sand shrimp,** Sedge Island National Resource Education Center, Sedge Islands Marine Conservation Zone, Barnegat Bay, New Jersey | *www.njfishandwildlife.com/sedge.htm*

**87: Blue wood shrimp,** Pure Aquariums, Lincoln, Nebraska

**87: Red banded snapping shrimp,** Pure Aquariums, Lincoln, Nebraska

**87: Coonstripe shrimp,** Alaska SeaLife Center, Seward, Alaska | *www.alaskasealife.org*

**88-9: Common warthogs,** Columbus Zoo and Aquarium, Powell, Ohio | *www.columbuszoo.org*

**90: White-bellied pangolins,** Pangolin Conservation, St. Augustine, Florida | *www.pangolinconservation.org*

**91: Pygmy hippopotamuses,** Omaha's Henry Doorly Zoo & Aquarium, Omaha, Nebraska | *www.omahazoo.com*

**92: Vietnamese mossy frog,** Houston Zoo, Houston, Texas | *www.houstonzoo.org*

**93: Mexican hairy dwarf porcupine,** Philadelphia Zoo, Philadelphia, Pennsylvania | *www.philadelphiazoo.org*

**94: Delacour's langur,** Endangered Primate Rescue Center, Cuc Phuong National Park, Vietnam | *www.cucphuongtourism.com*

**95: Malay tapir,** Omaha's Henry Doorly Zoo & Aquarium, Omaha, Nebraska | *www.omahazoo.com*

**96-7: Standing's day geckos,** Plzeň Zoo, Plzeň, Czech Republic | *www.zooplzen.cz*

**98: Big brown bat,** Nebraska Wildlife Rehab, Louisville, Nebraska | *www.nebraskawildliferehab.org*

**99: Clouded leopard,** Houston Zoo, Houston, Texas | *www.houstonzoo.org*

**100: Side-striped palm pit viper,** Houston Zoo, Houston, Texas | *www.houstonzoo.org*

**101: Short-beaked echidna,** Melbourne Zoo, Parkville, Australia | *www.zoo.org.au/melbourne*

**102-103: Yellow-bellied slider,** Riverbanks Zoo and Garden, Columbia, South Carolina | *www.riverbanks.org*

**104: Javan rhinoceros hornbill,** Cincinnati Zoo, Cincinnati, Ohio | *www.cincinnatizoo.org*

**105: Ariel toucan,** Dallas World Aquarium, Dallas, Texas | *www.dwazoo.com*

**106: Greater bilby,** Dreamworld, Queensland, Australia | *www.dreamworld.com.au*

**106: Red kangaroo,** Rolling Hills Zoo, Salina, Kansas | *www.rollinghillswildlife.com*

**106: Springhare,** Omaha's Henry Doorly Zoo & Aquarium, Omaha, Nebraska | *www.omahazoo.com*

**106: Matschie's tree kangaroo,** Lincoln Children's Zoo, Lincoln, Nebraska | *www.lincolnzoo.org*

**107: Four-toed jerboa,** Plzeň Zoo, Plzeň, Czech Republic | *www.zooplzen.cz*

**108-109: Jaguarundis,** Bear Creek Feline Center, Panama City, Florida | *www.bearcreekfelinecenter.org*

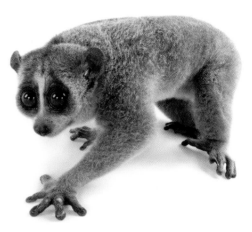

**Pygmy slow loris**
*(Nycticebus pygmaeus)* VU

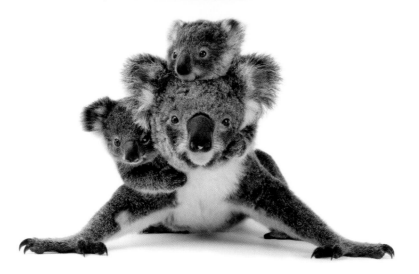

## Koalas *(Phascolarctos cinereus)* VU

230: **Northern tamandua,** Summit Municipal Park, Gamboa, Panama

231: **Coquerel's sifaka,** Houston Zoo, Houston, Texas | *www.houstonzoo.org*

232: **Spanish shawl nudibranch,** Research Experience and Education Facility, University of California, Santa Barbara | *www.msi.ucsb.edu/reef*

232: **Regal goddess nudibranch,** Gulf Specimen Marine Lab and Aquarium, Panacea, Florida | *www.gulfspecimen.org*

232: **California aglaja nudibranch,** Research Experience and Education Facility, University of California, Santa Barbara | *www.msi.ucsb.edu/reef*

232: **California sea hare,** Research Experience and Education Facility, University of California, Santa Barbara | *www.msi.ucsb.edu/reef*

232: **Hopkin's rose nudibranch,** Research Experience and Education Facility, University of California, Santa Barbara | *www.msi.ucsb.edu/reef*

232: **Lettuce sea slug,** Gulf Specimen Marine Lab and Aquarium, Panacea, Florida | *www.gulfspecimen.org*

232: **Warty nudibranch,** Gulf Specimen Marine Lab and Aquarium, Panacea, Florida | *www.gulfspecimen.org*

232: **Lion's mane nudibranch,** Alaska SeaLife Center, Seward, Alaska | *www.alaskasealife.org*

233: **Leopard slug,** St. Louis Zoo, St. Louis, Missouri | *www.stlzoo.org*

234: **Asian elephant,** Los Angeles Zoo, Los Angeles, California | *www.lazoo.org*

235: **Black and rufous elephant shrew,** Omaha's Henry Doorly Zoo & Aquarium, Omaha, Nebraska | *www.omahazoo.com*

236: **Red sea urchin,** Research Experience and Education Facility, University of California, Santa Barbara | *www.msi.ucsb.edu/reef*

237: **Atlantic sea spider,** Gulf Specimen Marine Lab and Aquarium, Panacea, Florida | *www.gulfspecimen.org*

238: **Pin-tailed whydahs,** Sylvan Heights Bird Park, Scotland Neck, North Carolina | *www.shwpark.com*

239: **Blue capped cordonbleus,** Sylvan Heights Bird Park, Scotland Neck, North Carolina | *www.shwpark.com*

242: **Hispaniolan hutia,** National Zoological Park, Santo Domingo, Dominican Republic | *www.zoodom.gov.do*

243: **Hispaniolan solenodon,** National Zoological Park, Santo Domingo, Dominican Republic | *www.zoodom.gov.do*

244: **Forest red-tailed black cockatoo,** Tracy Aviary, Salt Lake City, Utah | *www.tracyaviary.org*

245: **Long-billed corella,** Healesville Sanctuary, Healesville, Australia | *www.zoo.org.au/healesville*

246-7: **Banded leaf-toed gecko,** Bioko Island, Equatorial Guinea

248: **Strawberry poison dart frog,** Omaha's Henry Doorly Zoo & Aquarium, Omaha, Nebraska | *www.omahazoo.com*

249: **Strawberry poison dart frog,** private collection

249: **Strawberry poison dart frog (yellow phase),** National Aquarium, Baltimore, Maryland | *www.aqua.org*

249: **Strawberry poison dart frog,** National Aquarium, Baltimore, Maryland | *www.aqua.org*

249: **Strawberry poison dart frog (La Gruta morph),** private collection

249: **Strawberry poison dart frog (Almirante morph),** private collection

249: **Strawberry poison dart frog (Bruno morph),** private collection

249: **Strawberry poison dart frog (Rio Branco morph),** private collection

249: **Strawberry poison dart frog (Blue phase),** National Aquarium, Baltimore, Maryland | *www.aqua.org*

249: **Strawberry poison dart frog (Bri Bri morph),** private collection

250: **Volcan Darwin tortoise,** Gladys Porter Zoo, Brownsville, Texas | *www.gpz.org*

251: **Aquatic box turtle,** Gladys Porter Zoo, Brownsville, Texas | *www.gpz.org*

252: **Utah milk snake,** Los Angeles Zoo, Los Angeles, California | *www.lazoo.org*

253: **Eastern coral snake,** Riverbanks Zoo and Garden, Columbia, South Carolina | *www.riverbanks.org*

254: **African lion,** Omaha's Henry Doorly Zoo & Aquarium, Omaha, Nebraska | *www.omahazoo.com*

256-7: **Grackles,** private collection

## CURIOSITIES

259: **Fruit bat,** Bioko Island, Equatorial Guinea

259: **Secretary bird,** Toronto Zoo, Toronto, Canada | *www.torontozoo.com*

260: **Waxy monkey frog,** Rolling Hills Zoo, Salina, Kansas | *www.rollinghillswildlife.com*

262: **Eastern long-beaked echidna,** Taronga Zoo, Mosman, Australia | *www.taronga.org.au*

263: **Platypus,** Healesville Sanctuary, Healesville, Australia | *www.zoo.org.au/healesville*

264: **Red celestial eye goldfish,** Ocean Park, Hong Kong | *www.oceanpark.com.hk*

265: **Spectral tarsier,** Wildlife Reserves Singapore, Singapore | *www.wrs.com.sg*

266-7: **Horned screamer,** National Aviary of Colombia, Barú, Colombia | *www.acopazoa.org*

268: **African moon moth,** Omaha's Henry Doorly Zoo & Aquarium, Omaha, Nebraska | *www.omahazoo.com*

269: **Malaysian horned frog,** private collection

270: **Curl-crested araçari,** Dallas World Aquarium, Dallas, Texas | *www.dwazoo.com*

271: **Rio Fuerte beaded lizard,** Sedgwick County Zoo, Wichita, Kansas | *www.scz.org*

272: **Bat star,** Indianapolis Zoo, Indianapolis, Indiana | *www.indianapoliszoo.com*

272: **Pacific blood star,** Indianapolis Zoo, Indianapolis, Indiana | *www.indianapoliszoo.com*

272: **Rainbow sea star,** Minnesota Zoo, Apple Valley, Minnesota | *www.mnzoo.org*

272: **Cushion starfish,** Alaska SeaLife Center, Seward, Alaska | *www.alaskasealife.org*

273: **Purple sea star,** Blank Park Zoo, Des Moines, Iowa | *www.blankparkzoo.com*

273: **Leather starfish,** Boonshoft Museum of Discovery, Dayton, Ohio | *www.boonshoftmuseum.org*

273: **Vermillion sea star,** Indianapolis Zoo, Indianapolis, Indiana | *www.indianapoliszoo.com*

273: **Green and gold brittle star,** Indianapolis Zoo, Indianapolis, Indiana | *www.indianapoliszoo.com*

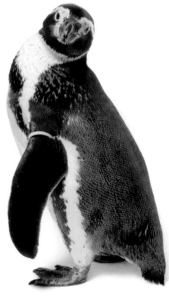

**Humboldt penguin**
*(Spheniscus humboldti)* VU

274-5: **Halloween pennant dragonfly,** Kissimmee Prairie Preserve State Park, Okeechobee, Florida | *www.floridastateparks.org*

276: **Gray-shanked douc langur,** Endangered Primate Rescue Center, Cuc Phuong National Park, Vietnam | *www.cucphuongtourism.com*

278: **Satanic leaf-tailed gecko,** Houston Zoo, Houston, Texas | *www.houstonzoo.org*

279: **Beaded gecko,** Conservation Fisheries, Knoxville, Tennessee | *www.conservation fisheries.org*

280: **Malay tapir,** Minnesota Zoo, Apple Valley, Minnesota | *www.mnzoo.org*

281: **Rio Xingu River stingray,** Dallas World Aquarium, Dallas, Texas | *www.dwazoo.com*

282-3: **Indian gharials,** Kukrail Gharial and Turtle Rehabilitation Center, Lucknow, India

284: **Red-headed uakari,** Los Angeles Zoo, Los Angeles, California | *www.lazoo.org*

285: **Gang-gang cockatoo,** Parrots in Paradise, Glass House Mountains, Australia | *www.parrotsinparadise.net*

286: **Bush hyrax,** Plzeň Zoo, Plzeň, Czech Republic | *www.zooplzen.cz*

287: **African elephant,** Indianapolis Zoo, Indianapolis, Indiana | *www.indianapoliszoo.com*

288-9: **Whooping crane,** Audubon Nature Institute, New Orleans, Louisiana | *www.audubonnatureinstitute.org*

290: **Dall's sheep,** Alaska Zoo, Anchorage, Alaska | *www.alaskazoo.org*

291: **Black-crowned Central American squirrel monkey,** Summit Municipal Park, Gamboa, Panama

292-3: **Aye-ayes,** Omaha's Henry Doorly Zoo & Aquarium, Omaha, Nebraska | *www.omahazoo.com*

294: **Blue-faced honeyeater,** Plzeň Zoo, Plzeň, Czech Republic | *www.zooplzen.cz*

295: **Turquoise dwarf gecko,** Cheyenne Mountain Zoo, Colorado Springs, Colorado | *www.cmzoo.org*

296: **Eyed saturnian moth,** Insectarium, Mindo, Pichincha, Ecuador

297: **Wolf spider,** Archbold Biological Station, Venus, Florida | *www.archbold-station.org*

298-9: **Giant Pacific octopus,** Dallas World Aquarium, Dallas, Texas | *www.dwazoo.com*

300: **Asian elephant,** Singapore Zoo, Singapore | *www.zoo.com.sg*

301: **Malay civet,** Singapore Zoo, Singapore | *www.zoo.com.sg*

302-303: **Glass catfish,** Wildlife Reserves Singapore, Singapore | *www.wrs.com.sg*

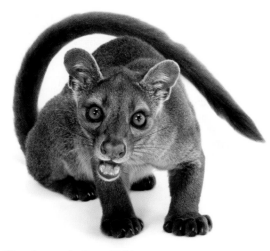

**Fossa** *(Cryptoprocta ferox)* VU

304: **Long-spine porcupinefish,** Nebraska Aquatic Supply, Omaha, Nebraska | *www.nebraskaaquatic.com*

305: **Black-fingered mud crab,** Gulf Specimen Marine Lab and Aquarium, Panacea, Florida | *www.gulfspecimen.org*

305: **Slate pencil urchin,** Gulf Specimen Marine Lab and Aquarium, Panacea, Florida | *www.gulfspecimen.org*

306: **Asiatic lion,** Kamla Nehru Zoological Garden, Ahmedabad, India | *www.ahmedabadzoo.in*

307: **Sulawesi stripe-faced fruit bat,** Plzeň Zoo, Plzeň, Czech Republic | *www.zooplzen.cz*

308: **Nelson's milk snake,** Seattle, Washington

308: **Eastern gray kangaroo,** Columbus Zoo and Aquarium, Powell, Ohio | *www.columbuszoo.org*

308: **Green frog,** National Aquarium, Baltimore, Maryland | *www.aqua.org*

308: **Monocled cobra,** Omaha's Henry Doorly Zoo & Aquarium, Omaha, Nebraska | *www.omahazoo.com*

309: **Red-tailed hawk,** Minnesota Zoo, Apple Valley, Minnesota | *www.mnzoo.org*

310-11: **Golden snub-nosed monkeys,** Ocean Park, Hong Kong | *www.oceanpark.com.hk*

312: **Verreaux's eagle-owl,** Zoo Atlanta, Atlanta, Georgia | *www.zooatlanta.org*

313: **Pink sponge,** Gulf Specimen Marine Lab and Aquarium, Panacea, Florida | *www.gulfspecimen.org*

314: **Ostrich,** Omaha's Henry Doorly Zoo & Aquarium, Omaha, Nebraska | *www.omahazoo.com*

315: **Grant's zebra,** Cheyenne Mountain Zoo, Colorado Springs, Colorado | *www.cmzoo.org*

316-17: **Clouded leopard,** Columbus Zoo and Aquarium, Powell, Ohio | *www.columbuszoo.org*

318: **Giant snake-necked turtle,** Tennessee Aquarium, Chattanooga, Tennessee | *www.tnaqua.org*

319: **Müller's gray gibbon,** Miller Park Zoo, Bloomington, Illinois | *www.mpzs.org*

320-21: **Naked mole rat,** St. Louis Zoo, St. Louis, Missouri | *www.stlzoo.org*

322: **Victoria crowned pigeon,** Columbus Zoo and Aquarium, Powell, Ohio | *www.columbuszoo.org*

323: **Spotted jellyfish,** Omaha's Henry Doorly Zoo & Aquarium, Omaha, Nebraska | *www.omahazoo.com*

324: **African spoonbills,** Houston Zoo, Houston, Texas | *www.houstonzoo.org*

325: **Proboscis monkey,** Singapore Zoo, Singapore | *www.zoo.com.sg*

326-7: **Orange spotted filefish,** Omaha's Henry Doorly Zoo & Aquarium, Omaha, Nebraska | *www.omahazoo.com*

328: **Silvery gibbon,** Gibbon Conservation Center, Santa Clarita, California | *www.gibboncenter.org*

329: **Frilled lizard,** Lincoln Children's Zoo, Lincoln, Nebraska | *www.lincolnzoo.org*

330: **Hylomantis hulli,** Pontifical Catholic University of Ecuador, Quito, Ecuador | *www.puce.edu.ec*

330: **Dyeing poison frog,** private collection

330: **Shreve's Sarayacu tree frog,** private collection

330: **Chiricahua leopard frog,** Phoenix Zoo, Phoenix, Arizona | *www.phoenixzoo.org*

330: **San Lucas marsupial frog,** Pontifical Catholic University of Ecuador, Quito, Ecuador | *www.puce.edu.ec*

330: **Diablito,** private collection

## STORIES OF HOPE

## ADDITIONAL PHOTO CREDITS

All photographs by Joel Sartore except the following: 76, Ellen Sartore; 170, Ashima Narain; 171 (LO), Ashima Narain; 240, Cole Sartore; 241 (LO), Cole Sartore; 300, Lim Sin Thai/The *Straits Times*; 361 (LO), Rebecca L. Wright; 391 (UP), Cole Sartore; 391 (CT), Courtesy Conservation International.

Since 1888, the National Geographic Society has funded more than 12,000 research, exploration, and preservation projects around the world. National Geographic Partners distributes a portion of the funds it receives from your purchase to National Geographic Society to support programs including the conservation of animals and their habitats.

National Geographic Partners
1145 17th Street NW
Washington, DC 20036-4688 USA

Become a member of National Geographic and activate your benefits today at natgeo.com/jointoday.

For information about special discounts for bulk purchases, please contact National Geographic Books Special Sales: specialsales@natgeo.com

For rights or permissions inquiries, please contact National Geographic Books Subsidiary Rights: bookrights@natgeo.com

ISBN: 978-1-4262-1777-7

Printed in the United States of America

17/LSCK-LSCML/2

**Prevost's squirrel**
*(Callosciurus prevostii)* LC